RENOIR

RENOIR

His Life and Works

FRANCESCA CASTELLANI

AN IMPRINT OF RUNNING PRESS
PHILADELPHIA · LONDON

First published in the United States in 1998 by Courage Books

All rights reserved under the Pan-American and International Copyright Conventions

Printed in Spain by Artes Graficas Toledo S.A.
D.L.TO: 805-1998

9 8 7 6 5 4 3 2 1

Digit on the right indicates the number of this printing

Library of Congress Cataloging -in-Publication Number 97-77964

ISBN 0-7624-0332-2

Published by Courage Books, an imprint of
Running Press Book Publishers
125 South Twenty-second Street
Philadelphia, Pennsylvania 19103-4399

CONTENTS

PREFACE

In 1952 an English film, The Glory of Renoir, gave a "present-day"
interpretation of the artist by comparing his canvases of Paris with the views
a visitor to the city can still see. Less than one hundred years earlier, in 1879,
Renoir's brother Edmond had created the lasting image of Renoir as the
"painter of modern life": "What he has painted can be seen every day it is our
very existence..." Thus was born Renoir's fame as the immediate interpreter of
everyday life, the instinctive and sensual translator of the most ephemeral,
pleasurable and entertaining aspects of his epoch; a painter "after nature" who
was able to record the moment in its very becoming, along the lines of the well-
established touchstone used to judge Impressionism. However, as correct as
this interpretation may be, it ended up leveling Renoir's artistic and stylistic
achievements to the common denominator of his most famous canvases,
delimiting his oeuvre solely to the blithe, luxuriant representation of flowers,
dances and splendid women and thus transforming his greatest quality—
lightness—into a drawback. Renoir's canvases therefore shared the judgment
often made of eighteenth-century painting, which had so influenced him
during his apprenticeship years as a porcelain decorator: pleasant art that
hardly "scratches the surface."
Certainly, Renoir's works do not have what we today would call a "social
message"; if anything, their "message" is painting itself and in this sense
are intrinsically modern. But we must not overlook the intentional,
even programmatic, aims that lay behind his choice of certain motifs:
the large-scale scenes of contemporary life conceived as modern counterparts
of historical paintings that set out to impart classical monumentality to
everyday life; the amazing analytical capacity he called into play even in the
"occasional" portraits that is so subtly revealed in certain details, be they
elaborate lacework or a corner of a salon bathed in light. Renoir's objectivity
only seems to be spontaneous, its lucid and rational nature is "masked" by the
fluency and facility of his rendering. Thus his dazzling talent often pushes
into the background the innovative and absolutely experimental character
of some of his Impressionist canvases. Nude in the Sunlight, a female bust
"blotched" with brushstrokes, is a bold, precocious work, a major breakthrough
in art, which is why the critics heaped abuse on it at the second Impressionist
exhibition in 1876; and with the vibrant canvases executed in 1869 at
La Grenouillère together with Monet, Renoir embarked on the path of the new
Impressionist style.
Therefore, in line with recent art criticism, we should give Renoir his due by
acknowledging his complexity both as an artist and as a man—eminently and
consciously modern and at the same time imbued with a nostalgia for
the past and a passion for the old masters; and capable of questioning his
achievements, such as during the crisis of his aigre period when, despite
having gained success with his Impressionist works, he turned to a new
rigorous style based on design: this is Renoir, an artist faithful to himself and
to his inner striving, but always receptive to the new, gifted with the humility
of an apprentice and with the love of, and pride in, his craftsmanship.

Francesca Castellani

"SOFT, GRACIOUS" PAINTING

The "Workman of Painting"

This statement—which Renoir never tired of repeating to friends, critics and to his son Jean (who collected his father's memoirs in a lively and touching book)—is a rare and accurate description of the man and, above all, of his art. For Renoir, art was not an inspired mission, but a

♦ *Pierre-Auguste Renoir in 1875, when he was thirty-four. A self-portrait executed the same year, now kept in Williamstown, Mass., shows him with the same emaciated features and keen, absorbed glance.*

"trade" practiced with the humility and devotion of an apprentice, the artist's senses receptive to the suggestions of the material rather than to the rules of the schools or intellectual theories of his time. In fact, Renoir played a role in "avant-garde" art precisely because he trusted his eyes and hands more than any preconceived ideas; he transcended the prevailing conventions of nineteenth-century art, imparting the need for everyday reality, and then took the revolutionary path of Impressionism; when this movement began to run the risk of becoming fossilized, he broke away from it to embark on an utterly personal and new artistic procedure. Perhaps Renoir's deep-seated love for

simplicity, or the "candour" that the critic Arsène Alexandre so appreciated as late as 1892, may only be explained by his modest origins. Auguste's paternal grandfather François made wooden shoes and, despite his boasting a hypothetical noble descent, was a foundling. His father Léonard was a tailor and his mother Marguerite a seamstress, one of the *grisettes* whose poetic image was so popular in Naturalist painting and literature. This did not prevent the couple's many children from becoming rather successful in their various fields (unlike what occurs in Zola's novels, where a person's destiny was marked by his environment): the eldest child, Pierre-Henri, became a goldsmith's engraver, Lise and Victor tailors and fashion designers; and this was especially true of the two youngest, Auguste and Edmond, the latter becoming a respected journalist who often supported his brother's artistic and aesthetic battles. Pierre-Auguste was born on February 25, 1841, when his family was still living in Limoges; three years later his father decided to move to Paris, in the neighborhood of the old Louvre,

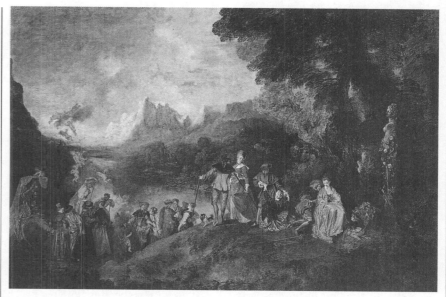

where Edmond was born in 1849. However, Auguste's birthplace played a role in his future. While attending a Catholic school in Paris his good voice and musical aptitude impressed no less a figure than the composer Charles Gounod (who later became renowned for his operas *Faust* and *Romeo and Juliet*), who at the time was choirmaster at St.-Eustache church. Gounod invited the boy to join his prestigious choir. We do not know whether it was due to his family or Auguste himself (as Renoir's son Jean claims) that Renoir did not become a musician. At any rate, his father's pride in the Limoges tradition and his own talent for drawing led the boy to

♦ *Jean-Antoine Watteau, Embarkation for Cythera, 1717. Oil on canvas, 124 x 129 cm (49 x 51 in). Musée du Louvre, Paris. The French rococo master captures the vanity of human desire through a high-keyed palette with light, airy tonalities. Renoir loved this work, which also influenced other artists such as Fantin-Latour.*

♦ *Pieter Paul Rubens, Enthronement of Marie de' Medici (from the History of Marie de' Medici cycle), 1621-25. Oil on canvas, 394 x 702 cm (155 x 276 in). Musée du Louvre, Paris. In 1861 Renoir, who had just begun studying in Gleyre's atelier, made a copy of this work, which was also copied by other artists such as Cézanne.*

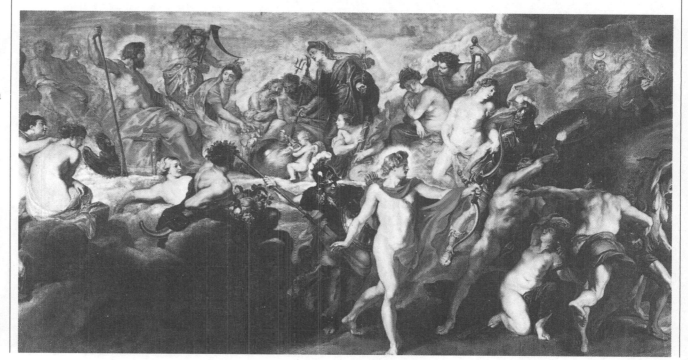

Artistic Organization in Nineteenth-century France

♦ *The Salon in the École des Beaux-Arts, with the plaster casts the students copied. The practice of making line drawing copies of casts of the most famous* *classical sculpture (and only then going on to copy the masterpieces of painting) was one of the cornerstones of nineteenth-century academic instruction.*

10

Among the institutions that regulated the "fine arts" in nineteenth-century France, the oldest and most prestigious was the Académie. Founded in 1648 under Louis XIV as the Académie Royale, it was abolished after the French Revolution in 1793 because it was considered a symbol of the élite (although restricted entry was adopted in the 1800s). Instruction in the fine arts, which had been the exclusive task of the Academy, was now transferred to the École Spéciale des Beaux-Arts.

The State became more and more involved in artistic education and therefore in the creation of a "national style" that would be able to attain public approval.

The educational precepts of the École were established from 1816 to 1819, under the guidance of Quatremère de Quincy. However, the subjects taught remained traditional: drawing instead of painting, which consisted in copying from ancient or live models, but according to the "careful selection of natural elements." The courses, held in the evening, were held by twelve teachers, each of whom taught for one month. Other "special" courses ranged from anatomy to perspective, ancient history and mythology. Academic studies were complemented by private instruction in the ateliers, where the pupils were under the guidance of a single teacher and could complete their training with experience in painting, passing from drawing to sketches and "*composition.*" Before 1863 painting was excluded from the École courses, but was part of the complex system regulating its hierarchy by means of competitions. In order to encourage emulation, the Académie established annual prizes and scholarships that singled out the best stu-

dents. The most important of these was the Prix de Rome, which to this day consists of a three-year stay in Rome. The winner of this scholarship first had to pass a test in "*composition*" and then complete a painting in 72 days.

Although this careful instruction guaranteed knowledge of the "metier," it inevitably led to a uniformity of style with a specific, dominating taste, the so-called golden mean; this marked the apogee of art pompier, as it was called in ironic Parisian slang—painting that aspired to ancient models, with a plethora of helmets, like a parade of firemen (pompiers).

The success and status of a painter was linked to the system of exhibitions that revolved around another public institution, the annual Salon. Established on a regular basis in 1747, the Salon grew out of a spirit of "democratic guarantee," and was thus open to anyone; but the initial selection of works on the basis of their so-called quality, as well as the awarding of prizes, was the task of a jury. As is only natural, the jury consisted for the most part of Academy members, hence the sensational protest of the excluded artists that culminated in Napoleon III's granting an exhibition for them, the 1863 Salon des Refusés. Up to the 1890s the Salon was the showcase that assured an artist fame and success as well as the place where works of art could be purchased. This contradictory two-fold function ended up undermining the prestige of the Salon; in 1881 it was entrusted to a private firm and no longer under the aegis of the government, which now concentrated on the Exposition Universelle—the centenary of which in 1900 marked the official consecration of Impressionism.

try his hand at being a craftsman. He become a porcelain painter for the Lévy brothers in the Marais quarter of Paris. With the advent of the Second Empire in 1854 the Sèvres porcelain factories had been reopened and those in Limoges flourished as well; there was a *revival* of interest in royalty,

and at Paris imitation china in the "pastoral" style and profiles of Marie Antoinette—which the young artisan painted for "three sous per plate"— sold very well.

And, most important, it allowed Renoir to learn the technique of glazing in which the white or

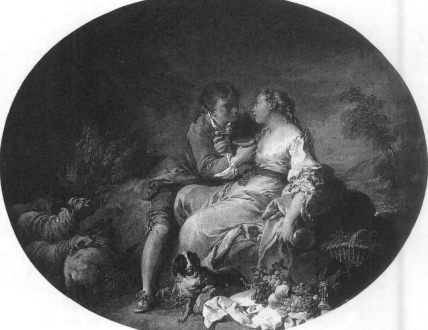

♦ *François Boucher (1703-70), Pastoral Scene. Oil on canvas, 61 x 75 cm (24 x 29 1/2 in). Hermitage, St. Petersburg. "I was brought up on the eighteenth-century masters [...] such as* *Watteau, Lancret and Boucher,"* *Renoir said. He adored Boucher's sublime nonchalance concerning the choice of motifs, which for him were a mere pretext for an exercise in style.*

♦ *Anonymous artist, Forty-three Portraits of Gleyre's Studio. Oil on canvas, 117 x 145 cm (46 x 57 in). Musée du Petit Palais, Paris. "No doubt it's to amuse yourself* *that you dabble in paint?" the Swiss teacher asked his pupil Renoir. "Of course," he replied, "and if it didn't amuse me, I beg you to believe me, I wouldn't do it!"*

transparent layer plays an important role in the luminosity of the colors, which according to Denis Rouart would be part of his art for the rest of his life. Again, it was the porcelain shop that led to Renoir's much more crucial encounter with the vaporous, fluid and precious painting of the French rococo masters with its warm colors and highly illusionary effects: Watteau, Fragonard, Boucher, Lancret, whose women and shepherds, flowery swings and dreamlike trysts were the rage in porcelain production but were "off-limits" as far as official artistic taste was concerned. The revival of the "eighteenth-century style"—which was

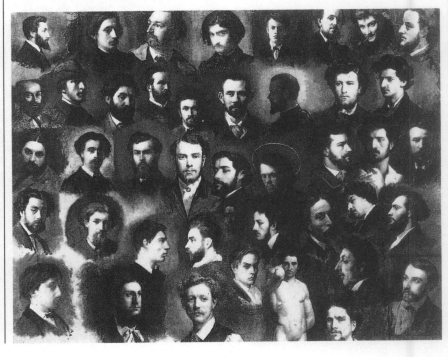

♦ *Pierre-Auguste Renoir, The Pont des Arts, 1867. Oil on canvas, 102 x 62 cm (24 1/2 x 40 1/4 in). Norton Simon Foundation, Los Angeles. In its vivid and summary contrast of light and shadow, this canvas reflects* *Monet's early efforts at plein-air painting (understood as a play of color areas). This was the first Renoir work purchased (in 1872) by Paul Durand-Ruel, the future art dealer of the Impressionists.*

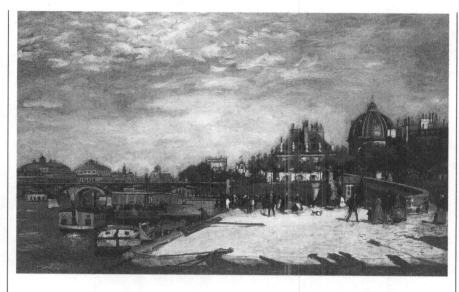

later promoted by the Goncourt brothers and the Parnassian poets and deeply influenced the Symbolist aesthetic—had not yet become fashionable, and perhaps the only artists who drew inspiration from Watteau's *Embarkation for Cythera* were Baudelaire in his verse and Renoir in his porcelain paintings. Traces of the soft, rounded brushstroke, so vibrant with life, or of the precious flashes of red and yellow that makes these masters so enchanting, can certainly be seen in the rich impastos and bright oranges of Renoir's last *Bathers*, as well as in the animated, golden canvases of his full-fledged Impressionist works. Compared to Manet, Monet, Pissarro or Degas, Renoir is much more "French rococo" than "Spanish" (as was early Manet, for example, especially after the Louvre opened its Spanish masters gallery) or "Japanese" (Oriental art influenced mid-eighteenth-century French artists).

From Workman to Student

Young Auguste continued to copy *Embarkation for Cythera*, even after M. Lévy's porcelain decoration shop went bankrupt in 1859 because the hand-work was replaced by machinery and Renoir was obliged to work for the Gilbert firm painting fans and window blinds for missionaries in Indochina, executing "cloud after cloud" with a passion. In the meantime he made extra money decorating cafés (at least twenty, according to his son Jean) with mythological scenes, transforming His talent, which everyone recognized, induced him to as he himself said, and take painting lessons; he was

encouraged to do so by his friends and by his brother-in-law, the engraver Leray. The fact that his family supported this decision is not surprising: in 1860 being a painter could mean fame and riches—provided that one painted in the academic style. So two years later, in 1862, having passed the entrance examination, Renoir enrolled in the École Impériale et Spéciale des Beaux-Arts.

Already in 1854 he had begun taking evening lessons at the School of Drawing and Decorative Arts, perhaps in order to improve his skill as a decorator. Here he met the painter Emile Laporte, who it seems was responsible, together with Renoir's brother-in-law Leray and the old painter Oullevé, for the decisive step he took towards an artistic career. This seems to be confirmed by the fact that when, years later, Laporte was well-known and Renoir was a full-fledged Impressionist, the former said: you had remained faithful to bitumen, you would have become another Rembrandt. What Laporte meant by "bitumen" was the nineteenth-century academic custom of underpainting in black and dark tones in order to impart a craquelure effect that resembled the cracked surface of an old oil painting. Renoir's first canvases

must have been "bituminous": the *Nymph with a Faun* rejected by the 1863 Salon, or *Esmeralda*, inspired by Hugo's *Hunchback of Notre-Dame*, which was accepted by the Salon jury the following year. Both these canvases were subsequently destroyed by Renoir himself. Few works of this

♦ *Pierre-Auguste Renoir, Trees in the Fontainebleau Forest, 1865-66. Oil on canvas. Formerly Christie's Collection, London.* *This forest scene has Corot's dark silver and green hues; the filtering light enhances the pure tonal contrasts.*

early period survive; one is a copy from Rubens's *Marie de' Medici* cycle, which Renoir executed at the Louvre in 1861. The other apprentices at Lévy's porcelain workshop called him "Monsieur Rubens"; this joke took on a deeper meaning, because at the time copying Rubens meant abandoning the "bitumen" procedure in favor of bright

colors, the smooth brush-work and rigid classicism of David's pupils for the rich palette and luxurious compositions of the Flemish master. Copying the great works in the Louvre was recommended by all the teachers at the Academy, and Renoir seems to agree with this when he says: "One learns how to paint at the museum." Recent art criticism has often underscored the influence of the great models of the past, especially the Renaissance masters, on the artists who seemed most committed to illustrating *la vie moderne* and breaking with academic tradition: Marcantonio Raimondi, Titian or Velásquez for Manet, Bronzino or Mantegna for Degas, and Watteau for Monet (certainly upon the suggestion of his friend Renoir). The difference between these artists and the "official" painters, or *pompiers*, who were so successful at the Salons, was that the former did not seek to imitate ancient or old art "as it was," or rather, as one

imagined it was, by pursuing an impossible reconstruction or, even worse, by repeating the dress and poses of past art, but rather set out to glean only the substance of the principles and technique of the old masters in order to "represent their own age more faithfully." Renoir said. "When I say that one learns to paint at the Louvre, I do not mean to say that one should scrape away the surfaces of the canvases in order to wrest their secrets and begin doing Rubens or Raphael once again. One must paint in conformity with one's age. But nature alone cannot provide the taste for painting, it must be acquired at the museum. One cannot say "I am going to become a painter" when observing a lovely place, but only in front of a canvas."

Renoir was certainly not the only one to set his easel in front of a Rubens at the Louvre; among the others who did likewise was Frédéric Bazille, who in 1863 wrote about this in a letter to his father. Auguste had met him at the end

♦ *The street in Marlotte that led to Mère Anthony's Inn. This photograph renders the intimate atmosphere of the village next to Fontainebleau forest that was the starting* *point for those artists in search of "virgin" nature, which they could reproduce unhampered by the conventions and canons of academic art.*

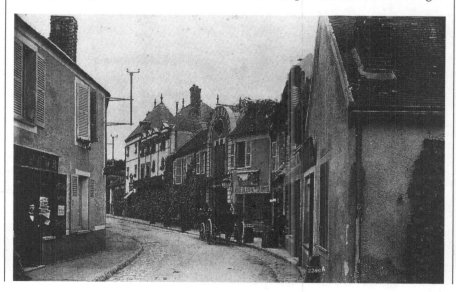

♦ Gustave Courbet, The Artist's Studio, 1885 (detail). Oil on canvas, 361 x 598 cm (141 3/8 x 234 5/8 in). Musée d'Orsay, Paris. The artist at his easel is working on a landscape; it is nature itself—the nude behind him—that inspires his "realistic" vein. Renoir was fascinated and influenced most of all by the master's anti-academic nudes.

of 1862 at Charles Gleyre's studio, where he was preparing for his entrance exam at the École des Beaux-Arts; this old Swiss painter had been teaching for some time but, following his socialist and Saint-Simonian principles, also taught inexpensive private courses. The atmosphere in Gleyre's atelier is vivaciously described in Jean Renoir's book about his father: the anecdotes, the young aspiring artists' pranks, and above all the air of rebellion that the

♦ Art students and copiers in the Louvre, in an illustration in "Harper's Weekly" (January 11, 1868) taken from a work by Winslow Homer. "Painting is not observed, one lives together with it"; this was how Renoir evoked the intensity of a visit to the Louvre. Copying allowed burgeoning artists to penetrate into the technical "secrets" of the great masters.

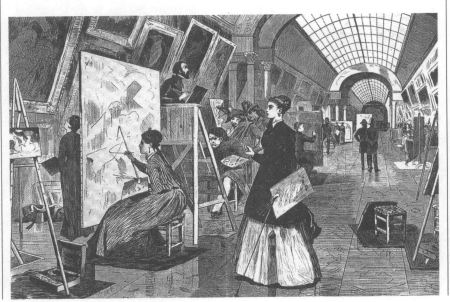

old artist tried in vain to curb but which did not exist elsewhere in the artistic milieu. There was very little in Gleyre's style and aesthetic principles, nurtured in a nostalgia for classicism, that gave an inkling of what his pupils would accomplish. One of the many anecdotes is worth mentioning: Gleyre, though admitting that Renoir had talent, scolded him for painting for his own amusement. Auguste replied: And indeed, a recurring criticism of the artist was precisely his cheerful, almost nonchalant attitude. In 1863 Claude Monet enrolled in Gleyre's atelier, where he caused a sensation with his knowledgeable air of a painter who had already learned from two *plein-air* masters such as Jongkind and Boudin, who worked on the coast of Normandy, using a light and bright palette.

So goes the dialogue between Claude and Sandoz in Emile Zola's novel L'Oeuvre. "Outdoor" painting, as opposed to painting in the studio and drawing "from memory," was at the time the novelty of direct contact with the "truly" natural and was becoming somewhat popular through the romantic interpretation of the so-called Barbizon school. In that same year, 1863, Bazille, Renoir and Monet—soon joined by Gleyre's newest pupil Alfred Sisley, and through him, his friends from the Académie Suisse, Camille Pissarro and Antoine Guillemet—went to the Fontainebleau forest in the summer in search of new visual sensations rather than "emotions" or "states of mind," as they were then called. Whereas the romantics interpreted nature in a literary or dramatic sense, But the localities of Chailly and Barbizon were too crowded and popular, so in 1865 the group moved to Marlotte, near Mother Anthony's Inn, already well-known thanks to Henri Murger's novel *Scènes de la vie de bohème*, and which Renoir immortalized the following year in a painting which seems to have

The Barbizon School Landscapists

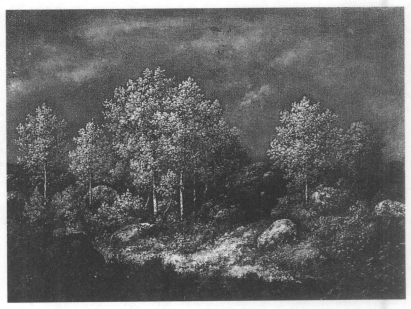

Despite the fact that it was called the "1830 School"—to emphasize the attitude of an entire generation that, disillusioned with the political situation, withdrew into itself—or the "Barbizon School," the group of painters that in the 1830s began to scour the Fontainebleau forest just outside Paris in search of new motifs was not a school in the strict sense of the word. What these artists had in common was the desire to transcend academic conventions, then dominated by the classicism of the mythological or "heroic" landscape, in order to interpret with immediacy the spirit of romantic individualism by shunning working in the studio from memory and painting outdoors in direct contact with nature. However, this was a nature permeated with a literary spirit and not conceived in its purely objective, atmospheric state. "Nature" for these artists meant above all simplicity, purity, a return to the uncontaminated origin of sensations in a world spoiled by artificiality and industrial mechanization. Moving from the "scientific" precision of the Venetians in the late 1700s to romantic pantheism, landscape painting took on emotional overtones. Faithfulness to the observation of nature was translated into an empathy that allowed the artist to penetrate her even more deeply. Théodore Rousseau, considered the leader of the barbizonniers, offered an admirable description of this atmosphere of total participation:
The choice of *plein-air* painting also had an ethical basis—the desire to adhere with total sincerity to nature in its most direct manifestation; an immediacy that becomes rapid,

♦ Narcisse Diaz de la Peña, Jean de Paris Hill, Fontainebleau, 1867. Oil on canvas, 84 x 106 cm (33 x 41 3/4 in). Musée d'Orsay, Paris. Like Renoir, Diaz also learned his craft by painting porcelain. In his maturity he achieved a soft, "neo-rococo" style and was Renoir's favorite Barbizon school artist.

agile treatment which is apparently sloppy but which despite itself cannot conceal its careful, academic compositional structure. Artistic conception became subjective, reflecting the temperament of the artist and viewer; but it was not yet the "pure," non-intimist sensation of the Impressionist eye.

Indebted to the low-keyed tones of the seventeenth-century Dutch masters, the *barbizonniers* became increasingly popular with the advent of Realism. From the flattering opinion of Baudelaire in his debut as art critic at the 1845 Salon, to their consecration in the 1855 Exposition Universelle, Rousseau, Dupré, Troyon, Diaz, Daubigny (and later Millet, and indirectly, Corot) influenced the "Lyons school", Courbet himself, and the Italian "Macchiaioli."

12

been influenced mostly by Courbet's realism. The solid consistency and opaque tones of the color in fact stemmed from the great "spatulator"— as Renoir called Courbet because of his frequent use of the spatula in order to achieve a thicker texture compared to that of the brush. But the master's influence is apparent above all in the crowded composition that does not conform to prevailing hierarchies or conventions: one figure is casually seated with his back to the onlooker and there is even a dog, the crippled Totò, placed prominently in the foreground.

Another canvas of the same period representing Renoir's friend Jules Le Coeur, is much more airy, with delightful effects of sunlight filtering through the leaves, rendered with broad brushstrokes. In this case the major influence was Narcisse Diaz, whom Renoir admired most among the Barbizon school artists, probably

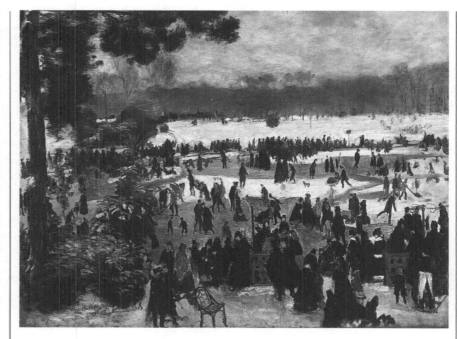

Salon jury, had a lasting influence on him; as late as 1884, during the height of the Impressionists' crisis, Renoir sought for traces of his solid classicism in the landscape of La Rochelle.

The younger generation held another contemporary in almost religious awe: Édouard Manet, Renoir said. In 1863 Manet caused an uproar at the Salon des Refusés with his *Dèjeuner sur l'herbe*, which had dared to "modernize" Giorgione and Titian's Renaissance by depicting modern figures in an everyday situation with the flat brushwork and lack of perspective he had gleaned from Japanese prints. Manet introduced a simplification of tonal contrasts and space. This can be seen, for example, in Renoir's *Portrait of Romaine Lacaux* (1864), where the palette is based on a play of whites and grays, or in the rapid brushwork in the facial features of his father Léonard, whom

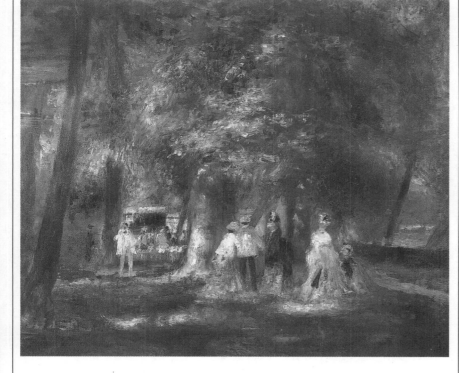

because of his almost blissful neglect of the low-keyed, dramatic tones employed by Rousseau and Daubigny. Diaz, who met Renoir by chance in the Fontainebleau forest, advised him to avoid the "bitumen": "Even the shadows in foliage are luminous." A third work executed at Fontainebleau, representing a clearing glimpsed amidst a group of trees with delicate tones of gray and green light, subdued yet solid, along the regular lines of the trunks, reveals Renoir's indebtedness to Camille Corot, the artist of the so-called school of 1830 most concerned about the purely formal values of landscape painting and the compositional potential of light effects. Renoir later stated. The master, who tried in vain to have Renoir's works accepted by the 1866

he portrayed in 1869, while still under the influence of Manet's contrast between white and black. The impression of lively naturalness as well as refined tonal balance, is particularly striking when compared to the *portrait of William Sisley*, his friend Sisley's father, which was executed in 1864 with the Salon in mind: a praiseworthy canvas that is, however, much more traditional in its dignified pose, accurate rendering of detail, sober tones and finished surface.

Manet's influence is still to be seen in an 1868 work, *Skating in the Bois de Boulogne*, in which the winter landscape once again offers a pretext for an exercise in a palette dominated by whites and grays and in which the composition, with its small, sketchy

♦ *Pierre-Auguste Renoir, Skating in the Bois de Boulogne, 1868. Oil on canvas, 72 x 90 cm (28 7/8 x 36 1/8 in). Private Collection, Basel. The high viewpoint, the color range* reduced to a play of whites and blacks, and the "flattened perspective" effect, reveal the artist's indebtedness to Manet, whom he observed carefully in this period.

♦ *Pierre-Auguste Renoir, The Park in the Saint-Cloud Quarter, 1866. Oil on canvas, 50 x 61 cm (19 x 24 in). Whereabouts unknown. This small canvas, which sets* a modern motif in the fable-like atmosphere of an eighteenth-century fête galante, has the velvety touch and soft light typical of Boucher or Watteau.

♦ *Nadar's studio at 35 Boulevard des Capucines in Paris around 1869. The famous photographer (whose real name was Félix Tournachon), who was also a* journalist, novelist and pioneer in hot-air balloon flights, was only too willing to turn his studio into a gallery for the first Impressionist exhibition, held in 1874.

figures, draws upon the older artist's *Concert in the Tuileries Gardens*; or the magnificent *Woman in a Garden*, in which many critics see the influence of Courbet, but whose masterly contrast between the green of the plants and the dark dress reminds one of the "flattened" passages between figure and background in *Déjeunur sur l'herbe*. When the artists who would later call themselves "impressionists" held a group exhibition in the photographer Nadar's studio in 1874, the art critics once again hastened to consider them "pupils of Manet"—but "disavowed" pupils—thus failing to grasp the originality of an artistic development which, from Manet to Monet, had in fact changed direction, with the young Claude as its true guide.

13

The Gestation of Impressionism

14

Much like what occurs in Murger's novel, for Renoir and his companions this was a *bohemian period*. They spent their time together, shared their friends, studios and often lodgings in the Batignolles quarter (today near Avenue de Clichy). Their evenings were spent at the Café Guerbois (11, rue des Batignolles), where they engaged in heated discussions about painting, which included poking fun at

La nouvelle peinture); painters Félix Bracquemond, Henri Fantin-Latour, Degas, Renoir and Bazille accompanied by his friend Edmond Maître and by Zola; often "fashionable" painters such as Alfred Stevens or Constantin Guys (the "painter of the *vie moderne*" whom Baudelaire admired); lastly, every time they came to Paris, Monet, Sisley and Zola's friend Cézanne went to the café.

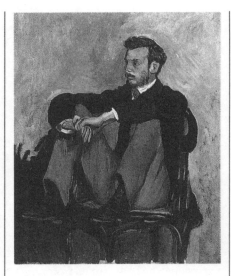

♦ Frédéric Bazille, Portrait of Renoir, 1867. Oil on canvas, 62 x 51.cm (24 1/2 x 20 in). Musée d'Orsay, Paris. Renoir's close friendship with Bazille began in Gleyre's studio and they soon became working companions. Renoir stayed in Bazille's studio from 1866 on, and the following year they executed portraits of each other.

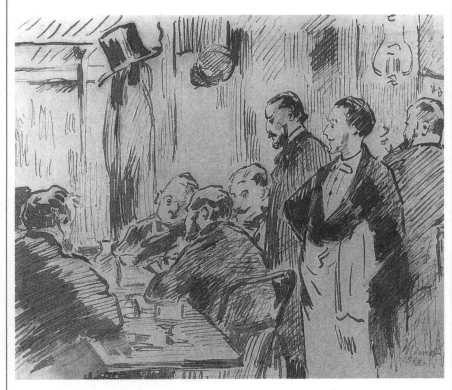

the Academy and the Salons and proclaiming the need for painting *en plein air*. These gatherings were immortalized by a drawing by Manet and by a perspicacious account by Monet: "Nothing could have been more stimulating than the discussions we used to have there, with their constant clashes of opinion. They kept our wits sharpened and supplied us with a stock of enthusiasm that lasted for weeks and kept us going until the final realization of an idea was accomplished. From them we emerged with a stronger determination and with our thoughts clearer and more sharply defined." For the most part the habitués who gathered there consisted of the "leader" Manet surrounded by his admirers: authors and art critics such as Zacharie Astruc, Armand Silvestre, Théodore Duret and the future "spokesman" of the group, Edmond Duranty (who in 1876 wrote the pamphlet defending the new artists,

♦ The Café Guerbois, at 11 Rue des Batignolles (now Avenue de Clichy), in a drawing by Édouard Manet done in 1869; 29.5 x 40.3 cm (11 1/2 x 15 3/4 in). Fogg Art Museum, Cambridge, Mass.

Described by the art critic Armand Silvestre and by Zola in his novel L'Oeuvre (where it is called Café Baudequin), this mythical café was the gathering place for the budding Impressionist group.

♦ Henri Fantin-Latour, A Studio in the Batignolles Quarter, 1869-70 (detail with Renoir in the middle). Oil on canvas, 204 x 273 cm (68 1/2 x 82 1/2 in). Musée d'Orsay, Paris. Fantin-Latour had already met

Renoir during a visit to Gleyre's studio and admired his talent. This canvas—a tribute to Manet, who is seated at the easel surrounded by his fellow artists—dates from the Café Guerbois period.

The solitary and taciturn Cézanne hardly took part in these animated discussions, an attitude that was certainly shared by Renoir. Thus began a friendship that lasted all their lives and continued with their children. Renoir mistrusted theoretical talk, At the same time the excessive criticism of museums and the masters of the past irritated him: "I used to have frequent discussions on this subject with some of my friends who argued in favor of studying only from nature. They criticized Corot for re-working his landscapes in the studio. They found Ingres revolting. I would let them talk on. I thought that Corot was right and secretly delighted in *La Source's* pretty belly and in the neck and arms of Madame Rivière." Renoir was especially attached to Bazille; when Sisley, who shared an apartment with Bazille, got married in 1866, Bazille put Renoir up in his studio at rue Visconti in the Batignolles quarter, where Monet was also a frequent guest. In a letter the generous Bazille wrote to his family, he described this studio as a "real infirmary" and Renoir as a person who—which, given the different economic status of the two, was

probably not true. They also posed for each other: in Bazille's *Portrait of Renoir* (1867) Auguste is represented in a casual pose, but with the intense, absorbed gaze that he has in Fantin-Latour's manifesto-painting, *A Studio in the Batignolles Quarter* (1869-70). In his *Bazille at His Easel*, on the other hand, Renoir depicts his friend with his back partly to the viewer, intent on painting a still life in his studio; the general distribution of space, structured around the horizontal lines of the canvas, the position of the figure, and the rich gamut of grays—call to mind Manet's *Emile Zola*.

Significantly, these burgeoning artists produced an ever increasing number of "portraits of artists" and "views of *ateliers*" which went hand in hand with a new awareness of their craft. A comparison between the famous canvas by Fantin-Latour (who appreciated Renoir, though warning him about the "excessive use of color") and Bazille's *The Artist's Studio, rue de la Condamine* (also executed in 1870) is quite interesting. The conception of the works could not be more different: the former is structured along the central line of the figures and set amidst low-keyed tonalities, while the focal point of the latter is entirely off-center, around the empty, luminous space. Here too

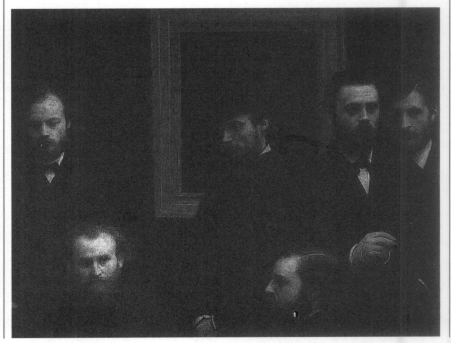

Renoir is depicted while observing the easel; at right, on the wall, a canvas of a "nude and clothed lady" outdoors has been identified as a lost work by Renoir. An X-ray examination of Bazille's canvas has revealed, under the layer of pigments, a sketch of Renoir's *Diana*, which was rejected by

similar to those achieved by Bazille in *View of the Village* and, to some degree, to Monet's The River, also executed in 1868. However, these artists had not yet achieved the transparent, colored shadows that would be the hallmark of Impressionism, and the dialogue

between light and shadow was rendered by Monet in a clear-cut contrast of daubs of color and by Renoir through a rather hazy effect in the areas covered by sunlight. Although Renoir's art in this period had different influences—Manet's *Mlle V. in the Costume of an Espada* in *Clown* (the same pattern of setting the figure against a neutral background) and Degas' *Hortense Valpinçon in Boy with a Cat* (the tilting viewpoint in order to better define the purely "mental," illusory depth)—the most important was certainly Monet, who like Renoir was interested in the practical side of painting and disdained theory. The two began painting together along the Seine in search of the changing, ephemeral effects of the light on water. From *plein-air* painting understood as the encounter and empathy between artist and nature, they passed on to working outdoors as a purely visual, optical opportunity to capture and render on the canvas, rapidly and without the filters of feelings or memory, the effect of the eye's perception.

and later described in Maupassant's novels. Renoir had been introduced to La Grenouillère by his patron Prince Bibesco the year before and had urged Monet to go there with him to work. The canvases they produced side by side are both similar and different; Renoir's brushwork is more minute and delicate, while Monet's is broader and accentuates light contrasts more

the 1867 Salon jury. The painting depicted the nude goddess *en plein air*, rendered quite realistically and with "flat" shadows; the model was Lise Tréhot, the artist's mistress, whose only mythological disguise was her bow and arrows—small wonder that the jury refused to accept this work, despite the artist's protests. However, the other portrait of *Lise holding an umbrella*, executed outdoors at Fontainebleau, was exhibited at the 1868 Salon together with Bazille's *The Artist's Family on a Terrace*, Manet's *Emile Zola* and other works in what the public mockingly called the "Hall of Reprobates" or "Rubbish Heap." In describing Renoir's portrait, the critic Lasteyrie spoke of "a fat woman splashed with white" and mentioned Manet's curious models as an influence, while the more receptive critic Thoré-Bürger recognized its delicacy. The most interesting comment was made by Zola, the only one who recognized its affinity with the new leader of the new "school," Monet, whose portrait of his future wife *Camille* had made a sensation at the 1866 Salon (though he had been mistaken for Manet). Lise, who had been introduced to Renoir by Jules Le Coeur in 1865, was a model for other works in this period up to 1871. Among these, *Alfred Sisley* and *His Wife and Summer* (1868) stand out for their qualities of soft, delicate light and shadow effects, which were rather

♦ *Pierre-Auguste Renoir*, The Road to Louveciennes, *1869. Oil on canvas, 38 x 46 cm (15 x 18 in). Metropolitan Museum of Art, New York. The road that goes from Versailles to Louveciennes was painted many times in 1869 and 1870*

by the group of artists who frequented the Café Guerbois, where they had passionate discussions concerning plein-air painting and colored shadows. The versions by Monet, Sisley and Pissarro are noteworthy.

♦ *Pierre-Auguste Renoir*, Fisherman, *ca. 1867-69. Indian ink on paper. Durand-Ruel Archives, Paris. The line delineates the*

forms with an elegance that reminds one of Japanese graphic art. The composition is based on the horizontal lines.

To Be "Only an Eye"

This approach was close to what might be called the Impressionist "utopia": to become pure sensation, the instrument of the immediate registering of the seen image into the painted image. In other words, to be "only an eye" ("but what an eye!" as Cézanne said of Monet) or the "cork bobbing on the water" that lets itself be moved by the current, to quote the metaphor that Renoir used to define himself. Subjectivity was no longer a sentimental factor, as it had been for the romantics, but a purely physical one: painting what one saw therefore meant painting without any transposition. This utopia took on form in 1869, at La Grenouillère, a bathing locality and restaurant that had become fashionable after a visit by the Emperor Napoleon and his wife

♦ *Jean-Auguste-Dominique Ingres*, Portrait of Marie-Françoise Rivière, *1805. Oil on canvas, 100 x 70 cm (39 3/8 x 15 1/2 in). Louvre, Paris. The limpid classicism of the French master, with*

its fluid outlines, could not fail to influence the young Renoir. Many years later, when he began his aigre *or dry style, he returned to the linear drawing and plastic synthesis of Ingres.*

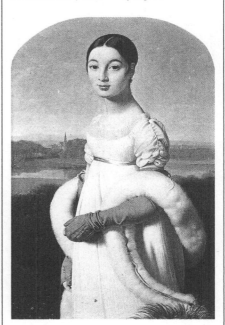

vividly, especially on the waves. But they had a common aim: to capture, through the vibration of the colors observed on the water, the mutability of the passing moment, that is, to succeed in rendering on canvas movement in its becoming, the fragrant, pregnant immediacy of the ephemeral instant—which is tantamount to the essence of "modernity": variation.

Thus was born the *tache*, the perceptible, brushstroke or spot of pigment that is separate from the others; at first employed to render the reflections in water, which are never unitary bodies but are fragmentary, this technique was then applied to the sky, figures and houses until it became the fundamental element of a superior unity of the canvas and—according to Lionello Venturi's most perceptive statement about Impressionism— "raised itself to become a principle of style."

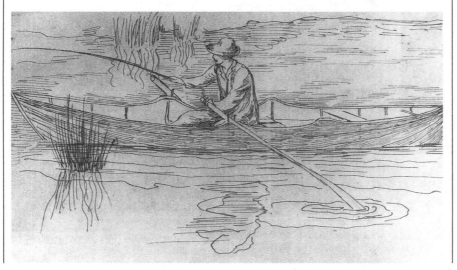

♦ *Pierre-Auguste Renoir*, Berthe Morisot and Her Daughter, *1894. Pastel on paper, 59 x 45.5 cm (23 x 18 in). Musée du Petit Palais, Paris. Berthe Morisot, Manet's* *sister-in-law, was a close friend of Degas, Renoir and Mallarmé. When she died in 1895, the artist and poet became her daughter Julie's guardians.*

The La Grenouillère canvases mark the beginning of this elaboration of a new pictorial style. At first, the particles of color were used only to render the motion of the river and did not concern the other parts of the landscape. And yet the genesis and nucleus of the progressive detachment of art from the need to represent reality, was already part and parcel of these works. "How" one paints became more important than "what" one paints, and the artists' attention

♦ *Yon*, La Grenouillère, *in "L'Illustration," June 20, 1868. A journalist for "L'Événement" wrote (June 20, 1868): "It is this little* *island that attracts most of the curious people who yearn to contemplate the human species reduced to its simplest expression."*

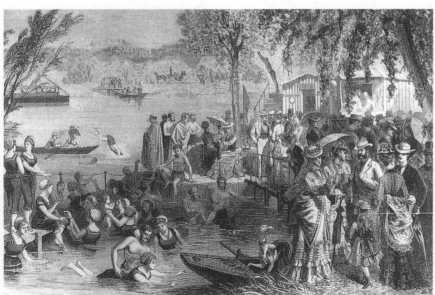

shifted from the contents of a canvas to its execution, hence to its purely formal aspect. Years later, Renoir remarked:

Together with this innovative pictorial research, Renoir maintained a style that was more acceptable for the Salon. In 1870 he exhibited a new "mythological" nude of Lise, *Bather*— which Sophie Monneret rightly considers a middle course between a classical Venus and Courbet's *Demoiselles au bord de la Seine*—as well as another portrait of Lise in an Oriental costume (*Woman of Algiers*). The title of the latter work is a tribute to another contemporary artist, Delacroix, whom Renoir had admired since the time of his artistic apprenticeship. In his old age, Renoir said: Julie Manet, the daughter of artist Berthe Morisot and Manet's brother Eugène, noted in her diary an exclamation of Renoir's at the Louvre when observing Delacroix's *Women of Algiers*: Renoir inherited the master's capacity to transform a banal subject by means of a luxuriant, changing palette and intense, palpitating brushwork; at the same time, the choice of a decidedly "indoor" motif denotes the artist's determination not to limit his procedure to the observation of nature outdoors, but to smooth over the contrast between *atelier* and *plein air* that in this period seemed irremediable for other artists. The artist's reconsideration of Delacroix's bright palette appears again in a series of canvases executed in this period, ranging from *Madame Stora in an Algerian Costume* (1870) to *Woman with a Parrot* (ca. 1871; but the link with the same motif painted by Manet in 1866 has so far been ignored by art critics) and above all in *The HHarHarem (Parisian Women in Algerian Dress*), executed in 1872, an imaginary harem set in a brothel which was judged rather severely, with the exception of a profound observation made by the art dealer

The Tache *from the Academy to Post-Impressionism*

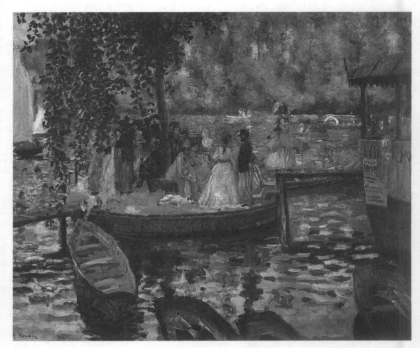

After being used in academic circles in the rapid and informal application of the preparatory sketch—which was quite distinct from the finished painting in the traditional hierarchy—the "separate" brushstroke or dab of color (*tache*) became an accepted stylistic technique with the advent of Impressionism. From the study of the disintegration of forms into the individual colored surfaces seen in the reflections of light on water, the *tache* was then adopted for the entire canvas in a new vision of the "optical truth" of the artist's eye, which does not perceive volumes and colors as isolated and independent, but as part of a vibrant whole that changes according to variations in light, movement and atmosphere.

In 1839 M.-E. Chevruel's *The Principles of Harmony and Contrast of Colors* was published. Chevreul, a chemist and director of dyeing at the Gobelins state tapestry manufactory, is often considered, perhaps to exaggerated lengths, the inspirer of Impressionism. In his opinion, what centuries of tradition had referred to as "local color" (the natural color of an object as it appears in normal light) was in reality never uniform, but was conditioned and modified through interaction with neighboring colors. The first thing perceived by the retina, before the brain makes any "cultural" mediation, is the "simultaneous contrast" between colors which obeys precise physical laws according to the relationships among the complementaries (red with green, made up of yellow and blue; blue with orange,

♦ *Pierre-Auguste Renoir*, La Grenouillère, *1869. Oil on canvas, 66 x 80 cm (26 x 31 7/8 in). National Museum, Stockholm. "One arrives at the* *boathouse via a series of very picturesque, but absolutely primitive, little bridges." ("L'Événement Illustré," 1868).*

made up of red and yellow, etc.). On a practical level a painter could obtain more natural and luminous results by avoiding the "bitumen" and directly contrasting spots of opaque paint, unmixed colors, leaving the task of fusing them and reconstructing the unity of the picture to the eye of the spectator. The concept of the "*optical mixture*" of separate, broken colors had already interested Delacroix, who in his *Diary* made notes of his observations of the behavior of interacting colors, shadows and reflections. In 1867, just two years before Monet and Renoir worked together at *La Grenouillère*, the critic Charles Blanc, future Director of Fine Arts, took up and completed these considerations, indicating precisely the "*optical mixture*" as the best technique, systematically regulated by the chromatic wheel, to obtain more intense luminosity and brilliance and hence greater "truth" on the painted canvas. By merging the light, color and space values, the tache became the very essence of the composition. However, it was only in 1884, with Seurat's pointillism, that the new optical theories and the science of perception became an integral part of the work of art, which had by then broken free from the conventions of academic "imitiation."

♦ Eugène Delacroix, Women of Algiers, 1834. Oil on canvas, 180 x 228 cm (71 x 89 3/4 in). Musée du Louvre, Paris. This work was exhibited at the 1834 Salon. Delacroix had made a trip to Morocco in 1832, but his "Orientalism" was more a studio creation than a real harem, as he mixed his on-the-spot impressions with half a century of traditional Western fantasies concerning exoticism. Renoir did something similar in 1872, ten years before he went to Algiers.

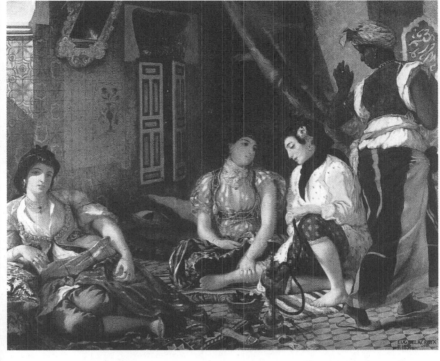

Camentron in 1898: The *Portrait of Edmond Maître* and the one of Maître's mistress *Rapha*, who welcomed Renoir as their guest in the trying summer of 1870, are qualitatively quite different. Rapha is depicted standing, holding a Japanese fan, in a gamut of variations on high-keyed tones that is reminiscent of the delicate portraits of women executed by Renoir's friend and Corot's pupil, Berthe Morisot.

In the meantime the Franco-Prussian war had broken out and in October 1870 Renoir was called up into the tenth regiment of cuirassiers, while Bazille enlisted voluntarily in August and was killed in November, which brought lasting grief to his friend and instilled a horror of war in him. Despite having to face many a danger, Renoir returned to Paris during the Commune, in 1871, and managed to paint some portraits, such as the two companion pieces, *Captain Paul Darras* and Madame Darras, which on a stylistic level remind one of Géricault's harsh, dark tonalities. Mrs. Darras was also the model, together with the young Joseph Le Coeur, for an important canvas that Renoir

♦ Photograph of the Seine at Argenteuil in the late nineteenth century. Lodgings in Paris were too expensive, so that at the end of the Franco-Prussian War Monet returned from England and took his family to Argenteuil. This locality thus became a "sacred" site of early Impressionism.

executed in 1873 with the hope it would appeal to the Salon jury. *A Morning Ride in the Bois de Boulogne*, if only because of its huge size, reminds one of seventeenth-century equestrian portraits more than Degas' horse race scenes; the horses and background are rendered with broad but rather well-defined brushstrokes, while the face of the woman with her veil, with that remarkable transparency of the black on the fair skin, is executed with more fluent and delicate effects of light. Naturally, this work was rejected by the Salon, but was exhibited in the Salon des Refusés, which was held for the first time since 1863. The relative success of this show, especially on the part of Renoir (whom the critic Castagnary called), was one of the reasons that induced the group to organize an independent exhibition the following year.

Tangible Light

As was to be expected, Renoir had not given up the idea of a "double artistic life", producing for the Salon while not neglecting his *plein-air* pictorial research. An 1870 canvas of two figures outdoors seems to combine the vibrant, separate brushstrokes used at La Grenouillère with the artist's renewed interest in Watteau galant painting; moreover, traces of Delacroix's tonalities can be seen in *The Promenade*, immersed in a thick, hazy atmosphere throbbing with life. The study of the play of light filtering onto the bodies and dress of the figures leads us once again to Monet who, having returned from London where he had taken refuge during the war, had rented a house at Argenteuil on the banks of the Seine that had the

two-fold advantage of affording cheap lodging and a great variety of landscapes. So Monet and Renoir took up where they had left off before the war, working together outdoors. This period perhaps marks the moment in which their styles resembled each other most—in their technique, which concentrated more and more on rendering the greatest possible gamut of atmospheric effects in a minute and tight web of dots, comma-like strokes and dashes of color; and in their felicitous, expansive naturalness. The same views (*Duck Pond, Country*

Road in Springtime and *Harvest Time*) are all interpreted in similar yet different ways by the two friends (Sisley sometimes joined them). In this phase Renoir seems to prefer the sunny views of summer at noon, when the shadows are shorter and light and shadow contrasts are stronger, while Monet was attracted most by the softer effect produced by overcast skies.

Notes of Corot's composed lyricism return in Renoir in the silvery and delicate tones of *Spring at Chatou*, but already in *Gust of Wind*, the title of which refers to a famous canvas by the master, a more immediate luminosity and brushstroke permeate the scene. Renoir also painted a series of portraits of Monet: while reading, smoking a pipe and in profile, or facing the viewer, or again while painting in a garden in bloom that competes with the flowers both artists were then painting so assiduously and were to use as a motif for the rest of

♦ Pierre-Auguste Renoir, A Morning Ride in the Bois de Boulogne, 1873. Oil on canvas, 261 x 226 cm (102 3/4 x 89 in). Kunsthalle, Hamburg. This work was rejected by the 1873 Salon jury and was exhibited in the Salon des Refusés. This exhibition, at first held in temporary wooden constructions, became so successful that it was moved to a more appropriate site.

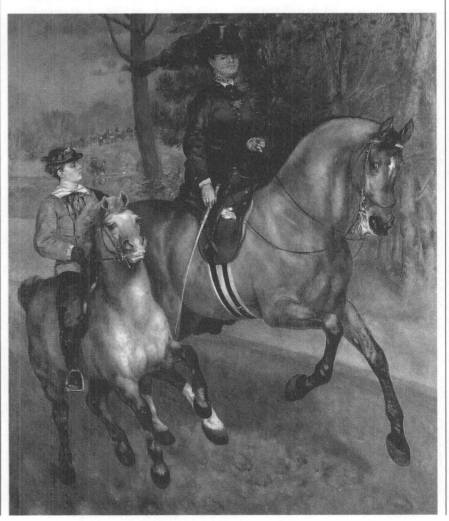

The Caillebotte "Affair"

♦ Gustave Caillebotte, Self-portrait, 1888-89. Oil on canvas, 55 x 46 cm (21 1/2 x 18 in). Private Collection. Renoir and Caillebotte met in 1875 at the Hôtel Drouot auction sale.

A year later Renoir signed the invitation asking Caillebotte to take part in the second Impressionist exhibition. In 1885 Caillebotte become the godfather of his friend's first child, Pierre.

In a self-portrait dated 1879, Gustave Caillebotte paints himself working at the easel, reflected backwards in a mirror; behind him is a "canvas within a canvas," a rather common element in these symbolic canvases of studios which act as a sort of pictorial anthology or intimate diary of the artist's personal taste. The work is Renoir's *Dancing at the Moulin de la Galette*, which Caillebotte had bought at the third Impressionist exhibition in 1877 together with *The Swing* and the controversial *Nude in the Sunlight*. Of all the Impressionists, Caillebotte was the most fortunate economically speaking; he was born into a well-to-do family, and when his father died in 1874 he inherited a fortune. Probably that same year he met the Impressionist group, though he was asked to exhibit with them only in the 1876 exhibition, contributing eight canvases, including the famous *Floor Strippers* (or *Planing the Floor*). Caillebotte is also to be crediting for having supported his fellow artists by helping to organize exhibitions, often at his own expense, and above all by purchasing their works—out of principle he chose the most controversial, "unsaleable" ones, and never bought them at an auction sale, where they were offered at a lower price.

On November 3, 1876 Caillebotte drew up a generous will in which he stated his desire to finance, (which was held in 1878, while he was still alive, with a large contribution on his part). Above all, the testament revealed his farsightedness. The second clause stipulated that he would donate to the State his collection of Impressionist canvases provided it agreed to place it adding: His prediction came true. Almost twenty years after drawing up the

will, Caillebotte died; but although the donation was received favorably by the press (which wrote: "The museum will finally deserve the name of museum of living artists"), there was an outcry from official academic circles. On behalf of the École des Beaux-Arts and the Institut de France, Jean-Léon Gérôme threatened to resign from the former: The collection represented the Impressionist group almost in its entirety, from Manet to Cézanne. Renoir and Caillebotte's brother Martial, executors of the will, had chosen about sixty canvases. Despite the prudent stance of the Director of Fine Arts, Henri Roujon, who called the bequest "a delicate affair" and with great embarrassment attempted to persuade Renoir to give up the idea of the Luxembourg museum, the two parties came to an agreement only in 1894, when Renoir and Martial Caillebotte decided to make a compromise: forty out of sixty-five works (including six by Renoir) would be selected by a committee. However, the canvases were not placed in the Luxembourg palace until 1897, which greatly irritated Gérôme.

The fact that Renoir was one of the executors comes as no surprise; he and Caillebotte were in fact close friends.

their lives. However, they also worked on the motif of the urban landscape, which was ephemeral in a different way: both the artists' canvases of *The Pont Neuf*, Paris represent the same famous view, in which Renoir once again adopts a more meticulous and dense approach, while Monet's rendering is softer and perhaps freer. The palette already has the dark blues, whites, and yellows of Impressionist Paris, whose shadows have been

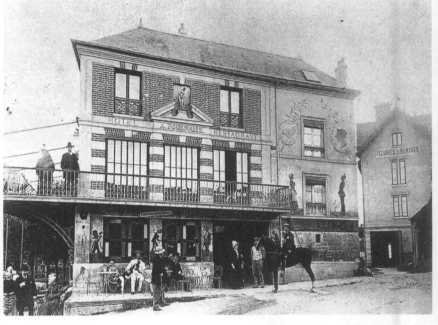

♦ La Fournaise restaurant at Chatou, near Argenteuil. This establishment on the banks of the Seine, managed by Alphonse Fournaise, was a fashionable gathering place for rowers; Guy de Maupassant drew inspiration here for his Restaurant Guillou, and in 1879 Gustave Goetschy used it as the setting

for his "naturalist poem" Les Canotiers (The Boaters). From 1870 on the restaurant was a favorite haunt of the future Impressionists, and Renoir used it in many a canvas; at left is the terrace which was the setting for Luncheon of the Boating Party (1881).

deprived of black—though later Renoir began to use this color again. The viewpoint is slightly from above and rather "casual," much like a snapshot, thus revealing the artist's indebtedness to photography. A similar approach is to be noted in Caillebotte, the artist who was the Impressionists' patron as well as working companion. Renoir met him that year (1872); they became such good friends that Caillebotte named

the sensitive, tenacious Renoir executor of his will, in which he bequests his collection of Impressionist paintings to the Louvre. The exceptional figure of this young art merchant who, after purchasing the works of the Barbizon school artists, had the courage to risk bankruptcy by supporting the Impressionists, was reconstructed admirably by Lionello Venturi in his *Archives de l'Impressionnisme*. Renoir met Durand-Ruel through Monet and Pissarro, who had become friends while staying in London during the Franco-Prussian War; the art dealer bought Renoir's *The Pont des Arts* for 200 francs, and sold it for 90,000 francs. In 1873 the young Renoir made another sale, which was important more from a psychological than economic standpoint: Théodore Duret, the art critic he had met in Degas's studio, bought his two portraits of *Lise*, *Lise* and *Summer*.

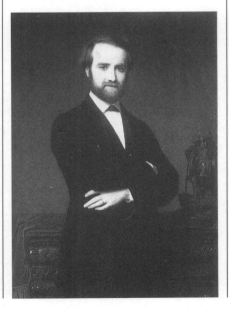

♦ Hugues Merle, Portrait of Paul Durand-Ruel, 1866. Oil on canvas, 113 x 81 cm (44 1/2 x 31 3/4 in). Private Collection. At an early age this art dealer was interested

in the Barbizon school landscapists. It was only after the Franco-Prussian War, after he had met Monet in exile in London, that he supported the cause of the "new painting."

The Impressionist Years

"The title [Anonymous Society of Painters, Draftsmen, Sculptors and Engravers] failed to indicate the tendencies of the exhibitors; but I was the one who objected to using a title with a more precise meaning. I was afraid that [...] the critics would immediately start talking of a "new school," while all we really wanted, within the limits of our abilities, was to try to induce painters in general to get in line and follow the Masters [...] and getting into line meant precisely [...] that the young painters should go back to simple things. How could it be otherwise? It cannot be said too often that to practice an art, you must begin with the ABCs of that art."

Renoir's recollection, filtered by the often imaginative pen of Ambroise Vollard, perhaps emphasizes personal opinions that were not shared by the group as a whole, such as the artist's horror of theoretical classification, his concept of "metier" in the artisanal sense of the word, and his insistence on learning from the masters. Be that as it may, this was the name that thirty young artists—already called "the

Intransigents" but not yet "Impressionists" by the scornful and ironic art critic Leroy—chose for their group when they decided to show their works to the public on an independent basis in the famous exhibition of April 1874 at Nadar's studio in 35 Boulevard des Capucines. The catalogue was written by Renoir's brother Edmond. Auguste submitted six canvases which virtually covered the gamut of his motifs, from portraits (*Parisian Lady* or "*La Parisienne*") to landscapes (*The Harvesters*, executed at Argenteuil) and modern "genre scenes" (*La Loge* and *Dancer*).

♦ Below, Pierre-August Renoir, The Box ("La Loge"), 1874. Oil on canvas, 80 x 63 cm (31 1/2 x 24 3/4 in). Courtauld Institute Galleries, London. Right, The Box, 1874. Oil on canvas, 27 x 22 cm (10 1/2 x 8 1/2 in). Hermann Schnabel Collection. These are two versions of the canvas exhibited at the first Impressionist show in 1874. The smaller one was painted for the private art collector Jean Dollfus, which showed that Renoir was beginning to be appreciated by art lovers.

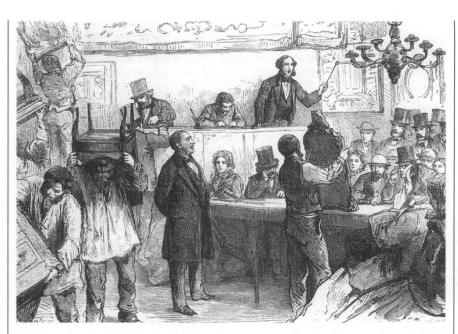

As is known, with rare exceptions, the reaction to the exhibition was violent. Despite Renoir's expectations, almost all the critics interpreted the "new school" as a sort of abortive Barbizon style, without attempting to grasp its stylistic originality, above and beyond its being *plein-air* painting. Many critics recalled the 1863 Salon des Refusés, when Manet had caused an uproar with his *Déjeuner sur l'herbe*, a work they now considered the "Louvre or the Uffizi" compared to those exhibited at Nadar's studio. One art critic spoke of "an attack against good

♦ M. Mouchot, Auction Sale at the Hôtel Drouot, 1867. Print. Bibliothèque Nationale, Paris. This auction site in Paris was the venue for some of the most famous sales in the second half of the nineteenth century, and the so-called "Impressionists" decided to hold their 1875 auction here.

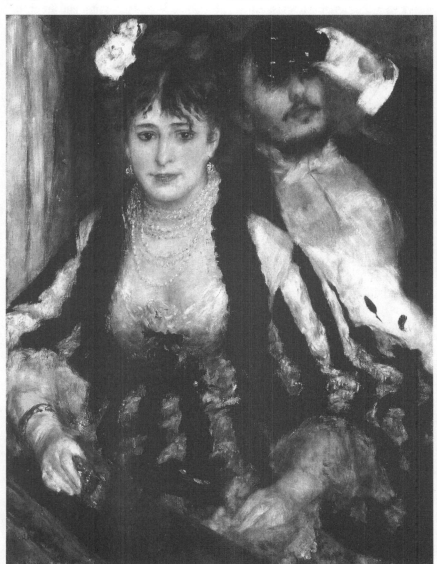

artistic customs" and others of thus grasping—albeit in a negative sense—the innovation of this pictorial procedure which questioned the validity of all the habitual visual expectations and reactions. Even those critics who were favorable had reservations. Armand Silvestre—unwilling to accept the lack of synthesis and hierarchy which was indeed the truly "revolutionary" aspect of these works—insisted that the artists' production was still immature. Castagnary made a similar comment, predicting that the group would soon split up. Yet he wrote one of the most discerning remarks concerning the new art: one wants to characterize them

with a single word that explains their efforts, one would have to create the new term of impressionists. They are impressionists in the sense that they render not a landscape but the sensation produced by a landscape. The enthusiastic opinion of Villiers de l'Isle Adam was like a voice in the desert; he considered Renoir the leader of this "ambush of radiant colors" or "fireworks of angry palettes." But except for Villiers, Renoir received few mentions, and most of these were negative. In particular, the female figure of *La Loge*—which is now recognized as the hallmark of as Félix Fénéneon said in 1886—was considered "vulgar."

There is nothing in this canvas that allows us to reconstruct the setting or even the possible relationship between the two figures. The strongly foreshortened railing of a theater box frames a woman dressed in Manet-like whites and blacks and immersed in that hazy light that somewhat obscures any clear definition of detail and at the same time creates the enchanting charm of the passing moment; behind her, the figure of the man (Edmond Renoir) is rather blurred, as if he had been photographed while moving. *Parisian Lady* also isolates the figure against a background as in Manet, but here the ground is made vibrant and vital by Renoir's subtle and lively brushstroke, which takes up the cobalt blue of the dress and heightens it with yellow; the vivaciousness of the whole is mirrored in the actress's lively, and by no means idealized, face. Renoir

20

recommended to his pupil Roussel-Masure in his old age. *The Dancer* is tinged with sky blue and light brown hues; the effect of immediacy lies wholly in the extemporaneousness of the girl's three-quarters pose, one foot placed slightly forward as she lifts her head in a gesture of curiosity. This movement reminds one of Degas, but

somewhat "wild side" in Renoir's profusion of color. His palette of whites, light blues and yellows reappears in the celebrated *Madame Monet Reading "Le Figaro,"* which is more an homage to friendship than a portrait; Monet's wife is reclining much like the odalisque Lise, but there is nothing artificial or affected about it

abandon (however, this is a mere illusion: his concept of craft was ever present). *The Seine at Argenteuil*, *Sailboats at Argenteuil* and *Railway Bridge at Argenteuil*, executed by Monet and Renoir, have the same views, the difference being that the former's brushwork is broader and has more contrast, while Renoir's is more refracted. The play of reflections and reverberations, once limited to the water, now become the vibrant breakdown of light in all the elements of the painting, the brightest tone being the white of a sail speckled with the blue from the sky.

*M*anet Paints Monet

Caillebotte sometimes painted with Monet and Renoir when he passed through Argenteuil, as did Manet, when in that summer of 1874 his *plein-air* style was in full swing. The older artist became irritated and jealous when Renoir planted his easel next to his and executed the same subject: *the Monet family in their garden at Argenteuil.* In Renoir's version, Camille Monet and her son are resting in the shade of a tree, and the scene is a pretext to render the woman's white dress spread out like a sail in the sun. In Manet's canvas the scene is more distant from the viewer, thus lending a "classical" serenity to the composition, while the black (which Manet always used) strongly heightens the contrasts with the light tonalities. As usual, Renoir's interpretation is more delicate, with subdued transitions from white to green, and at the same time more innovative in its extremely close-up, off-center view of the figures without a sky in the background and the rapidly applied, thin colors. Manet's remark, as narrated by an amused Monet, was most probably triggered by his momentary vexation, since the master really admired Renoir and even owned some of his paintings.

Again in 1874, Renoir was the guest of Jules and Charles Le Coeur at Fontenay, where he portrayed the brothers standing at their garden gate in a thickly textured gamut of whites and burnt hues quite like the effect obtained by the thick brushwork in his *Promenade.* During this visit, Renoir was asked to leave the Le Coeur home because of an amorous note he had written to Charles's young daughter; thus ended a long friendship. The unhappiness caused by this rupture was compounded by the death of the artist's father, who had been living in Louveciennes.

In the meantime his circle of friends grew larger. The Nouvelle Athènes supplanted the Café Guerbois as the

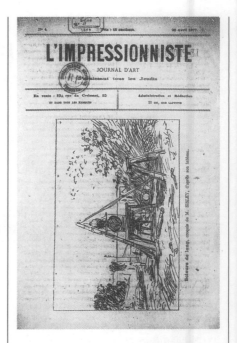

♦ *Cover of the fourth issue of "L'Impressionniste, Journal d'Art," April 29, 1877. In support of the third Impressionist*

exhibition, Georges Rivière published this periodical for the entire duration of the show. Renoir also contributed some articles.

meeting place of the young artists, who now included the future generation of Symbolists, and Renoir struck up a friendship with the composer François Cabaner—a sort of disorderly Debussy—and the writer and art critic Georges Rivière, who became a fast friend. On Thursdays Renoir frequented the salon of Théodore de Banville, a

♦ *Pierre-Auguste Renoir, The Milliner, ca. 1879. Pencil on paper, 42 x 27.5 cm (16 1/2 x 10 3/4 in). Paul Mellon Collection, Upperville, Virginia. A figure immortalized by*

Naturalist literature and a model for artists such as Gavarni and Degas, the grisette (young working woman) was also the subject of some of Renoir's works.

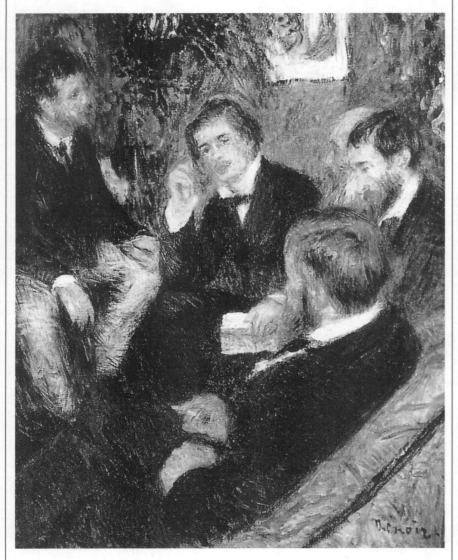

the model's expression of confident gaiety, underscored by the soft consistency of the impasto, is quite different in spirit from this artist's linear rigor.

I painted with light colors, it is because it was necessary to paint that way. It was not the result of a theory, but a need that was in the air, in everyone, unconsciously. It is worthwhile mentioning Renoir's Impressionist palette, which was high-keyed and bright but at the same time extremely simple. His son Jean speaks of a note his father wrote that indicates the colors he adopted in this period: silver white, three different hues of yellow, natural sienna, two reds, two greens and two blues—nothing else. For his entire lifetime Renoir succeeded in creating the amazing density of tones and texture with colors of Spartan moderation. It was more a question of how he painted, which Jean describes as rapid and lightning-like as "a bird in search of prey", that reveals the

♦ *Pierre-Auguste Renoir, The Artist's Studio, Rue Saint-Georges, 1876. Oil on canvas, 46 x 37 cm (17 3/4 x 14 5/8 in). Norton Simon Foundation, Los Angeles. Here Renoir portrays his friends in his studio.*

According to some critics, they are, from left to right, the painter Lestringuez, the art critic Rivière, Pissarro, and the composer Cabaner; in the foreground is Cordey, a student at the École des Beaux-Arts.

and the brushwork is so liquid and sharp that it cannot even be called a *tache*; it is more like an evanescent vapor that permeates the entire figure in a sort of miracle of light in which the spatial depth is congealed and synthesized, thus becoming nullified. That summer Renoir had returned to Argenteuil where, painting together with his friend Monet once again, the height of his Impressionist phase began, with spacious, airy canvases in which all technical preoccupations truly seemed to give way to sensory

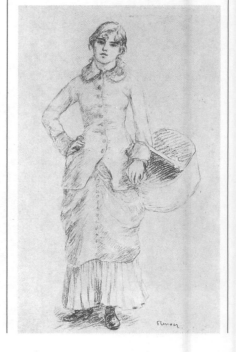

Parnassian poet, together with men of letters and musicians. Perhaps in the conversations on the importance of form Auguste confirmed his youthful love for the classical masters. This refined bohemian circle—which would later include such curious figures as Eugène Murer, a pastry cook who also painted and wrote poetry and novels—is portrayed in a small canvas executed in 1876, *The Artist's Studio, Rue Saint-Georges*, which was in fact Murer's place.

New motifs were taken from the theater and music milieus: in 1875 Renoir painted the lovely canvas of the

large collection of their works that many years later would be sought after by fashionable personalities in Paris. Naturally, he noted Renoir's affinity with his favorite artists; the evening of the auction sale at the Hôtel Drouot he wrote a highly complimentary letter to the artist, asking him to do portraits of himself and his wife, with one of his Delacroix works in the background: he told Renoir. The artist used the money from this commission to rent a large abandoned garden in rue Cortot, in Montmartre, which was the flower-filled setting for the canvas of the same name now kept in the Carnegie

♦ Pierre-Auguste Renoir, Two Women in the Street, ca. 1877. Oil on canvas, 44 x 36 cm (17 1/4 x 14 in) Ny Carlsberg Glyptotek, Copenhagen. The animated life in Paris is conveyed in *this lovely street scene "taken live," as it were: the unfinished effect of the brushwork, which avoids rendering outlines, lends greater movement in space to the figures.*

Museum of Art in Pittsburgh (on an equal footing with the canvases Monet would produce later at Ginevry), and perhaps also for *The Lovers*, which was shown at the second Impressionist exhibition in 1876. The quality of the softly refracted light on the bodies led Rivière to make comparisons with Watteau, while Zola spoke of Rubens and Velásquez. Here it is worthwhile mentioning an anecdote related by Renoir when, years later in Spain, he thought he had discovered the secret of the great Spanish master's art in an expression he overheard in a café: "*colorado y claro*" (ruddy and bright). *Nude in the Sunlight*, in which the female bust is almost completely absorbed and decomposed by the brushwork in the background, is a less successful work; in fact, at the second Impressionist exhibition the critic Albert Wolff spoke of "decomposing flesh and a corpse."

The outdoor "studio" in rue Cortot gave Renoir the opportunity to continue his experiments with painting figures dappled with light filtering through the foliage. He executed *The Swing*, perhaps one of his most famous works, a charming scene of eighteenth-century "gallantry" in which, however, the dabs of color constitute the structural backbone of the canvas, the brushstrokes embodying all the compositional and spatial values. *Nude in the Sunlight* and *The Swing* were purchased by Caillebotte together with

the artist's first truly demanding, large-sized work with many figures, *Dancing at the Moulin de la Galette*, the dance hall a few blocks away from the rue Cortot garden. This celebrated work was conceived and carefully "programmed" to be placed in a museum, as is attested by the series of preparatory studies and sketches Renoir did before embarking on the canvas, much like the academic approach to painting. One of these studies (kept in the Ny Carlsberg Gyptotek in Copenhagen) affords a close-up view of Renoir's pictorial procedure, which even in its rough-hewn state contains the essential features of the entire composition, with flashes of liquid color that his son Jean aptly called "the juice": everything is already there, the very sap of the representation. Friends, working girls and the occasional *cocotte* posed for this composition which further consolidates the role played by the Impressionist *tache* as the synthesis of space, which was no longer perspective but "continuous" in the contiguous spots of light and shadow. All of Paris can be seen in this festive scene that epitomizes the vivacity and changes of the period when Haussmann revolutionized the town planning of the capital. And one is reminded of what Duranty had said in 1856 (which he then published in *Nouvelle peinture* in 1876): "I have seen comedies of gesture and countenance that were truly paintable. I have seen a large movement of groups made up of relations among people, where they met on different levels of life [...]

concert pianist Nina de Callias (*The Pianist*), a delicate example of "indoor Impressionism" with somewhat darkened tonalities that still exude the artist's enchanting vaporous atmosphere. The woman's dress seems to swell from within, as if it had its very own vibrating, airy existence, overflowing into the room. In March of the same year Renoir tried to persuade the group of the already disbanded Anonymous Society to try their luck once more with an auction sale of their works at the Hôtel Drouot; it turned out to be a fiasco, despite the fact that the catalogue introduction was written by a highly esteemed critic, Philippe Burty. At the inauguration Berthe Morisot was actually insulted in public, which sparked a row with the students at the École des Beaux-Arts. One of the most excoriating judgments was made by the critic Gygès: Despite this disappointing outcome, the auction sale proved to be the occasion for new contacts with art patrons. The curious figure of Victor Chocquet, a customs official with modest means and a true passion for art, appeared on the artistic scene. Chocquet had discriminating and nonconformist taste; he adored Watteau and Delacroix and built up a

♦ Photograph of Rue Cortot in Montmartre in the late nineteenth century. Before the construction of Sacré-Coeur Church, Montmartre was a relatively wild part of Paris. Renoir *rented the garden in Rue Cortot with the money earned from his first sales; it later became an outdoor studio for other artists, including Suzanne Valadon and her son Maurice Utrillo.*

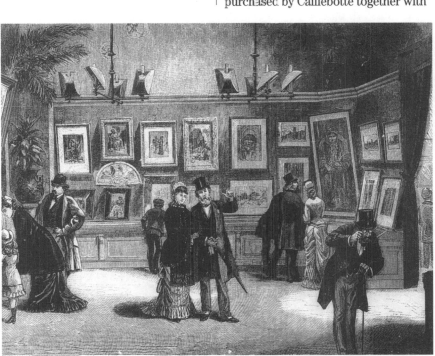

♦ E. Bichon, Exhibition of the Works of Watercolorists, Maison Durand-Ruel, Rue Lafitte, 1879. Print. Artistic societies were quite common in mid-nineteenth century France. This sale *held by the "Society of Watercolorists" took place in Durand-Ruel's gallery the same year that Renoir was received favorably at the Salon for his Madame Charpentier and Her Children.*

22

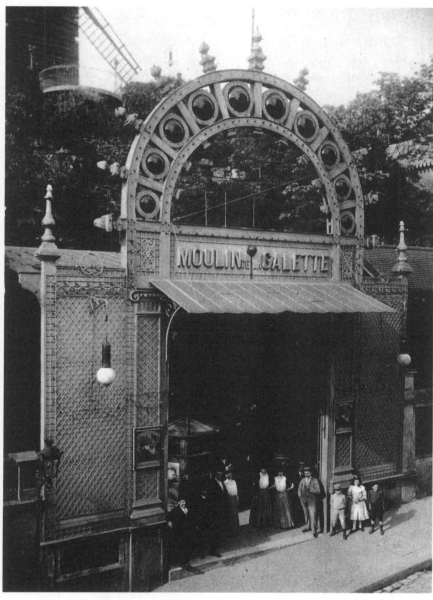

"new painting." A refined and rather shrewd person who was the friend and publisher of Proust and the Goncourt brothers, as well as an art collector, Charpentier had already bought works by Renoir at the 1875 auction sale on his wife's prompting. With affectionate irony, Renoir was called Charpentier's "devout official painter"; indeed, the "court" of Madame Charpentier's salon proved to be a valuable aid in making new and influential acquaintances after yet another fiasco in the 1877 auction sale and the meager consolation of the third Impressionist show (held the same year) in which Renoir had exhibited *The Swing* and *Dancing at the Moulin de la Galette.*

The artist did portraits of M. and M.me Charpentier as companion pieces that were hung on the staircase of their "palace." The two are in casual, homey poses much like the eighteenth-century Venetian *trompe-l'oeil* works, and M.me Charpentier is holding a Japanese fan, according to the prevailing fashion. She had had a Japanese-style parlor designed for her personal use where Renoir portrayed her with her two daughters in 1878. Here the official nature of the circumstance is emphasized by the careful attention the artist pays to the interior, in a masterly distribution of yellow and red hues that are made slightly rough and granular by the brushstrokes, as well as by the group's traditional pose. The palette is quite rich, once again reminding one of the "grand" manner of such old masters as Rubens and Van Dyck; the three figures are portrayed in their everyday setting in order to reveal their taste and character, according to the precepts of the "modern portrait" laid down by Duranty.

Madame Charpentier and Her Children thus marked Renoir's return to a more formal and "worldly" style, in other words back as a critic

commented at the 1879 Salon, where this canvas was received favorably. But this was by no means a regression in style or technique, as can be seen in the other portraits commissioned by wealthy patrons Renoir met through the good offices of the Charpentiers. For example, Pink and Blue: *Alice and Elizabeth Cahen d'Anvers* (1881), which reveals masterly skill in rendering the girls' shimmering lace dresses in the manner of Titian or Velásquez; or the portrait of the wife and daughter of the Undersecretary of

♦ *Pierre-Auguste Renoir*, At the Theater, *1880. Oil on canvas, 41.5 x 32.5 cm (16 1/4 x 12 3/4 in). Staatsgalerie,* *Stuttgart. In this composition the overlapping planes are rendered in fluid brushstrokes that do not convey a sense of depth.*

Fine Arts, Edmond-Henri Turquet, in *At the Concert (In the Box)*, in which the two retain the immediate freshness of the flowers in the middle of the canvas. Madame Turquet's spontaneous charm is not out of tune with that of the actress Jeanne Samary, whose skin as an enraptured Renoir used to say; Samary's white flesh tones speckled with red truly capture the brilliance of a theater in *The Actress Jeanne Samary*. The fact that Renoir was accepted again at the Salon in 1878 allowed him to devote himself to *plein-air* painting with less apprehension. In *The Seine at Arsnières*, which was perhaps executed in 1879, the sweeping, rapid brushstroke of the Argenteuil years reappears. The cobalt blue of the water is felicitously enhanced by the orange of the boat, and the oblique brushwork lends vigor to the composition. Aline Charigot, Renoir's future mistress and wife, appears for the first time in *Oarsmen at Chatou*, in which the artist renders the reflections of light on the water; but here the brushwork tends to be uniform, thus heralding the "return to order" that would prevail in the following decade.

Differences in dress played an important role and corresponded to the variations in physiognomy, carriage, feeling and action. Everything appeared to me arranged as if the world had been made expressly for the joy of painters, the delight of the eye." Paris in continuous movement, condensed in the flow of people in the street who are almost deformed and merged into one another by the altered, confused visual perception, is clearly seen in two canvases executed in 1877 and 1880 (*Two Women in the Street* and *Place Clichy*), two exemplary slices of city life whose greatest bard was Degas. "Modern Life" was also the title of famous periodical run by Renoir's brother Edmond and founded by the publisher Georges "Zizi" Charpentier in order to defend naturalism and the

♦ *The entrance to the Moulin de la Galette in Montmartre, in a late nineteenth-century photograph. This was one of the last seventeenth-century wooden* *mills to remain in Montmartre before the construction of Sacré-Coeur; it became famous thanks to the works by Renoir, Van Gogh and Toulouse-Lautrec.*

♦ *Pierre-Auguste Renoir*, Study of the Bérard Children, *1881. Oil on canvas, 62 x 83 cm (24 1/1 x 32 in). The Sterling and Francine Clark Art Institute, Williamstown, Mass.* *Renoir was introduced to Paul Bérard by the art collector Charles Deudon. Here he portrays his children André, Marthe, Marguerite and the newborn Lucie.*

The Crisis of the *Aigre* Period

The 1880s marked the onset of a crisis for more or less the entire Impressionist movement. This was caused both by the lack of success, which led to a strain in relations amongst the artists and even to ruptures (Renoir and Monet, for example, did not participate in the

♦ *Pierre-Auguste Renoir, Girls in Black, ca. 1881. Oil on canvas, 80 x 65 cm (31 3/4 x 25 1/2 in). Pushkin Museum, Moscow. This pleasant canvas of two women* at a café epitomizes the animated Paris of the time. The scene takes on life thanks to the vibrant brushstrokes, which foreshadow Renoir's future aigre style.

fifth Impressionist exhibition in 1880, as they preferred to exhibit in the Salon), as well as by the inevitable breakdown of what I have called the "utopia" of pure Impressionism. Therefore the prophecy of art critic Jules Castagnary, written in 1874, had come true: "Within a few years the artists who today have grouped themselves on the boulevard des Capucines will be divided. The strongest among them… will have recognized that while there are subjects that lend themselves to a rapid "impression," to the rendering of a sketch, there are others and in much greater numbers that demand a more precise impression." In Renoir's case the "crisis" lay mostly in the debate on the fleeting atmospheric effect of light versus the plastic consistency of figures; in other words, between design and free brushwork, *plein-air* painting and painting in the studio. A sign of this was already evident in the canvases that Renoir painted in the summer of 1879 at Wargemont, on the Normandy coast, where he was a

guest of the family of Paul Bérard, a banker whom he had met at the Charpentiers' and who was to become one of the artist's most sensitive patrons. *Landscape at Wargemont* has a range of hues that are darker and more elaborate than the sky blues and whites of Argenteuil: violets, browns and yellows, applied in rather compact and orderly fashion, tend to coagulate on the canvas.

In February 1881, Renoir went to Algiers with his artist friends Cordey, Lestringuez and Lhote: he later told his son Jean, perhaps meaning he had found a different "density" in light. While in Algeria, he painted some landscapes and a Muslim *Festival at Algiers* that mark a return to Delacroix's impastos (the master had also made a "pilgrimage" to Algiers in search of pure white tonalities). But Renoir was not satisfied with the Algerian women models and returned to Paris in April, where he created a *plein-air* composition with figures that is a sort of countermelody to *Dancing at the Moulin de la Galette*, a final Impressionist intermezzo: *Luncheon of the Boating Party*, which was finished in 1882. Set in the

popular La Fournaise restaurant on the Seine at Chatou, the outdoor rustic party-luncheon is an ideal sequel and companion piece to the nocturnal urban dancing scene at the *Moulin de la Galette* he had painted five years earlier. Aline Charigot is hugging a dog and opposite her Caillebotte is having fun playing the role of the crude oarsman. The table, rendered obliquely so as to suggest a summary perspective, has recently called the attention of art critics to Veronese's *Marriage at Cana* at the Louvre—a veritable object of worship for the nineteenth-century French art that was copied faithfully by art students up to Cézanne's time. Here too Renoir purposely tried to do something "impossible," that is, a composition in the "grand style," a modern museum piece. Over and above the purely anecdotal identification of the figures, this canvas can be interpreted on a formal level as a transition from the

♦ *Paolo Veronese, The Marriage at Cana, 1562-63 (detail). Oil on canvas, 666 x 990 cm (262 1/4 x 354 1/4 in). Louvre, Paris. This celebrated work was copied at the Louvre by* generations of artists. Renoir seems to have drawn inspiration from this detail of the banquet scene, which is enhanced by the foreshortening effect, for his *Luncheon of the Boating Party.*

♦ *View of Capri in a late nineteenth-century photograph. While cities such as Venice, Rome and Naples fascinated Renoir for their great museums and art treasures, Capri* represented the "primitive, pure" nature that was still connected to the ancient world. Renoir painted his Blond Bather (1881-82) on one of these cliffs.

atmospheric softness of Impressionism, seen in the rapid brushwork at left, and the smoother, more clearly defined outlines at right, centered around Caillebotte's white undershirt.

The three *dance* motifs executed in 1883 also lend themselves to a two-fold interpretation: executed in a style reminiscent of naturalist novels, but in a triptych-like format that appealed to the Symbolists. These ambitiously large canvases are almost life-size. In *Country Dance*, Renoir's future wife Aline is dancing with his friend Lhote (but John Rewald identifies this figure as Edmond Renoir), while Suzanne Valadon, the model for Puvis de Chavannes and future artist, is the

23

♦ *Pierre-Auguste Renoir*, La Roche-Guoyon (Houses), *ca. 1885. Oil on canvas, 47 x 56 cm (19 x 22 in). Art Gallery and Museums, Aberdeen. In the summer of 1885 Cézanne and* Renoir painted together at La Roche-Guyon, not far from Paris. Cézanne's influence can be seen in the solid, parallel brushstrokes that lend volume and space to the composition.

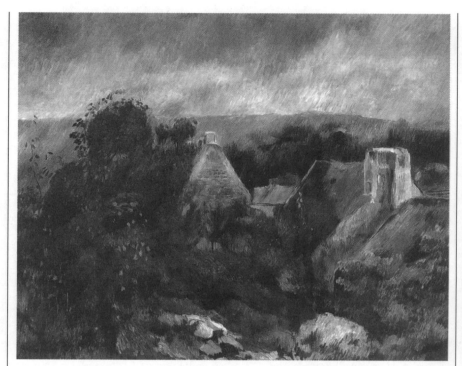

24 female figure in *City Dance* and *Dance at Bougival*. The three different settings capture the nuances of different social conditions in the situations or dress, without any ideological or moralistic aim beyond the mere observation of the urban "occasions" that Duranty spoke of. The painting technique, on the other hand, varies from the transparent effects of open light—especially in the background of the panel in *Dance at Bougival*, which is almost a quotation from *Dancing at the Moulin de la Galette*—to a clear-cut modeling of the volumes and the bodies of the dancers.

*T*he Trip to Italy

At the end of 1881, in an attempt to find an answer to the questions concerning the very sources of

painting, the already mature Renoir undertook what any artist would consider a fundamental stage in his early formation—a sojourn in Italy. He visited Venice, the city of light par excellence, where he executed some canvases in a purely lyrical Impressionist style, and then Florence, which he did not like except for the Uffizi. In Rome he visited the Vatican Museums and studied Raphael in particular, while he was not

particularly attracted by Michelangelo's "too many muscles." At the end of the year he was in Naples and Pompeii, where he was impressed by the timeless everyday air that exuded antiquity: "What I adore in painting is when it has an eternal air [...] but without proclaiming it is an everyday eternity that one takes in at the nearby street corner the maid who leaves off cleaning the pots for a moment to become Juno on Mt. Olympus!"

This "domestic eternity" is manifested in a canvas of the nude Aline that he painted at Capri from December 1881 to January 1882. *Blond Bather* absorbs and transforms the stimuli of the classical art Renoir had admired in the museums: a monumental pose, like a Roman Venus set in the *plein air* of "the present," in which an unprecedented calm light suffuses and enhances the woman's full, rounded form. As he later said to Monet, "I am a painter of figures."

"I went to see the Raphael's in Rome. They are very beautiful and I should have seen them earlier. They are full of culture and wisdom. He wasn't looking for impossible things like me. But they're beautiful. I prefer Ingres in oil paintings, but the frescoes are wonderful for simplicity and grandeur." These statements, from a

letter the artist wrote to Durand-Ruel, lend themselves to certain observations concerning Renoir's sojourn in Italy: his anxious search for something that was still unclear (the "impossible things"), the desire to achieve classical synthesis and equilibrium after the fragmentation and decline of Impressionist technique and, above all, his meditation on old painting procedures. "The workman of painting" felt his own procedure was no longer as fresh and efficacious as it used to be and thus sought a way out by studying the old masters. Although he preferred oil painting, the example of fresco work in Italy seemed the best way to simplify his palette—a sort of "strait-jacket" to eliminate all frills and return to the basics of painting: line and chiaroscuro. This marked the beginning of Renoir's *aigre* ("harsh, dry") period, in which he utilized a more clear-cut outline, thin, opaque colors and a smooth brushstroke almost without impasto. Back from Italy, he bought a copy of

♦ *Pierre-Auguste Renoir*, Edmond Renoir at Menton, *1883. Pencil on paper. Private Collection. The art critic and journalist Edmond Renoir, Auguste's younger* brother, is depicted seated comfortably in a natural pose. The fine hatching dwells on the outline, fraying it in order to create a plein-air atmospheric effect.

Cennino Cennini's *Libro dell'arte*, a treatise on the late trecento artistic techniques translated by one of Ingres' pupils, Victor Mottez, in the 1850s. Renoir began experimenting with colors, binders, brushes.

Critics have pointed out how the uncertainty of the transition from the "painterly" to the "dry" style is evident in *The Umbrellas* (ca. 1881-84), another large-size canvas that is difficult to date precisely because of its stylistic differences. Once again a

♦ *Pierre-Auguste Renoir*, Nude, *1880-90. Sanguine and white chalk on paper. British Museum, London. The monumental character of this female nude with her back to us, is highlighted by the* broad form that seems to spread over the sheet of paper and by the thick strokes of chalk that create the chiaroscuro effect. Traces of Ingres are thus combined with Degas's dry "naturalism."

Parisian square is bustling with gray figures in the rain; but the bourgeois family at the right—a woman with her two daughters—is still rendered in the soft Impressionist impasto, while the *grisette* in the foreground at left (Suzanne Valadon) seems to be sculpted by a compact and almost crystal-clear brushstroke, the same that defines the planes of the open umbrellas in the background. This "plastic," carefully constructed brushstroke reminds one of Cézanne most of all. The breakup of the Impressionist group had not interrupted their long and close

friendship, and Renoir was able to study the results of his companion's pictorial research when he returned from Italy and when to visit him at L'Estaque in 1882: this can be seen in *Rocky Crags* at L'Estaque, in which the harsh Midi light seems to congeal against the volumes of the rock. In 1885, it was Cézanne's turn to visit his friend at La Roche-Guyon, but the result seems to be the same, judging from the two landscapes they executed: the brushwork, besides its new consistency, is parallel so as to impart a feeling of perspective. In the extraordinary *The Children's Afternoon at Wargemont* (1884), which he painted in the Bérards' home, we again find Renoir's new dry brushstroke technique which,

however, retains its former capacity to absorb and reflect light. Rendered in firm strokes and a few light hues—from blue to white and chrome yellow—the interior of the room has the clear, soft brilliance of enamel or semi-precious stones. Renoir thereby cancels all traces of sentimentality so common to many nineteenth-century domestic scenes, which in his hands acquire a truly "classic" feeling. The same holds true for *Nursing* (or *Maternity*, 1885), which portrays Aline suckling their firstborn, Pierre, at Essoyes, her place of birth. Like a fifteenth-century Madonna, the charm of this group is heightened by the sinuous outline, while the light underscores the spatial planes; the colors are thin but bright, thus helping to create a dialogue between the figures and the landscape.

That same year Renoir again tackled a monumental composition with many figures. The subject—the nude—is one of those "absolute" motifs executed throughout the course of the history of art which allow one to consider only the basic problems posed by painting procedure. Renoir spent a lot of time preparing the execution of *The Bathers (Grandes Baigneuses)*—years of study and a series of preparatory drawings, much like an academic painter. This canvas reveals only the relationships between lines, color and volumes that so engrossed the artist. The large-format work was exhibited at the Georges Petit Gallery in 1887 and it is not surprising that it was lauded by the Symbolists, while it was received much more coolly by Renoir's old Impressionist group. Only Monet found it "sublime," while Morisot noted its strong ties with Ingres. A retrospective show of the old classicist's works, held at the 1867 Universal Exposition, had doubtless confirmed Renoir's first love for this exquisite interpreter of ivory female flesh. His indebtedness to Ingres and his linear, sinuous nudes—so sinuous they often discard all reality—never failed to crop up in Renoir's works in the form of clear references to *Reclining Odalisque*, *Bather of Valpinçon* (which Degas was also fond of) and *The Turkish Bath*. This "neo-classicism" on Renoir's part, so interesting and yet difficult to

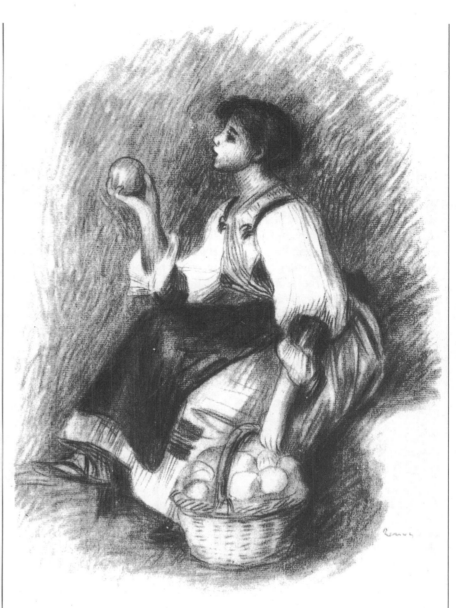

understand, responds to his need for order and rigor that is achieved, from 1886 to 1890, in the so-called pointillist works of Georges Seurat. However, Renoir's natural aversion to excessive theory in art led him to keep his distance from this new Divisionist movement; he felt that any formal rule an artist might accept must not be absolute and detached from the "events" or "accidents" of reality. These two statements by Renoir embody his reaction to the prevailing intellectual stance in painting, the

exponents of which he called "scientific artists." In order to oppose this trend he launched a proposal for the establishment of a Society of the Irregularists in 1884. However much the former Impressionist loved the old masters, he could not remain detached from the direct observation of nature for any length of time. The following decade would witness the reconciliation of culture and nature, studio and plein-air painting, mentioned above. "A picture is meant to be observed inside a house, where a false light comes in through the windows. So besides what you have done outdoors, a little work must be done in the studio. You should get away from the intoxication of real light and digest your impressions in the drabness of the room. Then you can take in the sunlight once again. You go out and work; you come back and work. That way your painting begins to get somewhere."

The "Pearly" Period: Monumentality and Elegance

The 1890s not only witnessed a reconciliation on a purely artistic level; Renoir's life also seemed to have become more serene, mostly thanks to the family life with Aline, whom he married in 1890, and his son Pierre (who would become an actor), later joined by future film director Jean (1894) and little Claude, nicknamed "Coco" (1901). Renoir's domestic life is evoked quite admirably in Jean's Renoir My Father. An important role in this family scene was played by the young Gabrielle Renard—one of

♦ Renoir at the age of fifty. The renewed freshness of his painting perhaps conceals the sheer physical exertion involved in his craft, which was aggravated by poor health, as can be seen in his emaciated face and somewhat melancholy air.

Aline's cousins, who took care of the children—and the comings and goings of the artist's models: besides Gabrielle, there was Marie—whom Renoir called "the Boulangère" (baker's wife) and "my Fornarina" in a facetious homage to Raphael—and Madeleine Bruno. He executed several portraits of Gabrielle and Jean with a detached, critical eye, thus channeling his personal feelings in an impeccable formal rhythm. The winters passed one after the other at their home-studio in rue Girardon nicknamed Château des Brouillards ("castle of fog") because of its rather shabby appearance and position on the Montmartre hill. In the summer the family spent a lot of time at Essoyes, where in 1895 Renoir bought a house that soon became a gathering place for his friends and admirers. His work was becoming more and more well-known and appreciated by critics. His "official consecration" took place in 1892, when a retrospective of 110 works—from Dancing at the Moulin de la Galette to The Bathers— was held in Durand-Ruel's gallery. That same year Renoir sold his first, and only, work to the government— Girls at the Piano; he executed many preparatory studies and six versions of this work, and the Ministry of Fine Arts ended up choosing one of the least successful. This commission was due to the good offices of Stéphane Mallarmé, and there is a touch of this poet's style, based on the evocative power of the phonetic qualities of the

♦ Renoir and Stéphane Mallarmé in an 1895 photograph taken by Degas, who creates an interesting composition through the skillful use of the spatial play of the mirror. The poet wrote some verses as testimony of their long friendship: "...paints Monsieur Renoir, / who before a nude shoulder / uses a color other than black."

word, in Renoir's brushstroke, which merely suggests, but never defines, the form. Mallarmé and Renoir saw a lot of each other from 1887 on at Berthe Morisot's salon and planned an illustrated edition of the former's poems, for which Renoir did his first etching in 1890.
Most of Renoir's painting in this period concentrated on the bare shoulders of his Bathers, an ideal surface for rendering the most delicate color transitions mirrored in the air and atmosphere of a wood or a rocky coast. According to Denis Rouart's felicitous statement. In these works the artist finally managed to create the plastic solidity of the nude with the mobile vibrations of the rapid dab of color. In fact the brushwork becomes longer and soft along the outlines, which are no longer rigorously linear, and models the volumes and the chiaroscuro contrasts without dissolving into the hazy chromatic atmosphere of Renoir's

♦ Pierre-Auguste Renoir, Gabrielle and Jean, 1895-96. Pencil on paper. Renoir's second eldest son Jean was born at the Château des Brouillards in 1894: Aline asked her young cousin Gabrielle Renard to live in with them and help run the house. This was a preparatory study for the canvas now kept in the Musée de l'Orangerie.

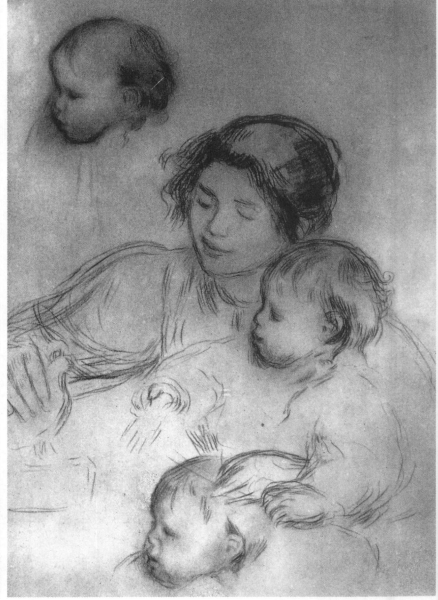

♦ View of Cagnes-sur-Mer from Renoir's villa Les Collettes. After many sojourns in the south of France, from Aix-en-Provence to Nice, Renoir decided to spend the long, difficult winters in Cagnes; from 1903 on he rented the Villa de la Poste, and in 1907 moved to Les Collettes.

♦ The Château des Brouillards in Montmartre, where the Renoir family lived from 1890 to 1897. In the highest and most humid part of the hill that overlooks Paris, the "Castle of Fog" was actually a complex of houses connected by a garden and surrounded by kitchen gardens. One of the Renoirs' neighbors was Paul Alexis.

♦ *Renoir painting in the garden in front of the Villa de la Poste at Cagnes-sur-Mer in 1903. His hands were deformed by arthritis that* *occurred after a bicycle fall in 1897, and he seems almost unable to hold the brush. He had sixteen years of activity and painful illness before him.*

Impressionist period. The colors also become softer-keyed, in a range that often echoes Corot's silvery hues, thus producing a precious, "pearly" transparency of the flesh tones, a "magical classicism" suffused by light. Renoir again drew some inspiration from the old masters. He embarked on a long period of travels that began in 1892; in Spain he "discovered" Goya, then he went to London, Dresden and lastly to Holland in search of Rembrandt's flashing beams of light, Rubens' reds and the limpid (and pearly) light of Vermeer. "I have gone back, for good, to the old painting, soft and gracious [...] (A sort of inferior Fragonard). Believe me, I'm not comparing myself to an eighteenth-century master, but it is important for me to explain to you the direction I'm taking. These painters, who didn't seem to be working from nature, knew more about it than we do," he wrote to Durand-Ruel.

The light sensuality of eighteenth-century painting—and of the old

♦ *Pierre-Auguste Renoir, Coco and Rénée, 1902. Pencil and pastel on paper, 61 x 47.7 cm (24 x 18 3/4 in). National Gallery of Canada, Ottawa. Claude Renoir, nicknamed "Coco," was born in* *1901. His father painted his portrait often during his infancy; here he is being held by the family maid Rénéz, in the same pose as the canvas, also kept in the Ottawa museum.*

"porcelain painting"—inevitably comes to mind when viewing the various girls (in *In the Meadow* or *Picking Flowers*), engrossed in picking flowers in a soft, lyrical pastoral-like landscape. Renoir paints these girls mostly in the utter calm of Mézy, Berthe Morisot's country residence, where Renoir was a guest in 1890.

Girls and bathers were to remain the dominant motif of this period: the flowers serve as exercises in color schemes and as a temporary relief from the labor of more complex compositions, while the landscapes were but "they help one to learn the metier." What Renoir meant by this is readily explained in his *Mont Sainte-Victoire*, executed in 1889, obviously together with Cézanne, during a summer sojourn at Montbriant, near Aix-en-Provence. Stimulated by his friend, he labored mightily in a quest for a new artistic procedure, as can be seen in the particular geometric configuration of the mountain profile against the sky, created by incisive, parallel brushstrokes to suggest space. After an attack of facial paralysis caused by rheumatoid arthritis, his doctors advised him to go to the south of France, which became an increasingly important component of his life and artistic evolution: first he sojourned frequently at Aix in 1888 and 1889 and, after a bad fall on his bicycle in 1897, he went to Cagnes-sur-Mer (1899), Magagnosc (1900-02) and then settled in Cagnes.

Renoir reacted to his ill health and

♦ *Pierre-Auguste Renoir, Ambroise Vollard, 1904. Lithograph, 23.8 x 27 cm (9 1/4 x 10 1/2 in). This print is part of a series commissioned by Vollard himself. In* *Jean Renoir's book of memoirs, Renoir enjoyed saying that the corpulent figure of the art dealer reminded him of the flaccid profile of a "Carthaginian general."*

♦ *At the end of the century Misia Godewska was a "muse" of the Symbolists and the circle of artists and men of letters associated with the periodical managed by her first husband, Thadée Natanson,* *the "Revue Blanche." Here she is portrayed by Toulouse-Lautrec on the cover of an 1896 issue. She later married the financier Alfred Edwards and was a friend of Renoir in his old age.*

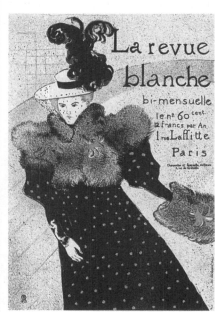

pain by becoming even more active and prolific; he executed several canvases of bathers, which were becoming more and more popular on the art market.

In the meantime, the 1900 Paris Exposition Universelle consecrated Impressionism; though he had refused the same honor ten years earlier, Renoir accepted the Legion of Honor (the Napoleonic decoration derided by Flaubert) and wrote a rather embarrassed letter to Monet to justify his attitude. Very few artists in the old group were still alive; Caillebotte had died in 1894, entrusting the management of his bequest to Renoir, and Morisot had passed away in 1895, naming her dear friend Renoir and Mallarmé the guardians of her daughter Julie and her two nieces. Above all, Morisot bequeathed "a posthumous donation" to Renoir, as the artist himself stated with irony:

Ambroise Vollard. As the art dealer Vollard was "gifted" with a disconcerting Levantine indolence and formidable artistic intuition: "That young man rests in front of a canvas like a hunting hound before game." Renoir, who already had an exclusive sales contract with "papa" Durand-Ruel, introduced Vollard to Cézanne, who put his entire oeuvre at the art dealer's disposal.

The Last Flames at Cagnes

28

The broken right arm caused by the 1897 bicycle accident had soon degenerated into rheumatoid arthritis. A few years later Renoir was forced to remain in a wheelchair and, what is worse, his hands became terribly deformed. A photograph taken around 1909 shows him bent and withered, his fingers and thumb shrunken and curled inwards against the palm of his hand. Jean Renoir recalls the terrible impression his father's hands made on visitors, together with the astonishment at his still being able to work. In his final years he had to wrap gauze around the brush so that it would not wound his thin skin. The "workman" who boasted about the manual dexterity of his craft and who even went so far as to judge people's character by the shape of their hands, seemed to have lost his most precious tool. Yet never before had touch played such a prominent role in his art. that is to say, the very urgency of nature to be described and depicted. This is the final version of the theory of the "cork bobbing in the water", of

♦ *Renoir in 1915, photographed at Les Collettes with Andrée Hessling, known as Dédée, his model and Jean's future wife. The artist's hands, deformed by*

rheumatoid arthritis, stand out clearly—the "sick and beautiful hands" that so moved the artist Odilon Redon when he paid Renoir a visit in 1901.

the utopia of the pure Impressionist eye; but now, in Renoir nature had found a totally free and imaginative accomplice rather than a faithful interpreter.
The "physical motif" of this period is the *Bathers*, which Renoir concentrated on almost exclusively, together with portraits—as though he had actually spent his entire life in pursuit of the same canvas, as indeed he himself claimed. The nudes are now modeled with a brushstroke that is more and more prehensile and plastic, so much so that the thick texture coagulates around it. The natural spin-off of this "tactile necessity" was that Renoir began to sculpt in 1913, urged to do so by

Vollard. A young Catalonian sculptor, Richard Guino, "lent" the artist his hands; in 1918 he was replaced by a modeller from Essoyes, Louis Morel. But painting was still the most suitable medium to interpret that merging of form and light in color Renoir had pursued during his Impressionist period; indeed, the volumes seemed to emanate from the color, like a ripe fruit.
Jean Renoir and Albert André describe the artist's technique in this last phase: the initial, rapid priming to define the essential masses, then modeling with the brush, which reinforced the shadows; often the background retained an "unfinished" smoothness and fluency, with rapid, flashing brushstrokes, as if he were improvising. The canvas was built around nuclei of light, which emerged from the white background as if from a well through the pigment—a sort of glazing procedure in reverse, from transparent tones to the denser and drier colors. Depth was achieved by means of a "negative" relief, the white ground serving the same function as the kaolin plates he painting during his youth. The result was an "orgiastic, Dionysian" procedure that totally fused the figure and the natural setting. he said. This was no longer a question of atmosphere, but of a physical equivalence between air and bodies.
Renoir applied blazing color without hesitation, at times even risking dissonances between bright yellows, greens and oranges. The 1918-19 version of *The Bathers*, which was found in his studio when he died and was donated to the Louvre by his children, was at first refused because it was "loud." Even today it is difficult to understand Renoir's sensual classicism. His favorite tones were now reds "à la Boucher," to use the American artist Mary Cassatt's felicitous expression. he stated, Once again the influence of the old masters is to be seen: Rubens, or better yet, the late works of Titian, with their almost indefinite, flashing

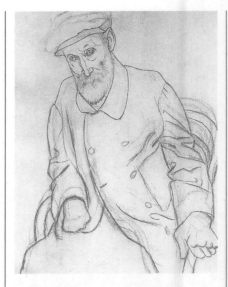

♦ *Using a 1915 photograph taken in Renoir's studio as a model, Picasso drew this portrait of the artist in 1919. Note the use of the outline, which synthesizes the*

volumes through pure line. After his Cubist period, Picasso began his "neo-Classic" style. Pencil on paper, 61 x 48.8 cm (24 1/8 x 19 1/4 in). Private Collection.

♦ *Below, Pierre-Auguste Renoir, The Judgment of Paris, 1908. Sanguine on paper, 47.3 x 61 cm (18 1/2 x 24 in). Phillips Collection, Washington D.C. Bottom, Pieter Paul Rubens, The Judgment of Paris, 1638-39. Oil on panel, 199 x 379 cm (78 3/8 x 149 1/4 in). Museo del Prado, Madrid. Before*

executing his most important canvases, Renoir did a series of preparatory drawings; this one was for the first version of The Judgment of Paris, which Renoir painted again in 1913-14. Rubens' influence is quite evident, especially in the figures of the goddesses at both sides.

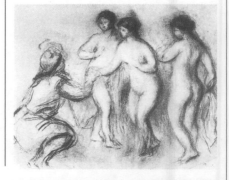

♦ *Pierre-Auguste Renoir*, Villa de la Poste at Cagnes, *1906-07. Oil on canvas, 13 x 22.5 cm (5 x 8 3/4 in). National Gallery of Art, Washington D.C. In the first years of his winter sojourns* *at Cagnes, Renoir stayed at the Villa de la Poste, where according to his son Jean he enjoyed himself most in the company of a simple and cheerful old man, a certain Dinand.*

forms. Renoir's Judgment of Paris drew inspiration from Rubens' canvas of the same name, which he had admired at the Prado in 1892 he did several versions of this work from 1908 on, including a low relief sculpture modeled by Guino in 1914-15.

*L*ight, Bodies, Space

Gabrielle had become Renoir's favorite model, posing for the goddesses and young shepherds (Renoir felt awkward with the male nude), and even for the heavy-set Mercury in the version of *The Judgment of Paris* now kept in the Hiroshima Museum of Art. Gabrielle also posed for a series of light-hearted boudoir scenes, while putting a rose in her hair or playing with jewels; here

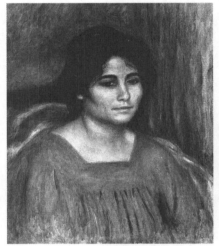

♦ *Pierre-Auguste Renoir*, Gabrielle in a Red Blouse, *ca. 1910. Oil on canvas, 56 x 47 cm (22 x 18 1/2 in). Fogg Art Museum,* *Cambridge, Mass. Gabrielle Renard was Renoir's favorite model until 1914, when she left the Renoir home.*

♦ *Renoir at Les Collettes (Cagnes-sur-Mer); at right is Gabrielle, while the old cook is standing a bit in the background at left. This photograph was* *certainly taken prior to 1910, when the artist was afflicted by yet another violent attack of rheumatoid arthritis that confined him to a wheelchair.*

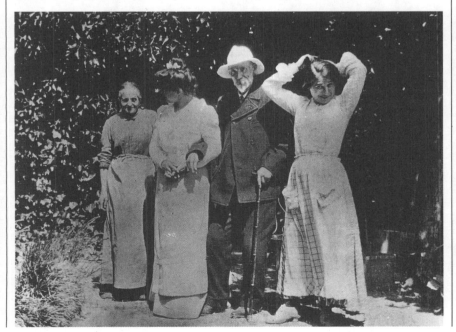

Impressionist Sculpture: Degas and Renoir

♦ *Pierre-Auguste Renoir and Richard Guino*, Venus Victorious, *1914. Bronze. Tate Gallery, London. Venus is holding the apple of victory awarded to her by Paris. Originally, the base was to have consisted of a bas-relief of the* *famous painting,* The Judgment of Paris. *There are many references to ancient sculpture in this work, but in the proportions of the rounded figure Renoir once again draws inspiration from Rubens' baroque painting style.*

With great clarity of judgment, Renoir noted in his friend's sculpting talent precisely that new element which, paradoxically enough, had made Impressionism a pictorial expression par excellence: the capacity to convey the ephemeral as an eminently "modern" quality. It is surprising that such deep understanding could have come from the only other Impressionist who practiced sculpture, but in an almost antithetical manner. Renoir preferred balance and the static and monumental front view, which Degas avoided and rejected. It is no accident that Renoir worked for the most part in high relief, the form closest to the "flat" dimension and one-point perspective of the canvas, while he was uncomfortable with freestanding sculpture. So Renoir was much more classical in sculpture than Degas, as were his sources of inspiration: the sixteenth-century *Fountain of the Innocents* by Jean Goujon, which was in the Marais quarter, or the relief in the Versailles park, Girardon's *Nymphs Bathing* (1668-70), which art historians have indicated as the model for *The Bathers*.

Almost as if to pay a debt and tribute, Renoir executed a series of about fifteen medallions and sculptures in 1914—including Ingres, *Delacroix and Corot*—conceived as his personal *Pantheon*; his freestanding figure of *Cézanne* is still at the fountain of the hot baths in Aix-en-Provence. It seems that his first sculpture dates from 1908—another medallion portraying his son Coco. That same year, Aristide Maillol went to Essoyes to sculpt a bust of

Renoir, having been asked to do so by the two artists' dealer, Vollard. And it was exactly Vollard (perhaps sensing a potential commercial success, as occurred with Degas) who in 1913 persuaded Renoir to do sculpture pieces together with the young Spanish sculptor Guino, a pupil of Maillol. Just as in the case of the aged Degas, infirmity played an important role here: Degas was half blind and sculpture was an extension of his eyes through touch, whereas Renoir's eyes replaced his deformed hands—he would dictate his ideas to Guino, correcting the forms modeled by the "borrowed hands" of the Spaniard. In June 1914 they executed a statuette of *Venus Victorious* which, redone on a much larger scale and worked out in more detail by Renoir himself, was exhibited at the Triennial held in Paris in 1916 (it is now kept in the Tate Gallery in London).

The choice of bronze, the monumental scale, the balanced frontal pose—reveal that Renoir the sculptor was also seeking a new poised and triumphant classicism partly inspired by the serene majesty of the Midi: The same solemn, fleshy Venuses that recur in Renoir's canvases of *Bathers* or in *The Judgment of Paris*, which was also sculpted in high relief (first in plaster then in bronze) by Renoir to serve as the base for the *Venus Victorious*.

the rich, warm colors hark back to the odalisques and to Delacroix, and Gabrielle's dark beauty is heightened by the contrasts with the dominant red in the flowers, while the blooming nude stands out in the light with tangible monumentality. Gabrielle left the Renoirs' home around 1914; Jean saw her again in Hollywood, married to the painter Conrad Slade. She was replaced by the red-headed Andrée, nicknamed "Dédée," who would become Jean's wife and the model for Renoir's last canvases in different poses, while bathing or combing her hair—mere pretexts for the artist to depict the body in dialogue with the surrounding space.

These intimate female scenes could be compared to the pastels of Degas's late oeuvre, which were also informal and filled with flashing light; but if in their late works both artists dramatically heightened their tonal values in a manner that is almost tantamount to abstraction, Renoir retained the softness and triumphant

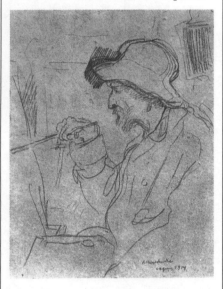

♦ *Albert André,* Auguste Renoir Painting, *1914.* *Pencil on paper. The artist was portrayed by his friend and disciple André at Cagnes while at* *work on a painting. Renoir's laborious and painstaking gesture makes his deformed hand become the focal point of the drawing.*

classicism of his figures, which were for the most part centrally placed, and Degas his sharp, penetrating line, cropped forms and odd viewpoints. After having lived in Cagnes since 1903 in the Ville de la Poste, which he painted, in 1908 Renoir bought the small Les Collettes estate, where he spent the winter. In the garden full of olive trees he had a studio built with walls that could be opened and closed according to the hour of the day and the light. He therefore solved the long-standing problem of whether to paint in the studio or outdoors.

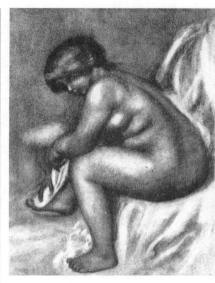

In the summer he sometimes went to Essoyes and Paris; in his new apartment at rue de la Rochefoucauld he worked on portraits of his friends or patrons, such as the Bernheim art dealers, the impresario Paul Gallimard and his mistress, the music hall actress Diéterle, and Maurice Gangnat, who became one of the most important collectors of Renoir's late works. Durand-Ruel, by then an elderly person, is portrayed in a pose of relaxed intimacy, his hand lying on his chest, his head thoughtful and noble, much like a Renaissance ruler; the black of his jacket is "false" since it is softened by the myriad touches of yellow and red that pass over it, blending it in with the background. The same colors enhance the affectionate, but not idealized, portrait of his wife Aline, painted in the same year, 1910; the summary treatment of the dress in thick, rapid brushstrokes seems to amplify the lines of a body that was already robust in Aline's youth and had become heavy because of diabetes. However, there is no melancholy trace of her illness. She died in 1915, after having rushed to the bedside of their son Jean, who had been wounded in battle. A frowning Coco is portrayed in a clown's costume (1909), and another "disguise" proves to be quite becoming for Ambroise Vollard Dressed as a Toreador (1917), a work in which the thick impasto of light and shadow actually brings to mind certain late works by Titian, the "fables" in the Prado and Escorial museums. Vollard

♦ *Renoir in his studio portraying* Tilla Durieux, *the wife of the Berlin art dealer Paul Cassirer (1914). The pose chosen by the artist is interesting; Durieux is seated in* *full daylight, facing the large window, so that in the finished painting the shimmering golden hues on the folds of the veil on her shoulders would be highlighted.*

♦ *Pierre-Auguste Renoir,* Woman Bathing, *1916. Sanguine on paper. The reference to Ingres' odalisques, with the pure* *arabesque of their long, sinuous backs, is here combined with the vigorous plastic qualities of the full rounded form covering the surface.*

appears in another 1908 canvas in the more appropriate dress of an art collector: leaning on a table covered with a precious rug, he is fondly holding a statuette by Maillol. The burgeoning sculptor, who also painted under the influence of Gauguin and his disciples in the Nabis movement, was that very year asked by Vollard to do a bust of Renoir. Jean Renoir relates that Maillol executed a masterpiece which collapsed and broke into

♦ *Renoir's studio at Les Collettes, Cagnes. Next to the easel is the artist's wheelchair. There was another studio outside with* *sliding windows on each side that allowed Renoir to capture the nuances of light at different hours of the day.*

hundreds of pieces; according to Maillol himself, the second version was not at all of the same quality. Among the other portraits, mention should be made of two delicate interpretations of female charm. The first is of *Misia Natanson* (1906), the Polish woman (née Godewska) who had been married to the "protector" of Symbolism, Thadée Natanson, founder of the "Revue Blanche," and then married the financier Alfred Edwards. In the portrait she stands out in a thoughtful pose against a background of subtle shades of yellow-blue. The other portrait is of *Tilla Durieux*, the wife of the German art dealer Paul Cassirer who is captured in the full bloom of her beauty, in a blaze of red and gold that again remind one of Titian.

Renoir's fame was by then consolidated everywhere. In 1904 an entire hall of the Salon d'Automne was

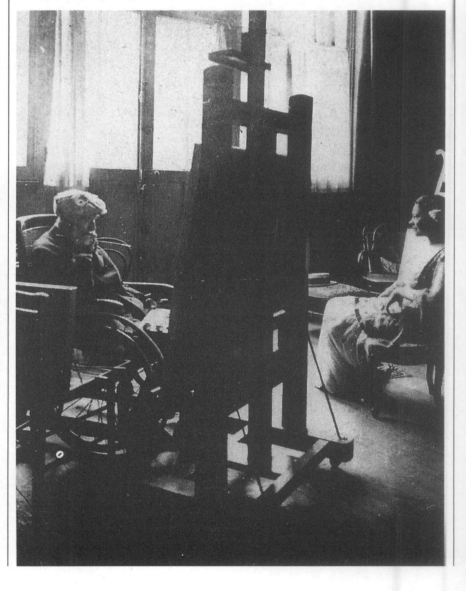

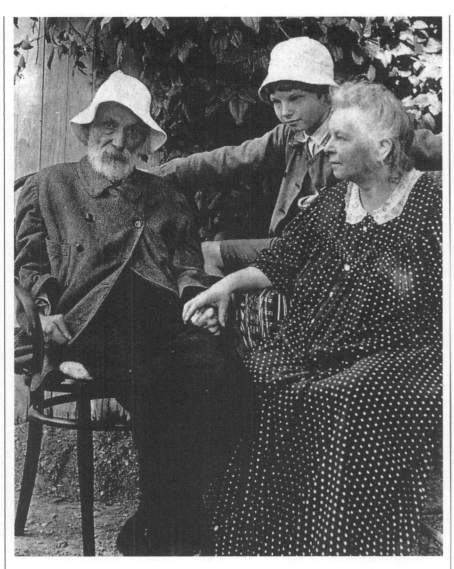

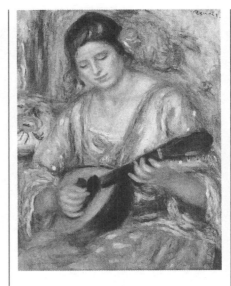

Renoir's influence on twentieth-century avant-garde art is perhaps less apparent than Cézanne's or Gauguin's; but his free treatment of color and brushwork, especially in his final years, certainly left its mark, as did his light, which was capable of creating life on the canvas. In the previous sections, mention has been made of certain characteristic "studio portraits." We might conclude with another emblematic work, HoHomage to Cézanne by the Symbolist Maurice Denis: behind the group of artists who are discussing a still life by their favorite master, one notes a woman's face in a canvas by Renoir—obviously another ideal tribute to a master. Renoir had no real pupils to speak of, except for Jeanne Baudot. His humble and practical conception of painting as a "trade" prevented him from thinking he could teach anything to someone else. But he was well aware of leaving a heritage for those who would follow him in artistic creation: Pierre-Auguste Renoir died the evening of December 2, 1919. If what his son Jean says is true, his last words were:

♦ *Pierre-August Renoir*, Girl with a Mandolin, *1918. Oil on canvas, 64 x 54 cm (25 x 21 1/4 in). Durand-Ruel Collection, Paris.*

This is one of the many variations on the theme of the "chamber concert"; the model, in Spanish dress, is perhaps Dédée.

♦ *Maurice Denis*, Homage to Cézanne, *1900. Oil on canvas, 180 x 240 cm (71 x 95 in). Musée d'Orsay, Paris. Drawing inspiration from Fantin-Latour,*

Denis portrays Symbolist artists and connoisseurs commenting on a canvas by Cézanne: behind them is a canvas by Renoir— another discreet and subtle homage.

given over to his works; in 1910, he was the only Impressionist to have a one-man exhibition at the Venice Biennial; two years later his works were exhibited at the Thannhäuser Gallery in Munich and Cassirer's gallery in Berlin; in the meantime, the first biography of Renoir had been published by Meier-Graefe in 1911. In 1913, five Renoir works were shown at the now legendary Armory Show in New York together with those by avant-garde artists. In 1917 *The Umbrellas* was hung at the National Gallery in London among works by the masters, and a hundred or so English admirers wrote to him: A few months before his death, this artist so

♦ *Renoir with his wife Aline and their youngest child Coco in 1912. Aline is fondly holding her husband's deformed*

hand. Because of diabetes she had become prematurely frail and ill, and died three years later.

enamored of the old masters was carried on a chair "like a pope on his throne" to visit the Louvre for the last time; he asked to be allowed to pay his final tribute to Delacroix, Corot, and Veronese's *Marriage of Cana.* Recognition of his role in the evolution of artistic style in the nineteenth century also involved pilgrimages on the part of young artists—from the former Nabis Édouard Vuillard and Pierre Bonnard (who so ably interpreted, in a totally personal manner, the atmospheric effects produced by Renoir's brushwork), to Albert André and his wife, and even Henri Matisse in 1917.

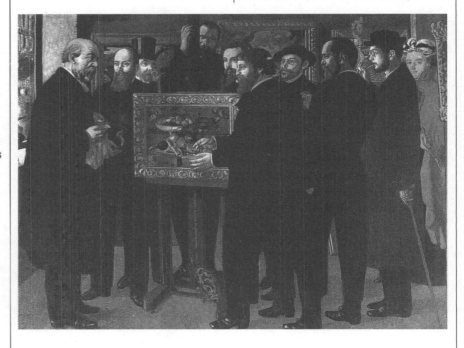

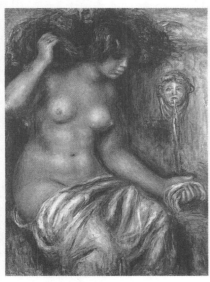

♦ *Pierre-Auguste Renoir*, Bather at the Fountain, *ca. 1910. Oil on canvas, 91 x 73 cm (35 3/4 x 28 3/4 in). Private Collection, New York. This work was*

executed at the apogee of Renoir's late classical style. Note the decorative rendering of the drapery and the "antique" quality of the fountain.

THE WORKS

*"He paints neither the soul nor the mystery nor
the meaning of things because one can grasp
a little of their meaning, mystery and soul only
if one pays attention to their appearance.
This is the secret of his youthfulness and joy.
"[...] Renoir is perhaps the only great painter
who never painted a sad picture."*

Octave Mirbeau, Preface to Renoir, catalogue published for the
Renoir exhibition held at the Bernheim-Jeune Gallery in Paris, 1913

Biography

Pierre-Auguste Renoir was born in Limoges on February 25, 1841, the sixth child of Léonard, a tailor, and Margeurite Merlet, a seamstress. Two of the couple's children had died in infancy; the eldest, Pierre-Henri, would become a goldsmith's engraver; his sister Marie-Elisa, an enthusiastic advocate of democratic ideas, would marry the engraver Charles Leray, one of those who first believed in his young brother-in-law's artistic aptitude; Léonard-Victor would become a tailor, while the youngest child Edmond was to be a journalist and art critic. In 1844 the Renoir family settled in Paris, in the neighborhood of the old Louvre; later, because of the new town-planning projects in this quarter ordered by Napoleon III, they moved to the Marais. Auguste abandoned a potential musical career that Charles Gounod, then his voice teacher and choirmaster at St.-Eustache Church, had proposed since 1850, and became an apprentice in 1854 at the Lévy brothers' porcelain painting establishment, probably because of the family's pride in the Limoges tradition. That same year he enrolled in the School of Drawing and Decorative Arts, run by the sculptor Callouet; here he met the painter Emile Laporte, who helped him to decide to embark on an artistic career. In 1858 the Lévy firm went bankrupt and Auguste began working on decorating fans in the Louis XVI porcelain style; the following year he started work in Gilbert's laboratory, which specialized in painting sacred screens for the Oriental missionaries, and also earned extra money decorating the walls of cafés and bistros.

While working he went frequently to the Louvre, where he was registered in 1860 as one of the authorized copiers thanks to the good offices of the art restorer Abel Terral, and he made his first attempts at painting: besides copying Rubens, Fragonard and Boucher, he did theater motifs drawn from the eighteenth-century galante painting.

In 1861 he must have already been studying at the studio of Charles Gleyre, since the old Swiss painter signed Renoir's request for authorized access to the Bibliothèque Nationale's print department, where the budding artist took his first steps in academic apprenticeship by studying the engravings of the masters. The following year he passed the admission examination to the summer session of the École Impérial et Spéciale des Beaux-Arts, finishing 68th out of 80 candidates. He then enrolled in the classes held by Émile Signol and his teacher Gleyre. He lived at Laporte's home (beginning the custom of sharing lodgings with his fellow painters) and began making friends at the *atelier*: Henri Fantin-Latour, who was already somewhat successful, and above all the future proponents of Impressionism, Alfred Sisley, Frédéric Bazille and Claude Monet. In 1863 Renoir went with them to initiate a new activity—painting outdoors in the Fontainebleau forest, in the wake of the Barbizon school artists; but he did not reject the precepts laid down at the École and placed well in the figure drawing (1863) and drawing (1864) competitions. This was the period in which Renoir was most receptive to the canons of official painting. He rented a studio and exhibited a canvas of literary inspiration, *Esmeralda* (from Hugo), at the Salon which received some praise but which the unsatisfied Renoir decided to destroy. He obtained his first portrait commissions: his friend Laporte, the young Romaine Lacaux, and Sisley's father William. This last portrait was exhibited at the 1865 Salon together with *Summer Evening*. Renoir moved in with Sisley and the two, together with Monet, Pissarro and Auguste's brother Edmond, spent long periods at Marlotte, in the Fontainebleau forest, at Mère Anthony's inn and then in the villa of their new friend Jules Le Coeur, where Renoir met his first mistress and model, Lise Tréhot. In 1866 Sisley got married and Renoir began to share a flat with Bazille. The works he submitted to the 1866 and 1867 Salons (a landscape and *Diana* respectively) were rejected and the group of young artists protested, asking in vain for another Salon des Refusés to be held. This was the period when Renoir frequented the Café Guerbois and executed his first portraits of his girl-friend *en plein air*. *Lise* was exhibited at the 1868 Salon,

paving the way for new commissions; the following year the Salon accepted his Study: *In the Summer*. Two decorative panels executed for Prince Bibesco, whom he met in 1868 through Charles Le Coeur, were lost in 1911; but his new friend introduced him to the Grenoullière restaurant on the island of Croissy, which Renoir and Monet painted side by side in 1869. That same year he met Edmond Maître and his circle of writers and musicians; he stayed at Maître's house when the Franco-Prussian War broke out in 1870 and after Bazille's tragic death in battle the following year. *His Bather with a Griffon and Woman of Algiers* were shown at the Salon in May 1871, just before he enlisted in the army. He lost track of Lise, who in the meantime got married, and in 1872 went frequently to Monet's home in Argenteuil, where the two worked together outdoors. In 1873 he sent *A Morning Ride in the Bois de Boulogne* to the Salon, but it was rejected; it was, however, exhibited at the Refusés show, where it was praised by Castagnary and Théodore Duret; the art dealer Paul Durand-Ruel also became interested in the young artist.

1874 witnessed the founding of the Anonymous Society of Painters, Draftsmen, Sculptors and Engravers and the inauguration, from April 15 to May 15, of the famous Impressionist exhibition held in Nadar's studio, where Renoir managed to sell three canvases. That summer he and Le Coeur broke up their friendship, and he continued to paint at Argenteuil with Monet. In Paris the Café Guerbois was replaced by the Nouvelle-Athènes as the group's haunt. In 1875, an auction sale organized by the group at the Hôtel Drouot was received with hostility, but Renoir met new patrons: the customs official Victor Chocquet, a collector of Delacroix's works, who commissioned two portraits; the financiers Henri Cernuschi and Charles Ephrussi; and above all the publisher Georges Charpentier. Despite these developments, the second Impressionist show organized by Durand-Ruel (1876) was poorly received, and in "Le Figaro" the critic Wolff censured Renoir's *Nude in the Sunlight*. With the proceeds from his new commissions, the artist rented an

abandoned garden in rue Cortot in Montmartre, which became his outdoor studio where he set about working on large-format compositions such as *The Swing* and *Dancing at the Moulin de la Galette*. He was a frequent guest at the Charpentiers' salon, where he met the writers Daudet and Rivière, the composer Cabaner, and actresses such as Henriette Henriot and Jeanne Samary, whom he immortalized in portraits. He was increasingly interested in theater motifs, as can be seen in his *After the Concert*. In 1877, at the third Impressionist exhibition, Renoir's portraits received praise and he acquired new commissions from the Countess de Pourtalès and the eclectic baker, writer and composer Eugène Murer. Two years later his portraits The Actress *Jeanne Samary and Madame Charpentier with Her Children* were accepted at the Salon, where he had exhibited *The Cup of Chocolate* the previous year.

No sooner had Duret published his pamphlet *Impressionist Painters* than the group split up; in 1879 Renoir decided not to exhibit with the Anonymous Society any longer. But he was becoming known, partly thanks to an article by his brother Edmond in Charpentier's "La vie moderne" on occasion of a one-man show organized by the periodical. The financier and diplomat Paul Bérard played host to him at his château at Wagermont on the coast of Normandy, which was to be one of Renoir's favorite sites. At nearby Dieppe he decorated the dining room of Dr. Emile Blanche's home with Wagnerian motifs. Through the Bérards he met the financier Cahen d'Anvers, who in 1880 and 1881 commissioned several portraits of his daughters. However, Renoir did not abandon his study of atmosphere and light outdoors: in 1879 he portrayed Aline Charigot, his future wife, several times on the banks of the Seine at Chatou, and the need for different inspiration for landscape painting led him to Algiers in March 1881. When he returned to Paris he did portraits of Aline, Caillebotte and other friends in his *Luncheon of the Boating Party* at the Fournaise restaurant in Chatou. He spent July at Wagermont and then went to Italy with Aline; they visited

Venice, Florence, Rome, Naples and Capri in 1881, and Palermo the following January, where he executed a rather unsuccessful portrait of Wagner. After returning to France, he went to visit Cézanne at L'Estaque for the first time, painting well structured, clear landscapes with his friend that seemed to denote a new style. After another stop at Algiers to regain his health after a bout of pneumonia, in May 1882 he returned to Paris, where he was again with Aline Charigot and began work on his ambitious triptych based on the *Dance* (Country Dance, City Dance, Dance at Bougival) with Aline and the future artist Suzanne Valadon as models. In 1883 he had a one-man show at Durand-Ruel's gallery presented by Duret and was accepted in the Salon, which consolidated his fame. But Renoir was taken up with research into new formal, technical problems and began studying Cennini's treatise on art translated by Ingres' pupil, Victor Mottez.

He spent the summer on the coast of Normandy, at Wargemont and Guernsey Island, studying the compositions of marine and bather motifs. In December he took his last trip together with Monet to the Riviera, but by now their artistic procedures and aims were diverging. Renoir concentrated on reading and made plans for a new society of painters, the Irregularists, writing a program in 1884 that stressed the importance of the old masters. The following year his first son, Pierre, was born; the tender portrait of Aline suckling their child amidst the peaceful countryside of her home town, Essoyes, was an occasion to refashion the clarity of the Renaissance Nativity scene in a luministic key. A visit paid by Cézanne confirmed his newfound interest in a more plastic and rigorous procedure that is revealed in the monumental canvas *The Bathers* (Grandes Baigneuses), which he worked on up to 1887. Exhibited at Georges Petit's gallery (Durand-Ruel was in financial straits and was trying to open a new market in the United States), this work was lauded by the Symbolists through the writings of critic Théodore de Wyzewa. Renoir frequented the circle of Stéphane Mallarmé, whom he had

met through Berthe Morisot, and the two planned to do an illustrated book of the poet's prose poems; although nothing came of this, it gave Renoir the opportunity to do his first etchings and engravings.

This period marked the apogee of Neo-Impressionism, with its precise, systematic application of dots of color, whereas Renoir went his own way, regaining freedom and ease of expression in works such as *Girl with a Basket*, which marked a departure from the synthetic dryness of his *aigre* period. At the end of the year he had his first attack of rheumatism and facial paralysis. He went to live in the drier climate of Essoyes (where he bought a house in 1895) and in the summer went south to Montbriant, in Provence, in the home of Cézanne's brother-in-law, where he painted a vigorous view of *Mont Sainte-Victoire*. 1890 was an important year for Renoir. In April he married Aline (their witness was the Italian artist Zandomeneghi) and moved to an apartment-studio on Montmartre hill, nicknamed the "castle of fog." In January 1891 he exhibited some nudes at the Symbolist group exhibition in Brussels organized by Octave Maus; a sign of the increasing appreciation of his works is the article De Wyzewa wrote in the periodical "L'art dans les deux Mondes," which was followed in 1891 by the important review Aurier wrote in "Mercure de France." His consecration arrived in 1892, with a large retrospective show of 110 canvases at Durand-Ruel's gallery. Thanks to the good offices of Mallarmé, he also received his first (and only) public commission: *Girls at the Piano*, which was purchased by the Director of Fine Arts Henri Roujon. He went on a trip to Spain with the art collector Paul Gallimard and later visited Pont-Aven, without meeting Gauguin. In 1894 his second child, the future film director Jean, was born and his friend Gustave Caillebotte died; Renoir and Caillebotte's brother Martial were executors of his will. The so-called Caillebotte *affair* concerning the donation of his collection to the state ended only in 1897 with the exhibition of part of the collection at the Luxembourg museum, much to the dismay of the academic world. 1895 marked another tragic event for

Renoir: the death of Berthe Morisot, a close friend and fellow Impressionist at whose Meulan home Renoir had stayed for long periods and had resumed his light, graceful style. After a series of trips that took him to London (where he admired Lorrain but did not particularly like Turner), the Hague and Dresden (to see Vermeer), in the summer of 1897 Renoir fell off his bicycle and broke his right arm. This was the beginning of the illness that would almost paralyze him. He went south in search of a drier climate: Cagnes-sur-Mer, near Antibes, in 1889, Magagnosc the following year, Cannet near Cagnes from 1902 on, and then at Cagnes again from 1908 onwards at the villa Les Collettes. In the summer he found relief from the heat at Essoyes with his family which in 1901 grew in number with the birth of Claude, called Coco. That spring Renoir stayed in Paris. Despite the constant pain and progressive deformation of his hands, he worked intensely. This was the period of his large canvases of voluptuous, brightly colored nudes. In 1900 he was awarded the Legion of Honor and almost apologized to Monet for this in a letter. He met with ever growing public and critical acclaim and recognition. In 1901 Odilon Redon paid him a visit, in 1902 Albert André became a neighbor, in 1908 the sculptor Aristide Maillol was commissioned to execute a bust of the artist, and in 1917 the already famous Matisse went to visit him. In the same manner, art collectors and dealers called in frequently: the aged Durand-Ruel with his sons Charles and Georges; and the younger generation such as Ambroise Vollard (whom he met through Morisot), the Bernheim brothers and the German Paul Cassirer. By now he was becoming internationally famous. After an important one-man exhibition at the Salon d'Automne in 1904, the Venice Biennale honored him in 1910 with an exhibition organized by Ugo Ojetti; the first monograph on Renoir, written by Julius Meier-Graefe, came out in 1911; in 1912 his works were shown at the Thannhäuser Gallery in Munich and at Cassirer's gallery in Berlin. The following year his canvases were exhibited at the Armory Show in New York and in 1917 one work was hung

in the National Gallery in London. After a trip to Munich as guest of the industrialist Thurneyssen, in 1911 he was confined to a wheelchair and, despite a series of operations and visits by specialists, his condition worsened. But although his health was failing he was sustained by his close friends; he painted portraits of them as well as of his wife, Coco and his favorite model Gabrielle, who had become part of the Renoir household in 1894. On commission from the new art collector Maurice Gangnat he executed mythological and decorative subjects, from *The Judgment of Paris* (1908) to the panels in Gangnat's dining room of the *Dancer with Castanets* and *Dancer with Tambourine* (1909). During this period Vollard encouraged him to work on sculpture; in 1913 a pupil of Maillol, the Catalan Richard Guino, "lent him his hands" and in 1914 the two executed the *Venus Victorious* statue, its plaster base in high relief depicting *The Judgment of Paris*, and a series of medallions and busts portraying artists. That June in Paris, Renoir went to the inauguration of the exhibition of Isaac de Camondo's Impressionist collection at the Louvre. The First World War broke out, Pierre and Jean were recruited and both were wounded in battle. In 1915 Aline died, exhausted by the many visits to the hospital to see her sons and debilitated by the diabetes that had been tormenting her for years. Renoir was alone, aided by his cook and by the models Marie "the baker's wife" and the Russian Dédée, Jean's future wife. He continued to work, especially on sculpture pieces; but in 1918, suspecting that Guino was circulating forgeries of his works, he broke off relations with him and took on a young man from Essoyes, Louis Morel, as his new sculptor. In August 1919 he returned for a short while to Paris and was carried through the Louvre on his sedan chair, like the "pope of painting." That autumn he returned to the villa Les Collettes and worked with another young sculptor, Marcel Gimond. On December 2, worn out, he worked on a still life with apples. It was the last canvas to be set on his easel: he died that night, watched over by his son Jean.

The Formative Years

On April 1, 1862 Renoir passed the entrance examination to the École Impériale et Spéciale des Beaux-Arts. This period was dominated by the classical linear style of Ingres and his followers and pupils, such as Hippolyte Flandrin, all of whom taught at the École. But the twenty-one year-old Renoir—having had practical training as a painter of porcelain and fresh from the experience of the relatively free atmosphere at Charles Gleyre's studio—did not completely forget the sensual, robust color used by Rubens, whom he copied at the Louvre, or the shimmering atmosphere of the beloved eighteenth-century masters. Though nothing remained of the figures of Marie Antoinette he had painted on vases and plates (the only surviving work executed at the Lévy brothers' workshop by the sixteen year-old porcelain painter is a candelabrum decorated with a flying figure), there are traces of Watteau in one of his earliest known canvases, *Return of a Boating Party*, the title of which calls to mind the old master's *Embarkation for Cythera*. And if the thick impasto and pre-eminence of the light-filled sky indicate an indebtedness to Boudin, who taught Monet to paint *en plein air* along the lines of the seventeenth-century Dutch landscapists, Renoir's taste for a light and vibrant brushstroke that breaks up the small figures in a scintillating effect, reminds one of French rococo painting. His canvases of vases and *bouquets*, with their light touch and riot of rich, sensual colors (as well as the motif

itself, appropriate to an intimate parlor or a transom, which Renoir in fact painted years later for Bérard's salon in the Wargemont château), also recall the eighteenth century. Renoir painted this subject throughout his career because it gave him the opportunity to experiment with colors without being conditioned by weighty or ambitious contents. Flowers and vases were also painted by the other future Impressionists, from Monet to Bazille, who followed the example set by Courbet and Fantin-Latour. But with the exception of *Still Life with Arum Lily*, with its strong light and shadow contrasts against the dark background, Renoir's flowers are softened by lighter tonalities, soft light blues and violets, which are foreign to the style adopted by his fellow artists.

Théodore de Wyzewa wrote the following in 1891: "Renoir's soul can be recognized in his paintings of flowers, the loveliest flower paintings ever created, so marvelously alive, bursting with color and ever alluring because of their eminently feminine mixture of gentle languor and a perturbing capriciousness."

Meeting Monet, Sisley and Bazille in Gleyre's studio was an important stage in Renoir's artistic formation. His receptiveness to originality and innovation did not prevent him from following the modus operandi called for by "official," academic art: he participated in the École's annual competitions (with fairly good results) and sought public acclaim by submitting canvases to the Salon. In

1863 he was not among the "Refusés" such as Manet and Pissarro, but the following year exhibited *Esmeralda*—a literary and romantic subject taken from Victor Hugo—at the Salon; unfortunately we can only imagine what this canvas was like, since an unsatisfied Renoir destroyed it. 1864 also witnessed the creation of a portrait, *Romaine Lacaux*, that adopted the light colors and free brushwork of his vases of flowers. Enhanced by a refined palette of grays and light blues like a court page by Van Dyck, this daughter of a humble potter stands out in the background in a delicate contrast of white on the unexpected black of her sash and hat that imparts a freshness and vivacity typical of Manet; the sensation caused by the latter's *Olympia* at the Salon des Refusés had not escaped the attention of the burgeoning artist. On the other hand, the rendering of *William Sisley* is smoother and more "academic"; this portrait of his artist friend's father is rather realistic (the gesture of the hand holding the glasses, as if he had been interrupted, the questioning and vigorous glance), but the details are much more well-defined and the pose is traditional—central and set against a neutral background like the works of Flandrin. It is therefore not surprising that this work was accepted by the 1865 Salon jury. However, the following year the jury rejected his *Landscape with Two Figures* and above all, in 1867, his *Diana*, in which for the first time he portrayed his new mistress and model

Lise Tréhot. The nude in a landscape was one of the basic motifs of academic art in this period, but in this canvas Renoir adopted it in a "scandalous" manner, à la Manet, without idealizing the model in any way and rendering all her human imperfection in the wide face, the fleshy roundness of her body, and rather stumpy feet. Furthermore, the light suffuses this white body with a violence that eliminates the chiaroscuro nuances so dear to academic circles and flattens the outline and "pastes" it, as it were, against the background. This canvas was very original and innovative—the first, albeit timid, attempt on Renoir's part to create modern mythology taken directly from present-day life, thus making it quite clear that the reference to classical times was a mere pretext. Renoir would employ the same procedure a few years later with *Bather with a Griffon*, which was unexpectedly accepted at the 1870 Salon; this canvas also followed Courbet's frankly realistic handling of nudes that was barely mitigated by the quotation from the ancient *Venus de Milo*. In the period that elapsed between his first Salon canvases and the above-mentioned one, the new experience of plein-air painting had influenced Renoir—not only as an occasion to work out the difficulties of painting directly from nature, which also involved the continuous changes in light, but as a different approach and "philosophy" in contact with reality. The *plein-air* procedure plays no

direct role in *At the Inn of Mother Anthony* (a work that Renoir himself underestimated but which was acclaimed at the 1910 Venice Biennale), yet the indoor scene of this tavern near Fontainebleau is rendered with vibrant immediacy, as if taken from real life. Monet, standing facing us, is holding a paper wrapping, perhaps containing food or tobacco; the owner is clearing the table, which gives Renoir the opportunity to execute a still-life in miniature worthy of Chardin's luministic style; his new friend Jules Le Coeur (whom he had also portrayed in a forest scene) is seated facing us. Sisley, with his back to us, is conversing about some article in "L'Événement" on the table, his legs crossed just like the figure in Manet's *Émile Zola* (the reference is explicit, as the author had defended Manet in a review in this newspaper that very year, 1866); but Sisley's face is turned away from the onlooker, and here lies the difference—and the new element— with respect to Manet's canvas. This informal group portrait of the artist's friends and fellow artists, which is so different from Fantin-Latour's restrained and slightly formal rendering in Studio in the *Batignolles Quarter*, does not include Frédéric Bazille, with whom Renoir had shared lodgings and studio since 1866, after Sisley married. But he portrayed his friend and working companion at work in Frédéric Bazille at His Easel, in a new harmony of grays and ochres that is still rendered with Manet's broad brushstrokes rather than with the

clear-cut forms frozen by a steady, limpid light so typical of Bazille's style. Interestingly enough, in this period Renoir was approaching the style of Monet, who already in 1865 had challenged Manet on an ideal artistic level by executing his version of *Déjeuner sur l'herbe* in which the study of light filtered in the woods dominated the formal aspect compared with Manet's masterpiece in a "mottled" effect that anticipated the Impressionist *tache* brushstroke. With the portrait of his wife, Camille, Monet had enjoyed his first success at the 1866 Salon (where some critics mistook it as a work by Manet). Renoir's *Lise* is quite similar to the latter work, especially in the flow of the dress that spreads out in broad folds in the foreground with a *plein-air* luminous whiteness; and in fact the work did not pass unnoticed in the 1868 Salon. Zola was the first to note the likeness to Monet; however, the author slipped up by misspelling Renoir's first name, which demonstrates how the artist was at the time playing a minor role in the battle for the "new painting." And yet it was precisely these two—Monet and Renoir—who took the decisive step towards the Impressionist "revolution." In 1869, at the restaurant and bathing site La Grenouillère that Renoir had discovered the preceding year, the two painters set their easels side by side and executed a brief series of canvases with the same motif and similar and yet different results. Monet resumed his research on light and touch by

emphasizing the contrasts with vigorous, mobile, separate strokes and patches; his great sensitivity to composition reveals his faith in himself and the clarity of his artistic aims in embarking on the new path of what would become standard Impressionist brushwork. Renoir's hand was less assertive, his touch more delicate and soft, tending to flicker, break up and fade away slightly in the hazy atmosphere; he was more interested in the general effect that in technical innovations. Yet his canvases are more exuberant and charming, they reveal a more polished and serene fluency and still have the flavor of Watteau's *Embarkation for Cythera*.

The Franco-Prussian War, which left so much death in its wake (including the tragic loss of Bazille), separated the two working companions and interrupted their *plein-air* sessions; but they resumed their work together in 1872 at Argenteuil, where Monet had settled. His studies of the Seine became more and more expansive, with an almost "tactile" perceptiveness of light vibrations that corresponded perfectly with his brushwork, in an even more effortless immersion in the atmospheric unity created by the brush. Renoir also executed portraits of his fellow artist while painting flowers outdoors or absorbed in reading, his figure consisting of a thick fabric of nervous, flickering dabs and commas.

The artistic dialogue between Renoir and Monet continued in the first "Impressionist" cityscapes—the new

gray and violet Paris built by Haussmann, with its wide boulevards and swarms of people. According to his brother Edmond, Renoir was the first to set his easel in front of the Pont Neuf; Edmond was entrusted with the task of stopping passers-by with some pretext in order to make them pose, unawares, while Auguste did rapid sketches from a nearby café window. From a technical standpoint one is reminded of the angles of vision adopted by his friend Gustave Caillebotte. Monet also painted the famous Parisian bridge, once again from the same viewpoint; but his brushstrokes are again broader, more separate and contrasting, while Renoir dwells on the areas of light that make the small figures stand out and ends up adopting a more conventional perspective.

For that matter, Renoir had not abandoned his hopes in success at the Salon. After submitting *Bather with a Griffon*, he tried his luck with *A Morning Ride* in the Bois de Boulogne (executed in 1873 and exhibited at the Salon des Refusés), a large-format canvas in which the artist again courageously faces the challenge of creating a monumental contemporary work. The dynamic movement is somewhat naively suggested by the diagonal lines on the ground; however, a certain deformation of the faces, especially that of the woman, reveals that Renoir made a more careful study of the effects of movement on the body—the influence of Degas had borne fruit.

38

♦ *Above,* Return of a Boating Party, *ca. 1862. Oil on canvas, 50.8 x 60.9 cm (20 x 24 in). Private Collection. This expansive canvas by the twenty-two year-old Renoir, who had just enrolled in Gleyre's studio, was painted under the influence of the* plein-air *works by Boudin and Jongkind. But the thick impasto, which is concentrated to highlight the masses, and the vivid and luministically precious color effects, hark back to two of the artist's great idols: Delacroix and Watteau.*

♦ *Opposite,* Still Life with Arum Lily, *1864. Oil on canvas, 130 x 98 cm (51 x 38 1/2 in). Kunsthalle, Hamburg. The composition is structured around the artful contrast between the dark greens and bright whites. The flat handling of this "exercise in style," especially in the foliage, cannot but remind one of Manet. Another, similar version of this motif, which has lighter tonalities, is kept in the Reinhart Collection in Winterthur.*

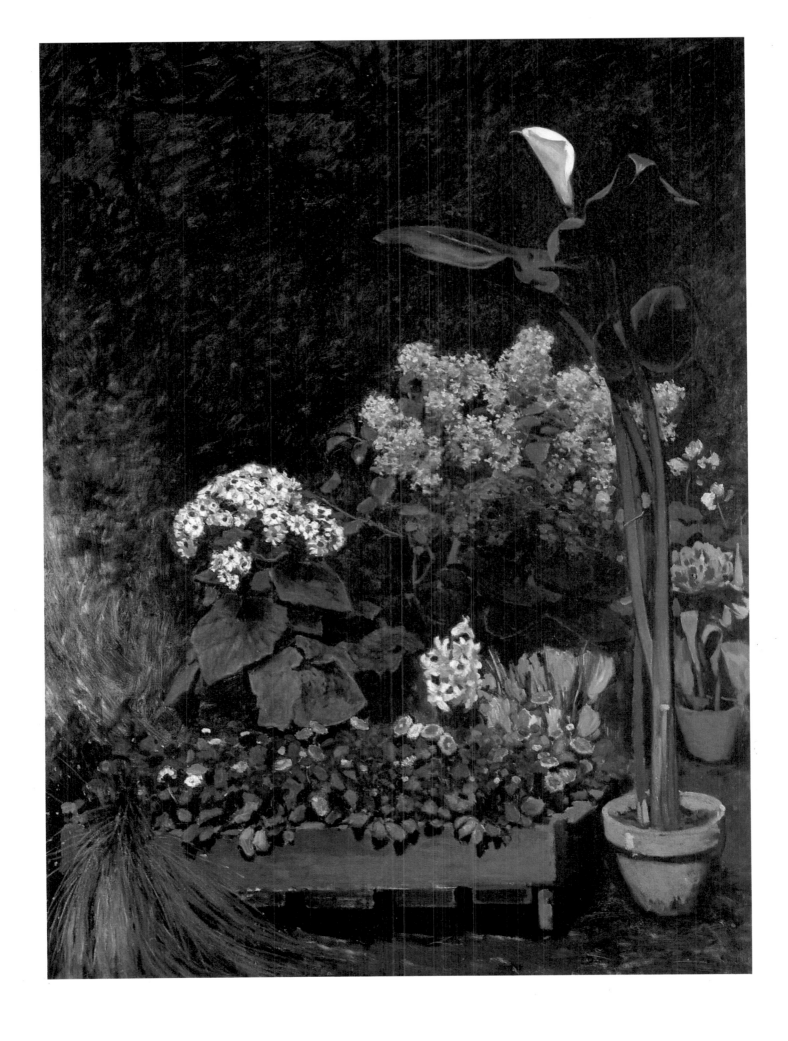

40

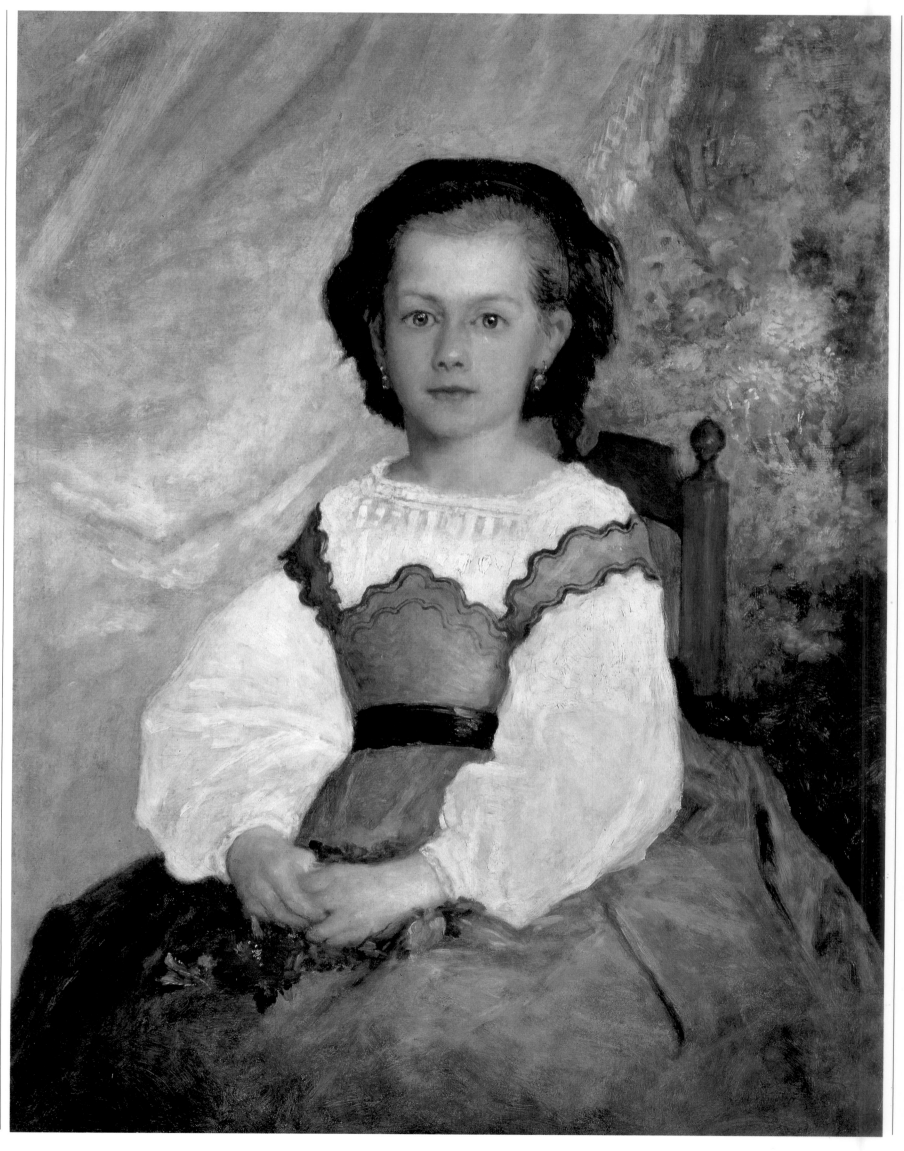

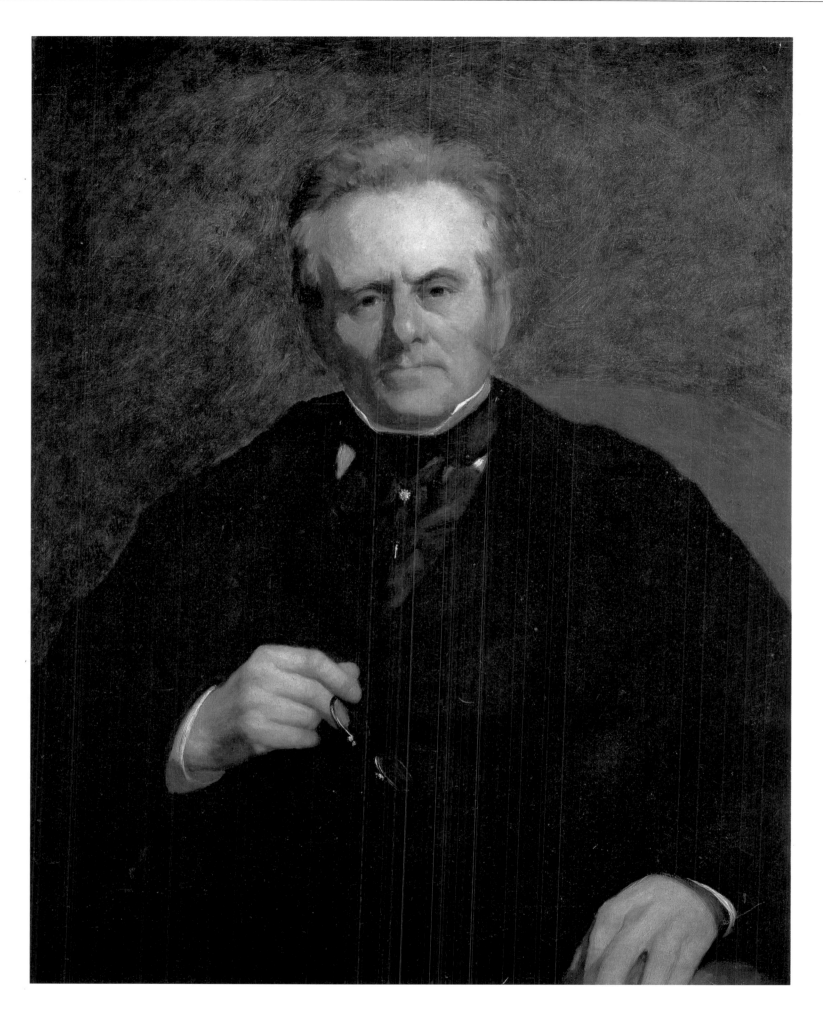

♦ *Opposite*, Portrait of Romaine Lacaux, *1864. Oil on canvas, 81 x 65 cm (31 3/4 x 25 1/2 in). Museum of Art, Cleveland. The daughter of the potter whom Renoir met while he was a porcelain decorator,* *is dressed simply. But the black in the ribbon and hat, which contrasts with the light grays, imparts the exquisite richness of the 17th-century portraits of "infantas" to this humble scene.*

♦ *Above*, William Sisley, *1864. Oil on canvas, 81.5 x 65.5 cm (32 x 25 3/4 in). Musée d'Orsay, Paris. The father of the artist Alfred Sisley lends himself to the frank and yet official tone of the first* *portrait Renoir submitted to the Salon. The austere dark clothing brings to mind what Baudelaire said about "the mournful spirit of the century," which has abandoned color in favor of black.*

42

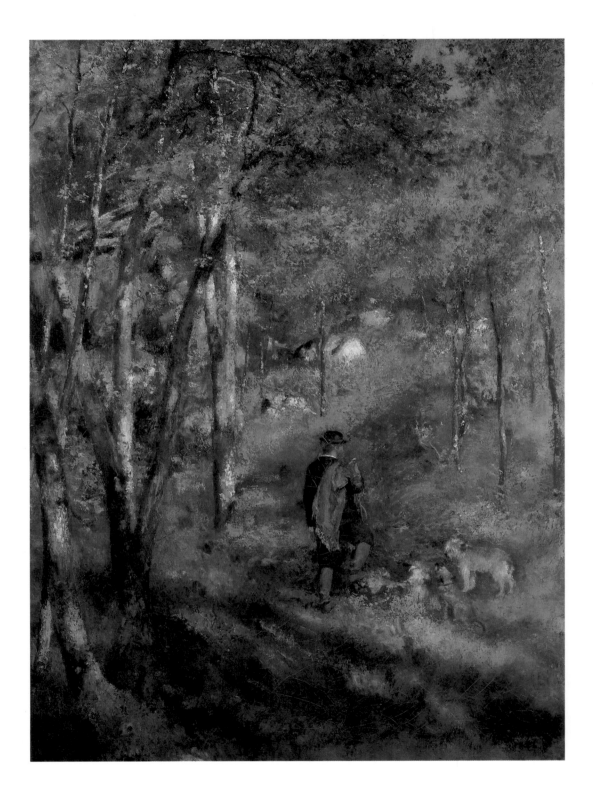

♦ *Above*, Jules
Le Coeur in
Fontainebleau
Forest, *1866. Oil on
canvas, 106 x 80 cm
(41 1/2 x 31 1/4 in).
Museu de Arte, Sao
Paulo. This view of a
clearing in the
woods clearly
reminds one of the
thick impastos and*
*warm, reddish hues
of the barbizonnier
Narcisse Diaz, but
the spatial
composition, with
the more fluid and
"dizzying" effect of
the abrupt rise of the
path, shows that
Renoir has departed
from traditional
academic canons.*

♦ *Opposite*, At the Inn
of Mother Anthony,
Marlotte, *1866. Oil
on canvas, 195 x 130
cm (76 1/2 x 51 in).
National museum,
Stockholm. The
writer Mürger had
set his Scènes de la
vie de la bohème at
Marlotte, on edge of
Fontainebleau*
*Forest. Renoir
refers to this in the
false graffiti
silhouette of the
author on the wall.
The figures are,
from left to right,
Nana the waitress,
Monet, the painter
Jules Le Coeur, Mère
Anthony and Alfred
Sisley.*

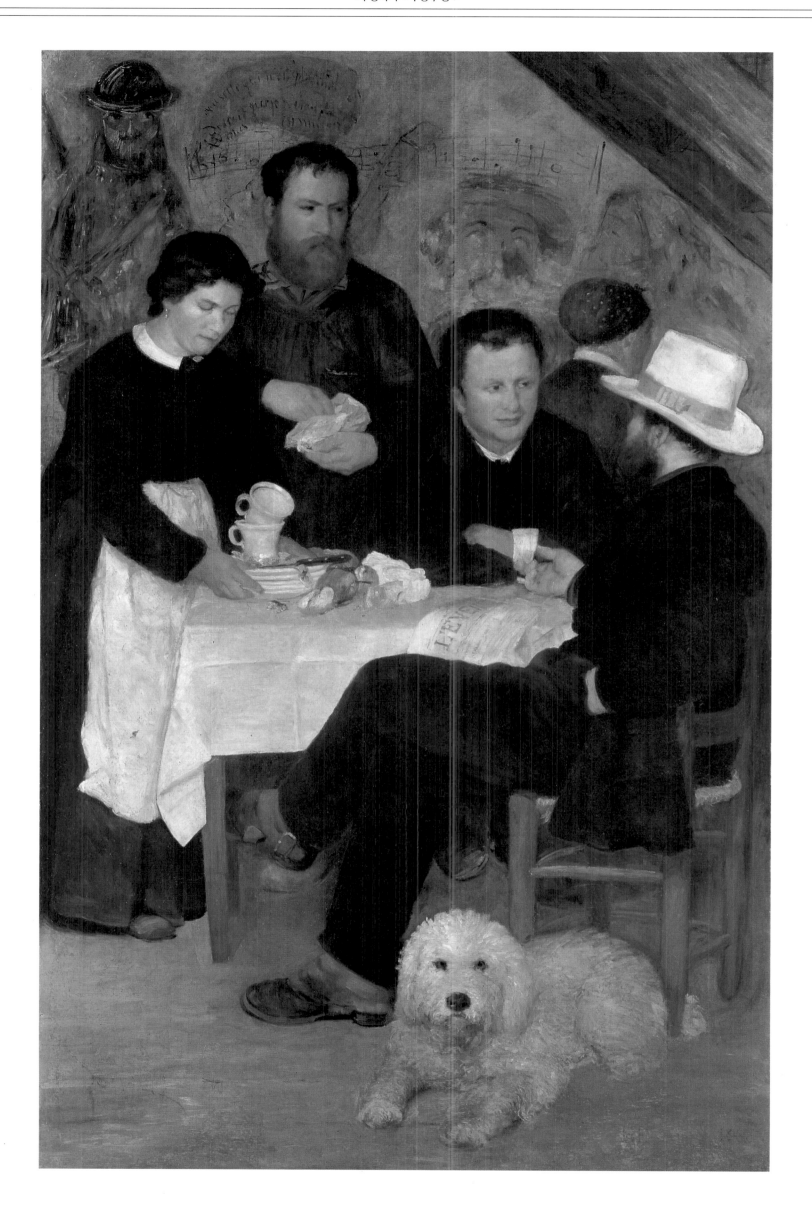

44

♦ *Above*, Flowers in a Vase, *ca. 1866. Oil on canvas, 81.3 x 65.1 cm (32 x 25 5/8 in). National Gallery of Art, Washington D.C.*

♦ *Opposite*, Vase of Flowers, *1866. Oil on canvas, 104 x 80 cm (41 3/4 x 32 in). Fogg Art Museum, Cambridge, Mass.* "Painting flowers rests my brain. It doesn't require the same intellectual effort I make when I have a model. When I paint flowers, I set color tonalities on the canvas and experiment with bold values, without worrying about wasting a canvas. With a human figure I would not be so daring, for fear of ruining everything. And the experience I gain from these experiments bears fruit in my works."

46

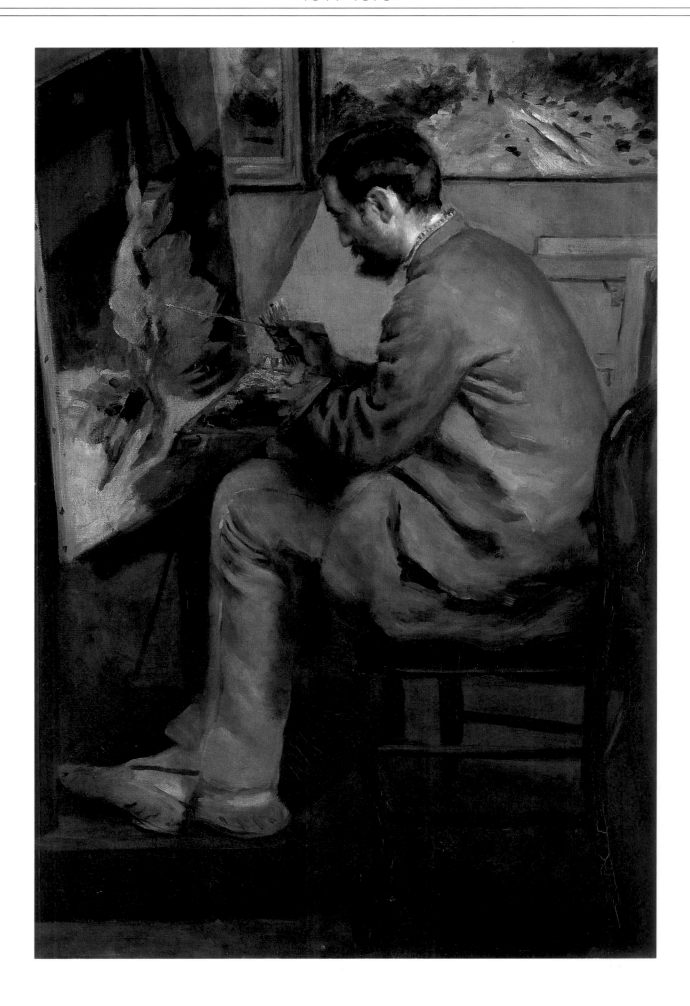

♦ *Above,* Frédéric Bazille before His Easel, *1867. Oil on canvas, 105 x 73 cm (41 1/2 x 29 in). Musée d'Orsay, Paris. In this "portrait of a studio" (quite common amongst the young "independent" artists of the time)* Renoir plays on the "picture within a picture": the one Bazille is painting, which is now kept at the Musée Fabre in Montpellier. The canvas on the wall is Monet's Road near Honfleur in the Snow.

♦ *Opposite,* Diana, *1867. Oil on canvas, 199.5 x 129.5 cm (77 x 51 1/4 in). National Gallery of Art, Washington D.C. This canvas is also connected with Bazille: X-ray analysis has revealed that under the paint* of his Bazille's Studio, Rue de la Condamine is a sketch Renoir made for Diana. It is therefore quite likely that he used to borrow his friend's canvases, or that the two painted over their less successful works.

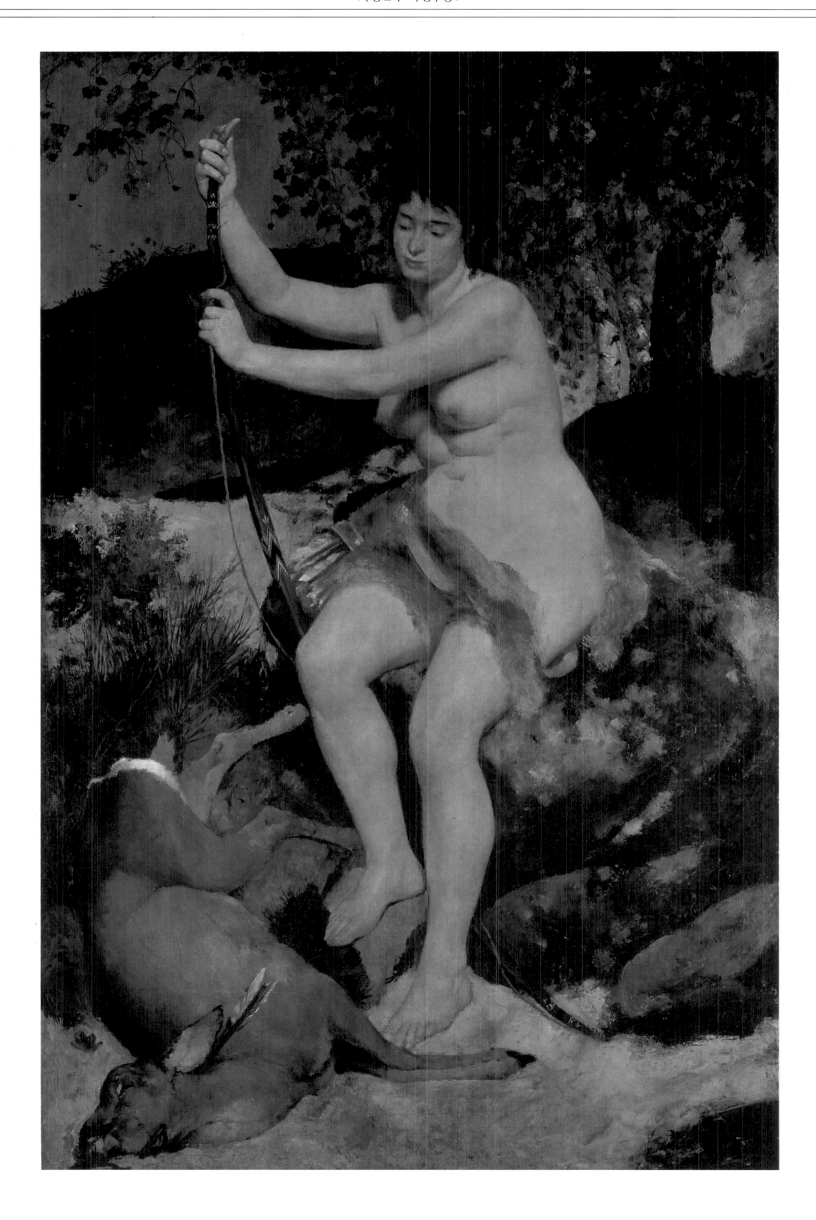

48

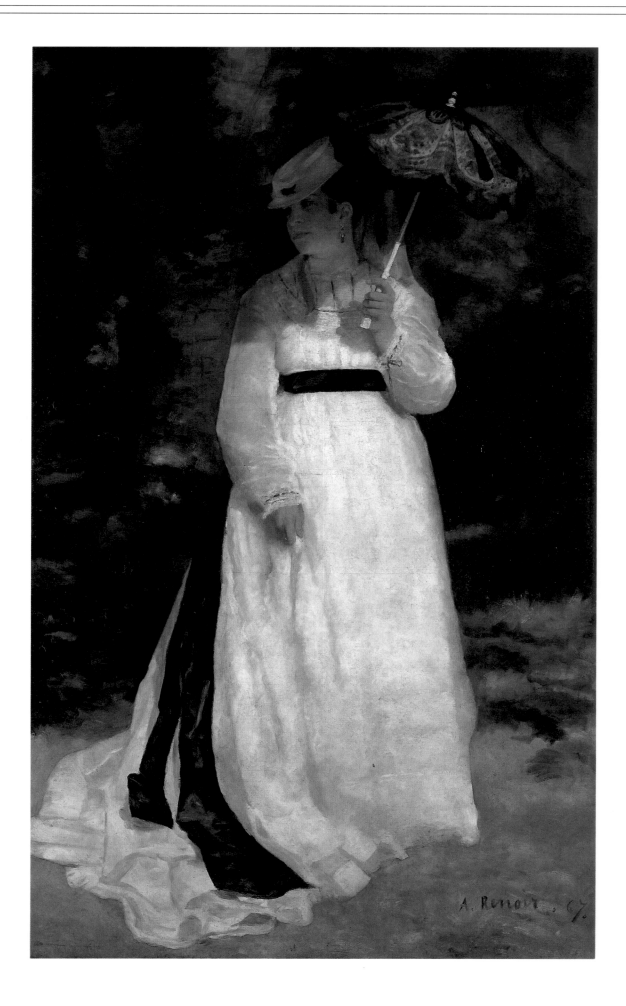

♦ Above, Lise, 1867. Oil on canvas, 184 x 115 cm (72 1/2 x 45 1/4 in). Folkwangmuseum, Essen. Lise Tréhot, Renoir's new model and mistress, posed outdoors for this canvas. The play of light on the white dress becomes the principal motif of this work, thus anticipating Impressionist painting. The critics correctly noted Courbet's influence in Lise's pose.

♦ Opposite above, Study: In the Summer, 1868. Oil on canvas, 85 x 62 cm (33 1/2 x 24 1/2 in). Nationalgalerie, Berlin. Once again Lise displays her girlish charm and features in this exercise in plein-air light.

♦ Opposite below, Alfred Sisley and His Wife, 1868. Oil on canvas, 106 x 74 cm (41 1/2 x 29 in). Wallraf-Richartz Museum, Cologne. Sisley and Lise posed for this canvas, which Picasso copied in 1919.

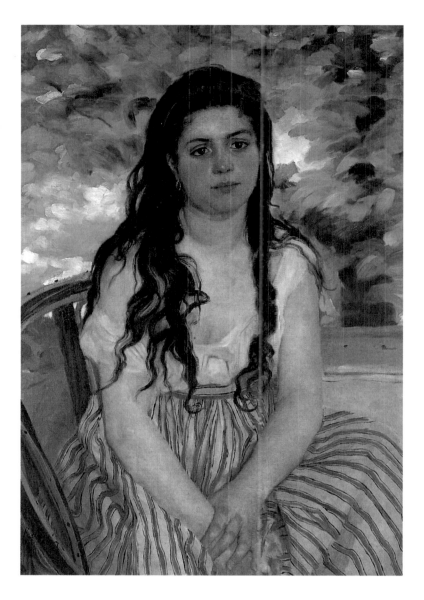

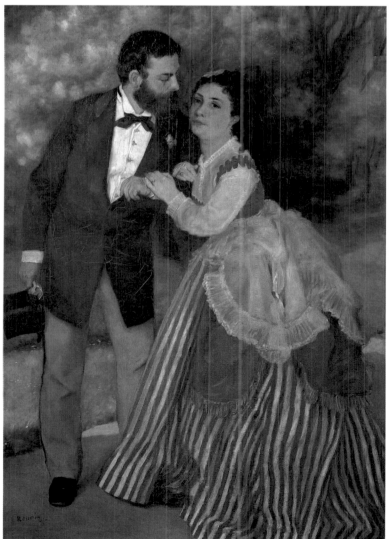

50

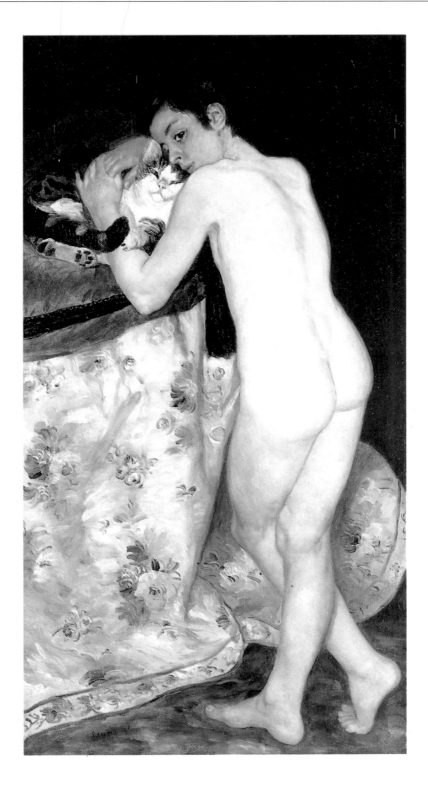

♦ Boy with a Cat, 1968-69. Oil on canvas, 124 x 67 cm (48 3/4 x 26 1/4 in). Musée d'Orsay, Paris. The elegantly linear curve of the child's back, which serves as a contrast to the abundance of color and "flatness" of the rug on the table, reminds one of the analogous, complex spatial composition of Degas. However, Renoir has not forgotten the subdued colors of his experience as a porcelain painter, and he attenuates the contrast by means of a subtle dialogue between related colors that revolves around the "cold" greens, grays and blues. The play of the adjacent heads of the boy and cat introduces a tender note that is foreign to Degas's conceptual rigor.

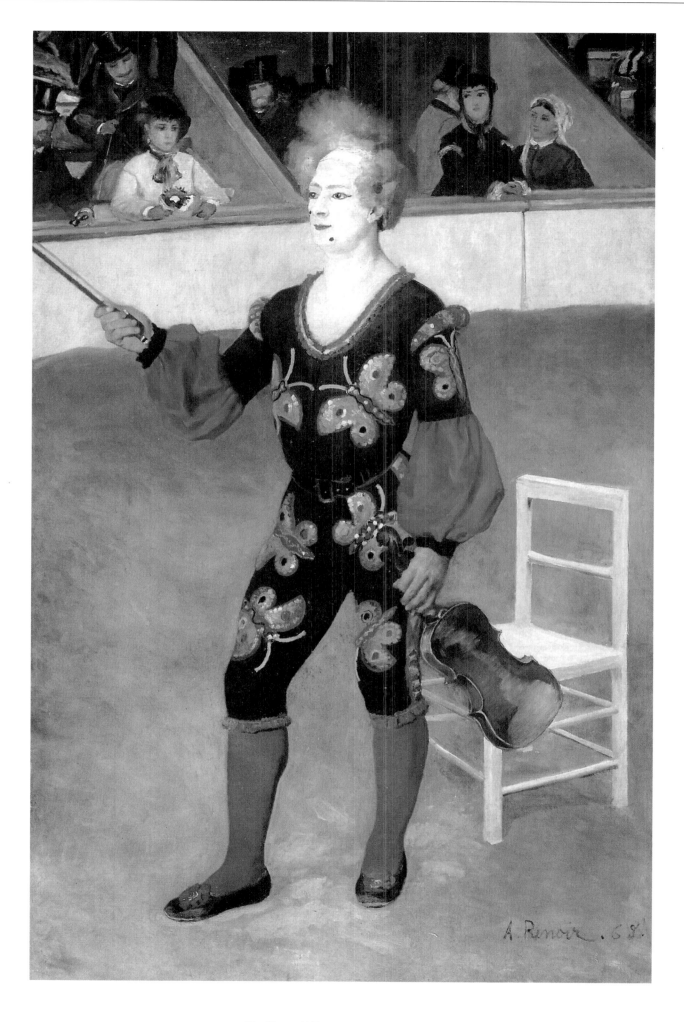

♦ The Clown, *1868.*
Oil on canvas,
193.5 x 130 cm
(76 1/4 x 51 1/4 in).
Rijksmuseum
Kröller-Müller,
Otterlo. The rising
curve of the ground,
which turns the
space towards the
viewer and
compresses it, is
characteristic of
Degas's art.
But the tone, based
on direct contrasts,
and the flattened
brushwork
reveal Manet's
influence.

52

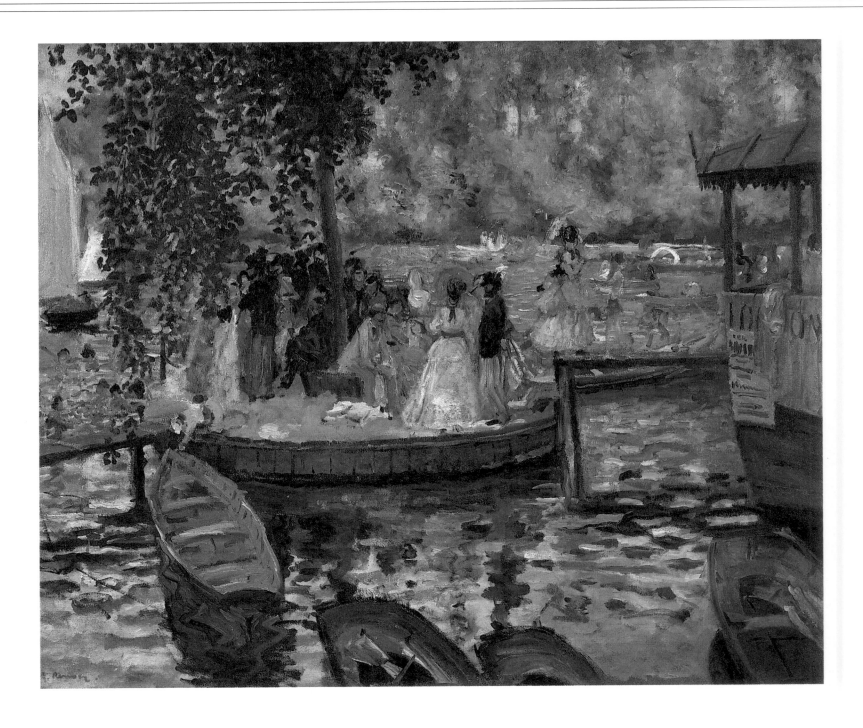

♦ *Above,* La
Grenouillère, *1869.*
Oil on canvas, 66.5 x
79 cm (26 x 31 7/8 in).
National museum,
Stockholm.

♦ *Right,* CLAUDE MONET,
La Grenouillère, *1869.*
Oil on canvas, 74.6 x
99.7 cm (29 x 39 1/4
in). Metropolitan
Museum of Art, New
York. On 25 September
1869 Monet confessed
in a letter to Bazille
that he had had "a
dream, a painting, the
baths at La
Grenouillère," of which
he had made only
"some sketches." But
these brief "chromatic
notes" were the first
step towards

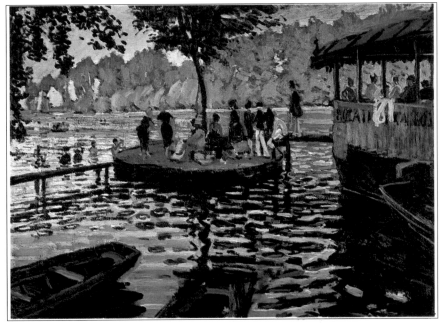

experimental
Impressionism.
Georges Rivière wrote
in 1879: "Treating a
subject in terms of
tone rather than
of subject matter—this
is what distinguishes
the Impressionists
from other painters."
Indeed, it was through
pure tone, which was
one and the same with
the brushwork, that
Monet and Renoir
achieved a new
definition of space,
which was no longer
rendered through
perspective, but
through color and
light. Note the
framing: Monet's is
wider, Renoir's more
restricted.

♦ Above, La Grenouillère, 1869. Oil on canvas, 59 x 80 cm (23 1/4 x 31 1/2 in). Pushkin Museum, Moscow.

♦ Right, CLAUDE MONET, La Grenouillère, 1869. Oil on canvas, 73 x 92 cm (28 1/4 x 35 3/4 in). National Gallery, London. The little bathing establishment and restaurant had become fashionable that summer, so that the motif was quite contemporary. Renoir and Monet chose more or less the same angle of vision, the right-hand side of the islet on the Seine, at the beginning of the bridge

that leads to the river bank. But whereas Monet achieves a more solid spatial composition, the diagonal lines of the boats creating the vanishing point of the river which is contrasted by the horizontal of the pier, Renoir is more interested in the rich effects of color and atmosphere. The figures—suffused with light, especially the women's ample dresses—are the real protagonists of the scene, as they dominate the foreground, which is slightly foreshortened by the silver-toned river.

54

♦ Flowers in a Vase, 1869. Oil on canvas, 64.9 x 54.2 cm (25 1/2 x 21 1/4 in). Museum of Fine Arts, Boston.
In the wake of the renewed interest in seventeenth-century Dutch painting, still lifes and flowers became a common motif amongst mid-century artists, from Courbet to the more delicate renderings of Fantin-Latour that harked back to Chardin's tonalities. Renoir also produced charming renderings of this subject by utilizing the precious color range of reds and blues of his porcelain painting period. The bouquet of dahlias and the light blue vase also appear in a canvas by Monet at the Getty Museum at Malibu, further confirmation that the two artists influenced each other.

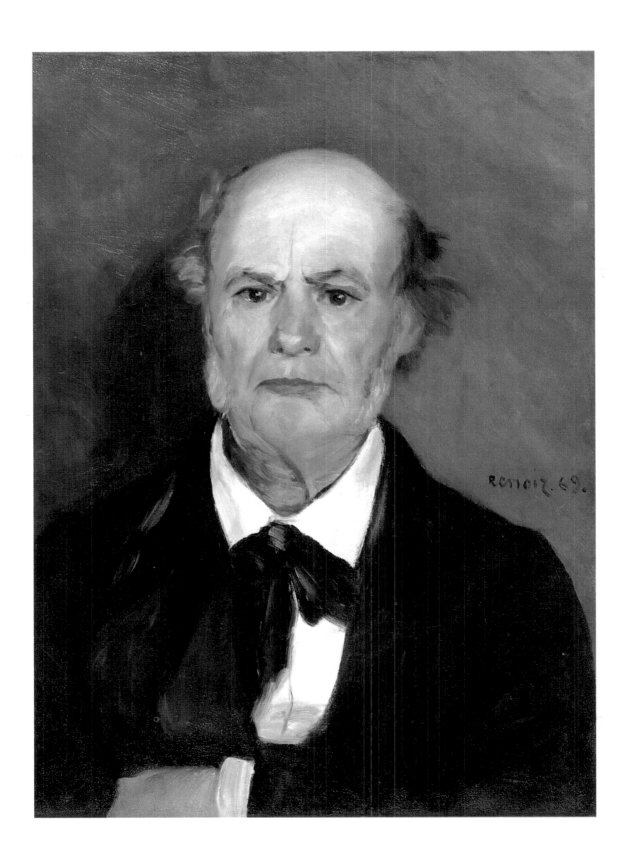

◆ Portrait of the Artist's Father, 1869. Oil on canvas, 61 x 46 cm (24 x 18 in). City Art Museum, Saint Louis. The intimacy of the subject, concentrated in a small format, is revealed by Renoir's choice of point of view in this portrait executed almost ten years after the one of his mother, which is its ideal counterpart. The artist avoids all sentimentality and concentrates on his father's severe look—the expressive wrinkles, pale flesh and vivid glance rendered almost scientifically. The dress is a simple flash of black that heightens and isolates the vigorous impression made by the face and is a contrast to the striking white of the shirt.

56

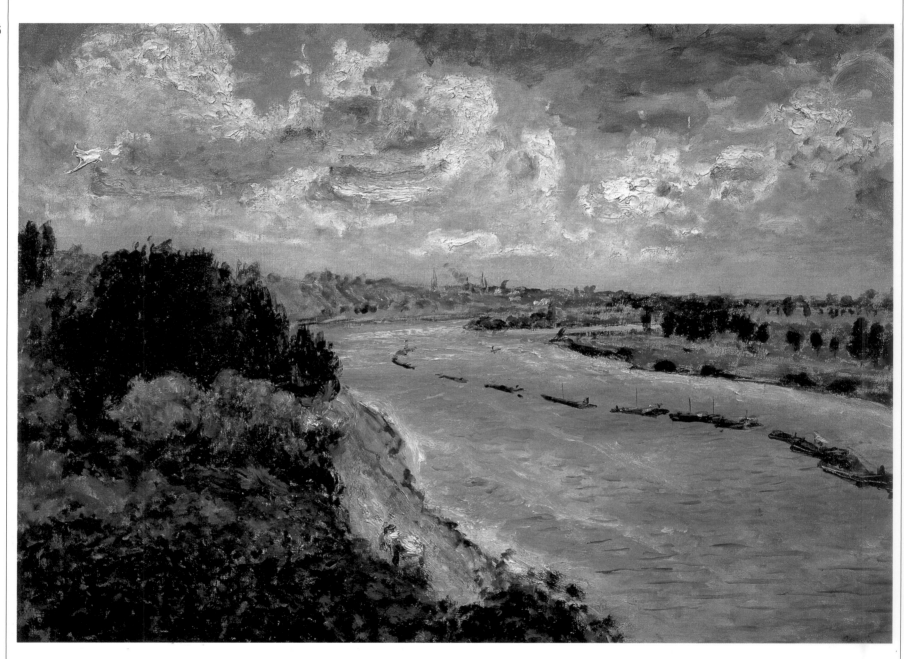

♦ *Above, Barges on the Seine, ca. 1869. Oil on canvas, 47 x 64 cm (18 1/2 x 25 in). Musée d'Orsay, Paris. In this river scene executed en* plein air *Renoir revives the delicate silver tonalities of Corot, whom he always admired.*

♦ *Opposite,* Head of a Dog, *1870. Oil on canvas, 21.9 x 20 cm (8 5/8 x 7 7/8 in). National Gallery of Art, Washington D.C. This was a study for the large canvas,* Bather with a Griffon, *which was exhibited at the 1870 Salon.*

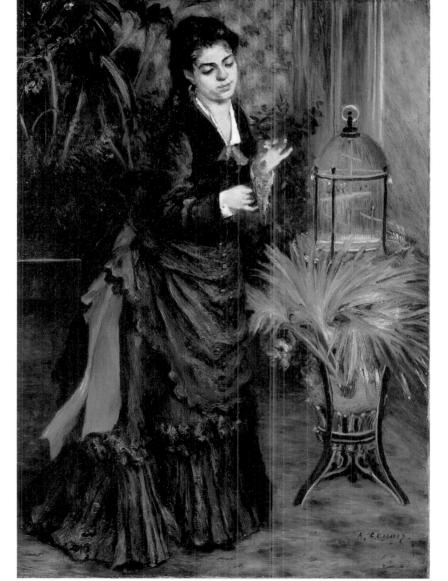

♦ *Opposite*, Bather with a Griffon, *1870. Oil on canvas, 184 x 115 cm (72 1/2 x 45 1/4 in). Museu de Arte, Sao Paulo. This is perhaps the work in which Courbet's influence is strongest: note the realistic rendering of the volumes of the body and Renoir's decision to abandon the traditional mythological pretext of the nude by refusing to idealize its purely physical aspect.*

♦ *Above*, The Promenade, *1870. Oil on canvas, 81.3 x 65 cm (32 x 25 1/2 in). J. Paul Getty Museum, Malibu. The filmy whiteness of the woman's dress serves as a pretext to concentrate on the play of light between the shadows of the foliage. The result is a charming effect of light, rapid brushstrokes on the surface that merge the figures in the setting, which is equally vibrant and rich.*

♦ *Below*, Lady with a Parrot, *1871. Oil on canvas, 92.1 x 65.1 cm (36 1/4 x 25 1/2 in). Solomon R. Guggenheim Museum, New York. The artist's study of decomposed light in the brushwork moves from outdoor scenes to interiors. This choice of motifs serves to contradict certain exclusivistic interpretations of plein-air Impressionist painting.*

♦ *Pages 60-61*, Woman of Algiers (Odalisque), *1870. Oil on canvas, 69.2 x 122.6 cm (27 1/4 x 48 1/4 in). National Gallery of Art, Washington D.C. The soft sensuality of Lise is Renoir's homage to Delacroix, who in Women of Algiers had created the prototype of "indoor" Orientalism, which played more on heightened use of color than on a reconstruction of real settings.*

60

62

♦ *Above,* Capitan Darras, *1871. Oil on canvas, 81 x 65 cm (31 3/4 x 25 1/2 in). Staatliche Gemäldgalerie, Dresden. The expressive dark tonalities of the uniform stand out against the dramatically colored backdrop, thus introducing a romantic note in this portrait. The companion piece, a portrait of Madame Darras, is in the Metropolitan Museum of Art.*

♦ *Opposite,* Parisian Women in Algerian Dress, *1872. Oil on canvas, 156 x 129 cm (61 3/8 x 51 3/4 in). National Museum of Western Art, Tokyo. This was one of the last canvases Lise posed for, as she married the architect Brière de l'Isle. The homage to Delacroix is perhaps more evident here than in* Woman of Algiers, *especially in the gamut of yellow-gold colors.*

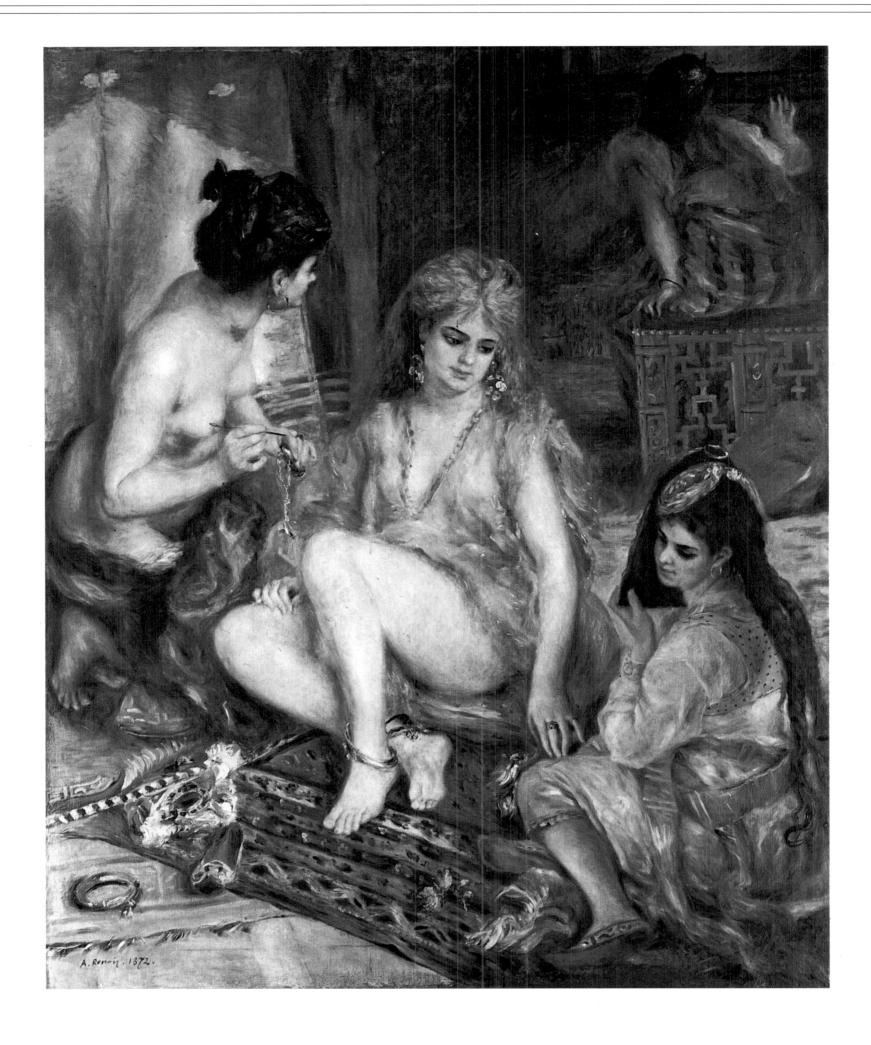

64

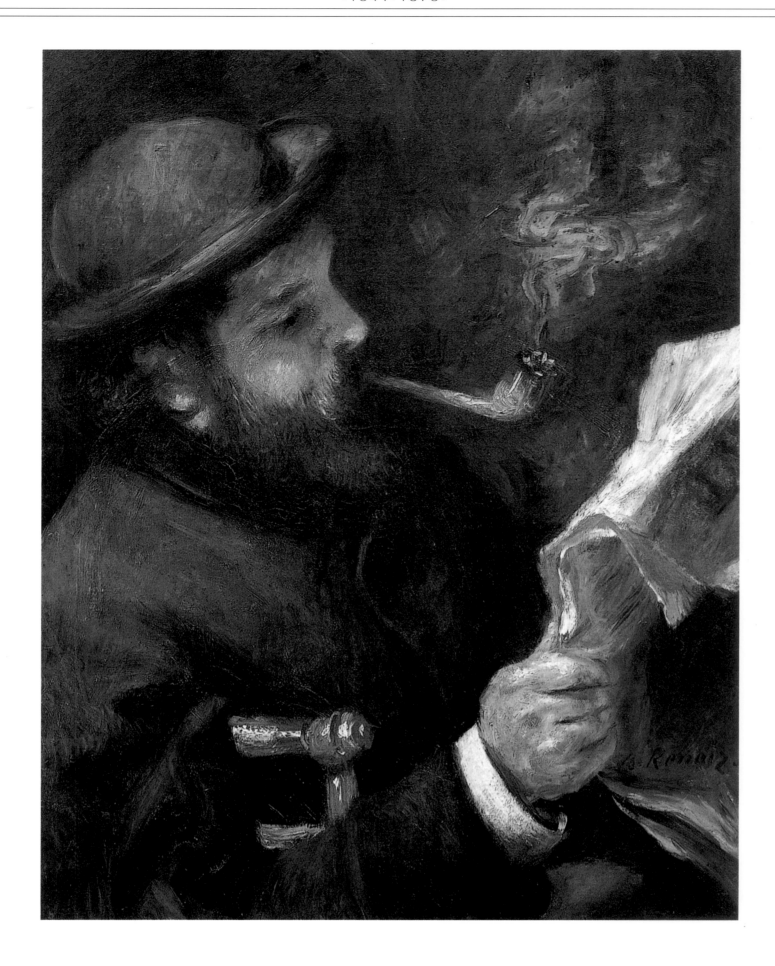

♦ Claude Monet Reading, *1872. Oil on canvas, 61 x 50 cm (24 x 19 5/8 in). Musée Marmottan, Paris. Quite unlike the portrait Renoir did of his father, in this intimate canvas Monet is captured in the* *immediacy of everyday existence, his relaxed three-quarters pose does not lend itself to any psychological interpretation. A companion portrait of Monet's wife Claude is also in the Musée Marmottan.*

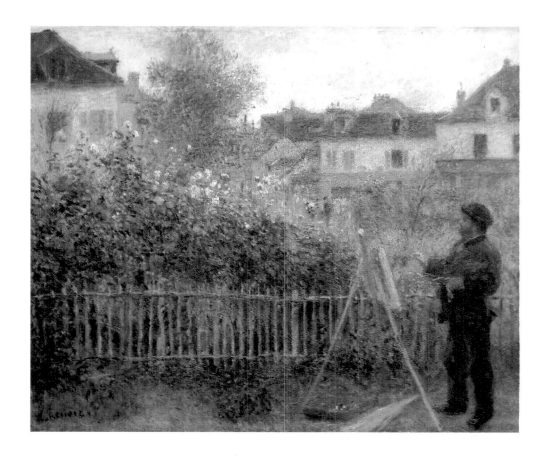

♦ Monet Painting in His Garden at Argenteuil, *1873. Oil on canvas, 46 x 60 cm (18 x 23 1/2 in). Wadsworth Atheneum, Hartford, Conn. The identical pictorial research carried out by Monet and Renoir, even more than their close friendship, is seen in this portrait of Monet absorbed in painting outdoors. The light, easily movable easel was part of Monet's* plein-air *"equipment," along with his ever-present round hat.*

Renoir pays careful attention to the balance between spatial and light values. The horizontal composition is enhanced by the fence, which clearly separates the foreground and background; the artist's dark silhouette at right is counterbalanced by the mass of rose-bushes at left. The gradual descent of the houses beyond the fence serves to heighten the focal point of the easel.

66

♦ The Gust of Wind,
ca. 1872. Oil on
canvas, 52 x 82 cm
(20 3/8 x 30 1/4 in).
Fitzwilliam Museum,
Cambridge. This
work has the rapid,
comma-like
Impressionist
strokes, but here they
lend body to the
masses; it was most
probably exhibited
at the 1875 Hôtel
Drouot auction sale
with a different
title—Strong Wind.
However, the present
title underscores
Renoir's
indebtedness to
Corot, which can
also be seen in his
choice of tonalities.

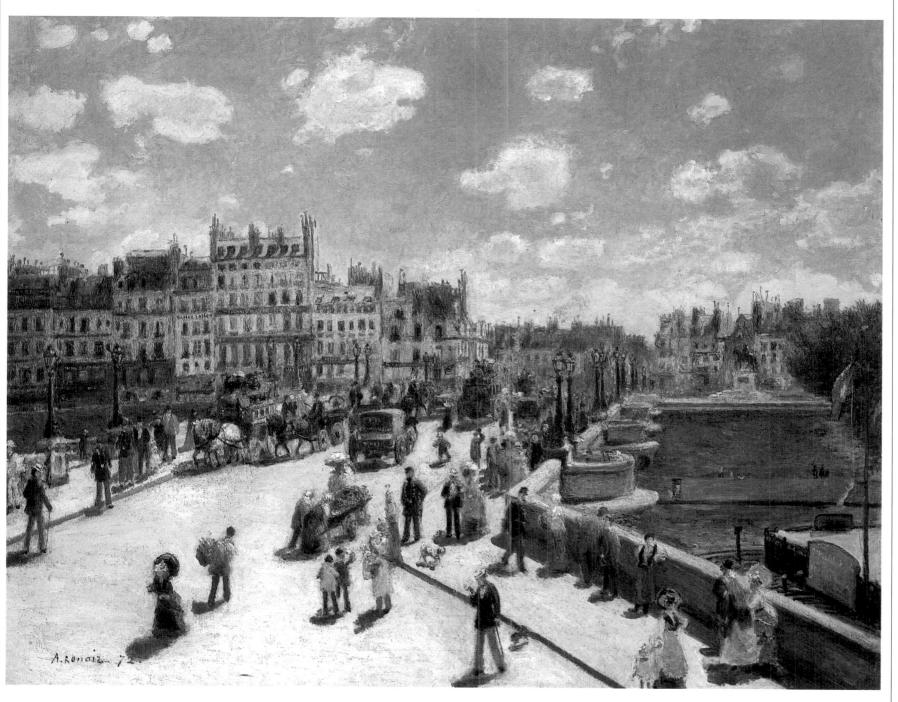

♦ The Pont Neuf, Paris, 1872. Oil on canvas, 75.3 x 93.7 cm (29 5/8 x 36 7/8 in). National Gallery of Art, Washington D.C. Renoir's view of Paris was executed from the upper floor of a café. His brother Edmond would stop passers-by, pretending to ask for directions, and as John Rewald says, "the painter had time to sketch the person. And in this spontaneous way the cheerfulness of the hour was preserved in Renoir's work."

68

♦ The Seine at Argenteuil, ca. 1873. Oil on canvas, 46.5 x 65 cm (18 1/4 x 25 1/4 in). Musée d'Orsay, Paris. The title of this work, with its low horizon line and filled with air and light, refers to similar works by Monet, Sisley and Caillebotte. The colors no longer have the charm of Corot's tonalities but take on a more immediate vivaciousness and energy in the contrast between the reddish-green hues of the banks and the pure blue of the river.

♦ Woman with a
Parasol in the Garden,
1873. Oil on canvas,
54 x 65 cm (21 1/4 x
25 5/8 in). Thyssen-
Bornemisza
Collection, Madrid
"It is by living in the
open air that he
became a plein-air
painter. The four cold
walls of the studio did
not weigh him down
[...]; having no memory
of the constraints to
which artists subject
themselves, he lets
himself be carried
away by his subject
and above all by
the setting in which
he finds himself."
(Edmond Renoir,
1879).

♦ *Above*, The Rose, *1872. Oil on canvas, 28 x 25 cm (11 x 9 3/4 in). Musée d'Orsay, Paris. Renoir returns to "genre" painting, animating this sensual woman with the lively, flashing brushwork.*

♦ *Opposite above,* Madame Darras *(study for* A Morning Ride in the Bois de Boulogne), *ca. 1873. Oil on canvas, 47.5 x 39 cm (18 3/4 x 15 1/4 in). Musée d'Orsay, Paris. The face acquires grace in the malicious play of the veil.*

♦ *Opposite below,* A Morning Ride in the Bois de Boulogne, *1873. Oil on canvas, 261 x 226 cm (102 3/4 x 89 in). Kunsthalle, Hamburg. Rejected by the Salon jury, this work was exhibited at the Salon des Refusés, which* attracted a large public and many critics. With a touch of irony, Jules Claretie commented: "Renoir paints improbable horsemen, impossible horses." However, the canvas was purchased, years later, by Henri Rouart.

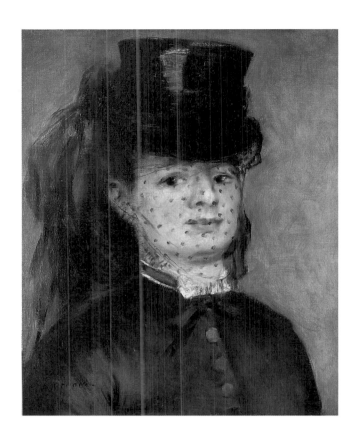

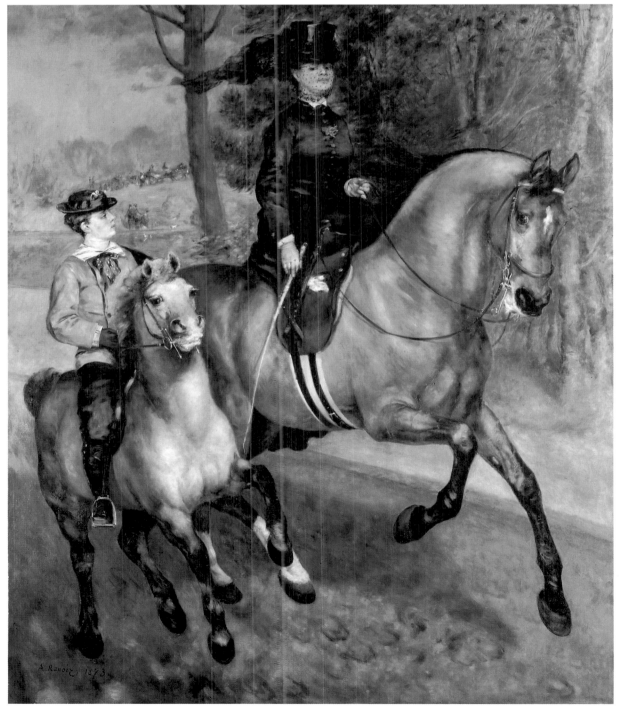

The Vitality of Light

Whether it was the disappointment caused by the 1873 Salon jury rejecting his *A Morning Ride in the Bois de Boulogne*, or an attempt to attract attention and break free from his isolation (as Pierre Vaisse suggests), in 1874 Renoir was quite active in the organization of the first Impressionist exhibition at Nadar's studio, being responsible for the hanging arrangement. He exhibited a series of very recent paintings, all of which were new to the public. It is well-known that for the most part the critics ignored this exhibition, while those who had something favorable to say all had reservations concerning the eclectic nature of the works shown and the lack of conscious and common aims among the group. However, Renoir received some praise, although he made very little money (only 18 francs, compared to 20 earned by Monet and 100 by Sisley). *La Loge* (*The Box*) was particularly well received because of the almost brazen freshness of the woman's smiling gaze, which was interpreted as representing "the spirit of the time": "Here, my young ladies is what you will become," reproached the poet Catulle Mendès, "your cheeks bleached by face powder, your eyes flashing in a banally passionate gaze [...] attractive, vacuous, delightful and stupid."

The female model Nini answered to the rather undignified nickname of "Fish Mouth," while the man behind her is Renoir's brother Edmond, who had written the essay for the exhibition catalogue. Above and beyond the purely social aspects of the subject, none of the critics seems to have noticed the innovative composition of this work: the artist's use of the photographic "frame" which excludes part of the figures (the girl's elbow and part of Edmond's arm), as if a snapshot had been taken of them, partly derived from Degas's technique. But the grainy rendering of the

material properties of this canvas is totally new; its sort of optical blurring tends to suggest space behind the figures despite the almost absolutely frontal pose of the figures. An anonymous critic, on the other hand, praised Renoir's use of the theater motif "as an aspect of modern life totally ignored by painting until now"; indeed, the theater world, which in this period was beginning to present naturalist works, would be the subject of many canvases by Renoir, who was perhaps attracted by the purely pictorial pretext to render the light shining on the bare shoulders of a lovely woman.

The theater milieu also gave the artist the opportunity to make new acquaintances such as the delicate and graceful actress Henriette Henriot, who seemed to be the incarnation of the subtle and urbane wit of Parisian women, as Théodore Duret said: "Slim, sprightly, elegantly dressed, smiling, naive. Renoir has given this Parisienne of the nineteenth and twentieth century a gracefulness and fascination that could be compared to those the seventeenth-century artists imparted to a completely different world and to women of quite a different class." This critic's intelligent interpretation, which notes the artist's harking back to the past in order to grasp the essence of the modern, seems to be a perfect fit for the portrait (also exhibited in 1874) of Henriot as *The Parisienne*. The light suffusing the blue of the dress is reflected in the changing, iridescent yellow-blue of the background, thereby establishing a play of complementary colors that might remind one somewhat of the "acid" halo in Manet's *The Fifer* and thus creating out of nothing the sense of a setting which is really pure color. With an artist's eye, Paul Signac in 1898 noted this contrast, which "makes the flesh yellow with greenish tonalities [...] And it is simple, it is beautiful and

it is fresh."

An analogous effect is produced in *The Dancer*, which was also exhibited at Nadar's studio in 1874: immersed in a hazy yellow and sky-blue atmosphere that at once absorbs and enhances the tulle-like brushwork, the white "dirtied" by the blue of the tutu, the girl's skin veiled with grays and greens, as fine as cloth. Once more Degas's influence is felt here, but Renoir is too interested in rendering the tactile values of the surface to bother about problems of space and motion.

These are indoor canvases that translate the technical solutions found in plein-air painting in an enclosed space—that rapid, separate brushstroke that imparts a new stylistic unity through the breakdown of light as it strikes the human body. As Renoir said: "Landscape is also useful for a painter of human figures. Outdoors one is led to employ color tones that would be unthinkable in the weak light of a studio." Renoir therefore continued his artistic research *en plein air* on the banks of the Seine at Argenteuil together with his friend Monet, and their working companionship attracted Sisley, Pissarro, Caillebotte and even the urbane Manet to this site. A sort of "artistic duel" with the famous master led to the creation of *The Monet Family in Their Garden at Argenteuil* by Manet and Madame Monet and Her Son by Renoir. The artist recalled: "I arrived at Monet's just when Manet was about to execute that very subject, and as you can imagine, I simply could not let asuch a wonderful occasion slip by, with the models already posing." Mention has already been made of the different spatial solutions in the two versions of this subject—a wider and more centrally unified view in Manet, a vantage point much closer to the viewer in Renoir. However, in another portrait of

Camille Monet in the same garden, *Woman with a Parasol and Child in the Meadow*, Renoir imparts a new sense of the inner energy of light through the impetuous diagonal brushstrokes; this canvas also has a high horizon line which by itself transmits all the luminosity of the unseen sky. Camille is also portrayed is a small intimate work—Madame Monet Reading "Le Figaro"—in which some critics have noted the influence of Japanese prints (which, in fact, never really aroused Renoir's interest very much) because of the blue figure standing out against the flattened backdrop of the divan. A work that might be considered "Japanese" is the Portrait of Monet against the light that Zola admired so much, in which the window frame behind the painter triggers a dialogue between interior and exterior that overturns the traditional system of "backdrops" and is somewhat analogous to the audacious spatial composition in the wood-cuts of Hokusai and Utamaro which Degas studied so carefully. This period from 1874 to 1876 also marks the moment when Monet and Renoir were closest in terms of artistic procedure. A fine example of this is the magnificent *Path through the Long Grass* (ca. 1874), the work in which Renoir is most similar to Monet; the outlines of the figures walking in the grass are totally absorbed in the tonalities of the meadow, which is clothed in green and yellow with a dash of red in the poppies and the parasol —a subtle effect that reveals the accurate construction of this apparent, felicitous extemporaneousness.

The year 1876 witnessed the second exhibition of the so-called Independents, who were now known as "Impressionists" (a term that Renoir abhorred); Auguste exhibited his latest attempt at replacing the traditional mythological guise with a form of

classicism intrinsic to nature itself, without any historical or cultural connotations: *Nude in the Sunlight* reveals a statue-like bust that is ever so slightly off-center and exposed to the chromatic variations caused by the reverberations of outdoor light. The exact title of this work is *Study*, which emphasizes its experimental, albeit objective, character. Armand Silvestre, the critic who often proved to be close to the "new painting," calls this canvas a "colorist piece." Unfortunately, Albert Wolff's oft-quoted comment in "Le Figaro" reflected the opinion of the general public more accurately: "Try to explain to M. Renoir that a woman's bust is not a mass of flesh in the process of decomposition with green and violet spots, showing a state of complete putrefaction of a corpse!" And this brings Mauclair's words to mind: "It is impossible to explain why such a colorist does not please everyone and why he has not enjoyed a tremendous success, he who was so voluptuous, clear, pleasant, agile and skilled and learned without being heavy-handed." However, Renoir was appreciated by private art collectors. After the Hôtel Drouot auction, which he personally organized in 1875, he received numerous commissions, especially in the more conservative and "safer" portrait genre. Two of these are of Victor Chocquet, a curious person indeed. He was a customs official who was so obstinate and exacting he would throw anyone he disliked out of his office, no matter how famous he or she was. Yet at a time when such choices were considered one step away from insanity, with his modest means and infallible judgment and taste he had amassed a magnificent collection that ranged from Watteau to Delacroix (whom he loved most of all). Chocquet's taste therefore coincided perfectly with those of Renoir, and they got along famously. He had

himself—and his wife in a companion piece—portrayed in front of works by Delacroix that he owned.
Chocquet had the smaller version of Renoir's *Dancing at the Moulin de la Galette*, certainly the artist's most well-known work together with *The Swing*, executed the same year. Both these works transformed the urban landscape of Montmartre into a profusion of light *en plein air*. But whereas *The Swing* maintains the happy, carefree atmosphere of an eighteenth-century pastoral subject, the *Moulin de la Galette* once again aimed at achieving a monumentality that would make modern life as eternal and absolute and classical mythology. This choral work resumes Renoir's "duel" with Manet, whose "canvas-manifesto" *Concert at the Tuileries Garden* had depicted contemporary Paris as in an ancient frieze or in a Baroque court painting. Renoir's transporting the "grand style" to the present was precociously appreciated in 1877 by the critic Georges Rivière: "Surely Renoir is right to be proud of *Dancing at the Moulin de la Galette*. Never has he been more inspired. It is a page of history, a precious monument to Parisian life done with rigorous exactitude. No one before him had thought of depicting an event in ordinary life on such a large canvas [...] This painting has a great significance for the future, which cannot be overemphasized. This is a historical painting [...] Let those who want to do historical painting do the history of their own era, instead of raising the dust of past centuries." And indeed, *Dancing at the Moulin de la Galette* was eventually hung in the Louvre.
Paris returns in such small-format canvases as *Young Woman with a Veil*, a delightful "hidden profile" of a woman modeled only by the fluid line of the black on ochre, or in the various

theater motifs (*The Debut, Reading the Role*, and *After the Concert*, which is a canvas on a monumental scale). There is always a female figure that animates the scene, captured in the innate charm of everyday occupations (*The Reader*) or in sensual idleness (the first "neo-classical" nudes) or again, caught up in worldly merriment—the female as a physical and solar creature, the epiphany of nature itself, a sublime and instinctive "animal" (we must remember that this was the period of positivism and Darwin's theories) who is more comforting and joyous the less she is spoiled by culture. Renoir was furious when superfluous psychological and sentimental attributes were given to one of his canvases, Young Woman Seated, and the absurd title of *The Thinker* was tacked on to it: "My main preoccupation has always been to paint creatures as if they were beautiful fruit. Take the greatest modern painter, Corot—were his women 'thinkers'?"
This fundamental femininity, this primitiveness, which was to lead to the *Bathers* of Renoir's final period that indeed blossom like ripe fruit, did not stop him from becoming the interpreter of canvases with worldly and social connotations: The Actress *Jeanne Samary; Madame Alphose Daudet* in a thoughtful pose; *Madame Henriot* suffused with whites and sky blues in order to heighten the vivacity of her dark eyes; *Madame Charpentier and Her Children* in a sort of public exhibition of her fashionable Japanese-style salon with its plush accessories.
As was mentioned above, Renoir had decided to return to the "safe" genre of portraits, which led to his being accepted again at the Salon. However, this annual exhibit had begun to lose its prestige by gradually accepting works that were a diluted, sentimental version of realism, exemplified by

Alfred Stevens or James Tissot. Renoir was gaining popularity, which was partly based on stereotypes, as "a true painter of young women; he knows how to render, in that gay sunlight, their blossoming skin, their velvety flesh tones, the pearly hues of their eyes, the elegance of their coiffure." This comment by Huysmans is partially confirmed by canvases such as *Woman Seated Outdoors, Woman with a Straw Hat* or *Luncheon on the River Bank* (kept at the Chicago Art Institute). Yet in the spacious, expansive atmosphere of this *plein air* there are hints of a careful reflection on the tactile values of the canvas and a new consideration of spatial composition: the mesh-work of the arbor in *Luncheon on the River Bank* that sharply separates the foreground from the background, the horizontal bank in *The Seine at Asnières* which articulates two different spatial depths. As in Renoir's early works, the figures tend to dominate the landscape; indeed, at bottom Renoir considered himself a "figure painter." Signs of a change in his style began to appear in the summer of 1879 during his sojourn at the Wargemont château of his new friend and patron, Paul Bérard, a diplomat, financier and collector of works by Monet, Sisley and Morisot. The harshness of the coast of Normandy veiled by the northern light inspired Renoir's *Landscape at Wargemont* which, with its low, virtually absent sky, is almost devoid of air and atmosphere and indeed is articulated around the thick masses of the trees, rocks and road. On the other hand, the sonorous effect of *The Wave* evokes the tonal arabesques of a Debussy-like musical composition; this work harks back to the scintillating romanticism of Courbet's weighty seascapes, while at the same time bearing in mind the intonation and timbre of the burgeoning Symbolism.

74

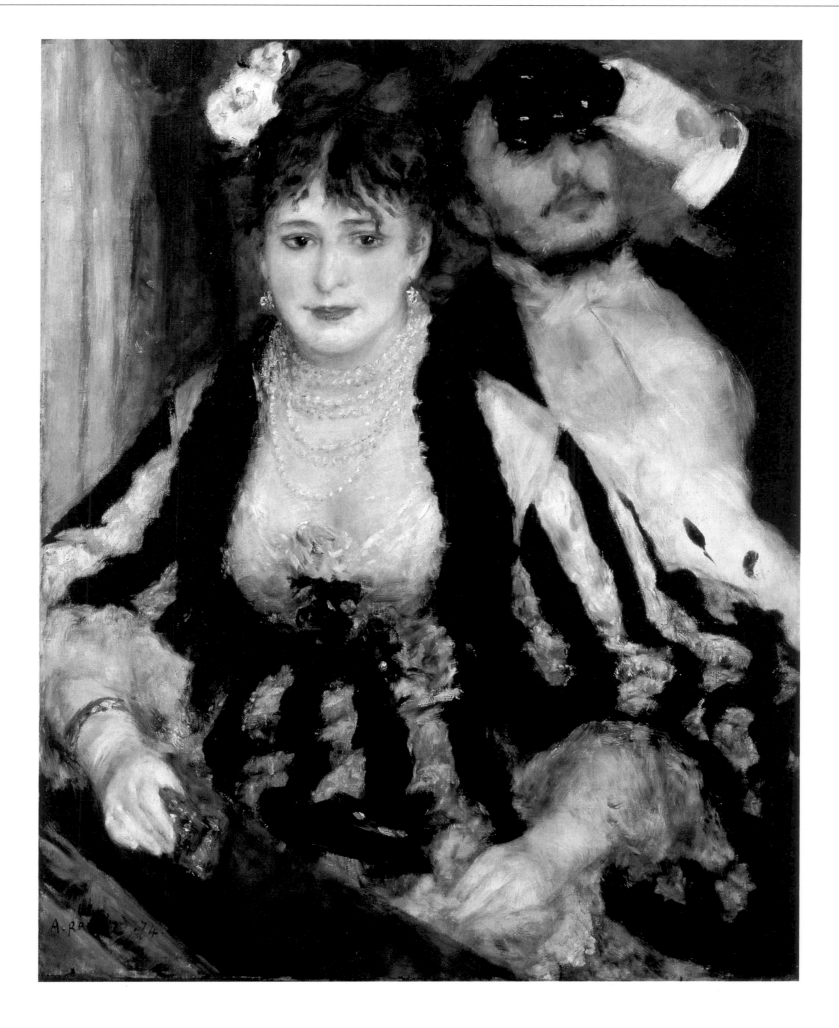

♦ *Above,* The Box
*("La Loge"), 1874.
Oil on canvas, 80 x
63 cm (31 1/2 x 24
3/4 in). Courtauld
Institute Galleries,
London.* "Isn't The
Box, *the masterpiece
of Renoir's
masterpieces, one* of those rare
canvases in which
everything enchants
one because of the
surprise, the novelty
and the unexpected,
while at the same
urging you to
compare it with the
great masters of art?" *(Paul Jamot,
1923). Commenting
on this canvas,
with its fine color
scheme that vibrates
in every detail,
Renoir said
he wanted it to be
"full, to the bursting
point."* ♦ *Opposite,* Reading
the Role, *1874. Oil on
canvas, 8 x 7 cm (3 x
2 3/4 in). Musée des
Beaux-Arts, Reims.
In this theater motif
the composition
seems to overflow
with the figures in
the foreground.*

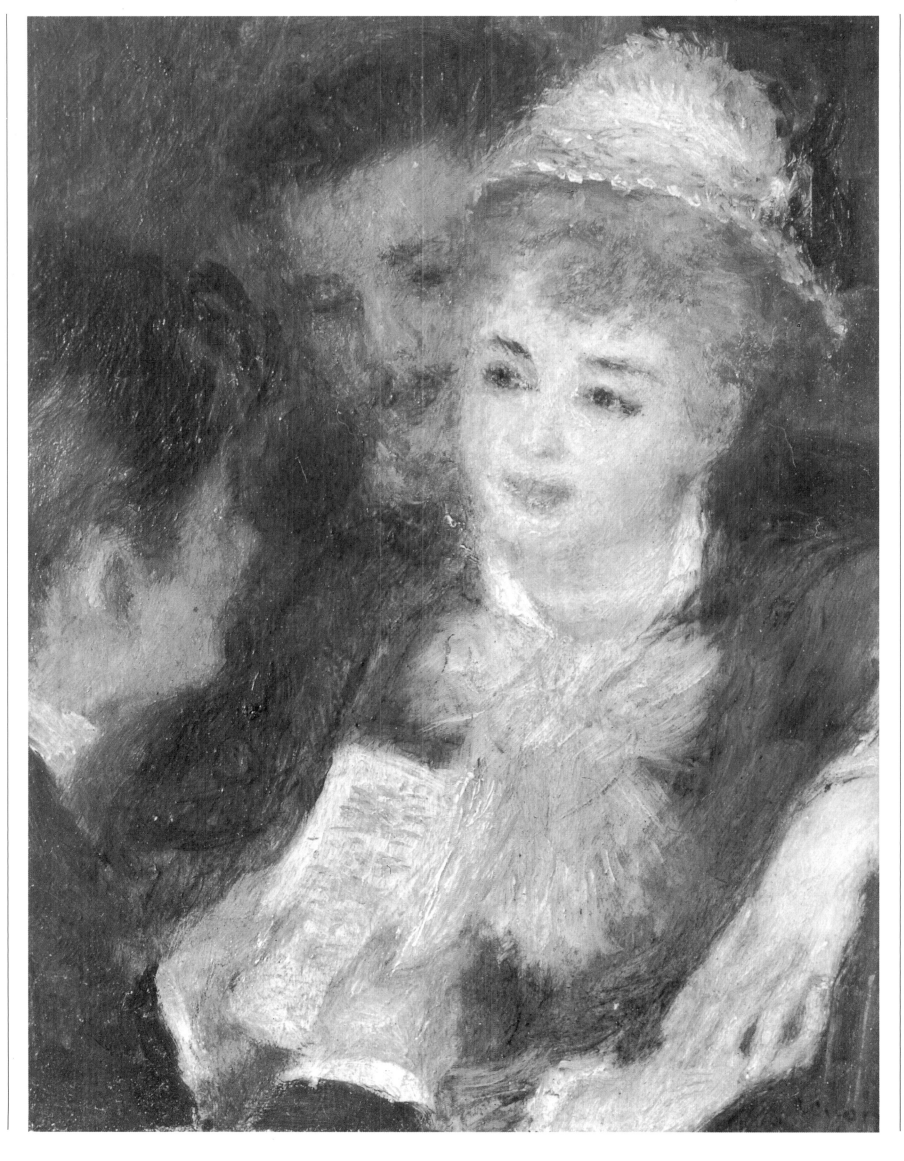

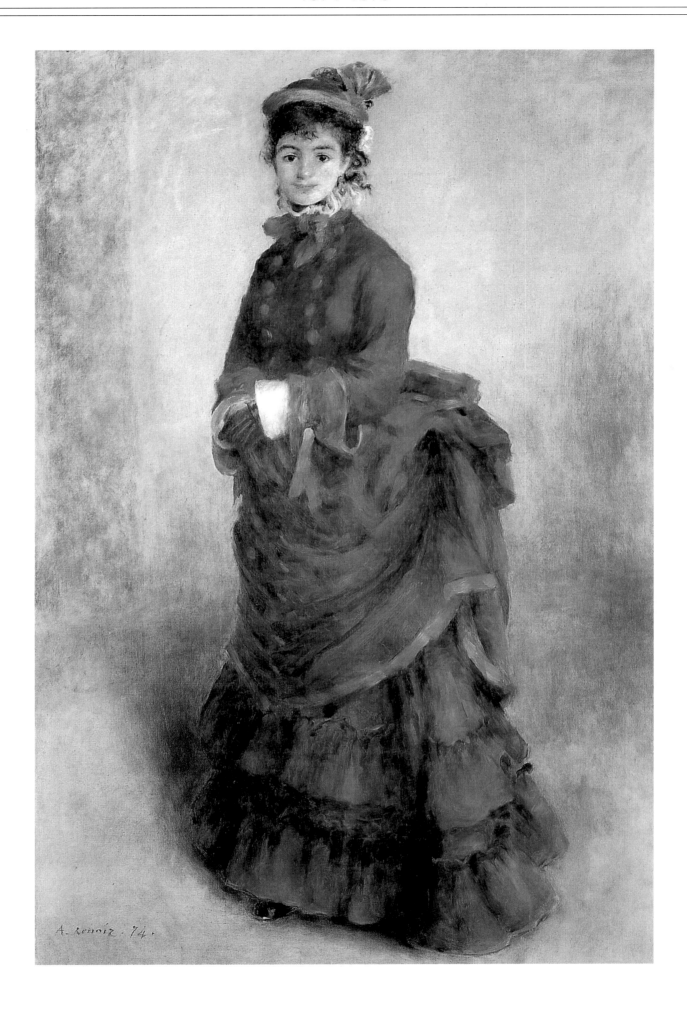

♦ *Above*, Parisian Lady ("La Parisienne"), *1874. Oil on canvas, 160 x 105.4 cm (63 x 42 in). National Museum of Wales, Cardiff. Along with* The Box, *this was one of the six canvases Renoir submitted to the first Impressionist exhibition in 1874. The model was Henriette Henriot, an actress and friend of the artist. Her mobile, vivacious expression vies with the artist's animated brushwork. The blue dress attracted Paul Signac's attention.*

♦ *Opposite,* The Dancer, *1874. Oil on canvas, 142 x 93 cm (56 x 36 1/2 in). National Gallery of Art, Washington D.C. Claretie must have seen this canvas before it was shown at Nadar's studio, since in 1873 he wrote: "I have seen his delightful Opéra dancers, of the kind Degas interprets so well." However, at the exhibition the critic Leroy commented viciously: "[...] his dancer's legs are as cottony as the gauze of her skirt."*

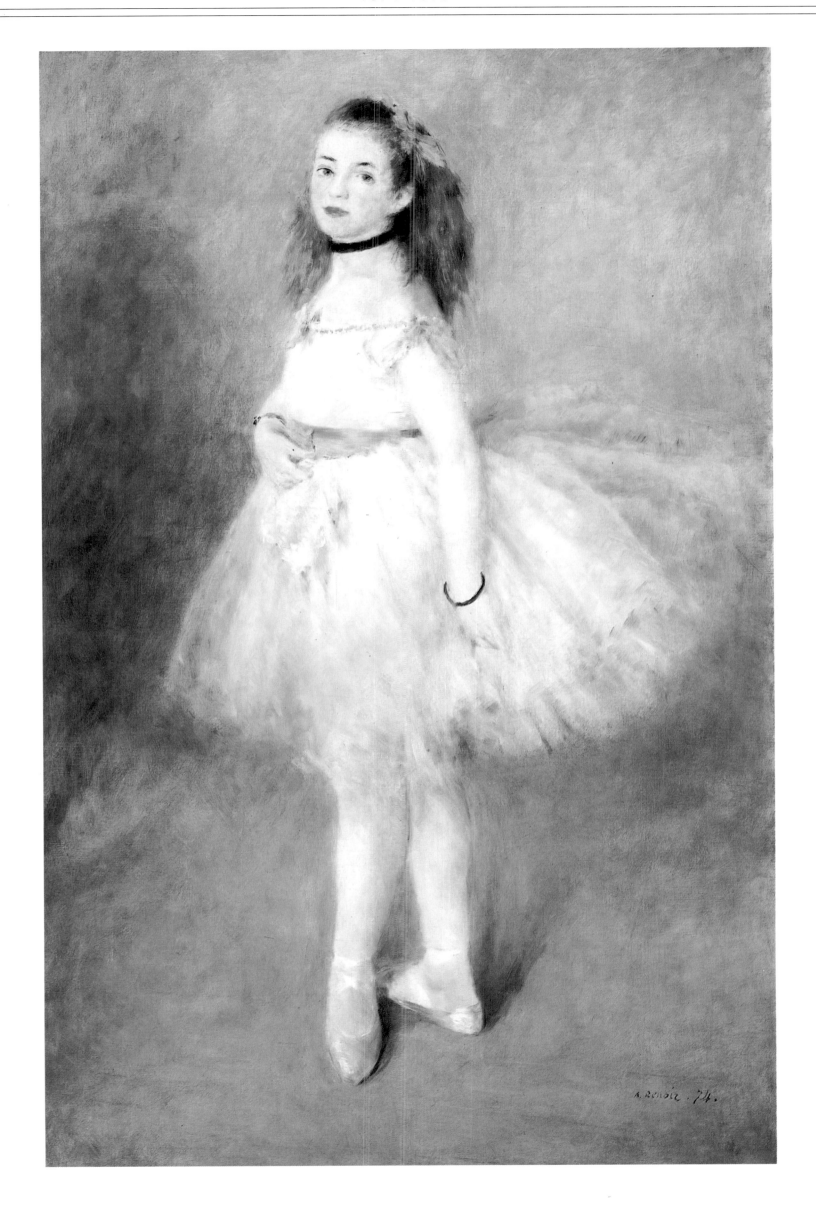

78

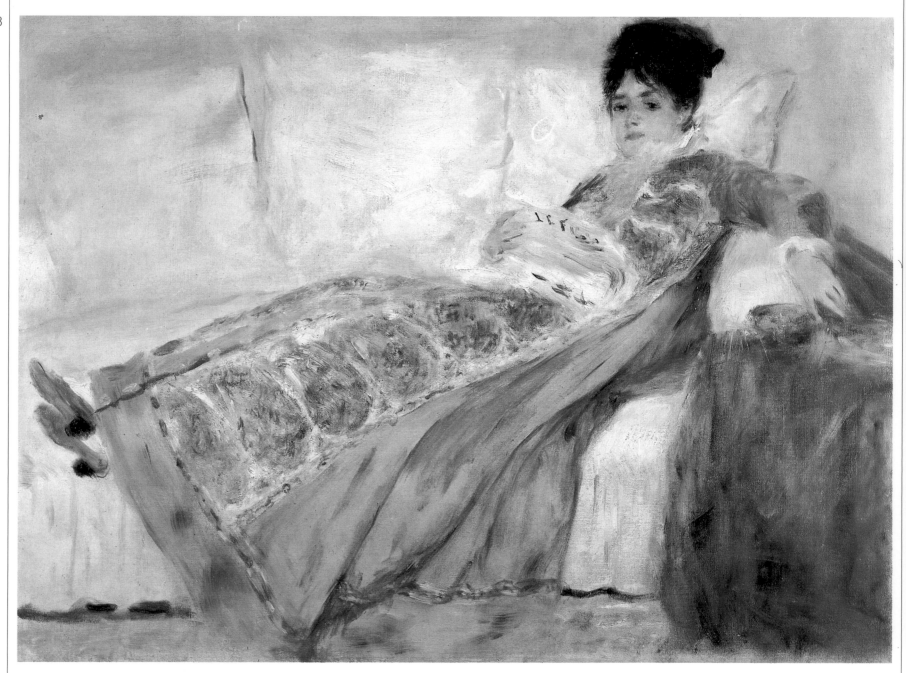

♦ Camille Monet
Reading "Le Figaro,"
ca. 1874. Oil on
canvas, 53 x 71 cm
(20 3/4 x 28 in).
Gulbenkian
Foundation, Lisbon.
This portrait of
Monet's wife is like
a Japanese silk-
screen, embellished
with light-filled
touches of color.
The composition is
solidly structured
on horizontals and
is animated by
unexpected
small differences
in perspective
in the dress, which
is flattened
against the white
divan.

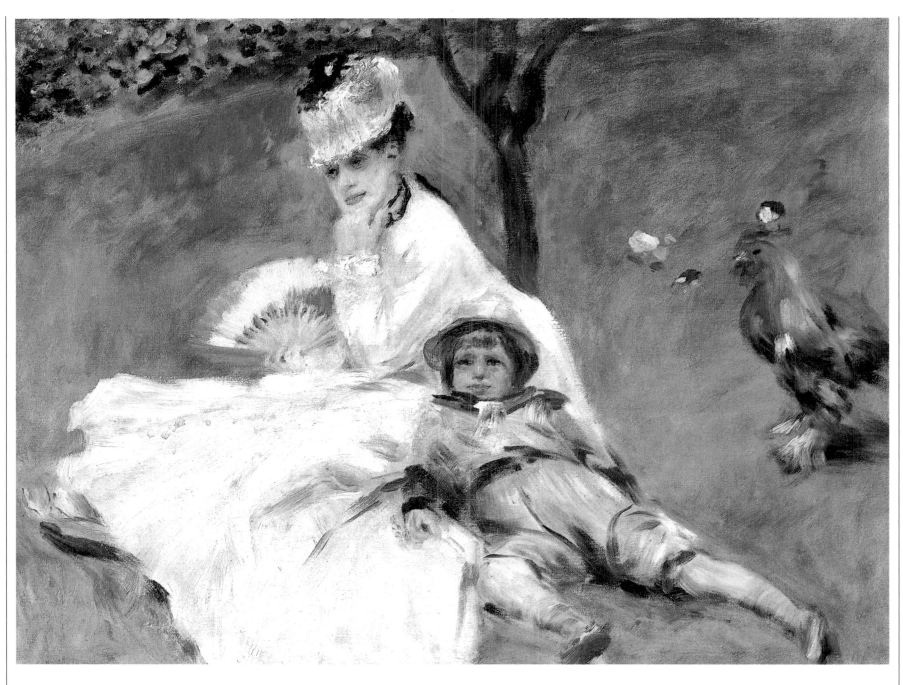

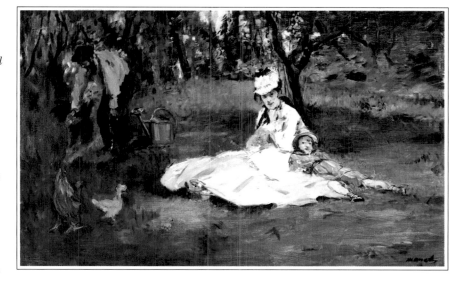

♦ *Above*, Madame Monet and Her Son, *1874. Oil on canvas, 50.4 x 68 cm (19 7/8 x 26 3/4 in). National Gallery of Art, Washington D.C.*

Right, ÉDOUARD MANET, *The Monet Family in Their Garden at Argenteuil, 1874. Oil on canvas, 61 x 100 cm (24 x 39 1/4 in). Metropolitan Museum of Art, New York. "It was painted in our garden at Argenteuil one day when Manet, seduced by the color and light,* had begun to paint a canvas [...] While he was working, Renoir arrived, and he too found the charming scene irresistible. He asked me for my palette, a brush, paints and a canvas and he began painting side by side with Manet, who observed Renoir out of the corner of his eye [...]; then with a grimace he passed close to me to whisper in my ear: "He has no talent at all, that boy!"" *(Claude Monet).*

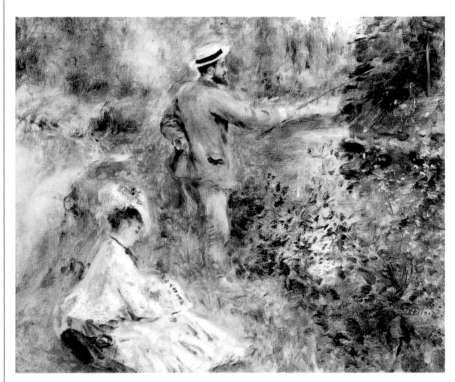

♦ *Top*, Garden at
Fontenay, *1874. Oil
on canvas, 50 x 61
cm (19 3/4 x 24 in).
Oskar Reinhart
Collection,
Winterthur.*

♦ *Above*, Fisherman
with Rod and Line,
*ca. 1874. Oil on
canvas, 54 x 64 cm
(21 1/4 x 25 1/4 in).
Private Collection.*

♦ *Right*, Path Rising
through the Long
Grass, *ca. 1874. Oil
on canvas, 60 x 74
cm (23 1/8 x 29 1/8
in). Musée d'Orsay,*

*Paris. These three
landscapes are
among Renoir's
most Monet-like
canvases; the setting
is animated by the
vitality of the
figures, who are
immersed and
transfigured in the
reverberation of
natural light.
"Landscape is also
useful for a painter
of human figures.
Outdoors one is
led to employ color
tones that would
be unthinkable
in the weak light of
a studio."*

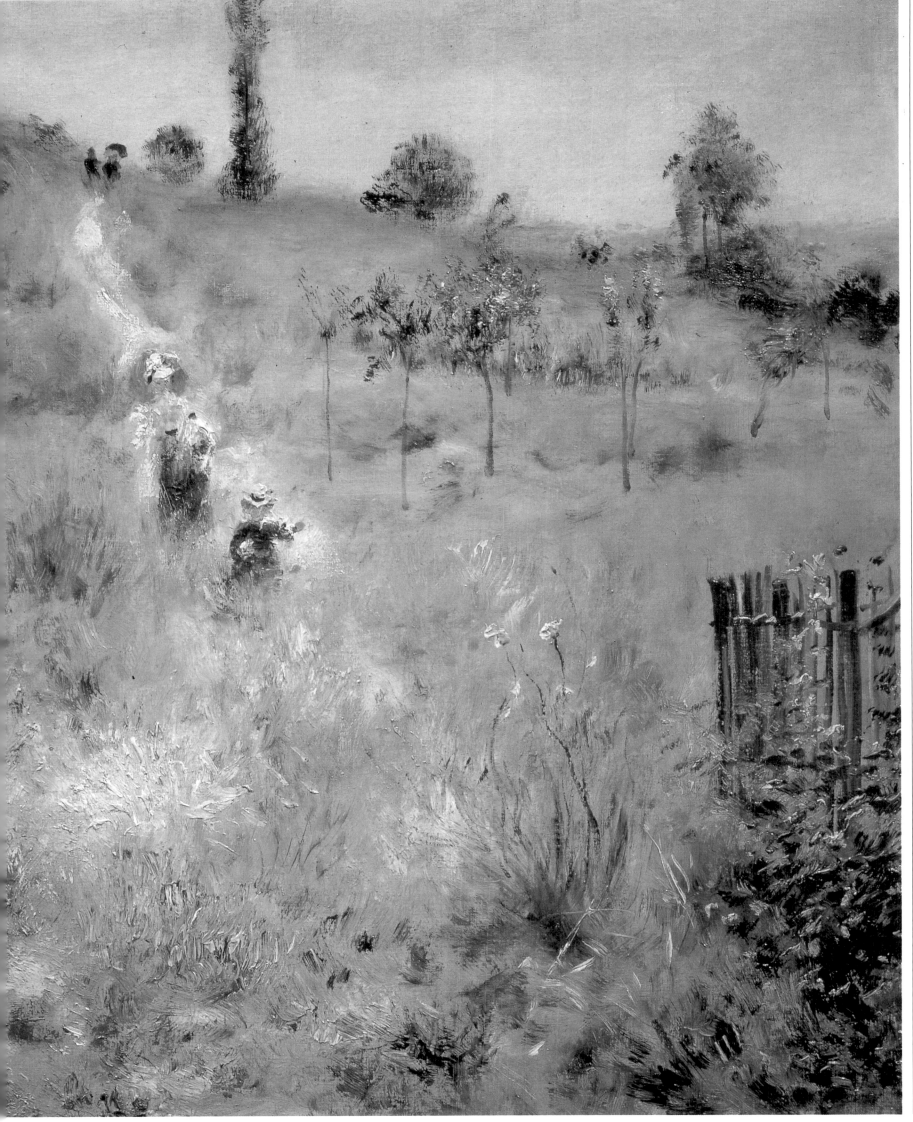

82

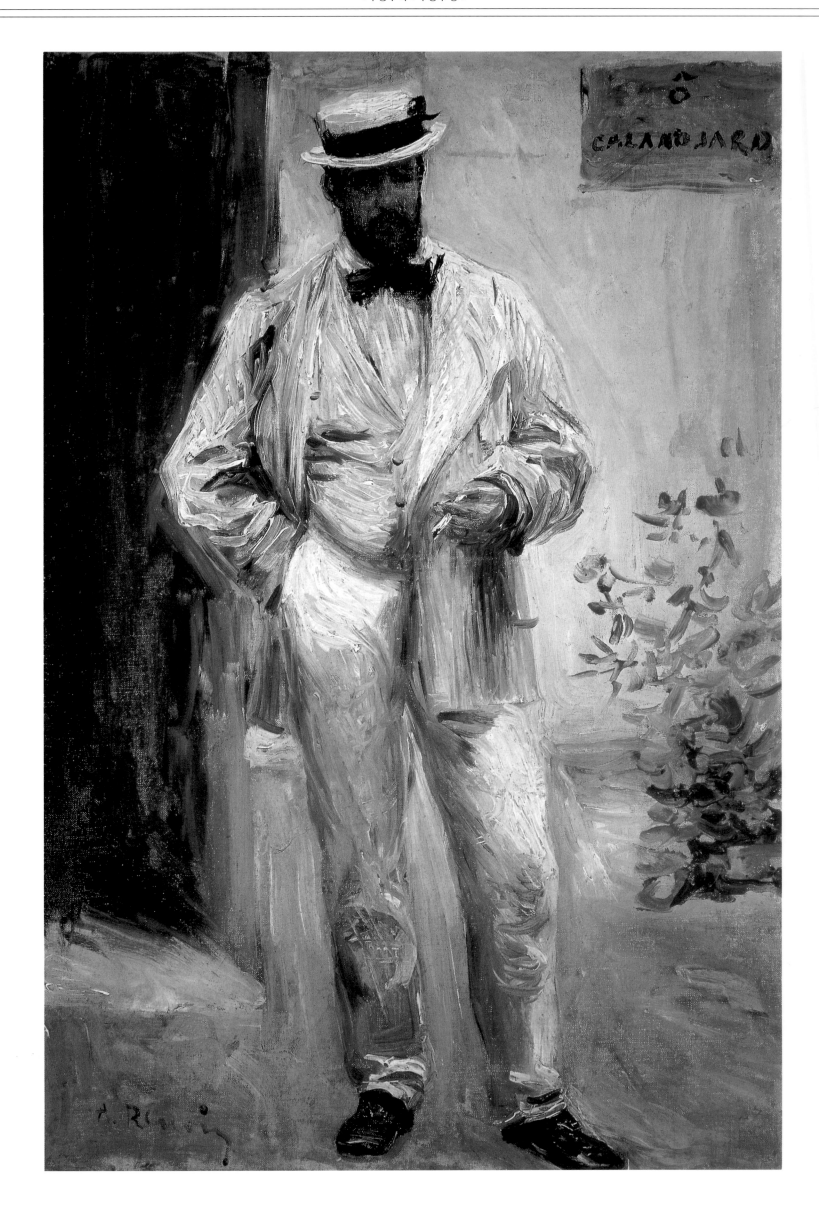

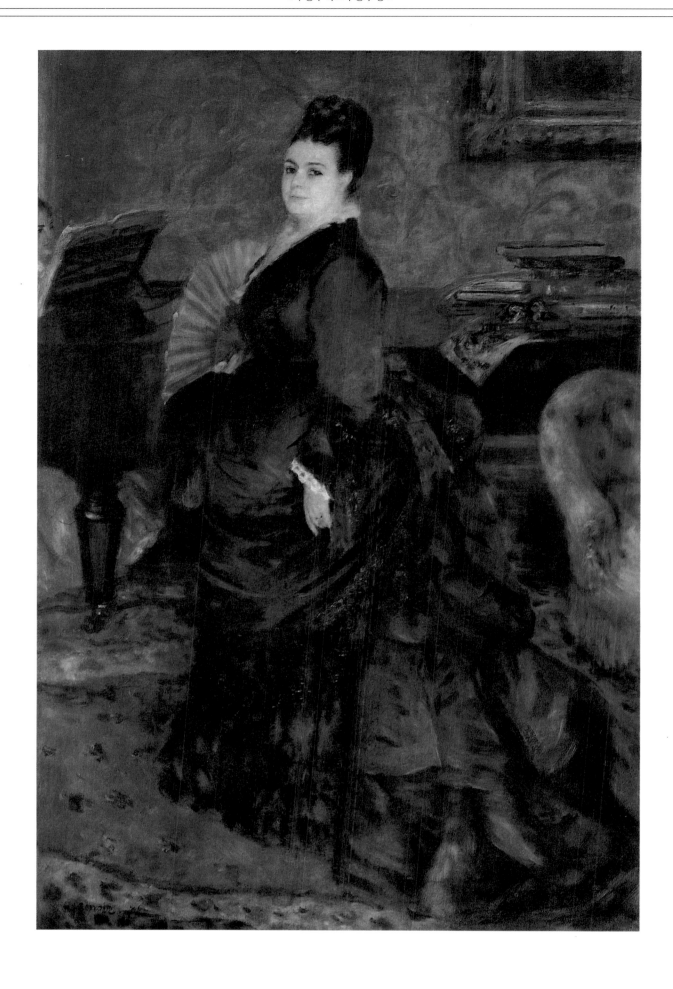

♦ *Opposite*, Charles Le Coeur in the Garden, *1874. Oil on canvas, 42 x 30 cm (16 1/2 x 11 3/4 in). Musée d'Orsay, Paris. A friend of Renoir's since the* *time of their romps in the Fontainebleau forest, Charles Le Coeur went to see the artist at his country house in 1874. But an indiscreet love note* *Renoir had written to Le Coeur's adolescent daughter and intercepted by her uncle Jules, brought the friendship to a sudden end.* ♦ *Above*, Portrait of a Woman (Madame Georges Hartmann), *1874. Oil on canvas, 183 x 123 cm (72 x 48 1/2 in). Musée d'Orsay, Paris.*

84

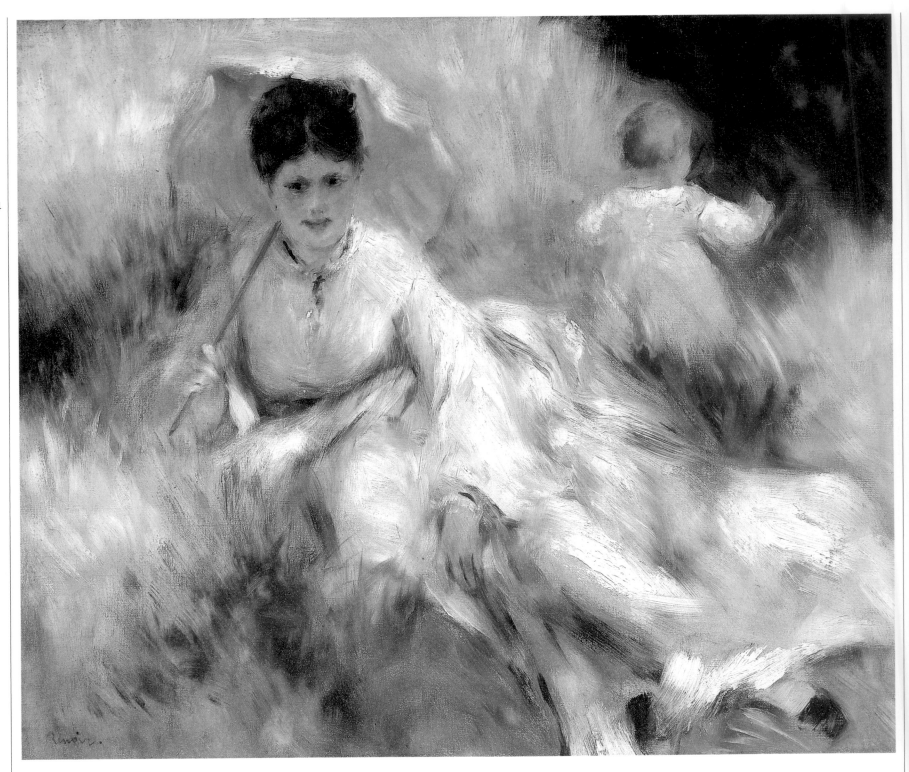

♦ *Above*, Woman with a Parasol and Child in the Meadow (Camille Monet), *ca. 1874-76. Oil on canvas, 47 x 56 cm (18 1/2 x 22 in). Museum of Fine Arts, Boston. The reflection of the green of the meadow is like a veil over Camille Monet's face,* which is isolated against the pink of the parasol. Renoir's brushwork is light and feathery, with broad oblique touches that animate the space. The light tone of the dress is subtly muffled by the brilliant yellow in the background.

♦ *Opposite*, Nude in the Sunlight, *1875. Oil on canvas, 81 x 65 cm (31 7/8 x 25 5/8 in). Musée d'Orsay, Paris. The experimental nature of this work lies in its bold treatment of an intimately classical theme of a nude* bathed in natural light. Exhibited at the Hôtel Drouot auction, the canvas was ridiculed by the critics Wolff and Enault, who said they should "hand her some clothing" to cover her flabby flesh.

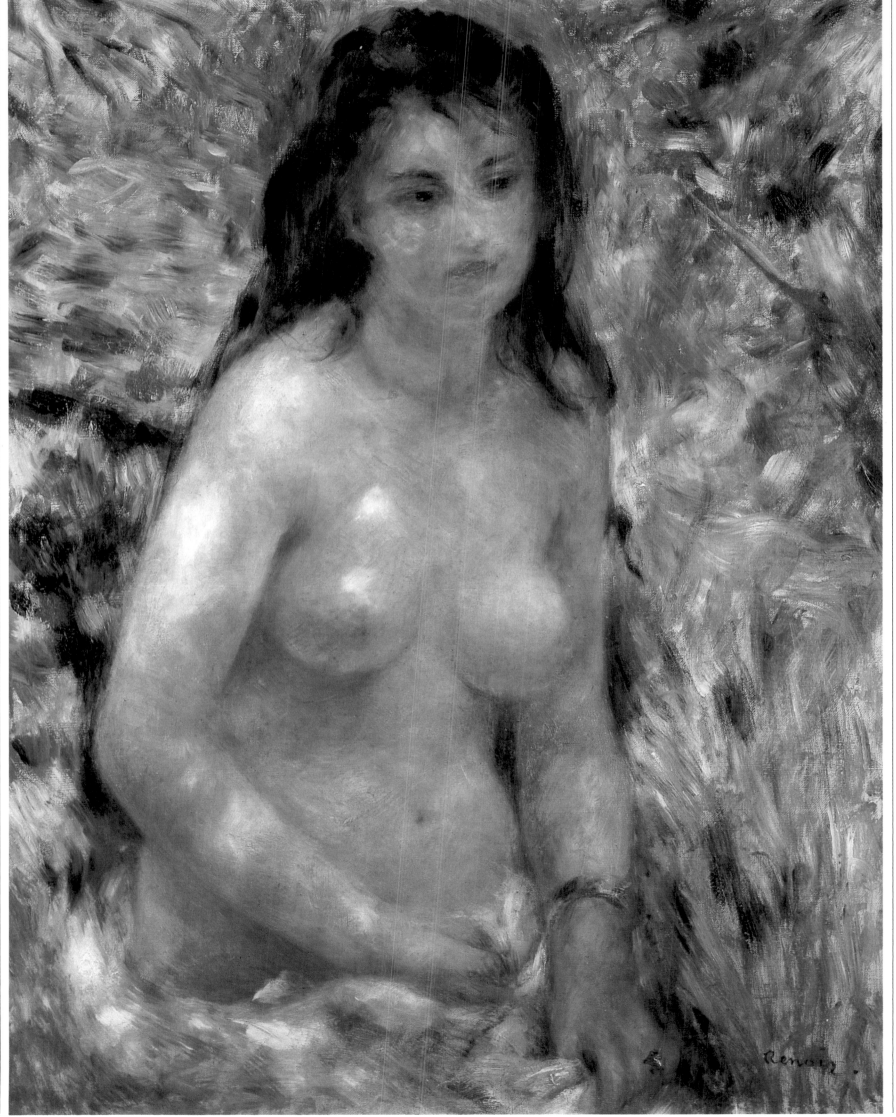

86

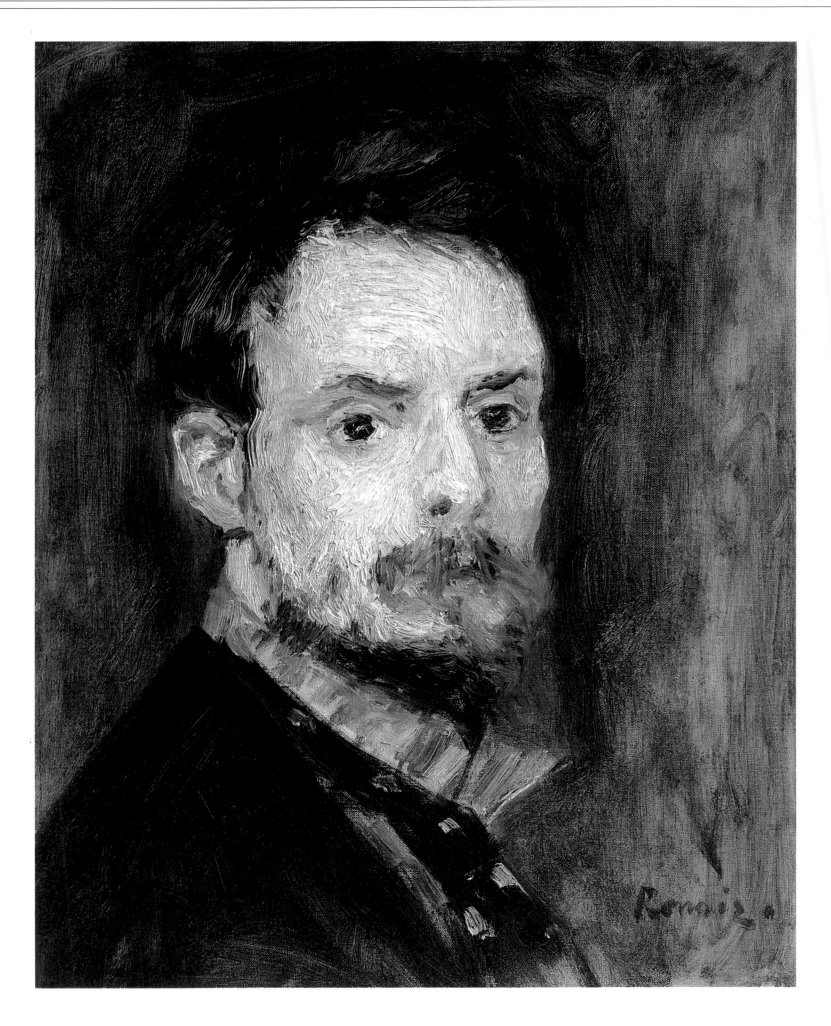

♦ *Above*, Self-portrait, *ca. 1875. Oil on canvas, 39.4 x 31.7 cm (15 1/2 x 12 1/2 in). Sterling and Francine Clark Art Institute, Williamstown, Mass. Also known as Self-portrait at the Age of Thirty-four, this canvas represents the artist in an unusual spiritual key—his emaciated face and rather feverish gaze directed at the viewer. It was purchased by De Bellio in 1877.*

♦ *Opposite*, Portrait of Monet, *1875. Oil on canvas, 84 x 60 cm (33 x 23 1/2 in). Musée d'Orsay, Paris. Once again we note the "tools of the trade"—the palette, brush, round hat—of Renoir's friend Monet. The backlighting effect makes the dark form stand out against the weak light coming from the window, imparting a nuance-filled intimacy to the atmosphere.*

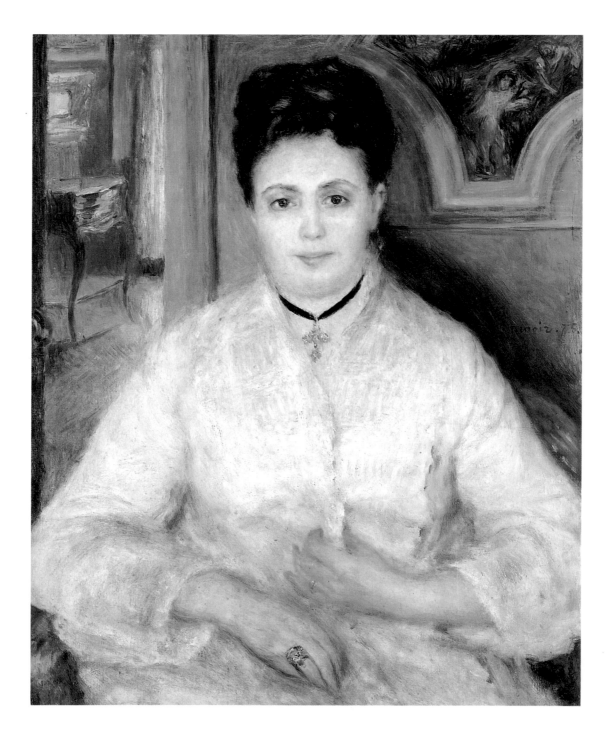

♦ Madame Chocquet, 1875. Oil on canvas, 75 x 60 cm (29 1/2 x 23 1/2 in). Staatsgalerie, Stuttgart. This portrait was a pretext for Victor Chocquet to meet Renoir. After the Hôtel Drouot auction, the artist's future patron wrote an enthusiastic letter to Renoir in which he commissioned a portrait of his wife. Madame Choquet is close to the viewer, smiling, her arms placed against her body, much like Verrocchio's sculpture, Bust of a Lady. Behind her, the sketch by Delacroix for the cycle he executed at the Palais Bourton influences the entire palette, which is based on warm tonalities.

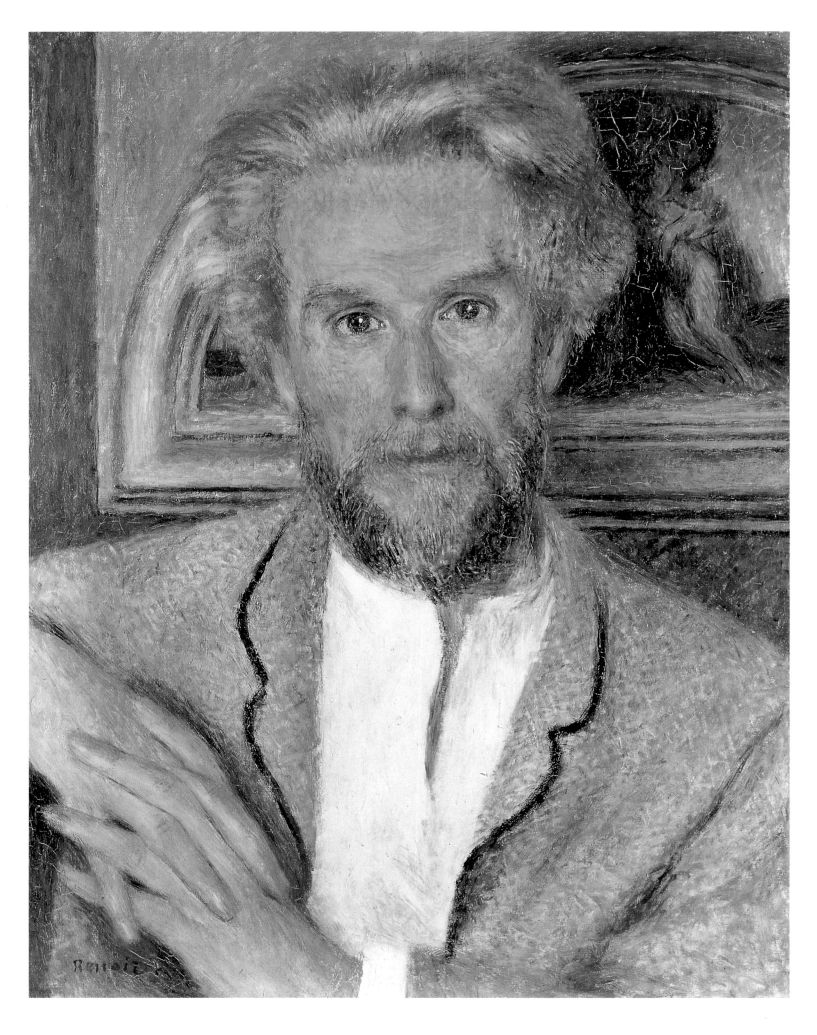

♦ Victor Chocquet,
ca. 1875-76. Oil on
canvas, 46 x 37 cm
(18 1/8 x 14 1/2 in).
Fogg Art Museum,
Cambridge, Mass.
The customs official
Chocquet was the
perfect embodiment
of an art collector,
with his quirks,
stubbornness and
dogmatic
preferences. With
modest means he
managed to amass a
noteworthy collection
of works by Watteau
and Delacroix when
no one else was
interested in these
artists. This canvas
is the companion
piece to the portrait
of his wife, and it
too has a work
by Delacroix in the
background,
a mythological
subject that was part
of Chocquet's
collection.

♦ *Above*, Portrait of Victor Chocquet with a White Background, *ca. 1876. Oil on canvas, 46 x 36 (18 1/8 x 14 1/8 in). Oskar Reinhart Collection, Winterthur. In a high-keyed palette* *that is rendered precious by the "Japanese" effect of the tapestry, the art collector's intense gaze is enhanced by the artist's keen psychological penetration.*

♦ *Opposite,* Alphonsine Fournaise, *1875. Oil on canvas, 41 x 33 cm (16 x 13 in). Museu de Arte, Sao Paulo. One of the future models for* Luncheon of the Boating Party, *the daughter of the proprietor of the restaurant on the Seine is depicted in a natural pose, much in the style of Manet.*

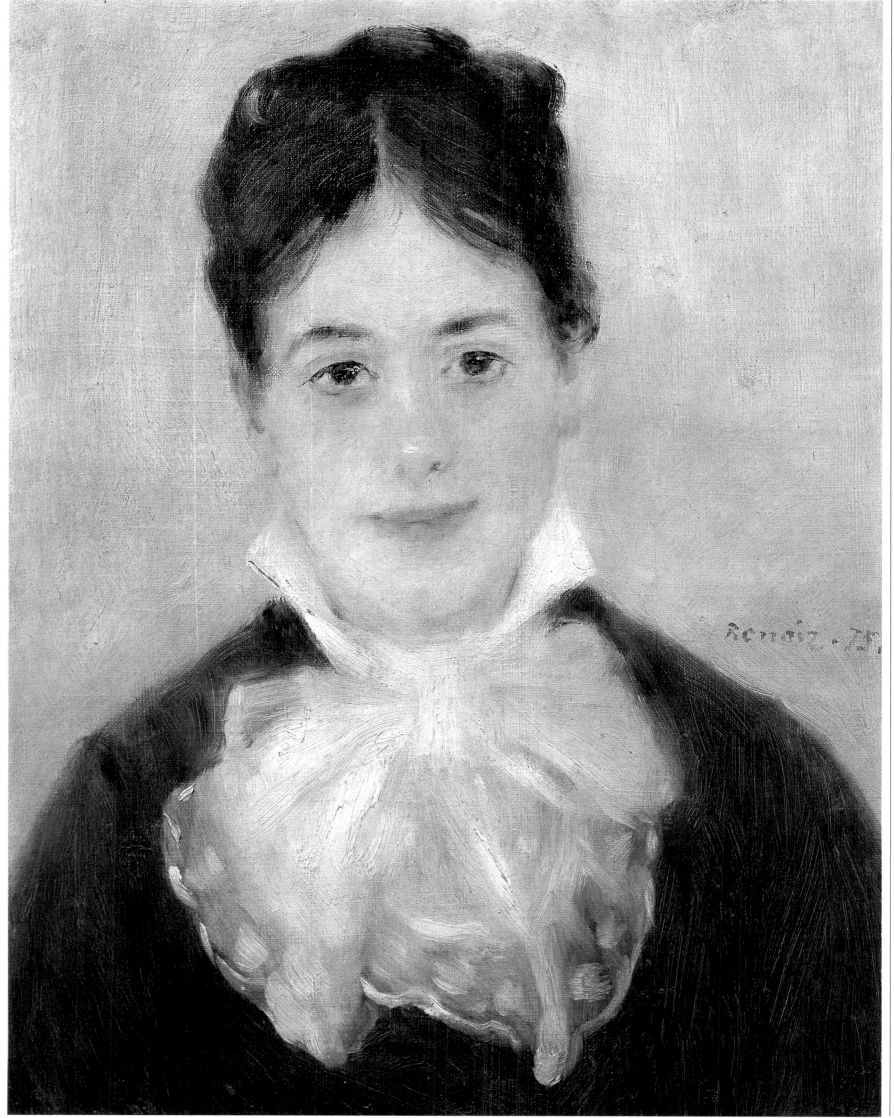

92

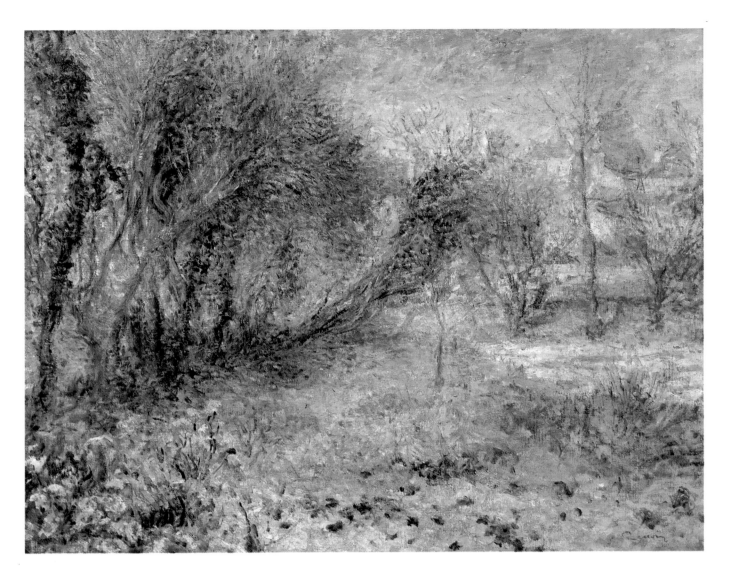

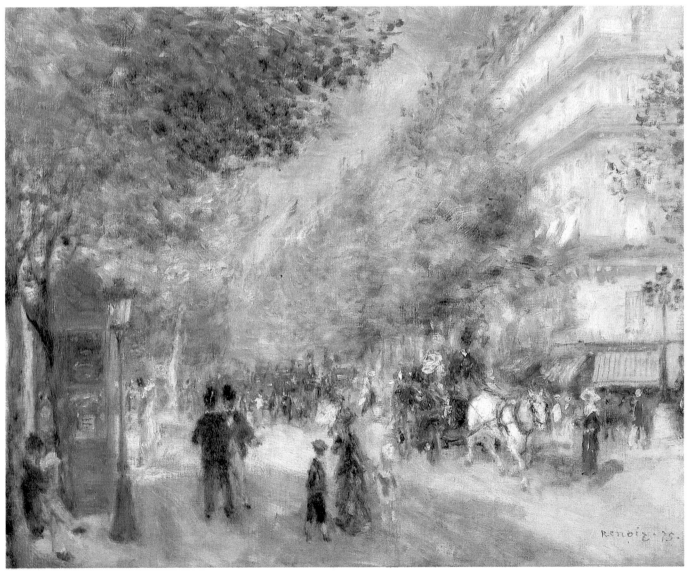

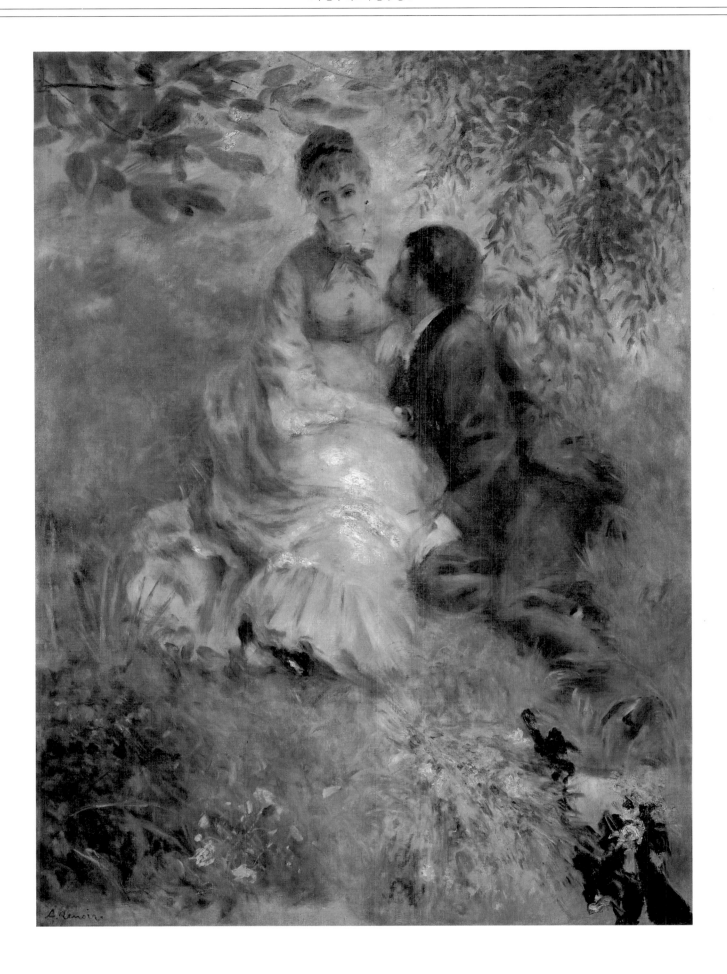

♦ Opposite above,
Snowy Landscape,
ca. 1875. Oil
on canvas, 51 x 66
cm. (15 3/4 x 25 3/4
in). Musée de
l'Orangerie, Paris.
"White does not
exist in nature. You
must admit that
there is a sky above
the snow. This
blue must appear on
the snow..."
(Renoir, 1910).

♦ Opposite below,
Paris Boulevards,
1875. Oil on canvas,
52 x 63.5 cm (20 1/2
x 25 in). Private
Collection. Bathed
in light, the morning
atmosphere is
depicted in all its
splendor in this view
of Paris in which the
vivaciousness of
modern urban life is
rendered by the
feathery brushwork.

♦ Above, The Lovers,
175 x 130 cm
(68 7/8 x 51 1/8 in).
Narodní Galerie,
Prague. The motif
of the human figure
in a dialogue
with nature's light
and colors, already
painted in
The Promenade, is
taken up here with
more supple, fluid
tones. Note the "still
life" of wheat and

poppies in the
foreground like an
inset of pure
grace executed with
the tip of the brush
and, at right,
the little hat with
the unexpected black
of the ribbon
in the woman's
hair—another
elegant homage to
Manet and his
Déjeuner sur
l'herbe.

94

♦ *Above,* Young Woman with a Veil, *ca. 1875. Oil on canvas, 61 x 50 cm (24 x 19 3/4 in). Musée d'Orsay, Paris. This "lost profile" lends the fascination of particular mystery to the unknown woman (who is perhaps the model Margot Legrand or Nini Lopez). The* play of whites and blacks concentrates the viewer's attention on the delicate pink bow that illuminates the hidden face ever so slightly. As in Degas, this angle of vision creates a sensation of the passing, ephemeral moment that is the "modern" hallmark of Impressionism.

♦ *Opposite,* Mother and Children, *ca. 1875. Oil on canvas, 168 x 104 cm (66 x 41 in). Frick Collection, New York. As in a canvas by Gainsborough, the simple circumstance of a morning walk in the park becomes the occasion for an exercise in rare pictorial brilliance.* The brushstrokes, with their palpitating touch, enhance the lights in the hems of the dresses and in the golden hues o the hair, while the green of the park heightens the effect of the complementary color, according to the theories of the scientist Charles Chevreul.

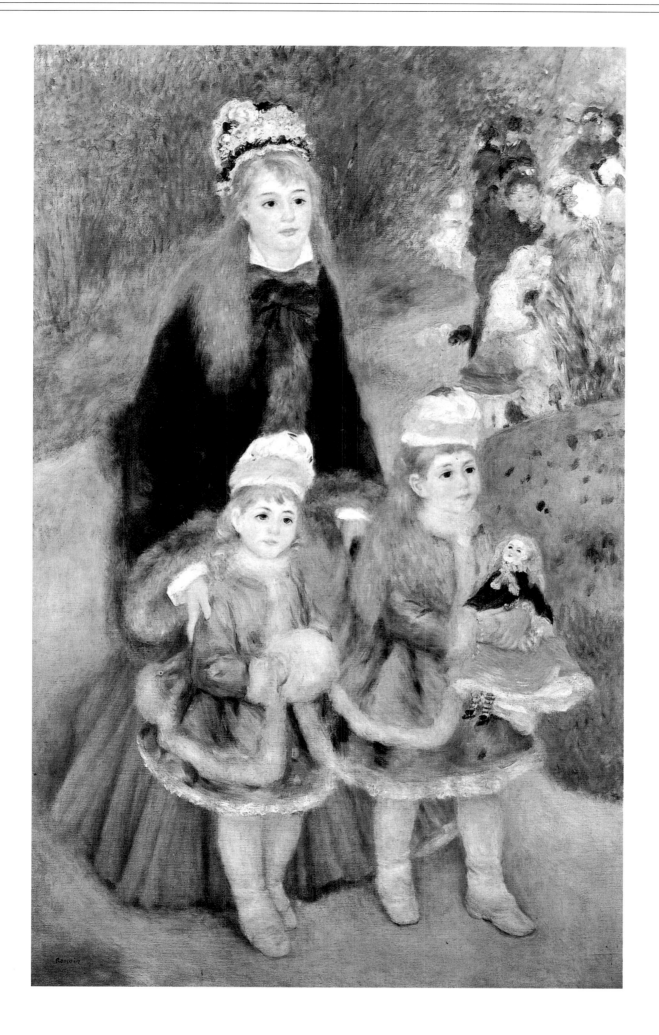

96

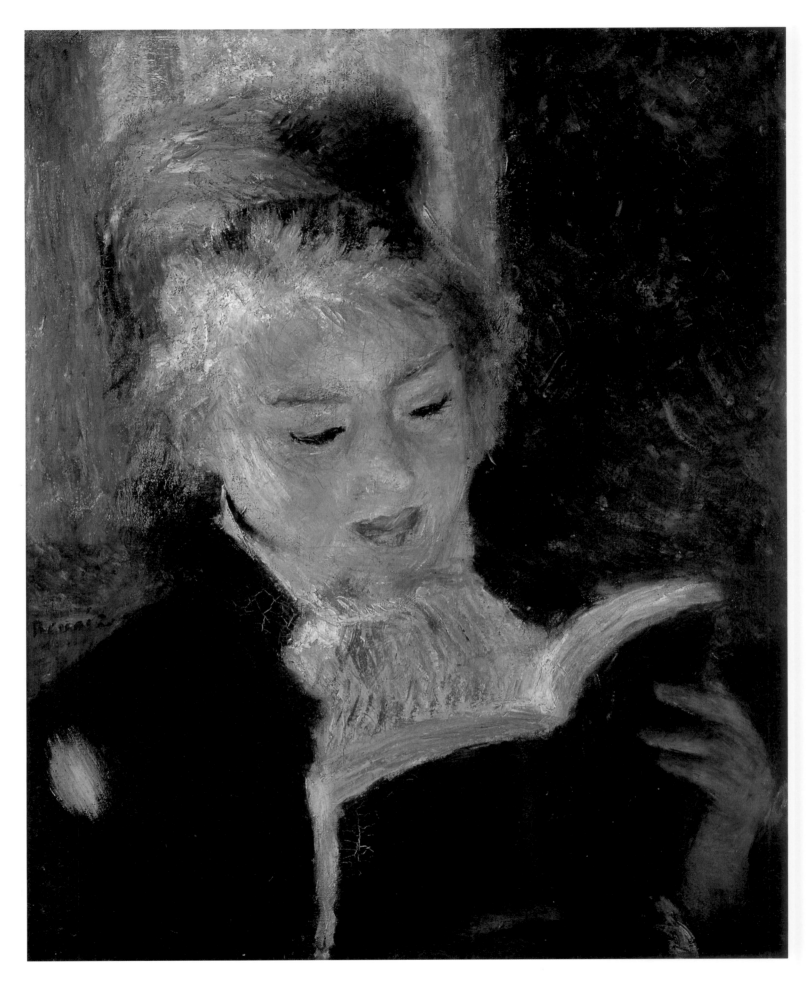

♦ *Above,* The Reader, *1874-76. Oil on canvas, 46 x 38.5 cm (18 1/8 x 15 1/8 in). Musée d'Orsay, Paris.* "One fine day one of us ran out of black, and Impressionism was born." *Renoir thus ironically keeps his distance from all technical dogmatism.*

Black, the so-called non-color, not only remained part and parcel of the Impressionists' palette, but here actually plays an important part in underscoring the half-closed eyes and the brightness of the face against the dark dress.

♦ *Opposite,* The Debut, *1876. Oil on canvas, 65 x 50 cm (25 1/2 x 19 3/4 in). National Gallery, London. Renoir introduces a narrative note with the title. But over and above the purely anecdotal aspect of this work, the*

compositional structure reveals more serious pictorial elements: the hazy effect of the surface that Renoir had already adopted in The Box *here suggests the ubiquity of space reflected as in the eye.*

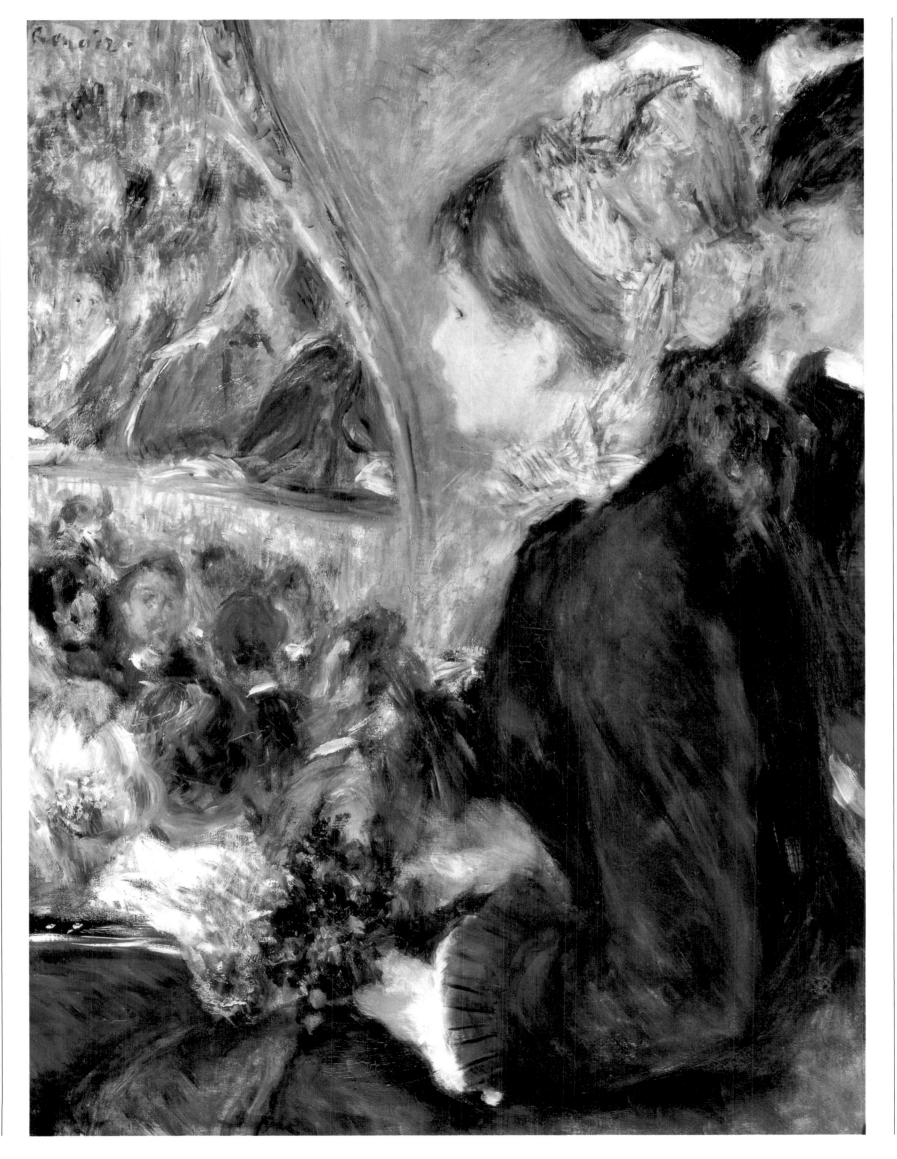

98

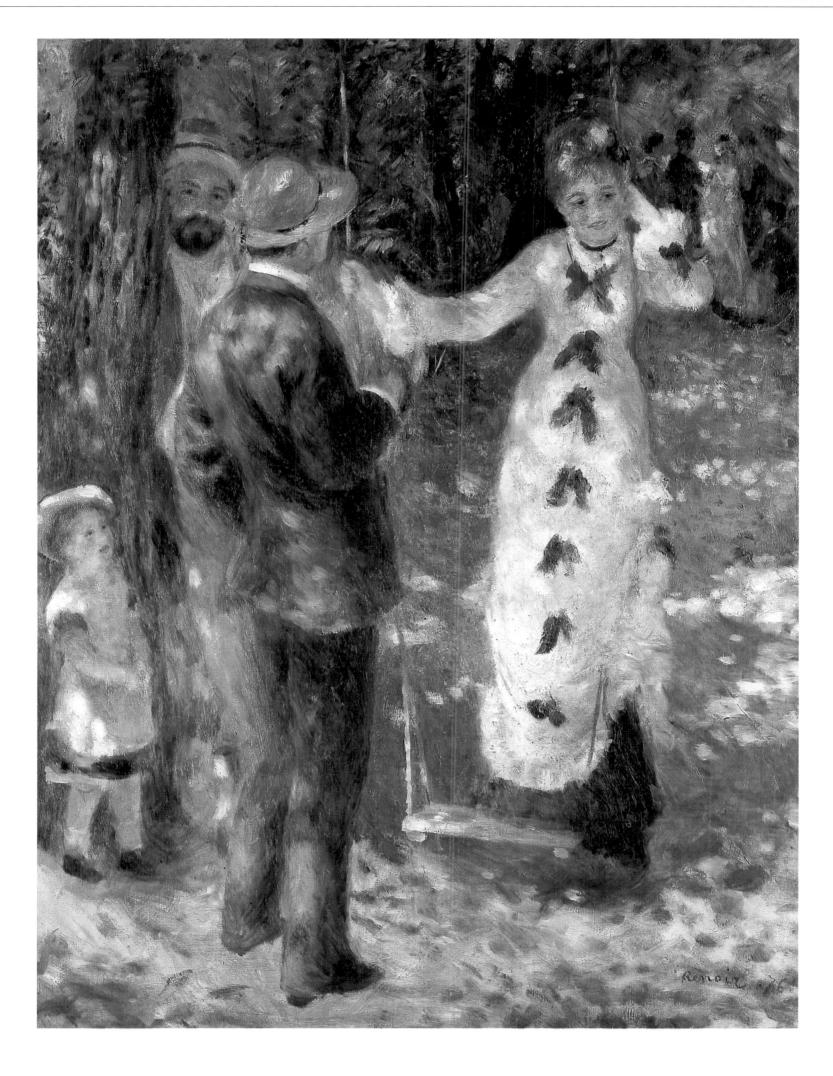

◆ *Opposite,* In the
Garden, *under the
Trees of the Moulin
de la Galette, 1876.
Oil on canvas,
81 x 65 cm (31 7/8 x*
25 5/8 in). *Pushkin
Museum, Moscow.
The figures fan
out over the surface
as in a bas-relief
sculpture.*

◆ *Above,* The Swing,
*1876. Oil on
canvas, 92 x 73 cm
(36 1/4 x 28 3/4 in).
Musée d'Orsay,
Paris. With the*
*proceeds from the
Hôtel Drouot
auction, Renoir
leased a garden in
Rue Cortot, in
Montmartre, where*
*he worked freely on
studying the human
figure in a landscape
with this small fête
galante. The
handling in dabs of*
*color creates a
uniformity of
chromatic values
that neutralizes the
perspective effect of
the view.*

100

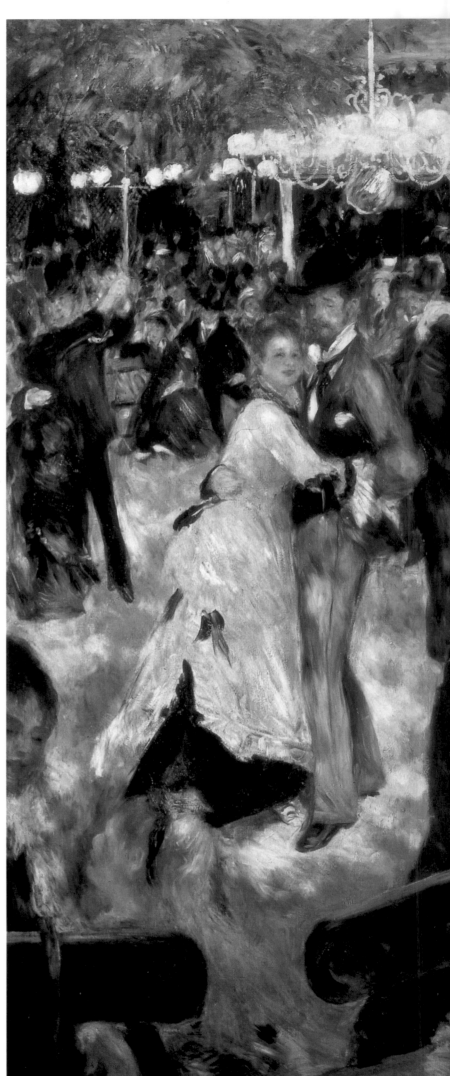

♦ *Above*, Study for "Dancing at the Moulin de la Galette," *1876. Oil on canvas, 64 x 85 cm (25 1/2 x 33 1/2 in). Ordrupgaardsamlingen, Copenhagen.*

♦ *Right*, Dancing at the Moulin de la Galette, *1876. Oil on canvas, 131 x 175 cm (51 1/2 x 68 7/8 in). Musée d'Orsay, Paris.* "Now he is painting the Moulin de la Galette; so he sets himself up there for six months, gets to know the locals with their idiosyncrasies (which models imitating their poses could not express) and by mingling with the popular tumult, he renders the rambunctious scene with amazing verve [...] We see the matter of his painting every day; it is our own existence that he has recorded, in works which will surely remain among the liveliest and most harmonious of our time." Renoir's brother Edmond points out the innovative nature of plein-air painting (understood for the most part as painting "live," directly from the "real-life" motif) as applied to a large-format rendering of social customs. The truth is, many of the figures were models, that is, good friends of Renoir: seated at the table, Georges Rivière and the painters Frank-Lamy and Goenuette, with the seamstress sisters Estelle and Jeanne; the other artists—Gervex, Cordey, Lestringuez and Lhôte—are dancing.

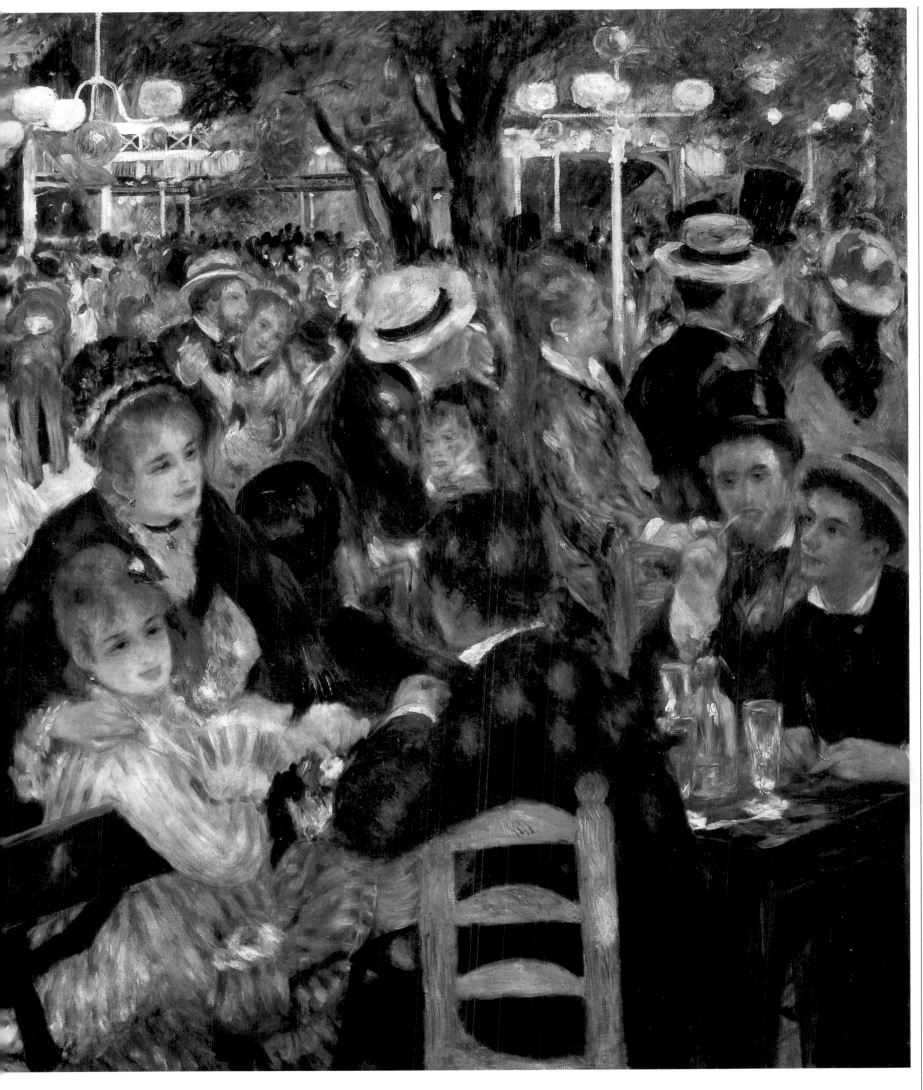

102

♦ *Above*, The Garden
in the Rue Cortot,
Montmartre, 1876.
Oil on canvas, 151.8
x 97.5 cm (59 3/4 x
38 3/8 in). Museum
of Art, Carnegie
Institute, Pittsburgh.
Just before the Sacré-
Coeur church was

built, the garden-
studio *on the top of*
Montmartre hill was
an area of abandoned
countryside in the
heart of Paris.
The composition is
vertical to make the
flowers stand out
more.

♦ *Opposite*, Girl with a
Watering Can, *1876.*
Oil on canvas, 100 x
73 cm (39 1/2 x 28
3/4 in). National
Gallery of Art,
Washington D.C.
This work, perhaps
painted in Rue
Cortot, concentrates

the luministic effect
on the webbed
brushwork, much like
a chromatic "drone".
The high horizon line
"forces" the young girl
into the foreground,
thus accentuating the
optical effect of
nearness.

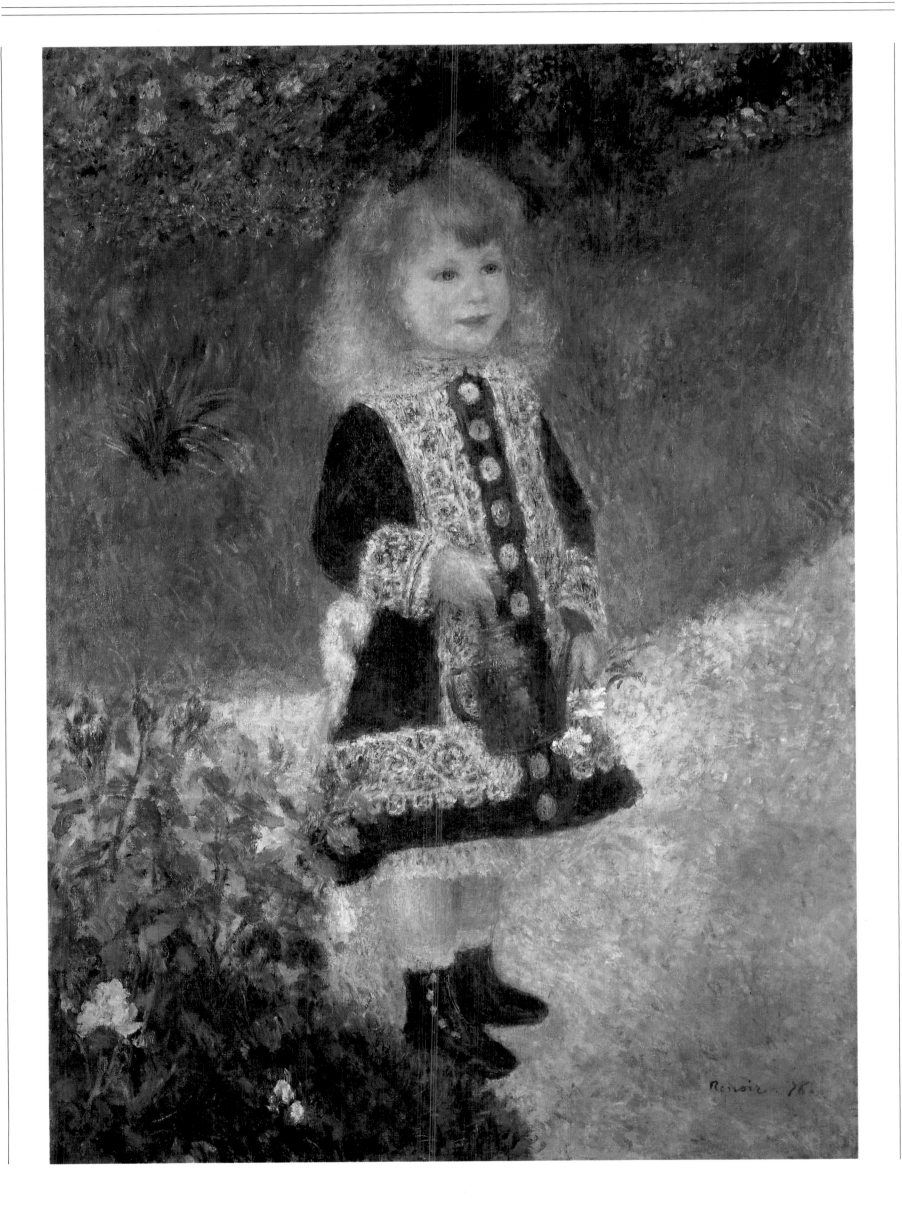

104

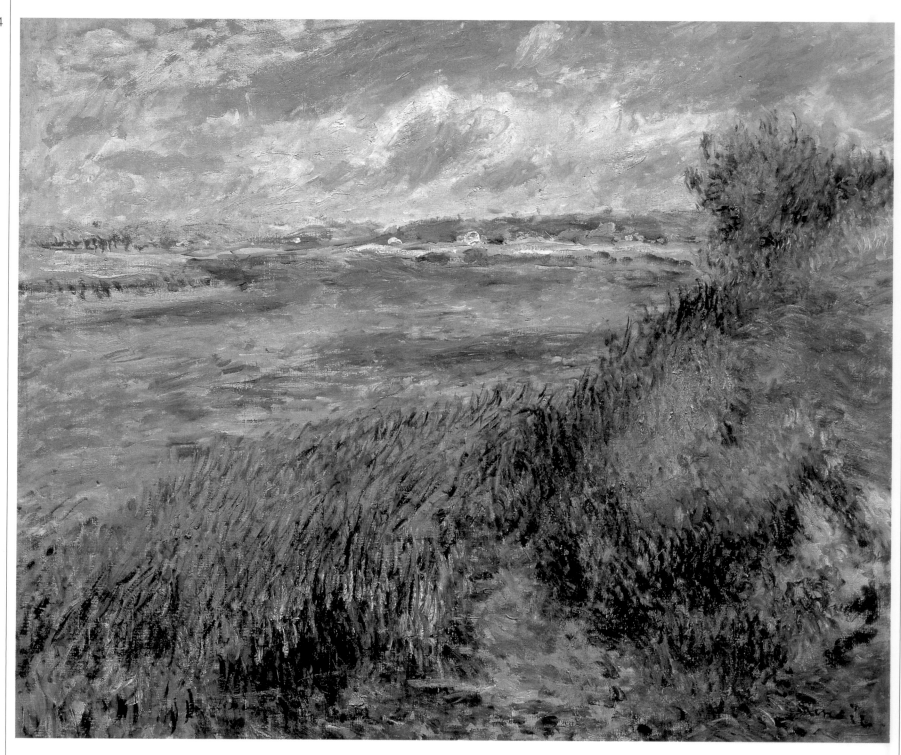

♦ *Above*, The Seine at Champrosay, *1876. Oil on canvas, 55 x 66 cm (21 5/8 x 26 in). Musée d'Orsay, Paris.* "What kind of profession is this, being a landscapist! You waste half a day to work an hour." *You finish one canvas out of ten, because the weather has changed." The oblique, feathery brushstrokes, especially in the vegetation, help to create the mobile restlessness of this canvas.*

♦ *Opposite*, Madame Alphonse Daudet, *1876. Oil on canvas, 46 x 38 cm (18 x 15 in). Musée d'Orsay, Paris. The refined gamut of tonalities, so crystalline and cold, lends a magnetic air to the face, which is otherwise in an extemporaneous pose. One gets a glimpse of subtle psychological dialogue in this intelligent, and benignly malicious, face of the wife of the writer Alphonse Daudet.*

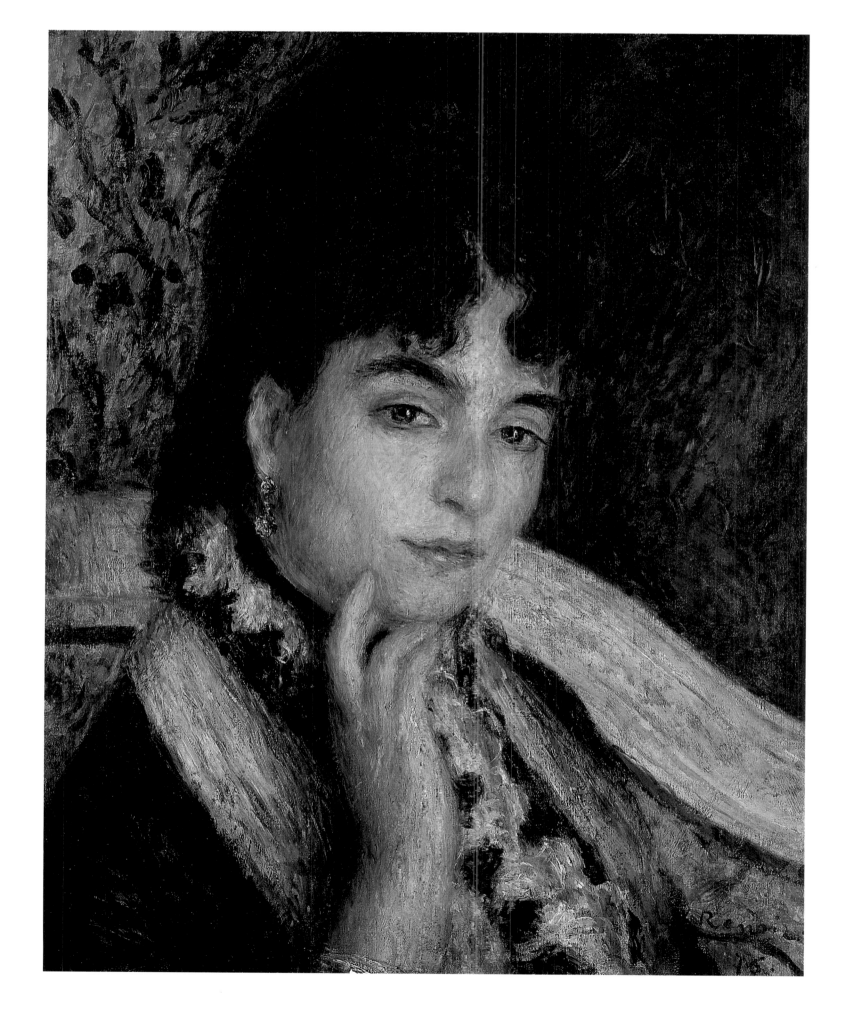

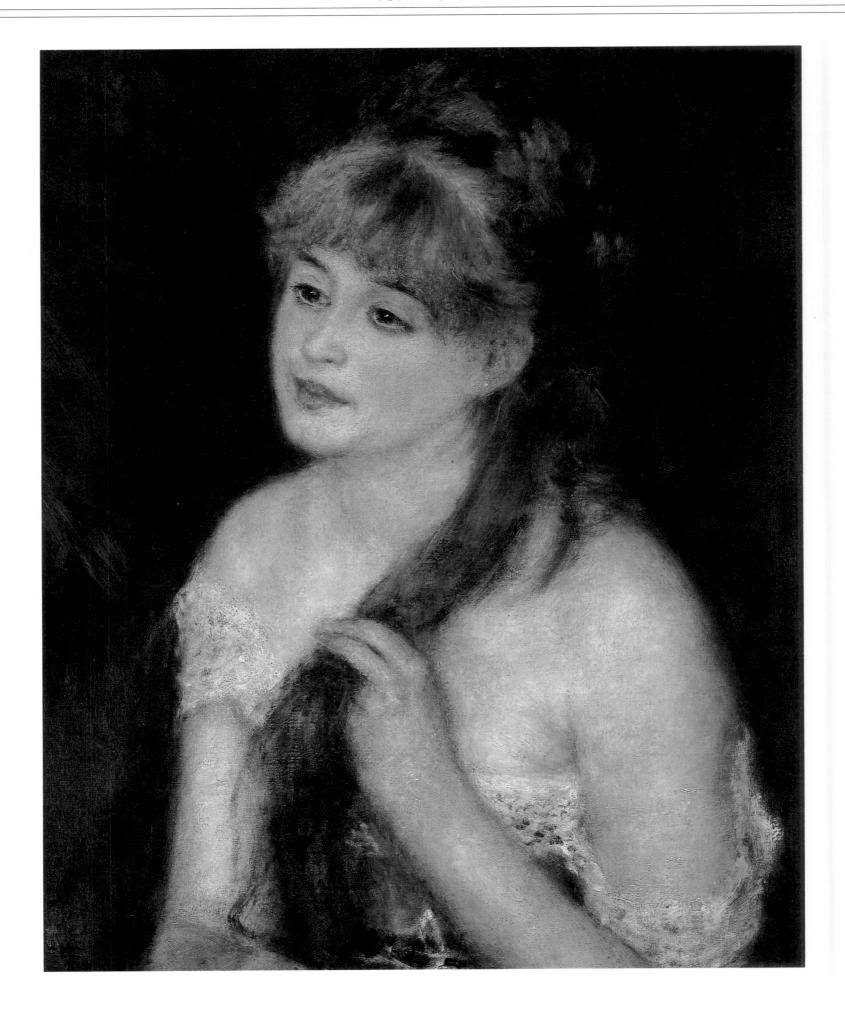

♦ Young Woman Braiding Her Hair, 1876. Oil on canvas, 56 x 46 cm (22 x 18 in). National Gallery of Art, Washington D.C. "His type of young girl has tried in vain to alter herself: elsewhere, in all her attitudes and under all her guises, we find the same delicious little being, like a cat in a fairy tale, peering sleepily out at the world through strange little eyes that are tender and malicious." (Théodore De Wyzéwa, 1891).

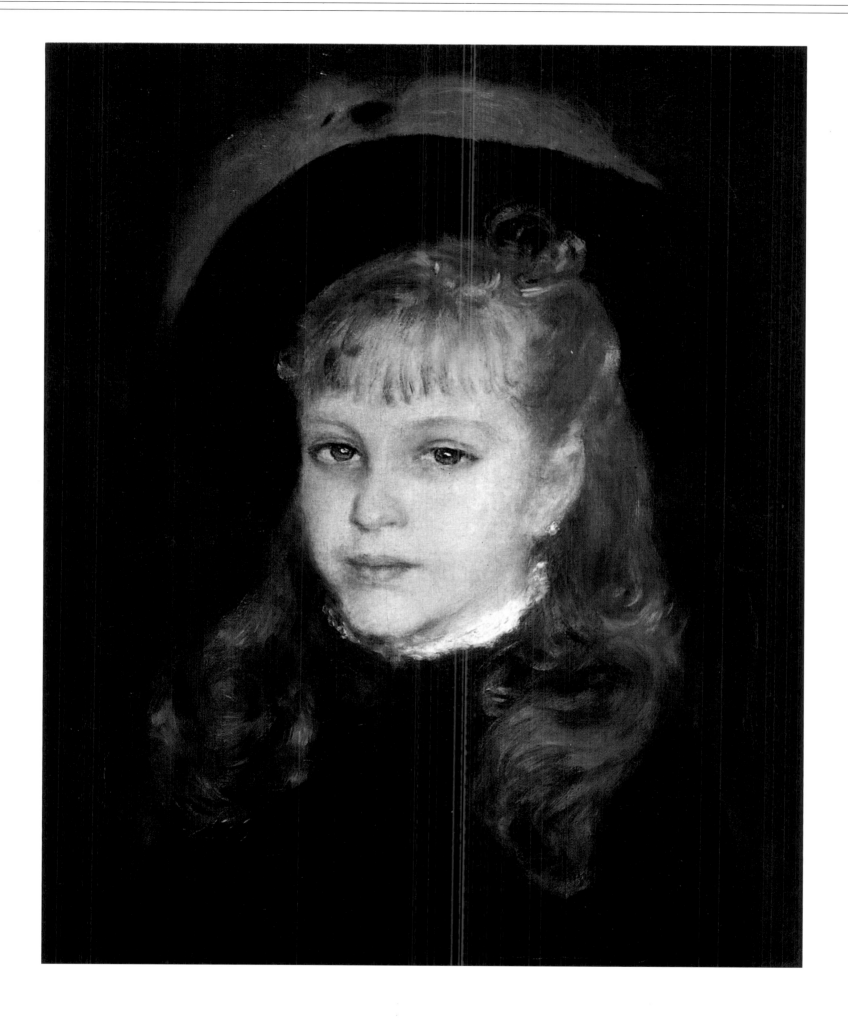

♦ Girl with a Pink
Feather, *1876. Oil on
canvas, 47 x 41 cm
(18 1/2 x 16 in).
Private Collection.
This splendid portrait
of a child marks a
return to seventeenth-
century art; the dark
background enhances
to the utmost the*
*brilliance of the girl's
hair, her soft flesh
and her liquid eyes,
which are not without
a hint
of seriousness and
languor. The pink
feather on her hat
imparts a note
of spontaneity to the
work.*

108

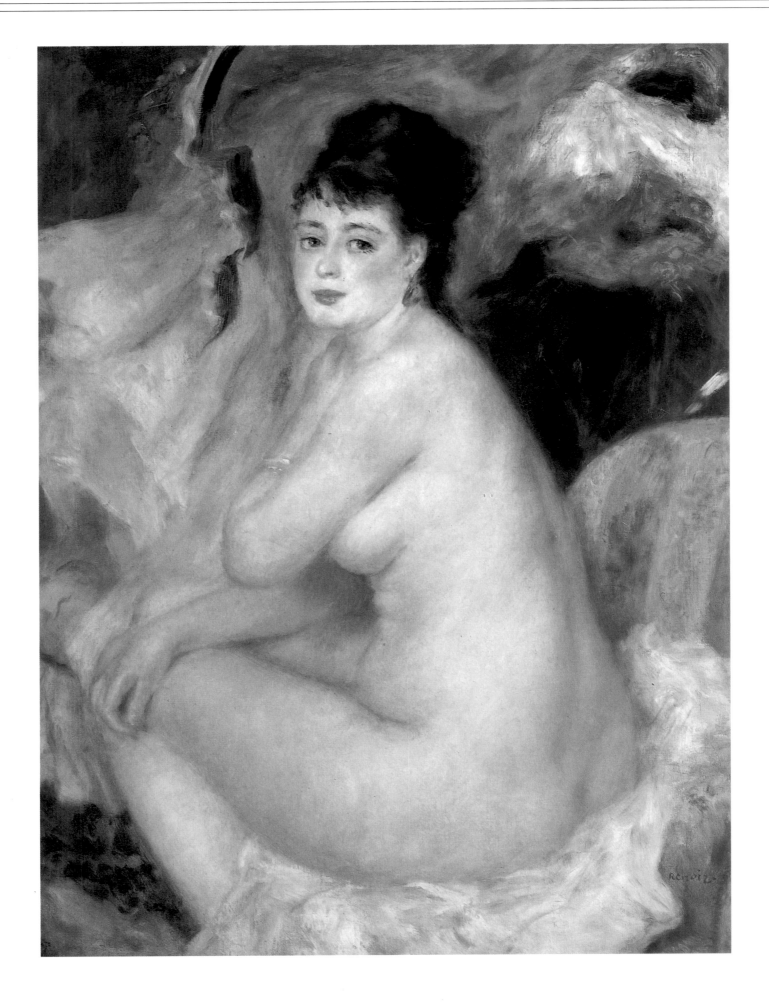

♦ Above, Seated Nude (Nana), 1876. Oil on canvas, 92 x 73 cm (36 1/4 x 28 3/4 in). Pushkin Museum, Moscow. For this work Renoir used same model who posed for Nude in the Sunlight, but here the forms are more compact and flattened on the surface, with an interesting à plat effect that solves the problem of space by making background and figure equal, and no longer through color permeation. The canvas was purchased in 1898 by the Russian merchant and art collector Shchukin.

♦ Opposite, After the Bath, 1876. Oil on canvas, 93 x 73 cm (36 1/2 x 28 3/4 in). Neuegalerie, Vienna. This pose is similar to the one in the canvas on the opposite page, as is Renoir's handling of figure and background. Yet here the bust is turned towards the viewer and one arm rests on the woman's knee and on the sheet, which imparts a more static, markedly more classic, tone to the composition. It is worthwhile comparing this work with the "mythological" nude Blond Bather (1881).

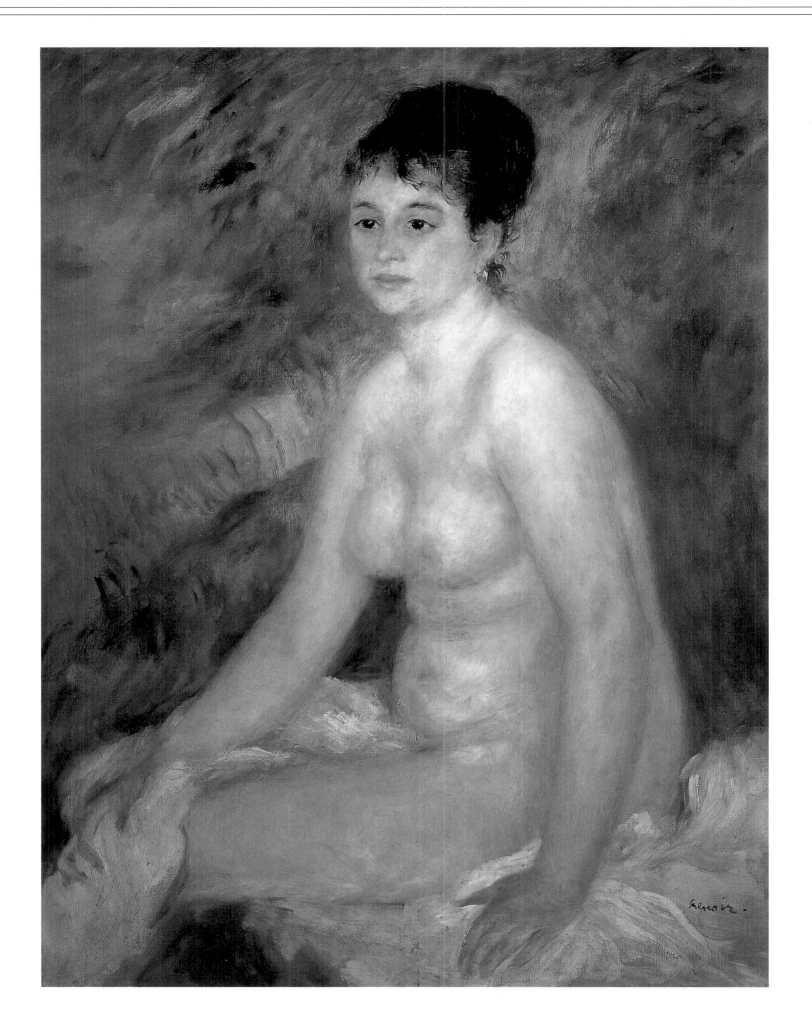

110

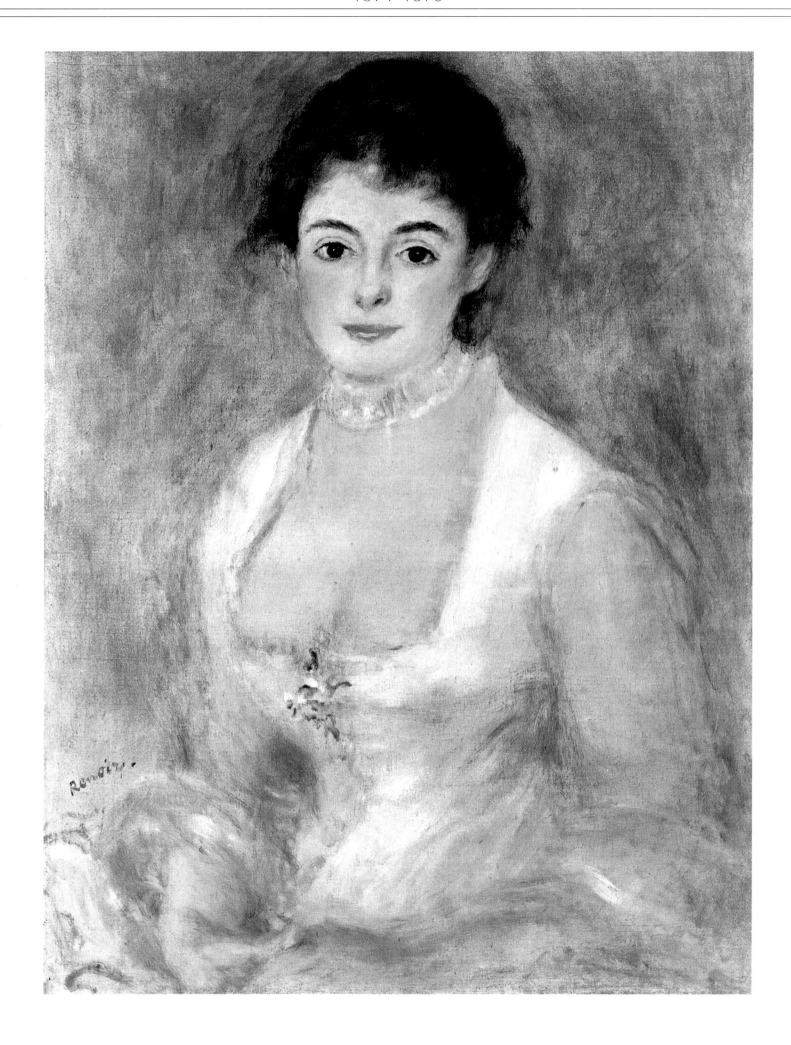

♦ Madame Henriot, 1876. Oil on canvas, 65.9 x 49.8 cm (26 x 19 5/8 in). National Gallery of Art, Washington D.C. The mobile and expressive features of the actress, whom *Renoir had already portrayed in* The Parisian Lady, *emerge with liveliness from the wavy sfumato of the background. The color nuances are highly refined,* *with the emphasis on the cold sky-blues and whites which enhance the delicate pink flesh and the brown hair and eyes. This work is a subtle homage to the sensual* *luminosity of Boucher's and Fragonard's female portraits, such as the latter's* Singer Holding a Music Score, *now kept in the Louvre (ca. 1770).*

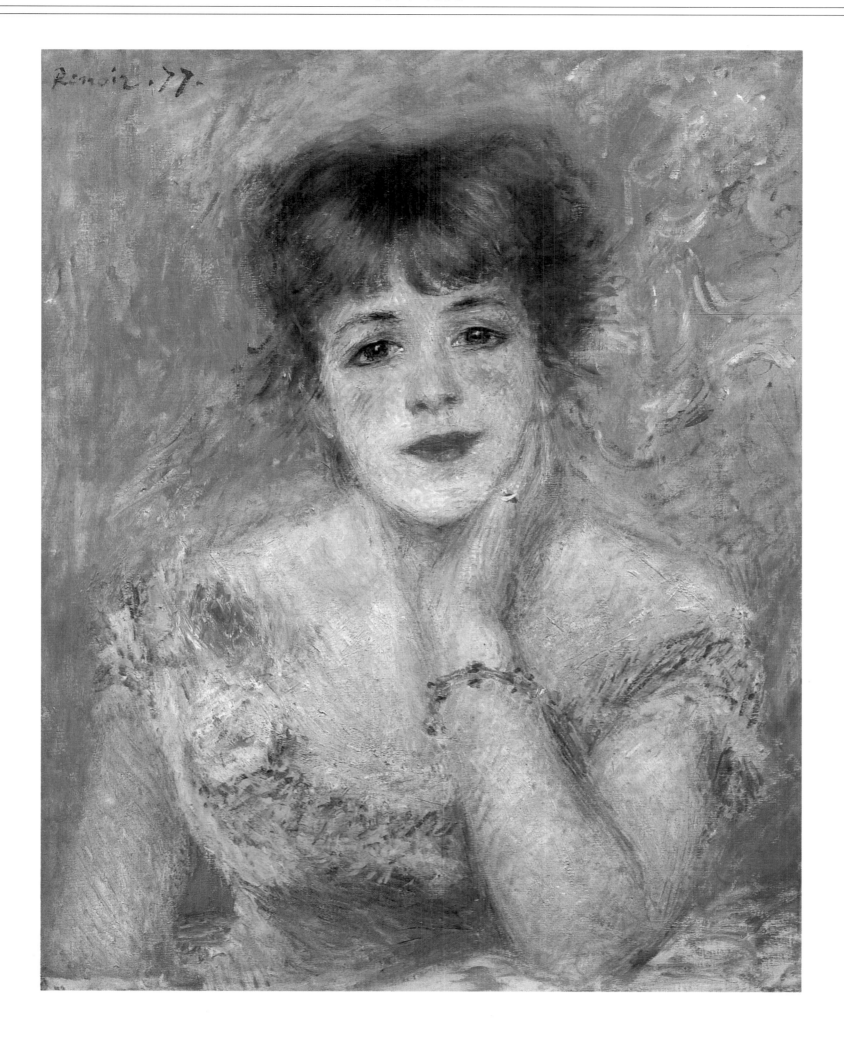

♦ Portrait of the
Actress Jeanne
Samary, 1877. Oil on
canvas, 56 x 46 cm
(21 1/4 x 18 1/4 in).
Pushkin Museum,
Moscow. This
portrait of Renoir's
friend is based on
warm tonalities—the
sprightly orange,
pink and red
hues. Here again the
rather cold tones
of Samary's
dress set off her
splendidly bright
shoulders.

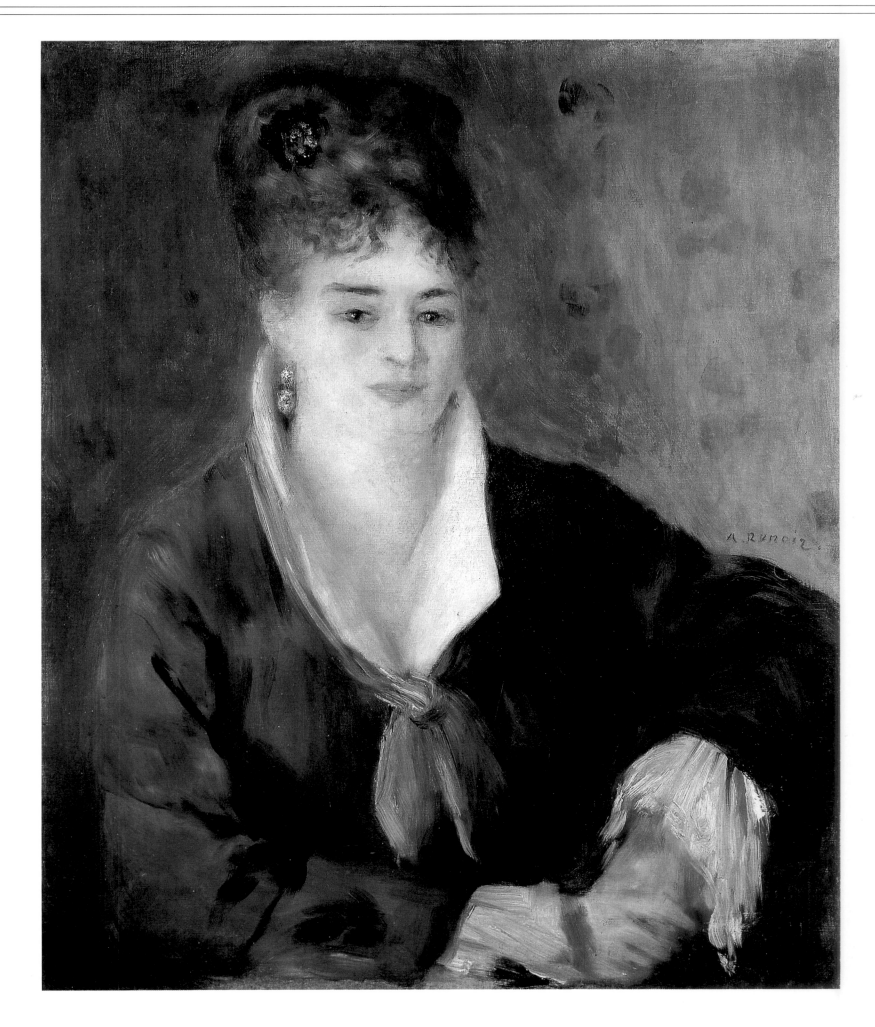

♦ *Above*, Lady in Black, *ca. 1876. Oil on canvas, 63 x 53 cm (24 3/4 x 20 3/4 in). Hermitage, St. Petersburg. Yet another exquisite color contrast between the vibrant white of* the woman's *jabot and lace cuffs and the black dress. The brushwork becomes broad and accentuates, in a classical, monumental sense, the plastic values of the figure.*

♦ *Opposite*, Portrait of the Countess de Pourtalés, *1877. Oil on canvas, 95 x 72 cm (37 1/2 x 28 1/4 in). Museu de Arte, Sao Paulo. With the sensual delight of a decorator, Renoir dwells on the* arabesque *of the motifs of the dress, as he would have done with the floral patterns in porcelain. This attention to ornamental detail again reveals his indebtedness to Ingres' portraits.*

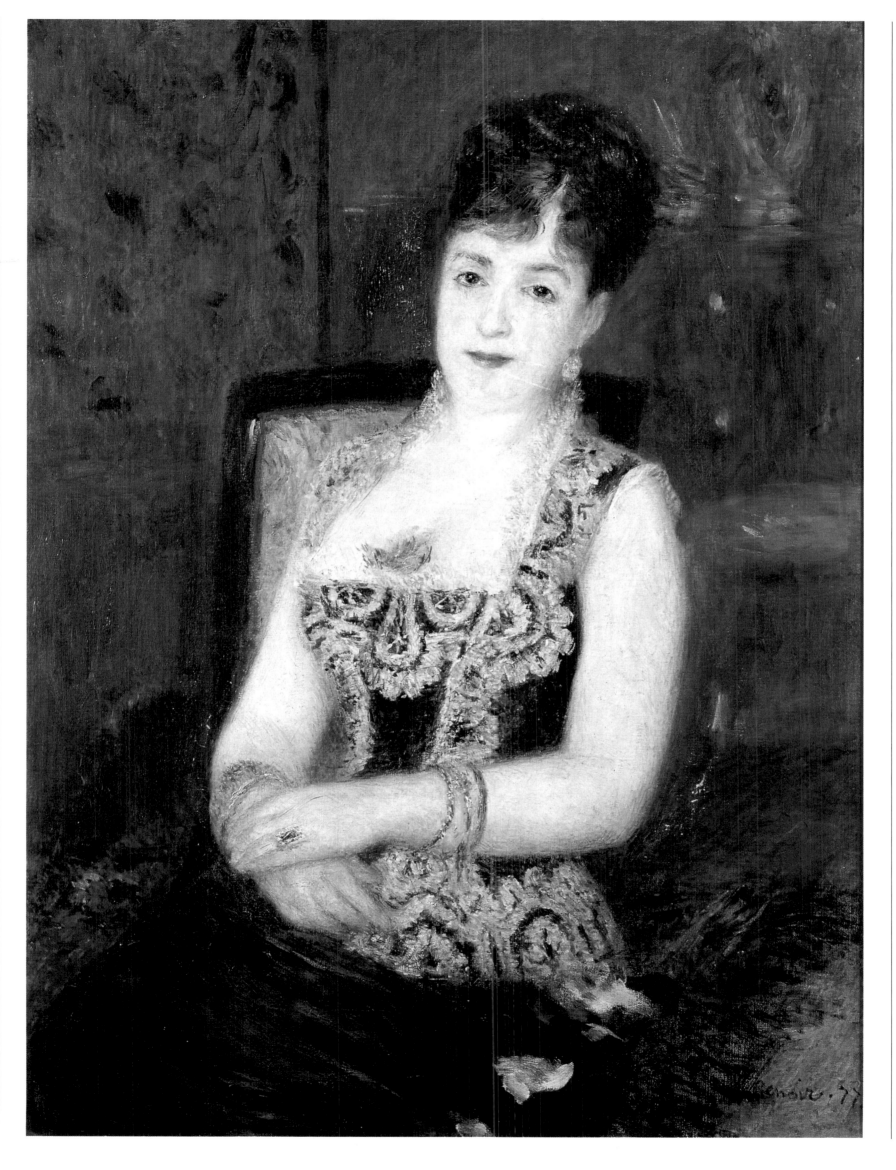

114

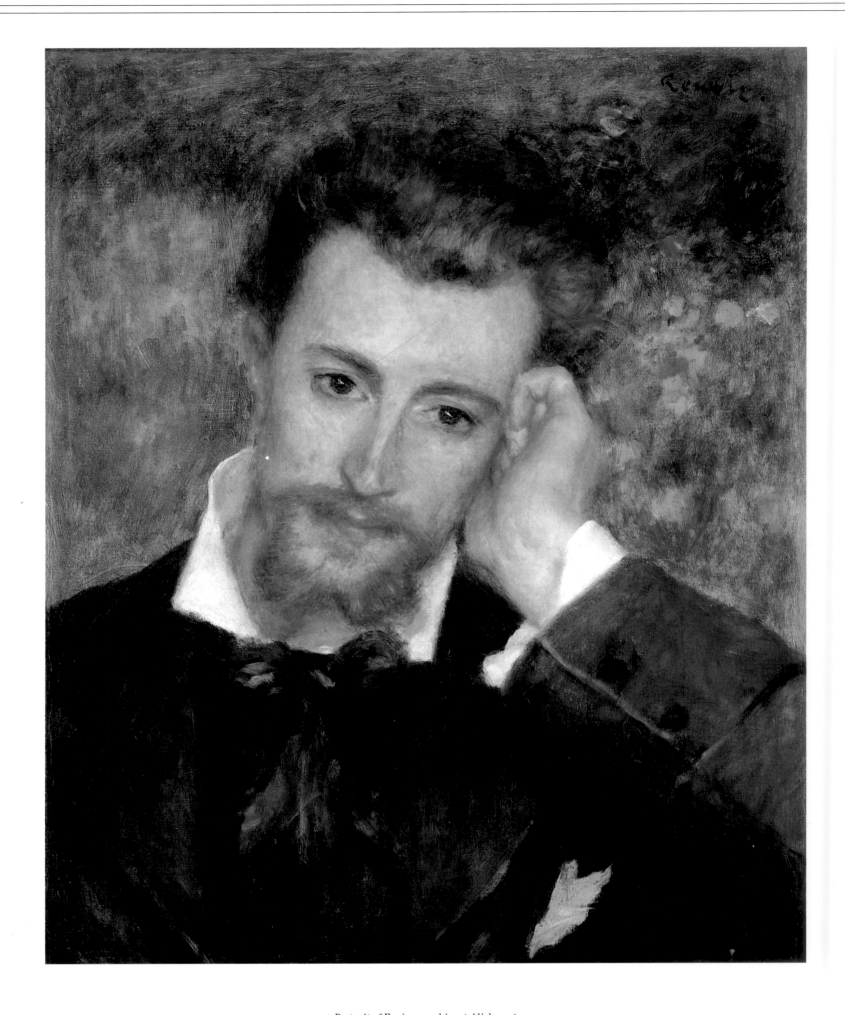

♦ *Portrait of Eugène*
Murer, 1877. Oil
on canvas, 46 x 38 cm
(18 1/4 x 15 in).
Mr. and Mrs. *Walter*
H. Annenberg
Collection, Rancho
Mirage. Murer, the
owner of a bakery
and a restaurant,
asked Pissarro and
Renoir to decorate
his establishments.
The latter thus found
himself again
in the role of
decorator, a metier he
had undertaken
enthusiastically
during his youth.
From 1877 on,
Murer began to collect
and commission
works of art.

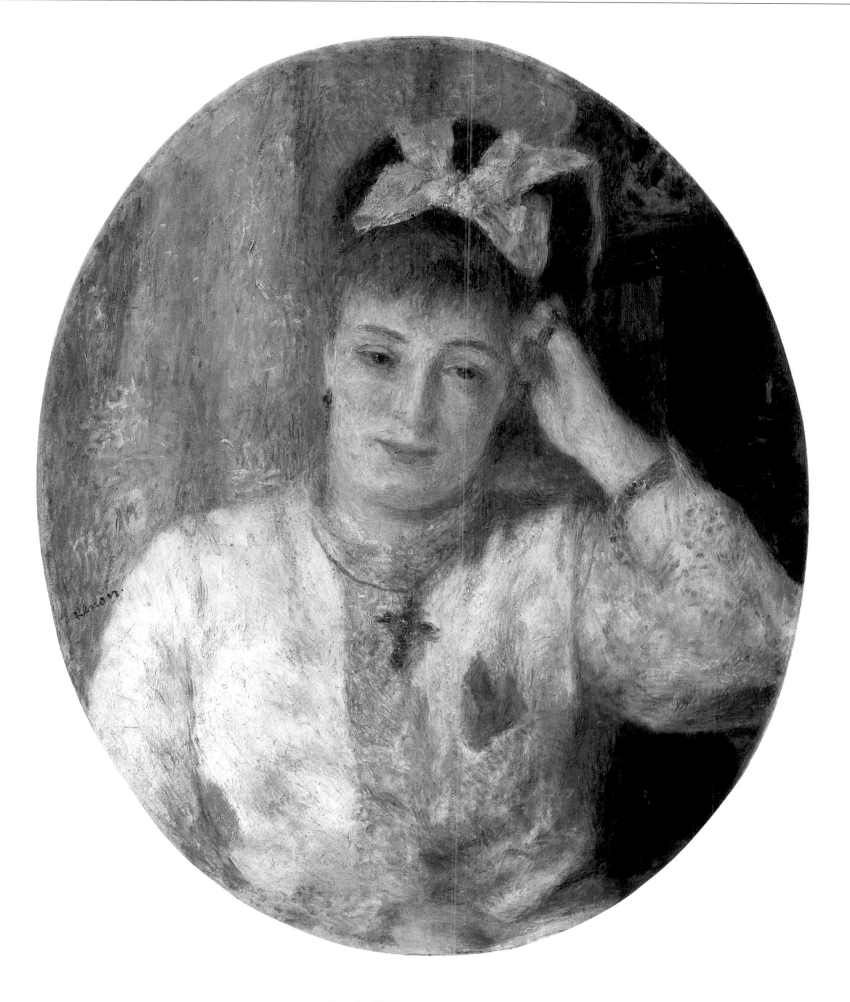

♦ Portrait of Marie
Murer, 1877 Oil on
canvas, 67 x 57 cm
(24 1/2 x 22 1/2 in).
National Gallery of
Art, Washington D.C.
Eugène Murer was
very close to his
sister Marie and in
1877 asked Renoir
and Pissarro each to
do a portrait of her
for 100 francs. Here
the young woman is
in a frontal view
absorbed in her
thoughts, her head
leaning on her elbow
in the same intimate
pose as her brother.
The oval shape of the
canvas highlights the
geometric purity of
the composition.

116

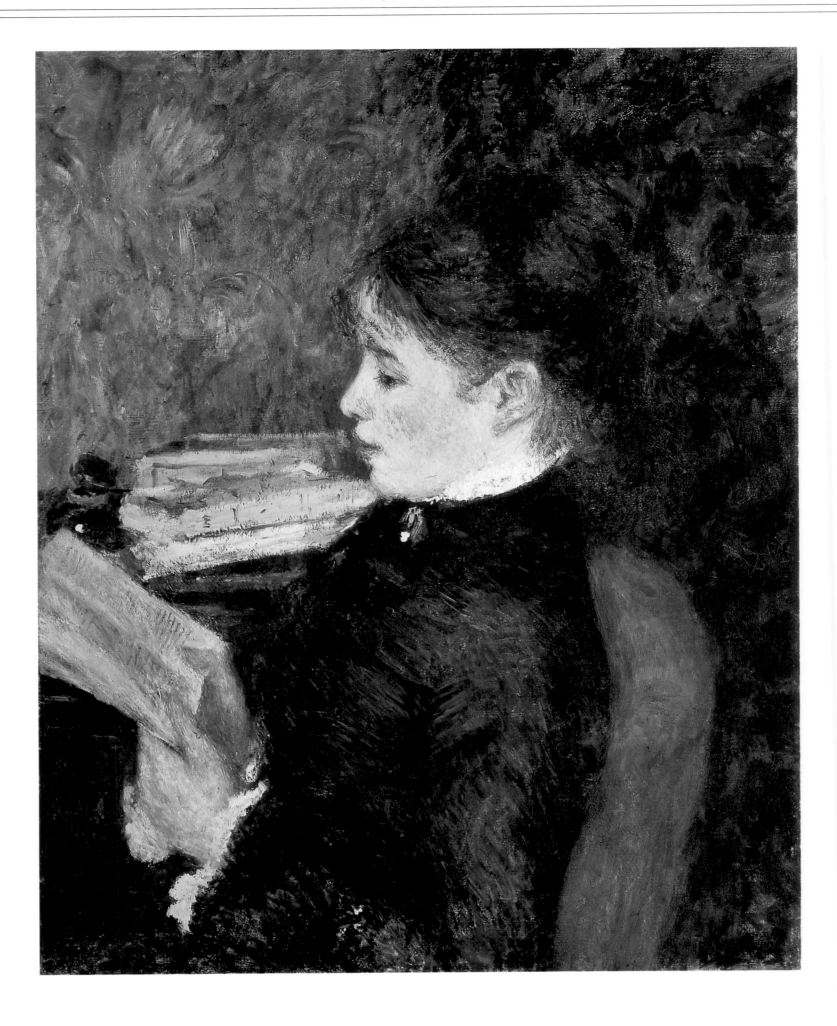

♦ Above, Woman Reading, 1877. Oil on canvas, 63 x 53 cm (24 3/4 x 20 3/4 in). Private Collection. The model Margot Legrand is depicted slightly from above, thus allowing Renoir to afford a view of the room which, according to Duranty's theories of "modern" portraiture, is a necessary part of the bourgeois setting of this true "genre" interior.

♦ Opposite, After the Concert, 1876-77. Oil on canvas, 187.3 x 117.5 cm (73 3/4 x 46 1/4 in). The Barnes Foundation, Merion, Pa. The monumental size of this canvas and its avowedly narrative aim of depicting a typical event of the vie modern (as was the case with Dancing at the Moulin de la Galette), makes it one of Renoir's best paintings of "contemporary history." According to Rivière, who posed for the male figure in the foreground, the artist began working on the canvas in October 1876 in front of the entrance to Renoir's studio in the rue Cortot, in Montmartre. He reveals a striking capacity to create a setting (which is musical, as can be seen by the score) through the mere connotation of the persons.

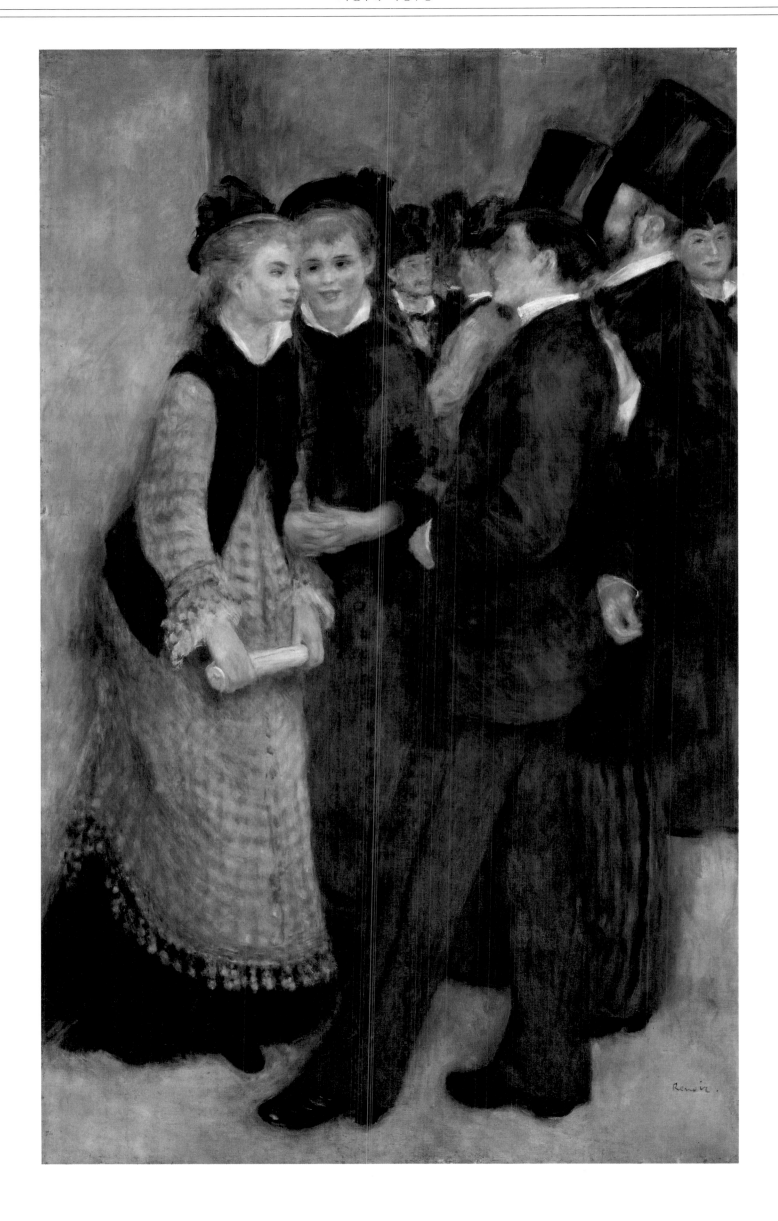

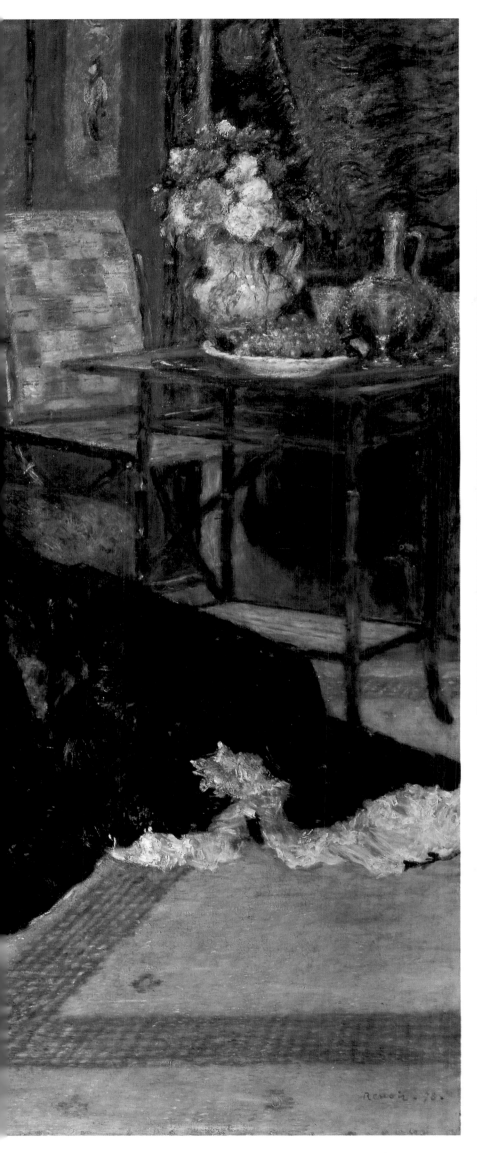

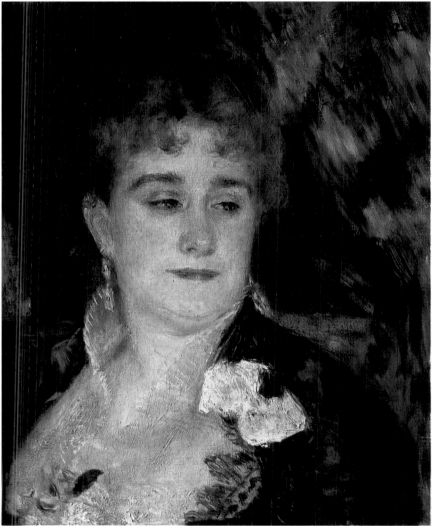

♦ *Left,* Madame
Charpentier with Her
Children, *1878. Oil
on canvas, 153.6 x
190 cm (64 1/2 x 74
1/8 in). Metropolitan
Museum of Art,
New York.*

Above, Portrait of
Madame Georges
Charpentier, *ca. 1876-
77. Oil on canvas, 46
x 38 cm (18 x 15 in).
Musée d'Orsay, Paris.
"Madame Charpentier
reminds me of my
childhood loves,
Fragonard's models.
The girls had
charming dimples.
I was warmly
congratulated and
forgot the attacks in
the newspapers."
Renoir's mention of*
*the "girls" is curious,
since Madame
Charpentier's
children were
Georgette, an eight
year-old girl, and her
son Paul, aged three.
As for the critics,
they were more or
less unanimous in
praising the color
effects but also in
reproaching Renoir
for his lack of
design: "Let's not
squabble with M.
Renoir; after all, he
has returned to the
bosom of the Church;
let us merely
welcome him, forget
the form, and not
speak about
anything except
coloring," the critic
Baignières said.*

120

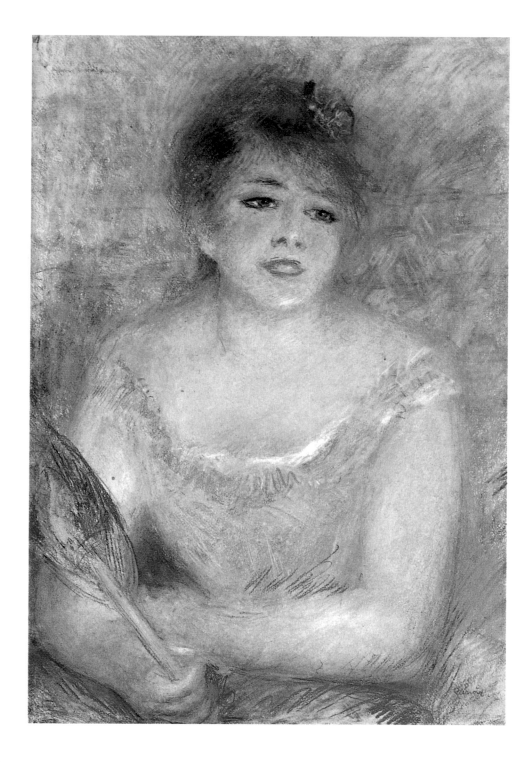

♦ *Above,* Jeanne Samary, *1877-78. Pastel on paper, 69.7 x 47.4 cm (27 1/2 x 18 3/4 in). Art Museum, Cincinnati. The ebullient figure dominating the foreground and the feathery handling of the palette remind one of another portrait of Samary executed in 1877.*

♦ *Opposite,* Portrait of the Actress Jeanne Samary, *1878. Oil on canvas, 173 x 103 cm (68 x 40 1/2 in). Hermitage, St. Petersburg. This large-format work was shown at the 1879 Salon together with* Madame Charpentier and Her Children, *but was hung in a poor*

location high above other canvases; this is probably why it went almost unnoticed by the public. Once again, this is an official portrait; the actress is represented standing, in the setting that witnessed her success—the plush

foyer of a theater. The folds of the dress are bathed in light and color, rendered with virtuosity by Renoir. The critic Castagnary, in his review of the Salon, rightly heaped praise on the artist's "agile and intellectual brushwork."

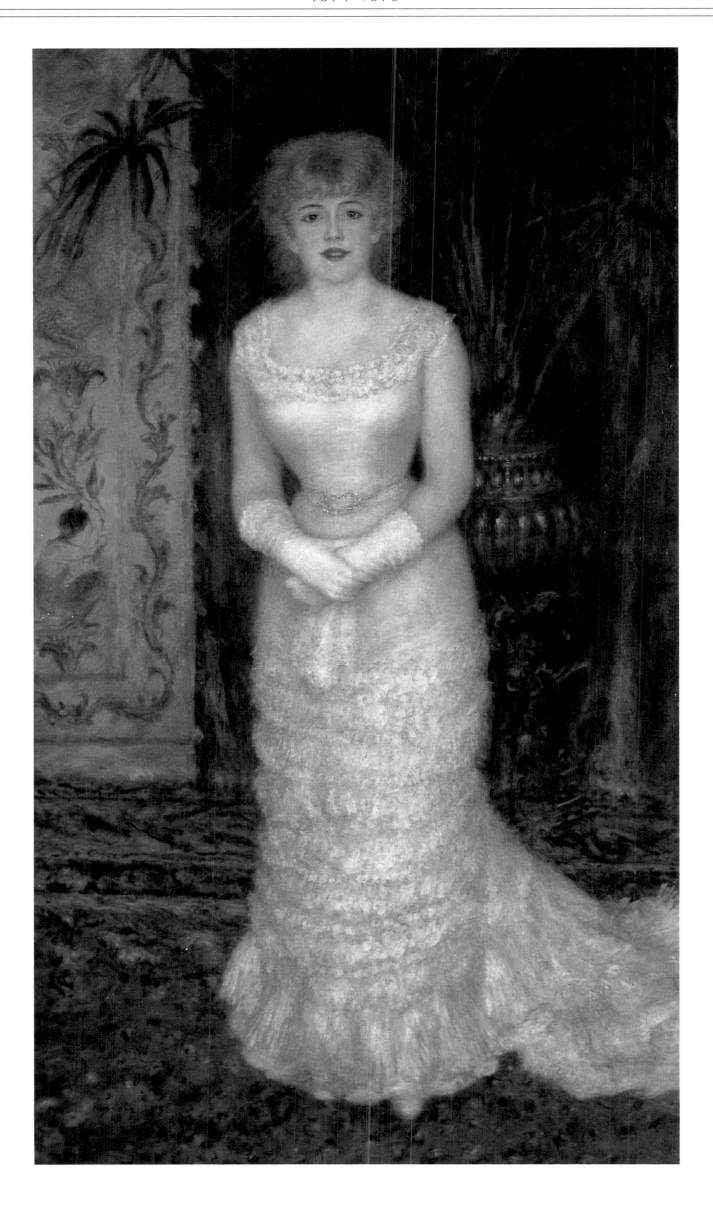

122

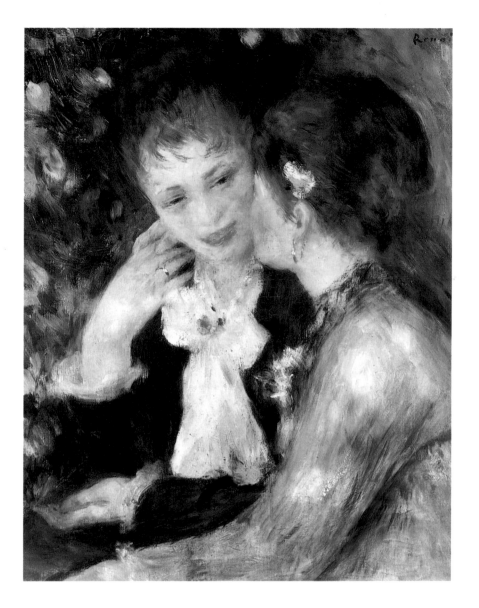

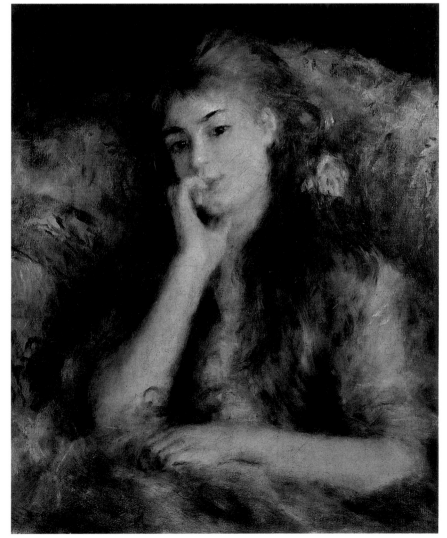

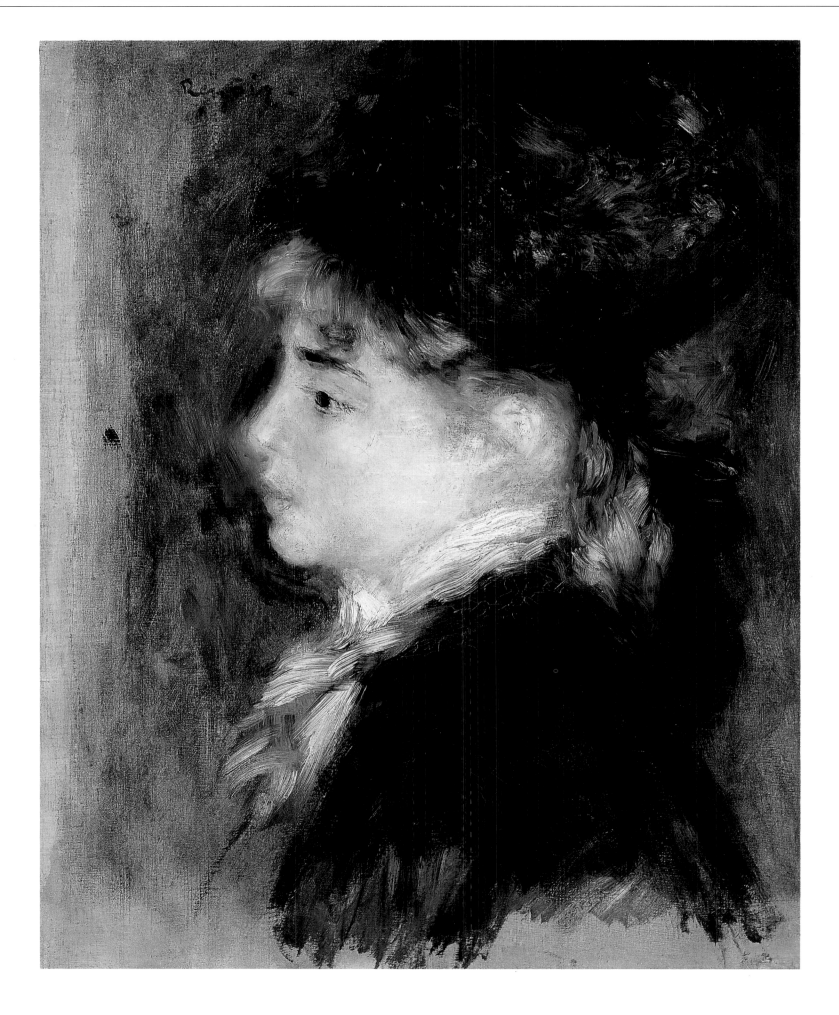

♦ *Opposite above,*
Confidences, *1878.*
Oil on canvas, 61 x
50 cm (24 x 19 3/4
in). Oskar Reinhart
Collection,
Winterthur.

♦ *Opposite below,*
Young Woman Seated
("La Pensée"), *ca.*

1876-78. Oil on
canvas, 66 x 55 cm
(26 x 21 5/8 in).
Formerly the J.
Cotton Collection,
donated to the
British Government.
The subtly malicious
pose, with the
young biting her
finger, did not

prevent this
delightful canvas
from having a
sentimental title
tacked onto it
*(*Thought*, by its first*
owner, Count Doria.

♦ *Above,* Margot,
1878. Oil on canvas,
46 x 33 cm (x in).

Musée d'Orsay,
Paris. The woman's
delicate profile,
which seems to
emerge by accident
from the vague
background,
embodies the
changing nature of
Parisian life.

124

♦Above, Edgar Degas, Mlle La at Cirque Fernando, 1879. Oil on canvas, 116.8 x 77.5 cm (46 x 30 1/2 in). National Gallery, London.

♦ Opposite, Two Little Circus Girls, 1879. Oil on canvas, 131 x 98 cm (51 1/2 x 38 1/2 in). Art Institute, Chicago. Degas and Renoir chose the Fernando Circus (established permanently in Paris since 1875) in order to experiment with the same subject but with very different compositional solutions. Degas concentrates on the bold angle of vision of the acrobat hanging in mid-air, while Renoir is interested in the overall color effect and set his little figures (Francesca and Angelica, Fernando's daughters) in a yellow semicircle on the ground. Other studies by Degas show that here he partly abandoned his drastic, "photographic frame" in which the public seems to leap out of the edges of the picture frame.

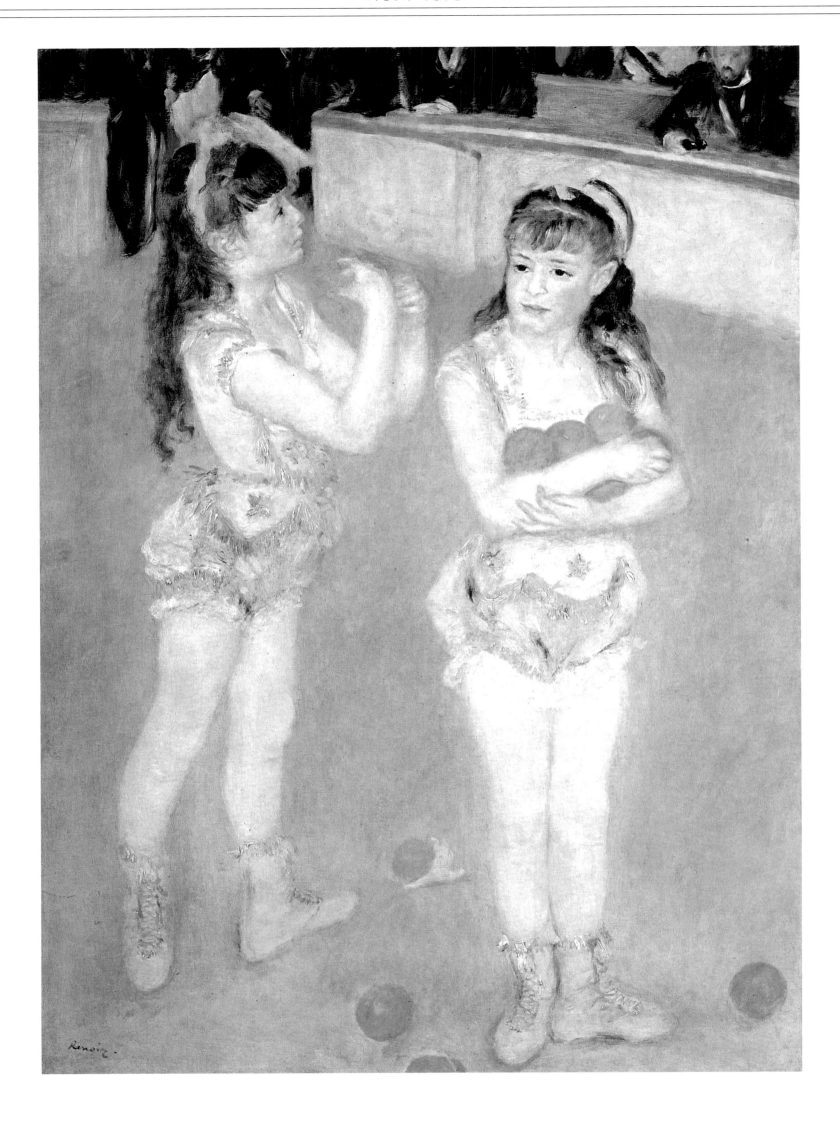

♦ *Above*, Portrait of Marguerite Bérard, *1879. Oil on canvas, 41 x 32. 3 cm (16 x 12 3/4 in). Metropolitan Museum of Art, New York.* Renoir's portraits of children were praised for their delicate charm; but this seems to be contradicted by the rather crude character of this image which, with the pathetic tones of the oversized eyes and the emaciated features, seems to herald the more clearly defined volumes of the artist's dry manner.

♦ *Opposite*, Marthe Bérard, *1879. Oil on canvas, 128 x 75 cm (50 3/8x 29 1/2 in). Museu de Arte, Sao Paulo.* Paul Bérard's eldest child is portrayed standing, in an elegant black dress with a bow, sash and white lace. Yet the lack of a definite setting isolates the figure in a more concentrated, austere space.

128

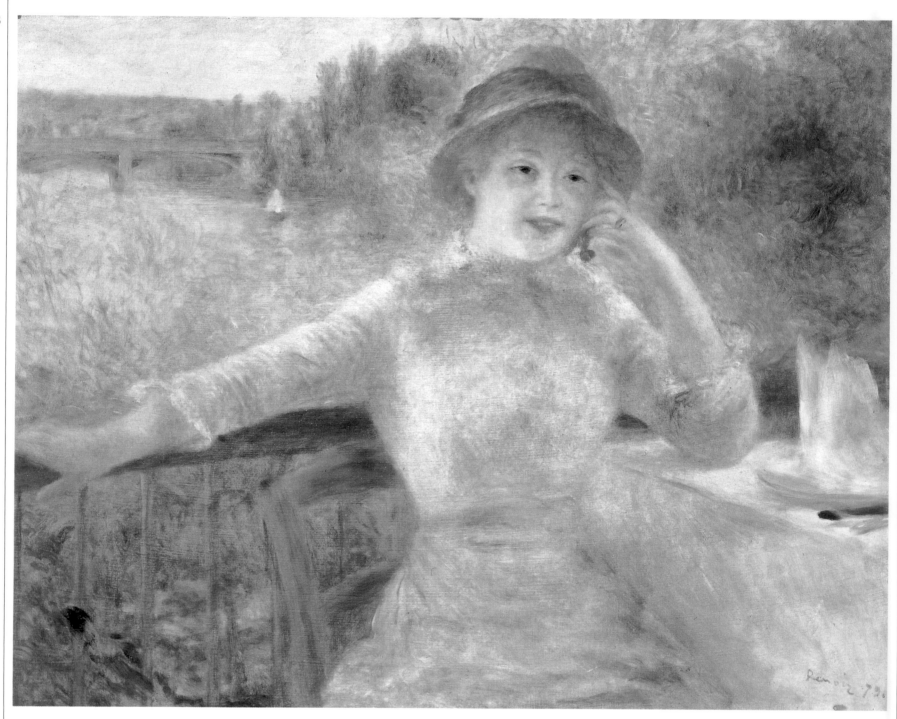

♦ Woman Seated Outdoors (At La Grenouillère), 1879. Oil on canvas, 72 x 92 cm (28 1/4 x 36 1/4 in). Musée d'Orsay, Paris. The light, feathery touches are reminiscent of the most exquisite atmospheric Impressionist aesthetic; but the detailed handling now tends to become thicker around the volumes. The model is perhaps Alphonsine Fournaise, depicted on the terrace of her father's restaurant. In the background one gets a glimpse of the railroad bridge of Chatou so often immortalized by Renoir.

129

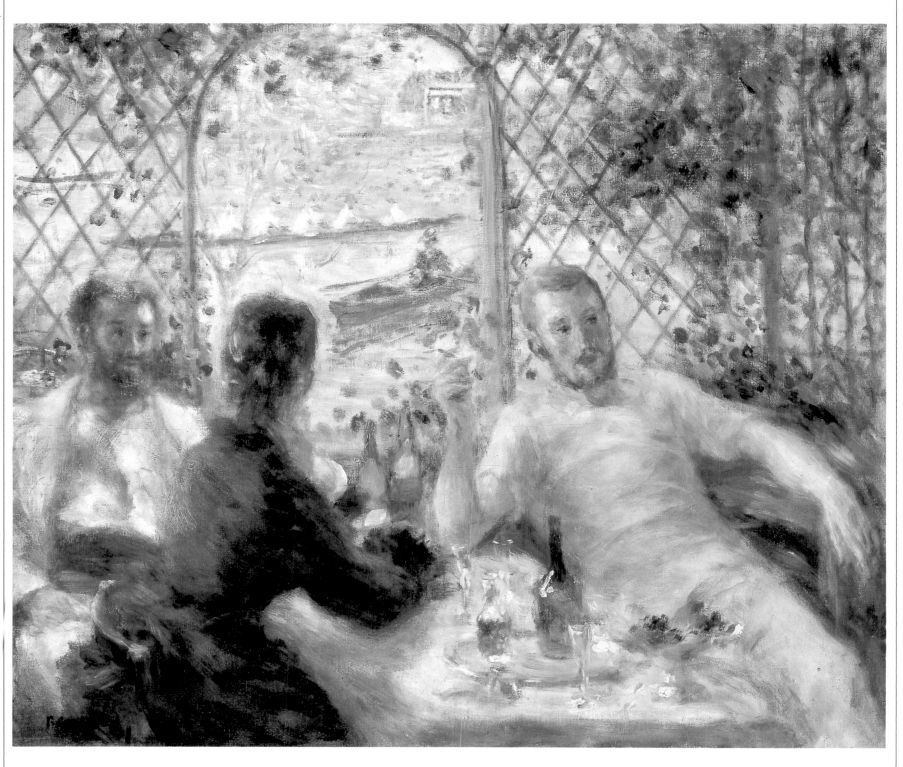

♦ Luncheon by the River, ca. 1879. Oil on canvas, 55 x 66 cm (21 3/4 x 26 in). Art Institute, Chicago. Probably painted at Chatou, this work has a fluid, summary, extremely rapid brushstroke, with an atmospheric quality that is underscored by the "predominant" light blue, as if water and air were merged. The scattered warm tonalities, such as in the boat on the river or the flashes of color from the roses, impart an overall equilibrium and a sense of harmony. What distinguishes this canvas from the high Impressionist period is Renoir's careful compositional structure, the space clearly divided by the trellis and the laid table. This was perhaps a study for the more famous Luncheon of the Boating Party executed in 1880-81.

130

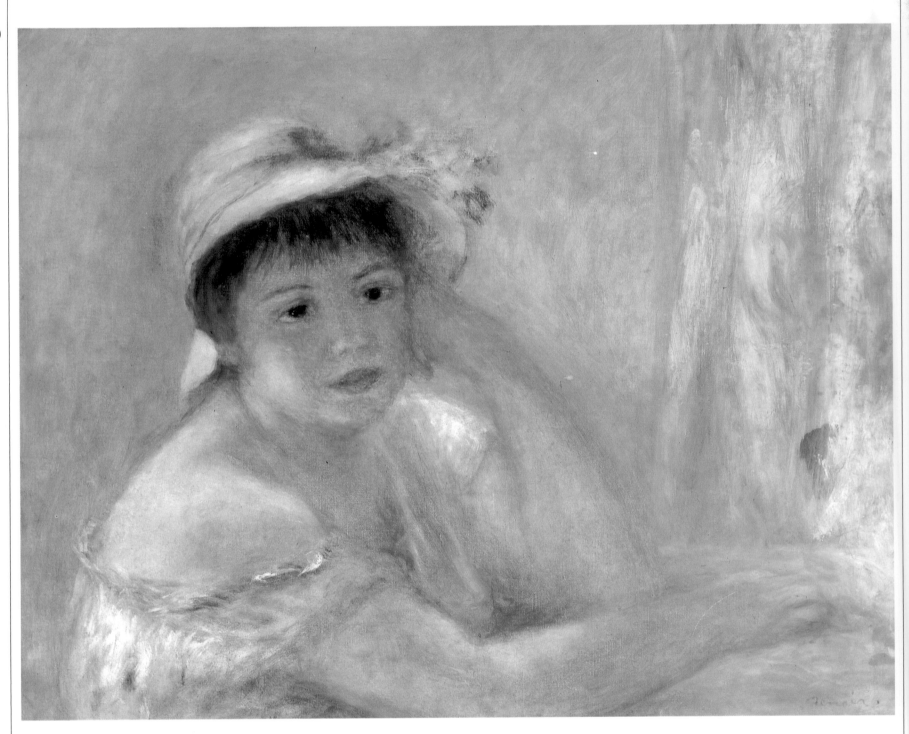

♦ *Above*, Woman
Dressed in Blue, *ca.
1879. Oil on canvas,
50 x 61 cm (19 3/4 x
24 in). Georges
Bigar Collection,
Lausanne. This
canvas confirms
Renoir's interest in
the figure, which
dominates the
landscape.*

♦ *Opposite*, After the
Meal, *1879. Oil on
canvas, 99.5 x 82 cm
(39 1/8 x 32 in).
Städelsches
Kunstinstitut,
Frankfurt. Rivière
recalls that this
canvas was executed
in a Montmartre
restaurant that
Renoir had decorated
with landscapes and
pastoral scenes.*

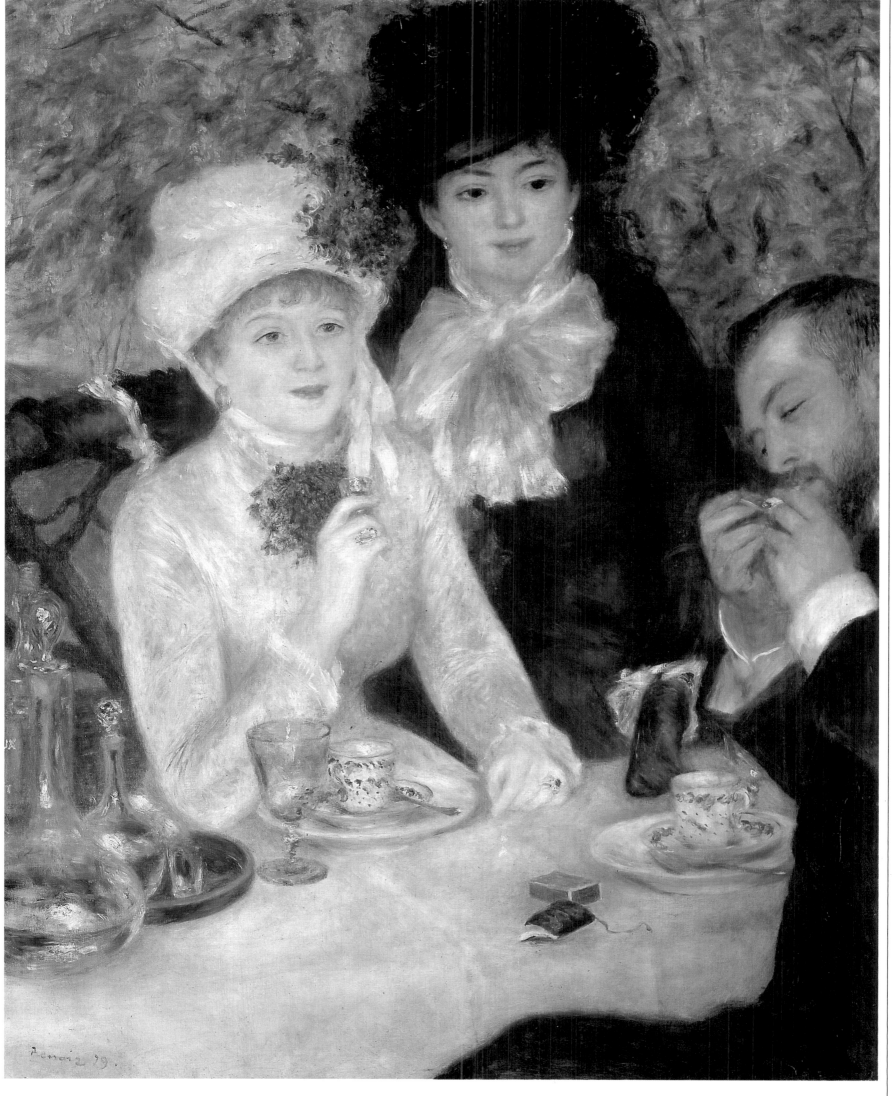

132

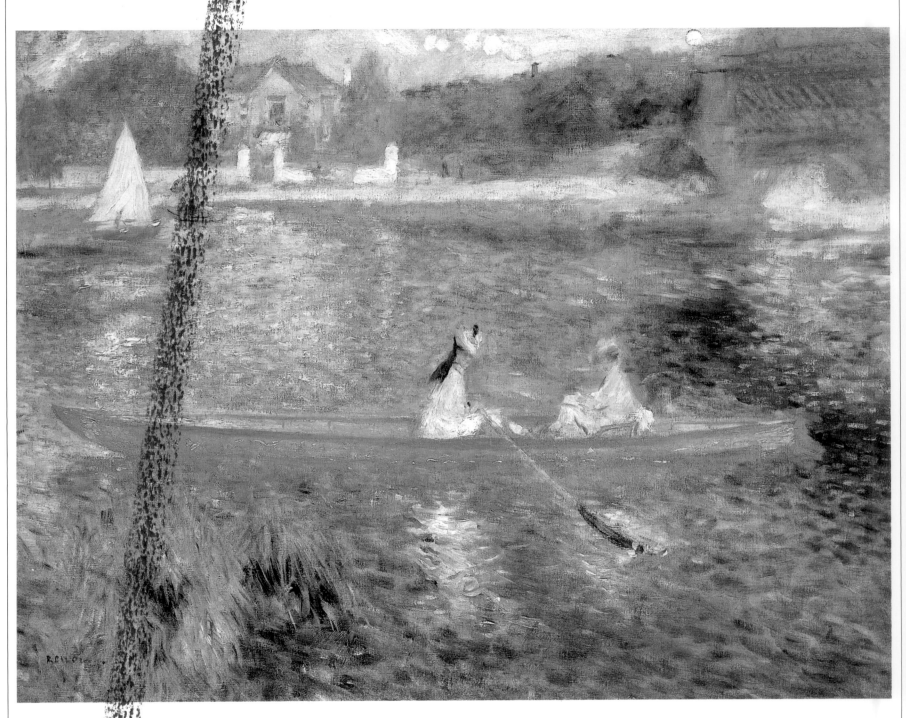

♦ The Seine at Asnières, ca. 1879. Oil on canvas, 71 x 92 cm (28 x 36 1/4 in). National Gallery, London. The detail of the boat skimming over the waves seems to almost to have been taken from Luncheon by the River. The dynamic effect is rendered by the vibrant touches of paint which, through the mere direction of the brushstrokes, creates perspective depth, which would otherwise have been delimited by the horizontals of the coast and long hull. However, the optical axis is solidly fixed on the line of the boat, which establishes a compositional balance quite removed from the Impressionist aesthetic.

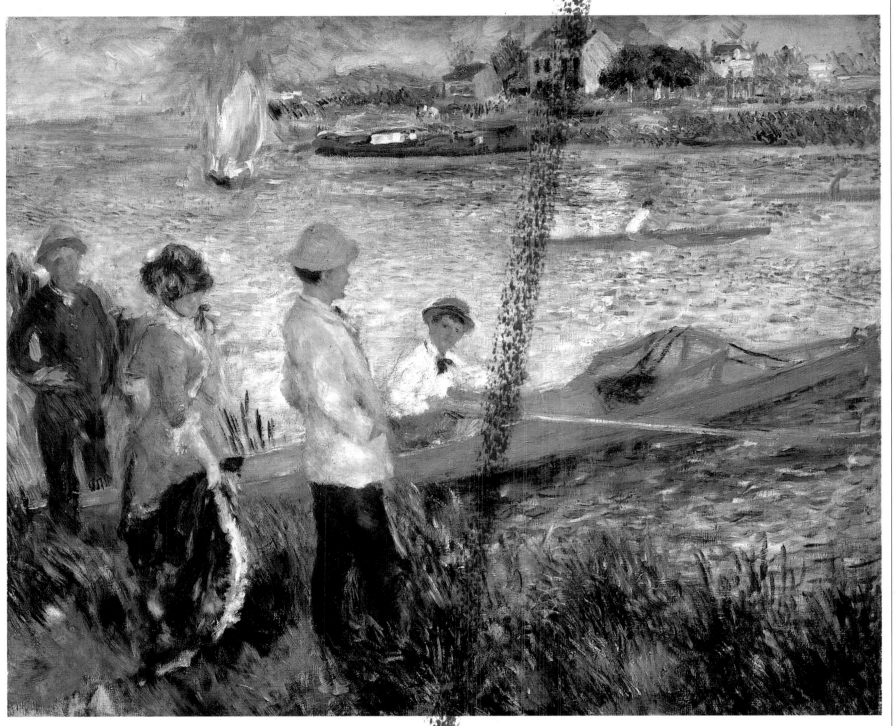

♦ Oarsmen at Chatou, *1879. Oil on canvas, 81.3 x 100.3 cm (32 x 39 1/2 ins). National Gallery of Art, Washington, D.C. The models for this scene along the Seine are Aline Charigot, Renoir's future wife, and fellow artist Gustave Caillebotte, who was a rowing buff. The palette is once again based on the contrast* between warm and cold tonalities which is embodied in Aline's red jacket and blue skirt. The male figure in the boat seems to be waving at someone or extending an invitation—perhaps a subtle reference to Watteau's "galante" style, a thinly veiled Embarkation for Cythera.

134

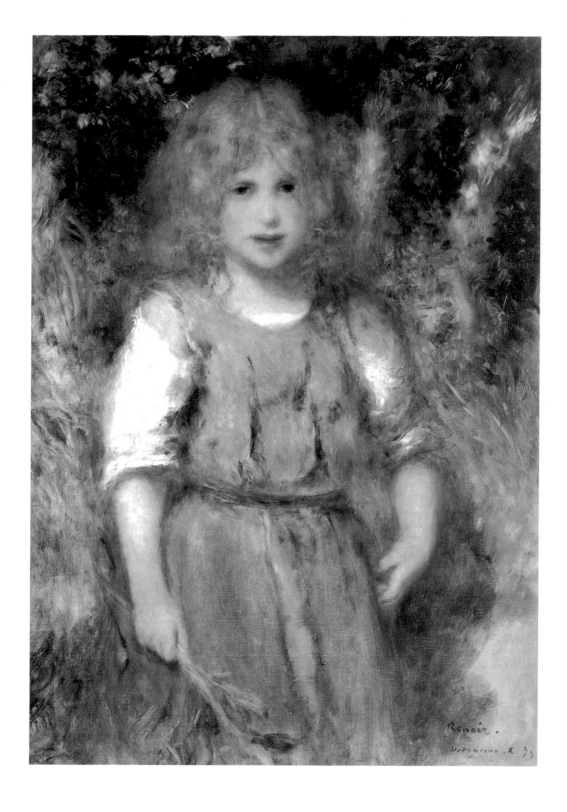

♦ Gypsy Girl, 1879. Oil on canvas, 73 x 54 (28 3/4 x 21 1/4 in). Private Collection. Almost transparent against the backdrop of the woods from which it seems to barely emerge, like a dubious apparition, this figure actually marks a decisive turning point in Renoir's art, from the refulgent plein-air Impressionist style to a more intimate and subdued tonalism veined with feeling. The brushwork is fluid but, significantly, the girls' face and gaze, the object of the viewers' attention, are rendered with precision and clarity.
The palette again revolves around a delicate harmony of violet, green, and golden hues that bring to mind the refined color handling of eighteenth-century painting: an "autumnal" color range that almost transforms this sweet portrait into an allegorical statement with a touch of melancholy.

135

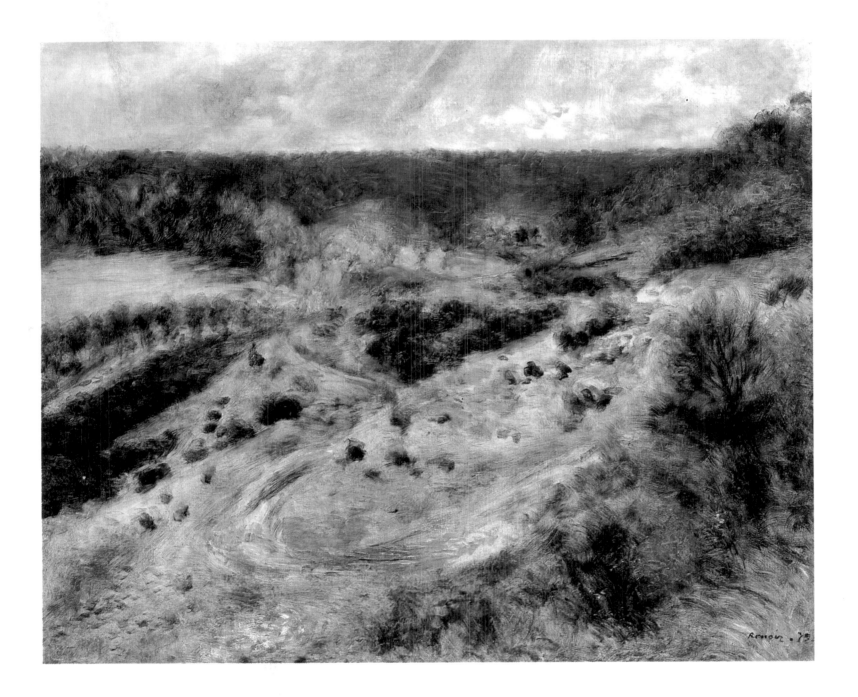

♦ Landscape at Wargemont, *1879. Oil on canvas, 80 x 100 cm (31 1/2 x 39 1/4 in). Museum of Art, Toledo, Ohio. Like Gypsy Girl, this canvas was painted when Renoir was a guest of the Bérards at Wargemont, near the coast of Normandy. And the artist transmits all the "northern" austerity of this region through the low-keyed palette, which is permeated with dark greens and purples. The high horizon overturns the usual Impressionist relationship between the sky and earth. The texture is thin, yet the masses are clearly rendered in a new approach to volume and pictorial "weight."*

136

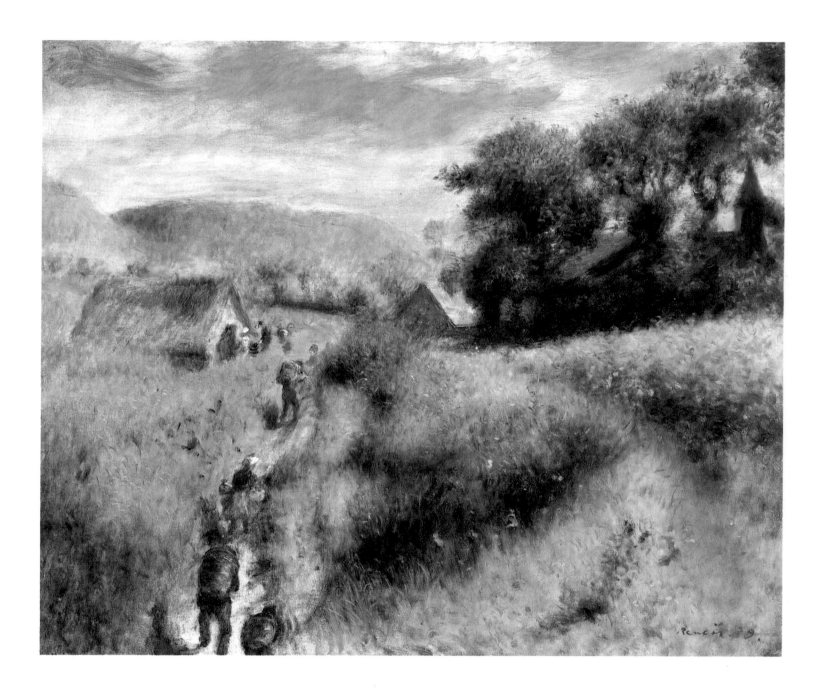

♦ The Vintagers, 1879. Oil on canvas, 54.2 x 65.4 cm (21 1/4 x 25 3/4 in). National Gallery of Art, Washington D.C. In this landscape, as in the one on page 135, the earth has replaced the sky as the repository of color reverberations woven by a brushstroke that becomes thicker where the image is more "plastic": the areas of shadow, the roofs, the figures. This work is somewhat similar to Path through the Long Grass, but the handling is more regular and the light is subdued.

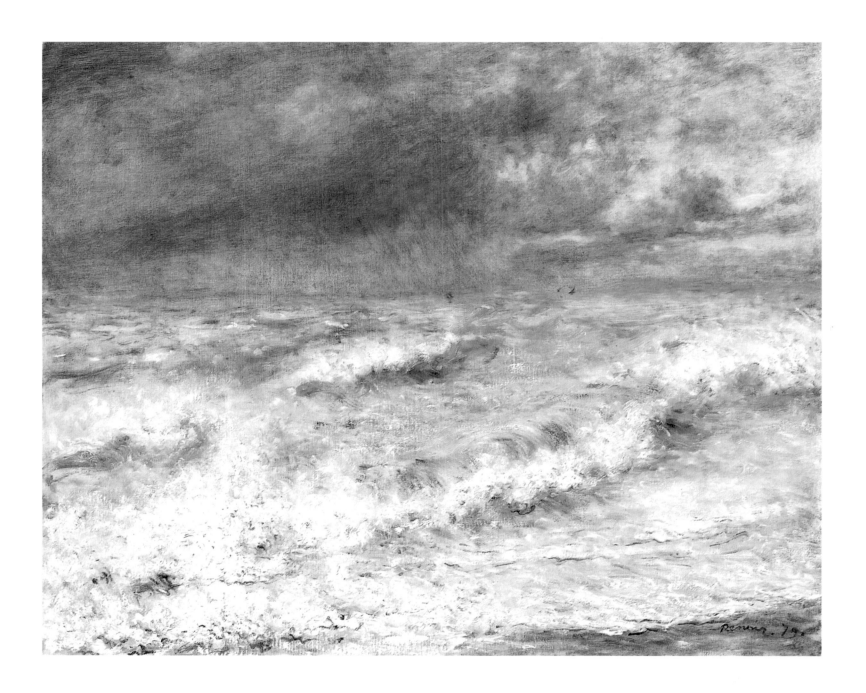

♦ The Wave, 1879.
Oil on canvas, 64.8 x
99.2 cm (25 1/2 x 39
in). Art Institute,
Chicago. This view,
which revolves
around the
impressive, majestic
movement of the
wave rolling back
onto itself, is
reminiscent of
Courbet's seascapes:
romantic in the
interpretation of the
storm, with a solid
texture that grows
thicker around the
crest or the deep blue
of the sea. However,
one also notes the
influence of
Japanese prints,
such as Hokusai's
Wave at Kanagawa.

Plastic Linearity

"Renoir has been exquisitely attentive and sensitive in his rendering of the clear, happy eyes of a child [...] Renoir himself never thought he could find a line that was supple and fluid enough, a color that was soft enough, or matter that had the qualities of enamel but was more alive." This comment by Arsène Alexandre (published in 1892) confirms the aptitude of Renoir—who had become a successful artist in the late 1880s—for portraying children. His gifts as a colorist, and above all as a sensitive interpreter of the luxuriance of tactile values—once again echoing French Baroque and rococo—are enhanced in two portraits, *Irène Cahen d'Anvers* and *Pink and Blue: Alice and Elizabeth Cahen d'Anvers*, executed in 1880-81 for the rich Parisian financier. The former is more meditative and sentimental; the young Irène seems to "freeze" her youth in a childlike *reverie*, with exactly the right touch of melancholy called for by the aesthetic ideals of the time. The latter work is at once more spectacular and joyous; the two girls are bathed in the pure rapture of brilliant light that strikes the lace of their dresses, reflecting the golden and reddish tonalities of the dark background. Renoir's masterful skill adapts itself perfectly to the social image needs of his new upper-class patrons; but the splendid light saturation effect that characterizes these works also corresponds to his deep-rooted ideal of a highly "decorative" art which is ennobled by the very pleasure it affords to the eye: "Painting is intended to decorate walls, isn't it? So we must make it as rich as possible."

Such luxuriant material qualities and color were again brilliantly rendered in certain *plein-air* works executed in this same period, such as *The Seine at Chatou* or *On the Terrace*, this latter again presenting a foreground animated by a woman with her child, and a background, clearly separated by the balustrade, which opens out onto the landscape. These signs of Renoir's greater interest in compositional balance are supported by a thicker, more regular brushstroke that seems to be striving for a new texture around the forms. Later on, the contrast between foreground and background in the marvelous *By the Seashore* will acquire more abstract overtones (related to Odilon Redon's style?) in the purely chromatic, rather indistinct, quality of the fluid landscape in the background. The uneasiness caused by Renoir's new, indefinite needs led him to seek motifs far removed from the usual ones that had been immortalized in the heyday of Impressionism. After his first trip to Algiers in 1881, Renoir paid a final homage to the scenes of merriment along the river he had depicted so often by once again creating a choral work in the setting of the La Fournaise restaurant at Chatou (*Luncheon of the Boating Party*). His friends and models are engaged in normal conversation in a scene of natural friendship and intimacy. According to one of the interpretations art critics have made of this famous canvas, one can recognize Renoir's future wife, Aline Charigot, at left, cuddling the dog; the restaurant owner is behind her; seated in front of Aline is Renoir's friend and fellow artist Caillebotte, and next to him Père Fournaise's daughter Alphonsine is chatting with Baron Raoul Barbier. However, what makes this work yet another example of "historical painting of contemporary life" is its large format—the same size as *Dancing at the Moulin de la Galette*—and above all the cryptic reference to Veronese's *Marriage of Cana*, which had been venerated and copied at the Louvre by generations of aspiring artists and which the crippled Renoir asked to see on his last visit to the Louvre, where he was carried in his sedan chair by friends in 1919, shortly before he died. The quotation from the Italian master can be seen in the diagonal of the table, the still life on the tablecloth, and especially in the spirit that transforms the individual gestures into a more complex articulation of parts of a whole, into a "history." Worthy of note again is the clear-cut separation between figures and landscape, which are no longer intimately and mutually merged, as can be seen especially in the emphasis laid on the more sharply drawn volume on the right-hand section of the canvas.

Venice, home of the great "master colorists," was the first leg of the journey Renoir made to Italy in 1881, when he was already a mature artist, thus running counter to the usual custom of visiting this land of art during one's artistic formation. The result was a mutable, atmospheric Venice, interpreted "impressionistically" for the first time in the canvases Renoir sent to Durand-Ruel in France: *St. Mark's, Venice* and *Venice—Fog* anticipate the versions of the "apparent" city par excellence that Monet would offer later on, yet Renoir did not lost sight of the views of Venice that had made Canaletto so famous. But even more than the color used by the Venetian masters, or the dramatic, powerful titanism of Michelangelo (which would soon be taken up by Rodin), it was line and design that Renoir seemed to be seeking in Italy: the orderly, classical formalism typical of Raphael, whom Renoir had rejected during his apprenticeship at the École des Beaux-Arts, where the Italian master was a mythical figure. This can be seen in a letter the artist wrote to Madame Charpentier from Italy: "I was seized by the feverish desire to see the Raphaels [...] A man who has seen the Raphaels! What an extraordinary painter!" However, he has the following to say about his impressions of Venice: "Would you like me to tell you what I saw in Venice? Well, here goes. Take a boat and go the Quai des Orfèvres, or opposite the Tuileries, and you will see Venice. For the museums, go to the Louvre. For Veronese, go to the Louvre..."

Yet there was a touch of Veronese, Raphael, and especially of Ingres, as well as traces of the everyday classicism of Pompeii, in the most famous canvas Renoir executed while in Italy—*Blond Bather* (1881), a return to "mythology" that was, however, understood as an eternal element, a timeless, candid figure. A slightly idealized Aline (with a false wedding ring on her finger to satisfy the traditionalists—the two got married only in 1890) presents her nudity with the absolute, and quiescently carnal, serenity of an Olympian goddess, while the landscape of Capri illuminates with yellow and violet reflections her white body, which has been only "grazed" by the brush.

Before and after his trip to Italy, Renoir had gone to Algiers, which he saw through Delacroix's eyes; we need only observe the impasto in *Algerian Landscape* (Ravin de la Femme Sauvage), Banana Plantation and *Muslim Festival* in Algiers to note the mixtures, the ochre hues, the dynamic contours and the thickly woven colors that the master had used to replace depth and perspective. On his way back from Italy, Renoir stopped briefly in the Midi, at L'Estaque, which would later be made famous by Picasso's and Braque's first Cubist studies and that had first been the site of Cézanne's prophetic works. Under the influence of his friend, Renoir painted a sun-filled view of *Rocky Crags* at L'Estaque in which the light, in the brightness of a blue sky without atmospheric effects and reflections, clarifies and defines

the masses and outlines instead of confusing and merging them. Eight years later, in 1889, Renoir tackled Cézanne's almost obsessive motif, the ever-recurring *petite sensation* of *Mont Sainte-Victoire*; although he understood his friend's innovation in spatial composition achieved through brushwork that suggests planes and depth, he interpreted this subject in his own way, with a feathery brushstroke that softens the plastic articulation of the volumes.

His return from the Midi marked the beginning of a stylistic "crisis". He felt unable to work with the magical and enchanting self-assurance of preceding years. "I had wrung Impressionism dry and I finally came to the conclusion that I knew neither how to paint nor how to draw. In a word, I was in a blind alley as far as I was concerned [...] I realized that it was too complicated an affair, a kind of painting that made you constantly compromise with yourself [...] If the painter works directly from nature, he ultimately looks for nothing but momentary effects; he does not try to compose, and he soon becomes monotonous..."

After his experience with the "historic" canvases *Dancing at the Moulin de la Galette* and *Luncheon of the Boating Party*, the Impressionist atmosphere, which had already been questioned by his adoption of well thought-out composition, now began to give way to a new stability achieved through more solid, simpler forms. This is the case with the *dance* "triptych" painted in 1882-83—Dance in the Country (Dance at Chatou), City Dance and Dance at Bougival—which takes up the *Moulin de la Galette* theme articulated in three separate canvases in which the protagonists are so strongly modeled that the British critic Roger Fry spoke of a bas-relief effect. The sense of

musical tempo is intelligently suggested in these works by the ideal circle formed by the three couples' faces, which are in different positions. The deliberate attention Renoir pays to the scenery, accessories, clothes and hair styles, also plays an important role. This was the period of Naturalist literature, in which social status determined the destiny of a family for generations. This careful handling of the setting returns—but with a different spirit—in the first canvas by Renoir that could be attributed to his *aigre* (dry) manner: *The Children's Afternoon at Wargemont* (1884), which represents the playroom of the Bérard children in an extremely sharp and penetrating light. There is no trace of the haziness that had pulverized the contours and merged human life with nature in a calm, continuous dialogue; in this unrelenting clarity and lucidity, even the world of children acquires a harsh tone. In a word, Renoir's children are now less conventional than they were in previous works. The objectivity of Renoir's eye is confirmed when his portraits strike notes of personal intimacy; his first child, Pierre, was born in 1885, and the artist's portraits of Aline suckling him (*Nursing*) are like a Renaissance maternity scene, in which the classical rigor of the pose eliminates all sentimentalism. Another portrait of Aline, who is perhaps pregnant (even the meek and discreet Berthe Morisot remarked on her robustness), does not idealize the female figure but rather depicts her imposing volumes with flat, diagonal brushstrokes that remind one, albeit in a less radical form, of the portraits Cézanne did of his wife. This sort of "return to order," which in Renoir coincides with a period of experimentation with tempera and oil techniques (which was tantamount to eliminating the richest quality in his painting, brilliance) that was inspired

by his study of Cennino Cennini's writings, resulted in a meditation on the formalism of Ingres, an artist he had admired despite the apparent difference in their styles. He executed numerous nudes and bathers that were sometimes immersed in the hues of a wooded landscape or seascape; but the modeling was no longer achieved with those tonal transitions and that hazy effect which he had formerly used to represent the pantheistic identification and fusion with the natural world. Now his style was dominated by line, which was refined by the light flesh tones that accentuated a diaphanous, pearly effect and attenuated the ponderous physical presence, precisely by approaching Ingres' technique. From 1884 to 1887 he produced his masterpiece in this style, *The Bathers* (*Grandes Baigneuses*), which was inspired both by François Girardon's seventeenth-century bas-relief sculpture *Nymphs Bathing*, which he had admired in the park at Versailles, and Ingres' *Turkish Bath*, that veritable "repertory of nudes;" he retained the mannered poses and movements of the figures, as their artificiality lent them greater freedom. This was the peak of Renoir's "graphic" period, in which his major concern was pure decoration that in a certain sense prefigures even the art of Matisse. In the final analysis, this development was nothing else but the natural consequence of the path marked out by Manet with *Déjeuner sur l'herbe*, which is so classical and yet so modern. Despite this, most people did not understand The Bathers. The public appreciated Renoir's fresh textural qualities more than his compositional rigor. And Pissarro commented: "[...] I am well aware of all the effort involved; it's very well not to want to stay in the same place, but he has only been concerned with line, the figures stand

out one against another without taking their relations into account, and so it is incomprehensible. Not having the gift of drawing and without the pretty colors that he used to feel instinctively, Renoir becomes incoherent." But the "arabesque" in *The Bathers* has overtones of the burgeoning Symbolist movement and Marcel Proust consecrated its fame in his *A Remembrance of Things Past*, where he ranked it as the most beautiful painting executed by the artist Elstir. Perhaps conditioned by the rather negative reception *The Bathers* received at the Esposition Intérnational in Georges Petit's gallery, in 1888 Renoir began to attenuate the dry tones of his *aigre* period by returning to a softer modeling of volumes and a more suffused atmosphere. This change came about under the aegis, as it were, of another master—Corot, whom Renoir had so admired in his youth and whose influence now predominated after Renoir made a "pilgrimage" to La Rochelle in 1884.

The portrait of Berthe Morisot's daughter, *Julie Manet with a Cat*, still bears traces of the sharp profiles of *The Children's Afternoon at Wargemont*, but there are also the precious silvery grays of a very early work, Portrait of *Romaine Lacaux*. In another portrait of a child, *Girl with a Basket*, the return to the Impressionist *tache* technique—which is more detailed in its tonal transitions and vivacious thanks to a more energetic, feathery brushstroke—is already fully achieved. The exact date of *In Luxembourg Garden*, however, remains uncertain; certain faceted volumes are close to Renoir's sharp *aigre* style, while the free, "flame-like" handling of the composition, which is concentrated around the hoop, heralds the glowing works he executed around the end of the century.

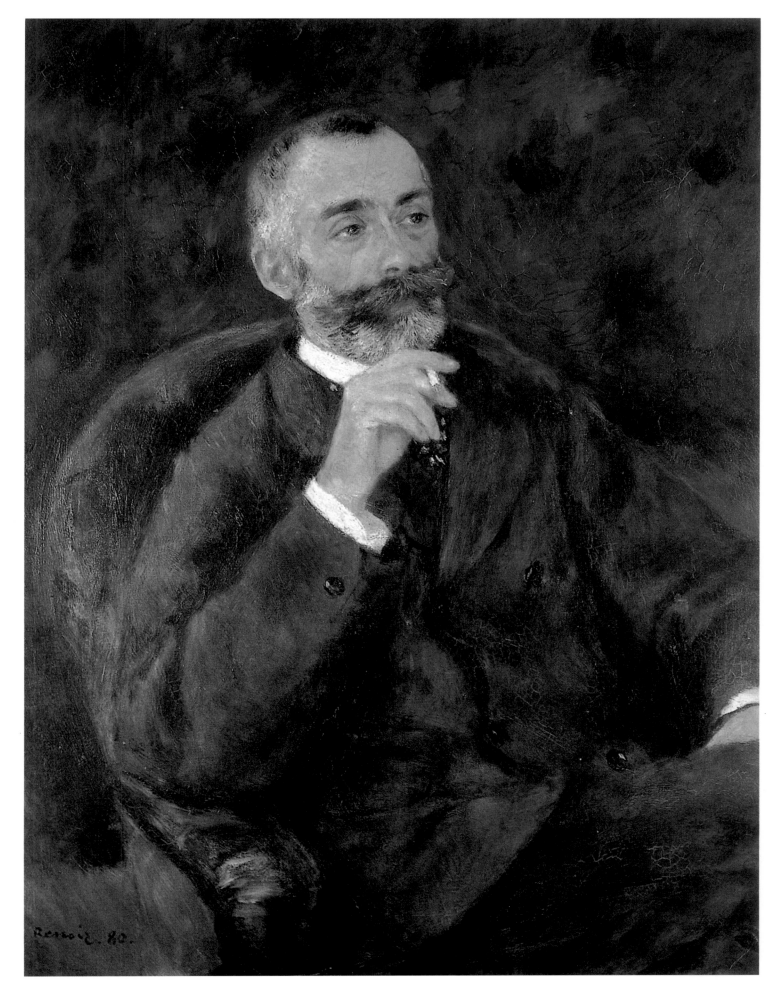

♦ *Above*, Paul Bérard, *1880. Oil on canvas, 81 x 65 cm (31 3/4 x 25 1/2 in). Private Collection. A diplomat, connoisseur and collector of works by Monet, Sisley and Morisot among* others, *Paul Bérard was introduced to Renoir by Charles Deudon, whom he had met at the Union Artistique. The artist was a frequent guest at the Bérard château at Wargemont.*

♦ *Opposite*, Woman with a White Jabot, *1880. Oil on canvas, 46.3 x 38 cm (18 1/4 x 15 in). Musée d'Orsay, Paris. Compared to the portrait of Paul Bérard, executed the same year, this* unknown model is portrayed with a more delicate brushstroke that is only too happy to dwell on the brilliant light of the jabot.

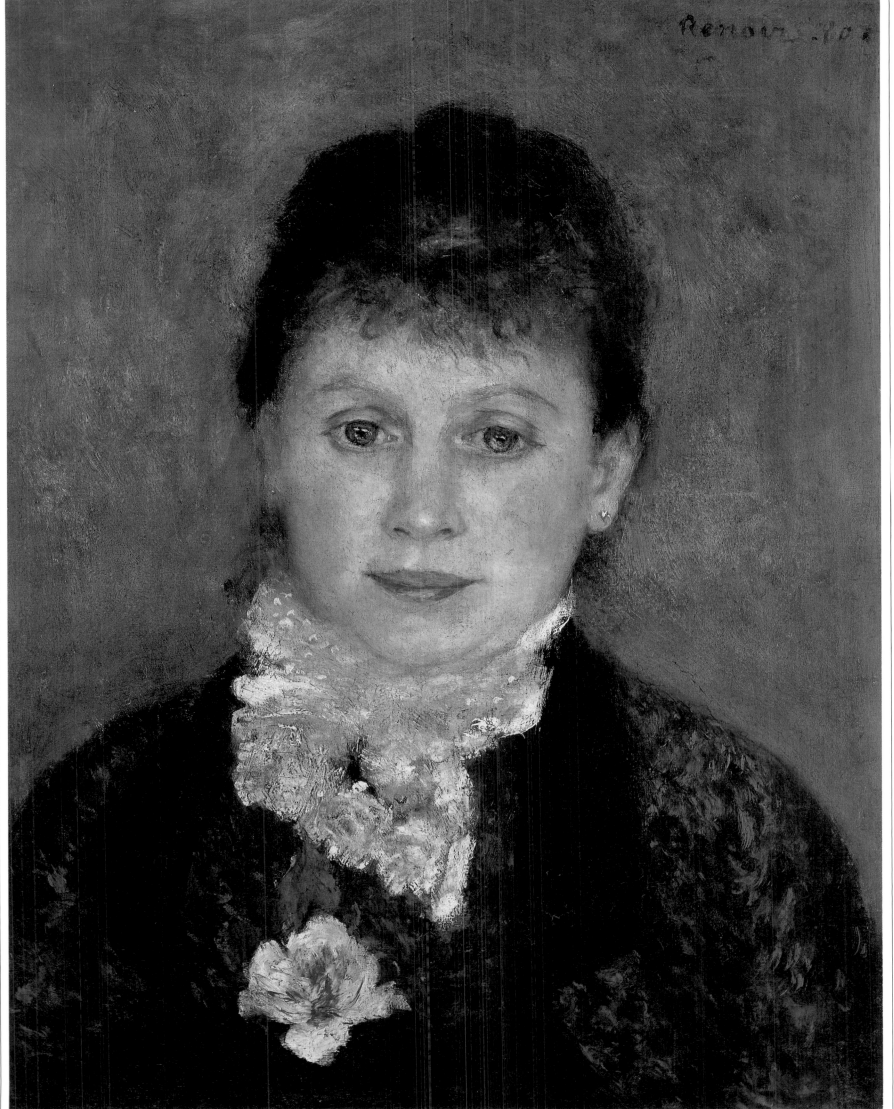

142

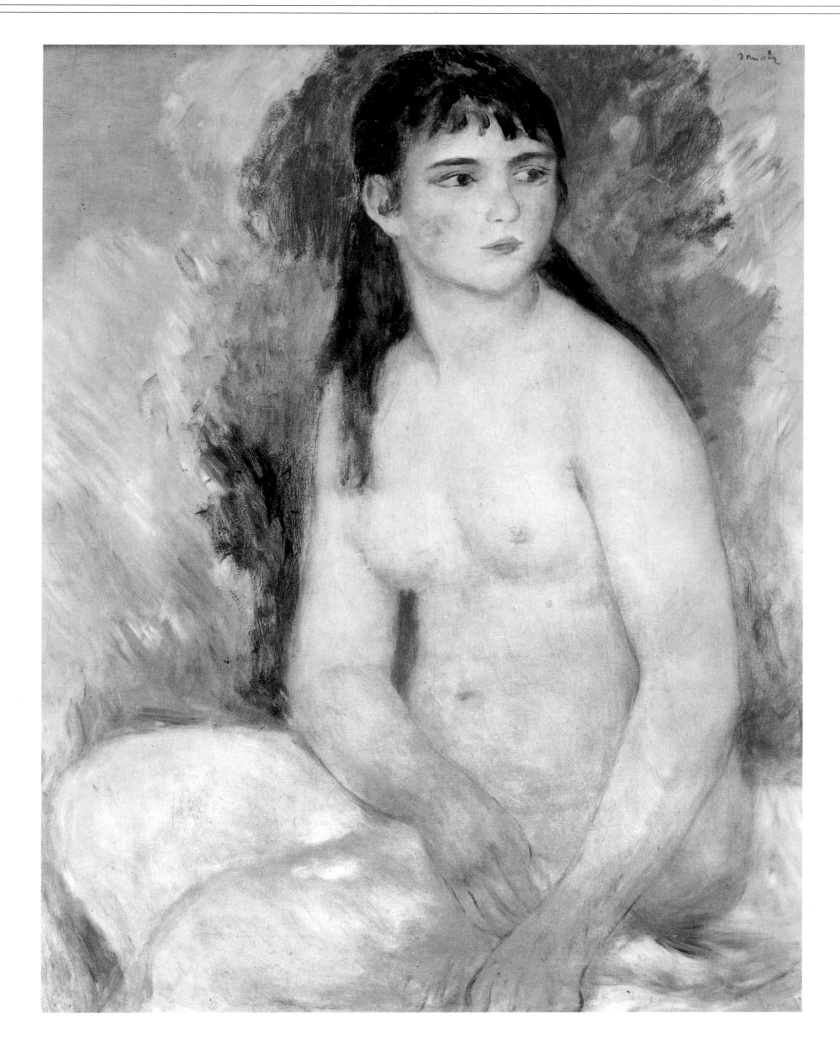

♦ *Above, Seated Nude, 1880. Oil on canvas, 80 x 65 cm (31 1/2 x 25 5/8 in). Musée Rodin, Paris. When Rodin accidentally discovered this canvas at the shop of the art dealer Leclanché, he immediately bought it. While the palette is noteworthy for its free handling and transparent tones, the plastic values and impressive figure could not but stimulate the imagination of the most sensual and open-minded French nineteenth-century sculptor.*

♦ *Opposite above, Place Clichy, 1880. Oil on canvas, 64.5 x 54.5 cm (25 1/4 x 21 1/2 in). Fitzwilliam Museum, Cambridge. The female profile in the foreground is in striking contrast with the vaguely defined crowd. This arrangement, which creates dynamism through spatial imbalance, was often used by Degas.*

♦ *Opposite below, Girl Reading, 1880. Oil on canvas, 55 x 46 cm (21 3/4 x 18 in). Städelsches Kunstinstitut, Frankfurt.*

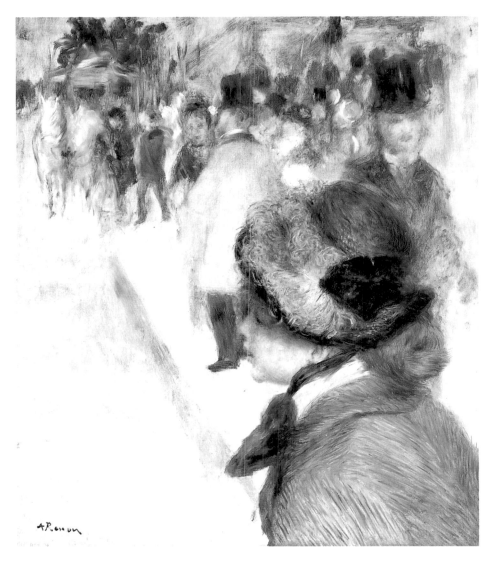

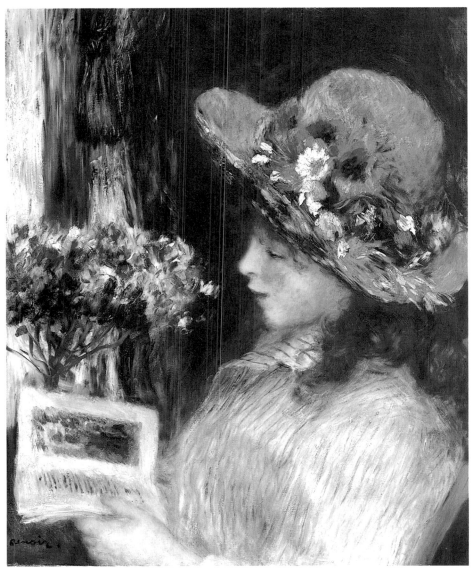

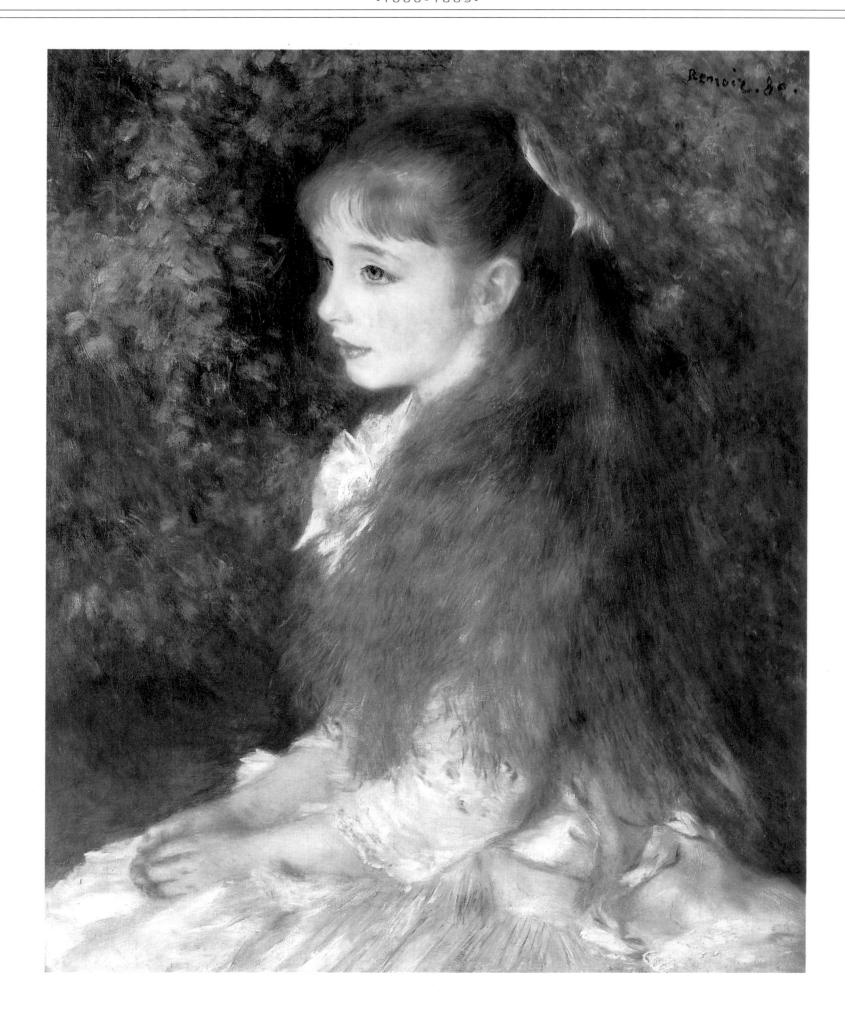

♦ *Above,* Irène Cahen d'Anvers, *1880. Oil on canvas, 65 x 54 cm (25 1/2 x 21 1/4 in). Bührle Collection, Zurich. The eldest daughter of the banker Cahen d'Anvers is depicted against the romantic background of a* garden in this intelligent interpretation of the great English portraitists. The solidly balanced and pyramidal structure marks Renoir's renewed interest in classical composition.

♦ *Opposite,* Pink and Blue, Alice and Élizabeth Cahen d'Anvers, *1881. Oil on canvas, 119 x 74 cm (46 3/4 x 29 in). Museu de Arte, Sao Paulo. The Cahen d'Anvers' younger daughters, with the lovely lace dresses,* provide Renoir with the opportunity to dwell on the splendid light and color effects in a perfect evocation of Van Dyck's or Velásquez's "grand style." But the family did not like the canvas and put it in the servants' quarters.

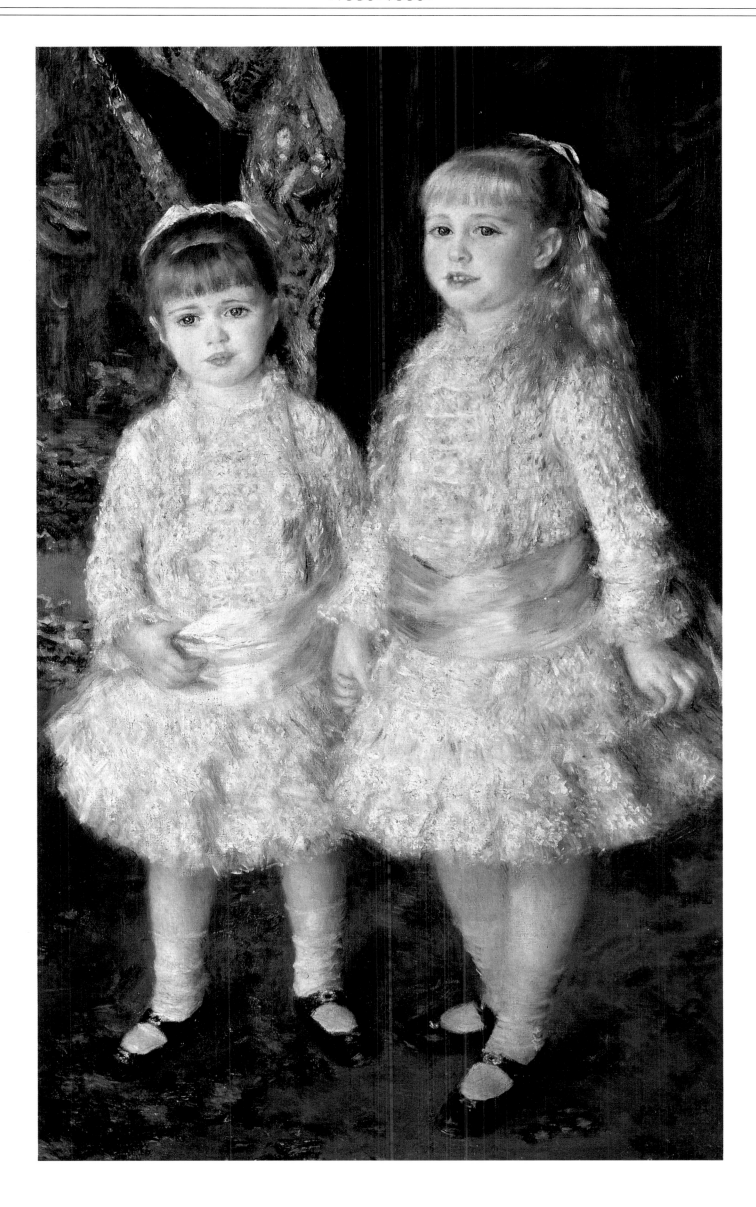

146

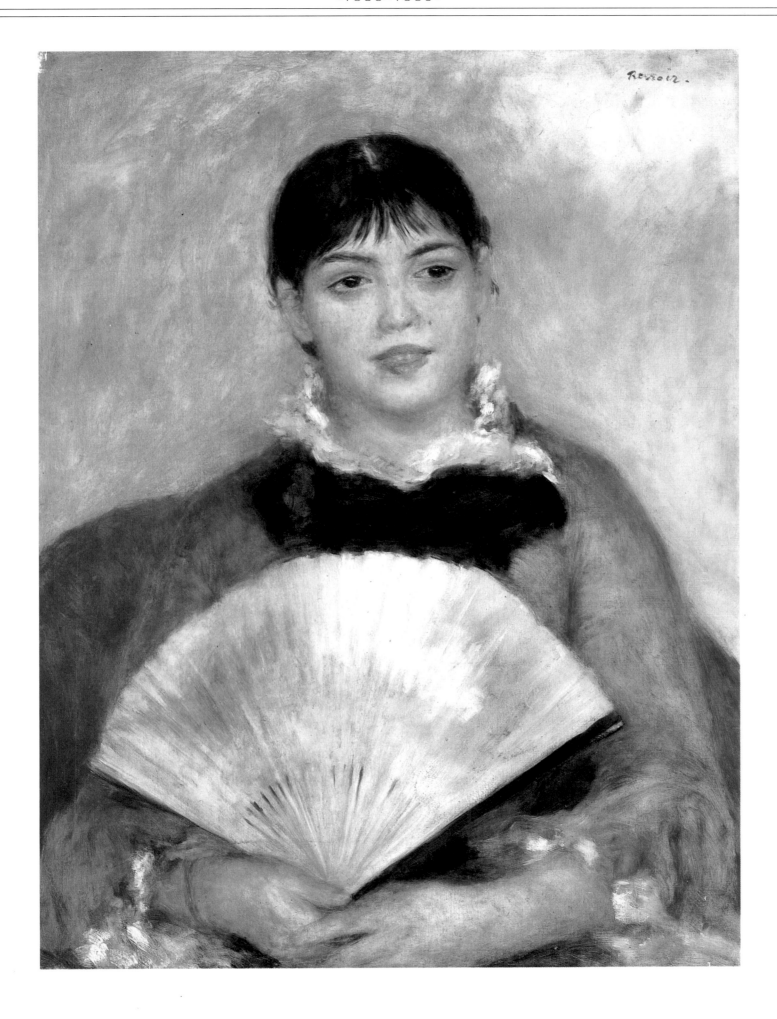

♦ *Above,* Woman with a Fan, *1881. Oil on canvas, 65 x 50 cm (25 1/2 x 19 3/4 in). Hermitage, St. Petersburg. Alphonsine Fournaise, the daughter of the* proprietor of the *restaurant at Chatou and future model for* Luncheon of the Boating Party, *is depicted in this charming pose by Renoir.*

♦ *Opposite,* Girl with a Blue Hat, *1881. Oil on canvas, 40 x 35 cm (15 3/4 x 13 3/4 in). Private Collection. This is perhaps Jeanne Henriot, Henriette's daughter. She also* became a famous theater actress whose career ended tragically and prematurely when she died in a fire at the Comédie Française.

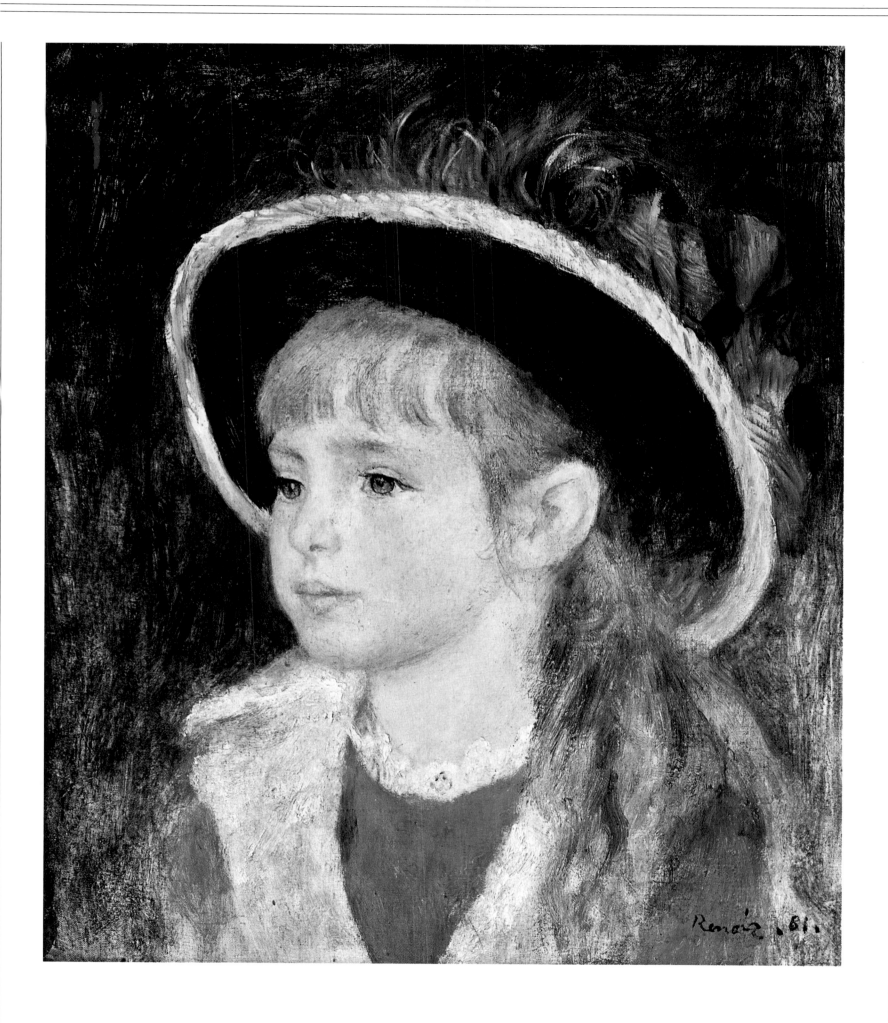

148

♦ *Top*, Railroad
Bridge at Chatou,
*1881. Oil on canvas,
54 x 65 cm (21 1/4
x 25 1/2 in). Musée
d'Orsay, Paris. This
canvas has the
classical structure in
horizontal and
vertical lines.*

♦ *Above*, The Seine at
Chatou, *1880-81. Oil
on canvas, 73.6 x
92.6 cm (28 7/8 x 36
3/8 in). Museum of
Fine Arts, Boston. In
this work the "flat" of
the tree in the
foreground lends
depth, solidity and*
*balance to the
composition.
Renoir's more
carefully structured
canvases—compared
to his Impressionist
works—marks the
onset of the "crisis"
in plein-air
painting: "The artist*
*who depicts nature
seeks only
momentary effects.
He does not bother
about lending
artistic form to the
image, and his
canvases soon
become
monotonous."*

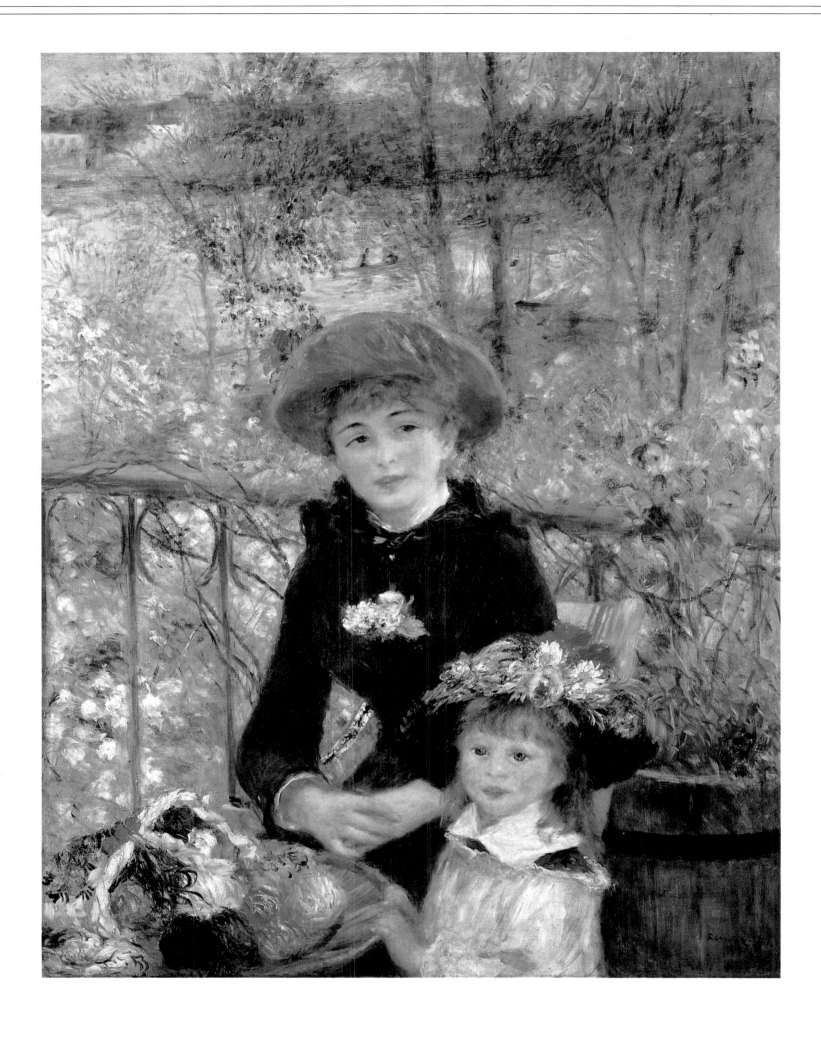

♦ On the Terrace, 1881. Oil on canvas, 100 x 80 cm (39 3/8 x 31 1/2 in). Art Institute, Chicago. The felicitous touches of color quiver with life on the foliage and in the reflections of light on the river, but they become even more vivid in the figures, reverberating on the woman's hat and in the magnificent "still life" of flowers on the girl's hat. This work was probably executed on the terrace of the Fournaise restaurant at Chatou; the model is the Comédie Française actress Darlaud.

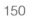

150

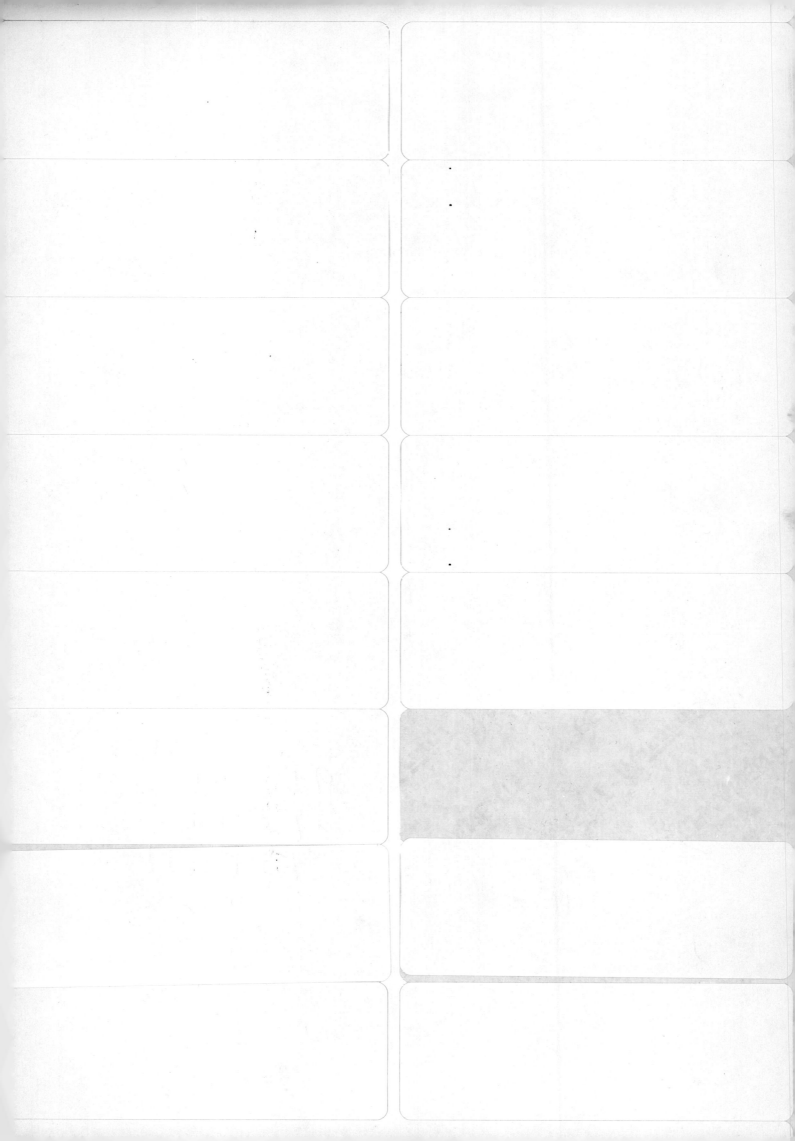

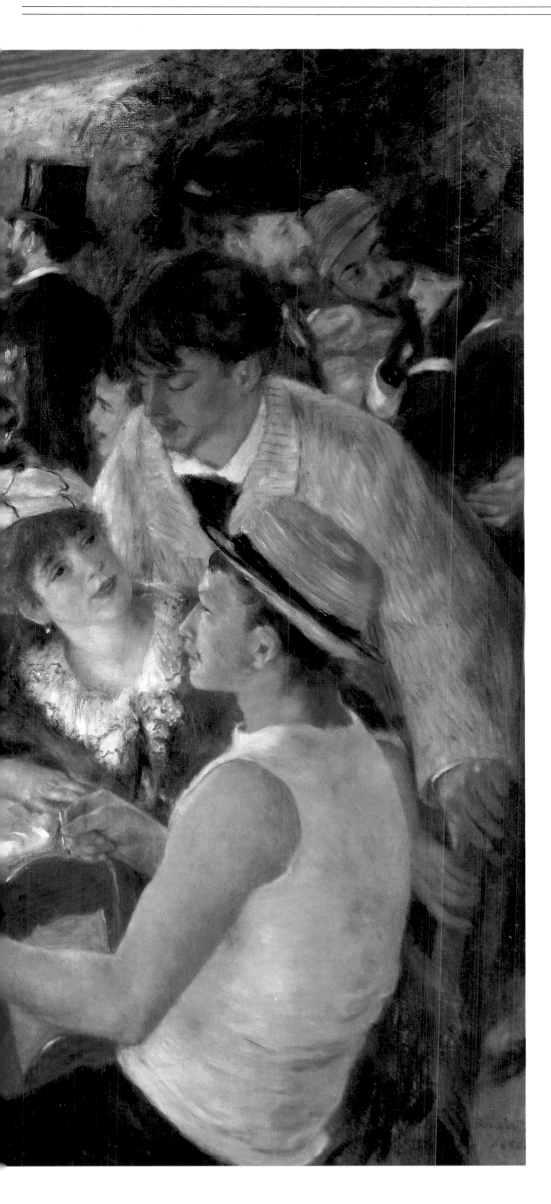

● Luncheon of the Boating Party, 1880-81. Oil on canvas, 130 x 173 cm (51 1/4 x 68 1/8 in). Philips Collection, Washington D.C. "I'm at Chatou... I couldn't resist saying the hell with all decoration. I'm doing a picture of boaters I've been itching to do for a long while. I'm getting on and I didn't want to put off this little party for which I wouldn't be able to pay the expenses later on, it's already hard going. I don't know if I will finish it, but I related my misfortunes to Deudon, who agreed with me that even if I couldn't finish the painting because of the enormous expenses, it is still progress; every so often one must try things beyond one's strength." In the summer of 1880 Renoir described his economic difficulties to Bérard (but Durand-Ruel bought this major work already the following February) as well as his enthusiasm over the new, large-scale work he was about to begin. In a sense, Luncheon of the Boating Party was a reply to the provocatory challenge Zola had made that same summer when he asked the Impressionists to go beyond mere summary sketching and embark on ambitious, well thought-out representations of modern life.

152

♦ Venice—Fog, *1881.*
Oil on canvas, 45 x
63 cm (17 3/4 x 24
3/4 in). Kreeger
Collection,
Washington D.C.
Venice was the first
stop in Renoir's trip
to Italy—the city of
the "master colorists"
whom he loved and
had copied at the
Louvre, and above all
the city of light. In
this view of the
Grand Canal, Renoir
concentrates on the
play of reflected color
between sky and
water in the fog, thus
offering a surprising
anticipation of the
phantasmagoric
effects achieved by
Monet in his 1908
views of Venice.

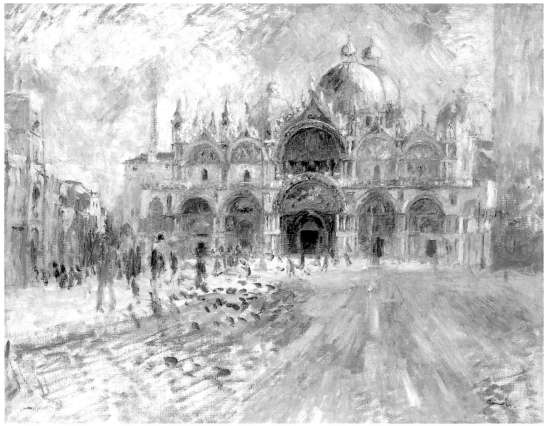

♦ St. Mark's, Venice,
*1881. Oil on canvas,
65.5 x 81 cm (25 3/4
x 31 3/4 in).
Institute of Art,
Minneapolis. St.
Mark's Basilica
seems to be
suspended like an
air bubble, an
evocation. The
horizon line is quite
high so that the wet
pavement of the
square reverberates
with the vibrating
hues from the sky
and the church; the
spatial ambiguity so
typical of Venice
inspires Renoir to
return to the fluent
Impressionist
brushstroke.*

154

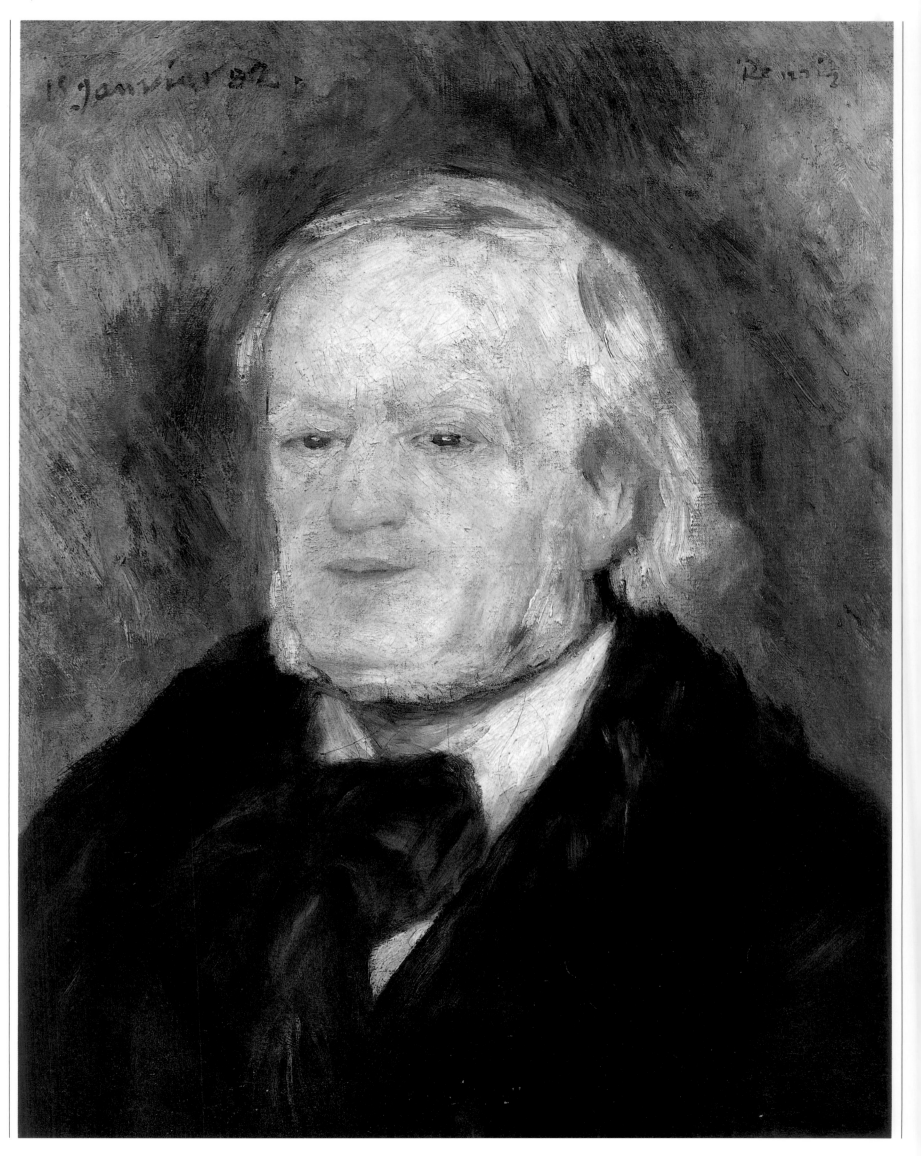

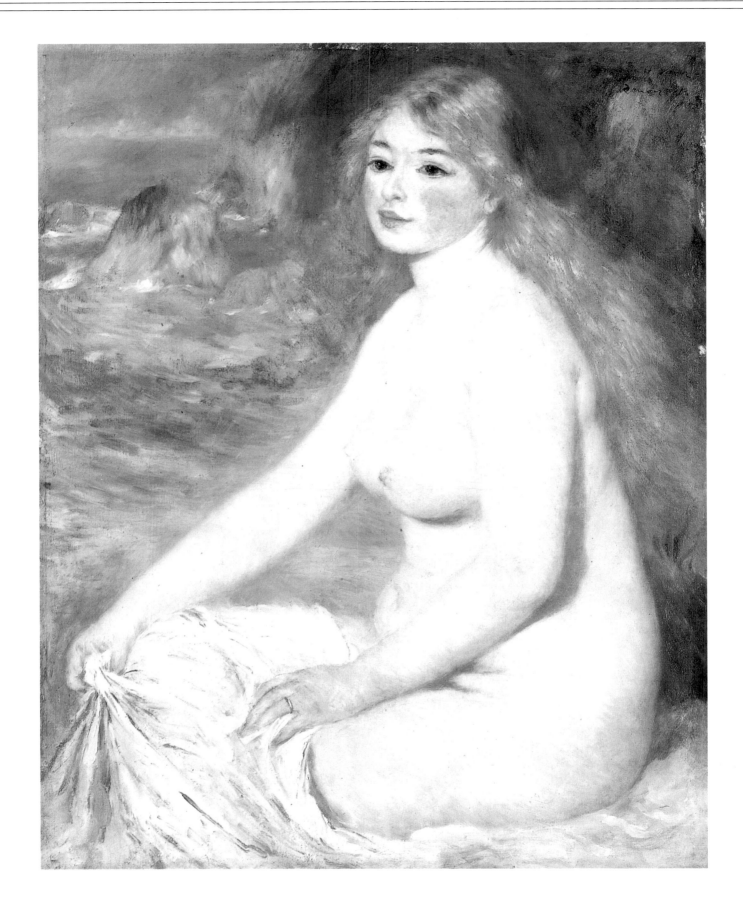

♦ *Opposite,* Portrait of Richard Wagner, *1882. Oil on canvas, 53 x 46 cm (20 7/8 x 18 in). Musée d'Orsay, Paris. The "Wagnerian craze" had reigned in Paris during the time of Baudelaire and the "Revue wagnerienne." While traveling in Sicily in January 1882, Renoir received a letter from Jules de* Brayer, *a fervent admirer of Wagner, who commissioned him to portray the composer during his sojourn in Palermo. On January 15, in only one sitting, Renoir hastily sketched the portrait, which Wagner did not like very much; and in fact, the two did not particularly take to each other.*

♦ *Above,* Blond Bather, *1881. Oil on canvas, 81.8 x 65.7 cm (32 1/4 x 25 7/8 in). Sterling and Francine Clark Art Institute, Williamstown, Mass. "The Blue Grotto has an extraordinary transparency and a blue that we haven't got on the palette." The blue described in Renoir's letter is perhaps the same* that inundates the background of this portrait of the nude Aline and actually penetrates her flesh, even in the shadows. The solid pyramidal composition (which reminds one of Raphael's Madonnas), the monumental character of the figure, and the firm contours inaugurate Renoir's "neo-classic" period.

156

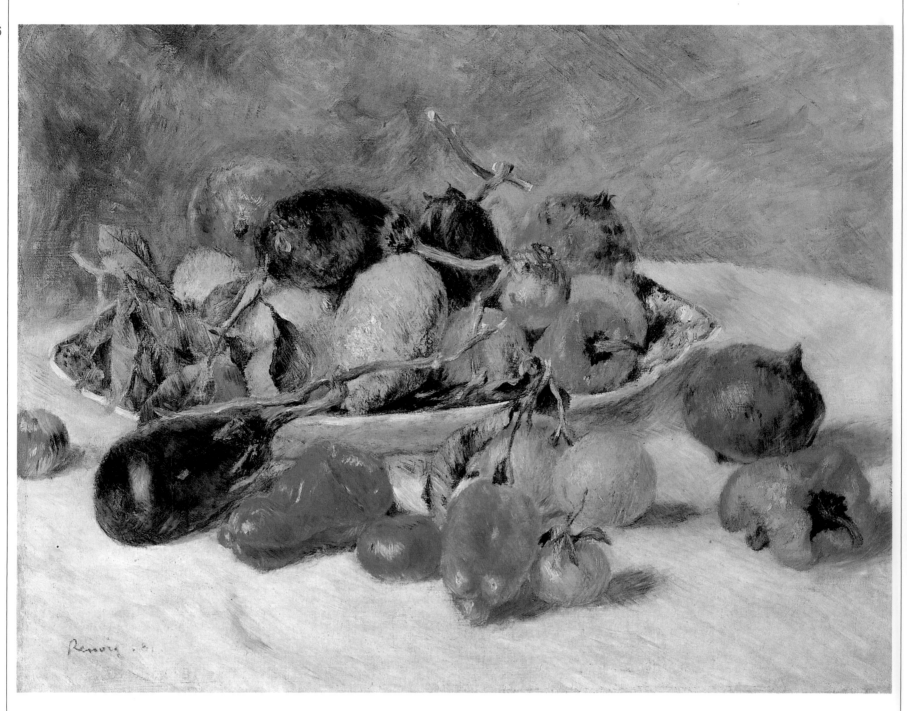

♦ Fruits of the South, 1881. Oil on canvas, 51 x 68.5 cm (20 x 27 in). Art Institute, Chicago. The dazzling light of the Midi is excluded from this interior and is replaced by saturated reds, oranges, violets and the bold Veronese green in the background. This canvas was perhaps executed "by heart" after Renoir's return to Paris from Algiers. Some critics note the influence of the solid brushwork of Cézanne, whom Renoir visited on his way back home.

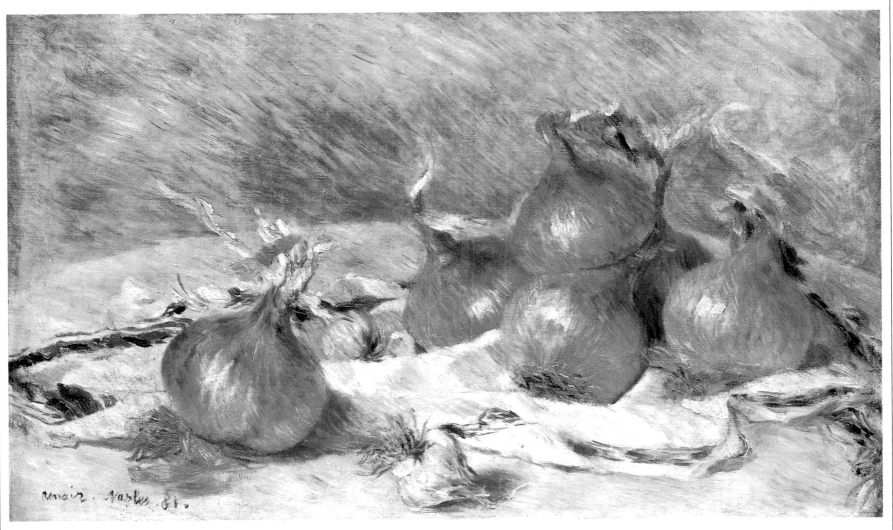

♦ Onions, *1881. Oil on canvas, 39 x 60 cm (15 1/4 x 23 1/2 in). Sterling and Francine Clark Art Institute, Williamstown, Mass. Dated "Naples '81,"* this canvas has a simple structure, arranged around the semicircle of the table and the sole dominating hues of the onions, which shine in the light. The rapid, oblique, "slashing" brushstrokes model the volumes and impart energy to the whole. The plain motif has led certain art critics to state that Renoir is here liberating himself from the luxury "imposed" upon him by his most prestigious patrons.

158

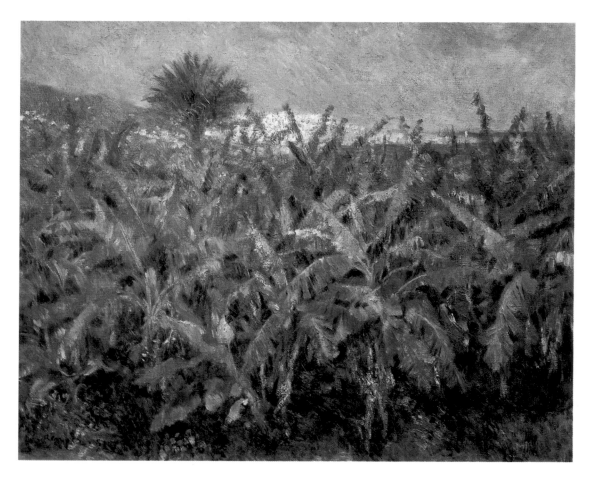

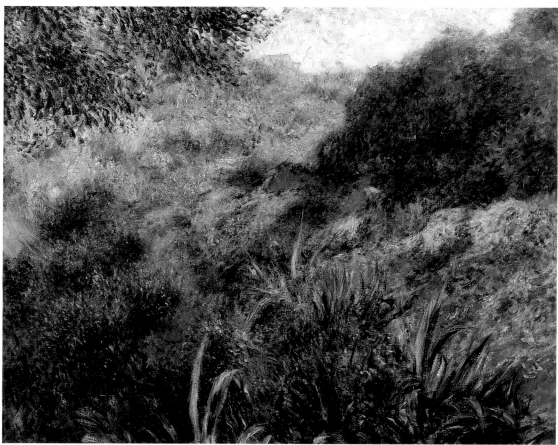

♦ *Top*, Banana
Plantation, *1881. Oil
on canvas, 51 x 63. 5
cm (20 x 24 3/4 in).
Musée d'Orsay,
Paris. Renoir
painted this work
during his first
sojourn in Algiers.
The high horizon*
*line is covered with
the interlacing
foliage which is
rendered in the same
tonalities.*

♦ *Above*, Algerian
Landscape (Ravin *de
la Femme Sauvage),
1881. Oil on canvas,
65 x 81 cm (25 1/2 x
31 3/4 in). Musée
d'Orsay, Paris.
During his first trip
to Algeria, Renoir
was struck mostly by*
*the landscape, as can
be seen in this view
without figures,
which is a rare event
indeed for an artist
who proclaimed
himself a "figure
painter."*

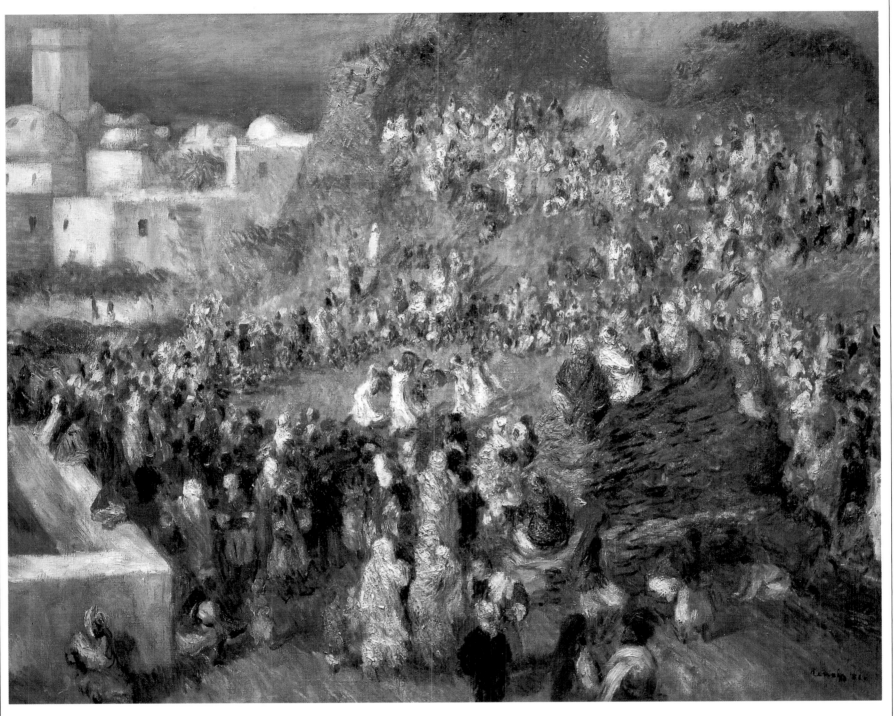

♦ Muslim Festival at
Algiers, *1881. Oil on
canvas, 73 x 92 cm
(28 3/4 x 36 1/4 in).
Musée d'Orsay,
Paris. A multitude of
people is certainly
an exception in
Renoir's Algerian
works. The motif has
never been identified
with certainty, the*
*interpretations
ranging from a
religious gathering
at a mosque (as
Durand-Ruel's 1892
catalogue states) to
an exhibition of
acrobats, who can be
seen in the middle of
the canvas.*

160

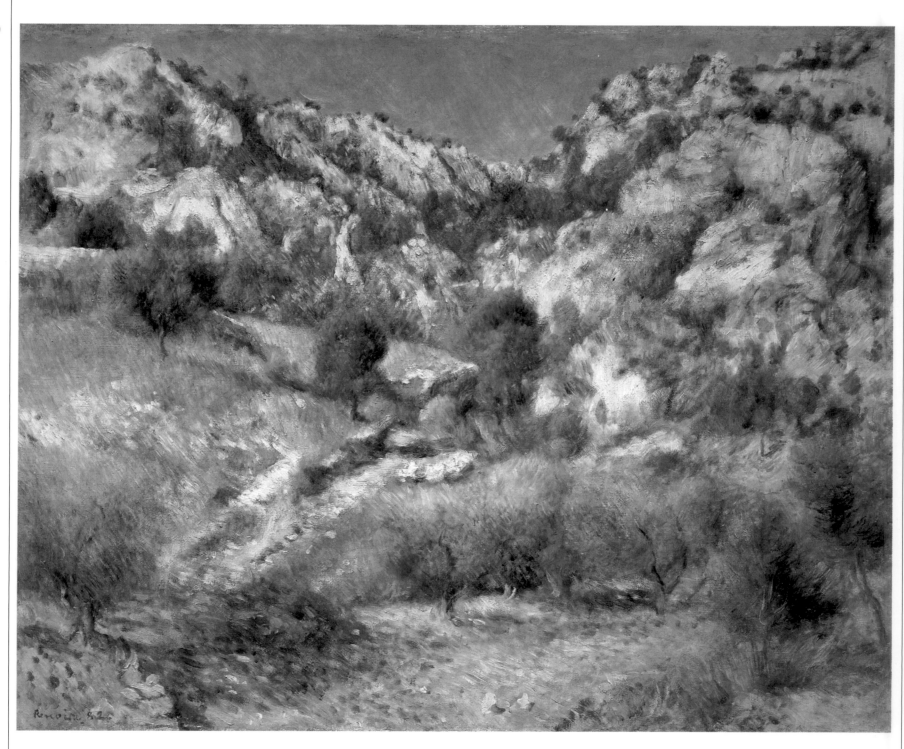

♦ Rocky Crags at L'Estaque, 1882. Oil on canvas, 66 x 82 cm (26 x 31 7/8 in). Museum of Fine Arts, Boston. At the end of January 1882, on his way back from Italy, Renoir stopped at L'Estaque, a locality near Marseilles made famous by Picasso's and Braque's pre-Cubist works. Perhaps because a change was in the air, or due to the presence of Cézanne, the canvases he executed in his two months' stay here reveal a new, structural function of the brushwork that heightens the masses and volumes. Renoir's relationship with Cézanne became closer, and the latter took care of him when he was in bed with pneumonia.

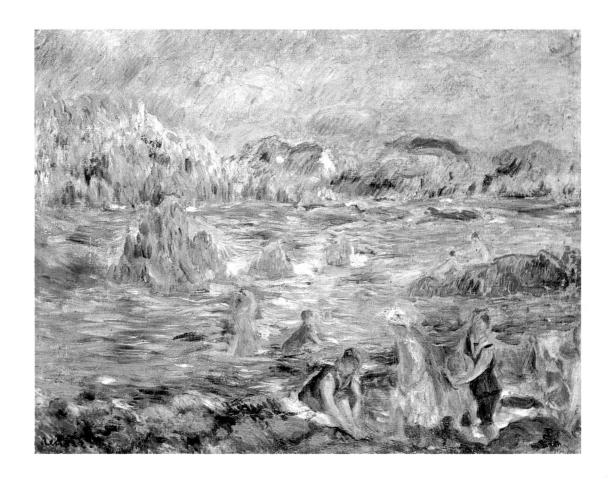

♦ Top, Women and Children by the Seashore, Guernsey, 1883. Oil on canvas, 32 x 41. 5 cm (12 1/2 x 16 in). Hahnloser Collection, Bern.

♦ Above, Landscape with Bathers, 1882.

Oil on canvas, 54 x 65 cm (21 1/4 x 25 1/2 in). Ny Carlsberg Glyptotek, Copenhagen. "Here we bathe among the rocks used as cabins, since there is nothing else; there's no better

sight than this mixture of men and women crowded together on these rocks. It's more like being in a landscape by Watteau than real life. I will therefore have a source of real, graceful motifs

I'll be able to make use of.", (Letter from Renoir to Durand-Ruel, written on the island of Geurnsey.)

162

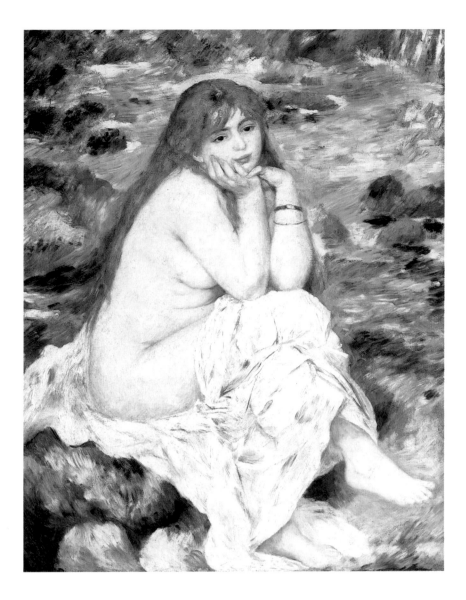

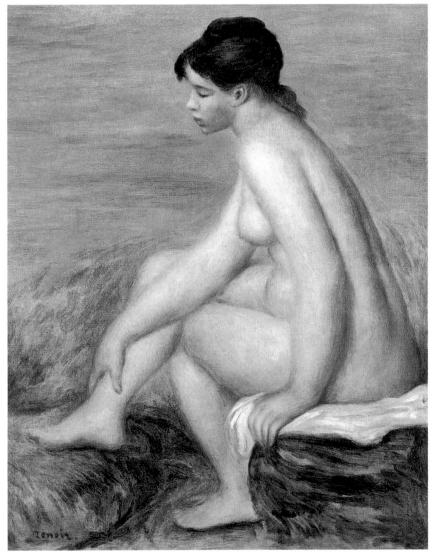

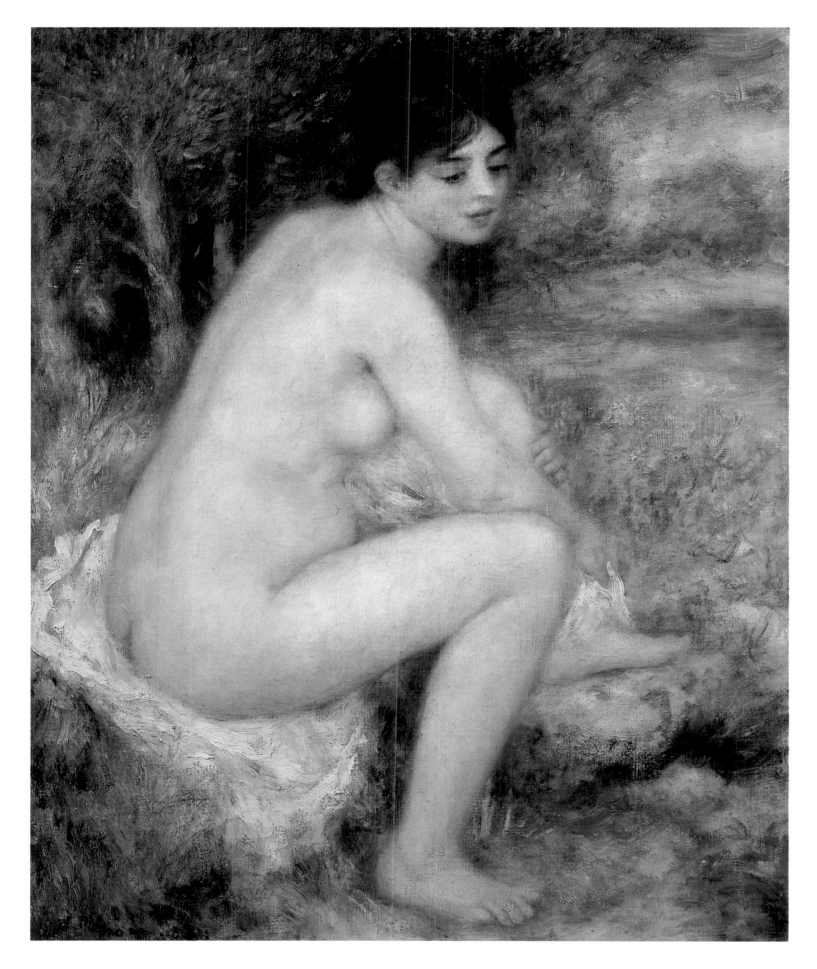

♦ *Opposite above,* Seated Bather. *ca. 1883-84. Oil on canvas, 121 x 91 cm (47 3/4 x 35 3/4 in). Fogg Art Museum, Cambridge, Mass. Drawing upon his experience at Guernsey, Renoir executed one of his first bathers (probably in the studio, as can be seen in the different handling of the figure and the landscape), merging the classical monumentality of the form with the simple casualness of the pose and expression.*

♦ *Opposite below,* Seated Bather, *ca. 1882-85. Oil on canvas, 54.5 x 42 cm (21 3/8 x 16 1/2 in). Whereabouts unknown. The setting is similar to that in the preceding canvas, but the pose is much more traditional and the brushwork more compact.*

♦ *Above,* Nude in a Landscape, *1883. Oil on canvas, 65 x 54 cm (25 1/2 x 21 1/2 in). Musée de l'Orangerie, Paris. This nude, whose amplitude is rendered by the brushwork, reminds one of Rubens' and Rembrandt's various "Rebeccas" and "Susans and the Elders."*

166

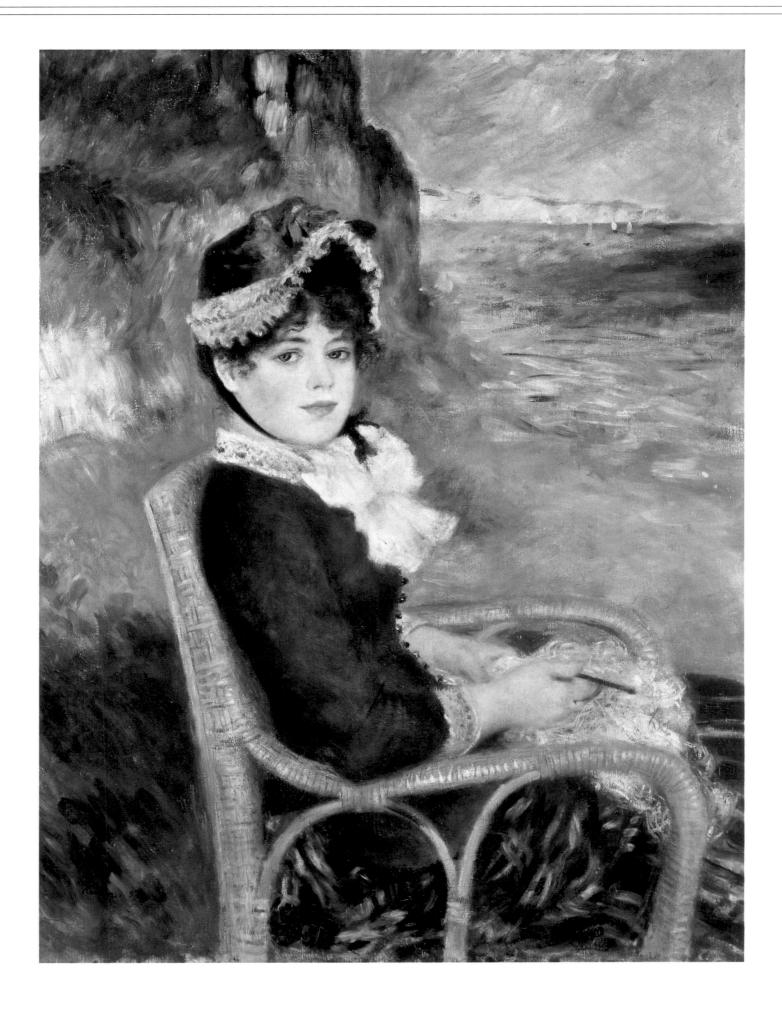

♦ *Above*, By the
Seashore, *1883. Oil
on canvas, 92 x 73 cm
(36 1/4 x 28 3/4 in).
Metropolitan Museum
of Art, New York. This
work was executed
either in Guernsey or,
more probably, in the
studio, based on
sketches Renoir did
outdoors.*

♦ *Opposite*, Dance at
Bougival, *1882-83.
Oil on canvas, 182 x
98 cm (71 3/4 x 38
5/8 in). Museum of
Fine Arts, Boston.
Another example of
an ideal slice of
Parisian life, this
series of three almost
life-size canvases
was not conceived as*

*a "triptych" of
companion pieces to
be exhibited together.
In fact this panel is
slightly larger than
the other two.
However, there is an
implicit sequence
than links the three
works, which
represent different
social settings.*

*Renoir used a
preparatory drawing
for this work to
illustrate a story by
his friend Lhote, who
together with
Suzanne Valadon
posed for this
canvas.*

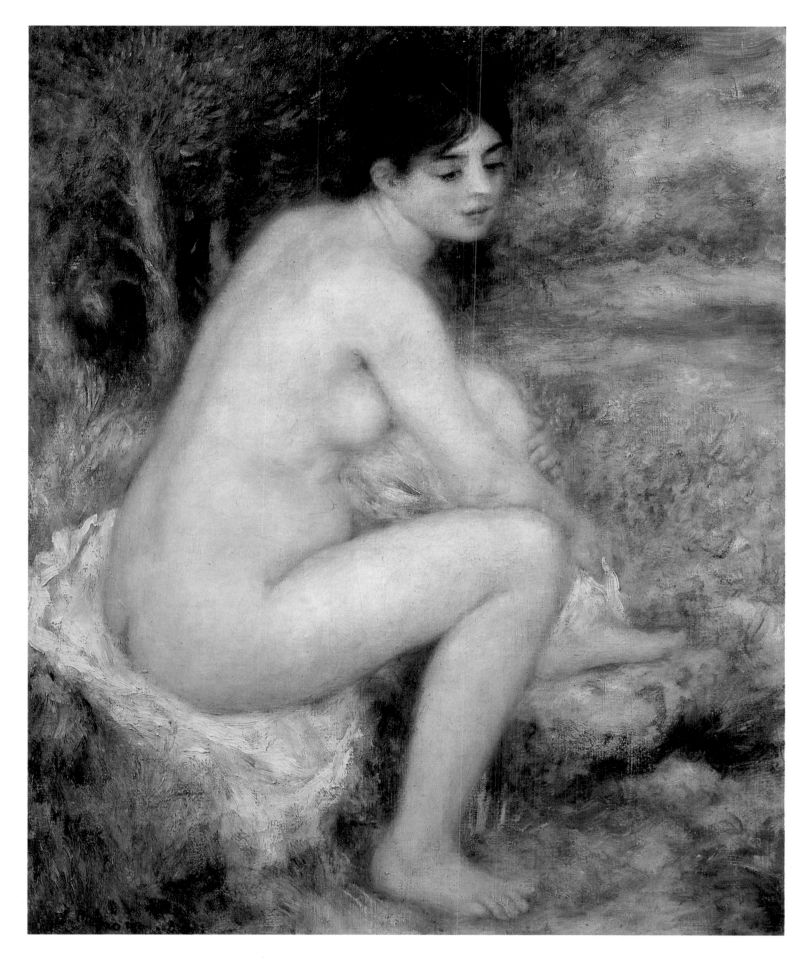

♦ Opposite above, Seated Bather, ca. 1883-84. Oil on canvas, 121 x 91 cm (47 3/4 x 35 3/4 in). Fogg Art Museum, Cambridge, Mass. Drawing upon his experience at Guernsey, Renoir executed one of his first bathers (probably in the studio, as can be seen in the different handling of the figure and the landscape), merging the classical monumentality of the form with the simple casualness of the pose and expression.

♦ Opposite below, Seated Bather, ca. 1882-85. Oil on canvas, 54.5 x 42 cm (21 3/8 x 16 1/2 in). Whereabouts unknown. The setting is similar to that in the preceding canvas, but the pose is much more traditional and the brushwork more compact.

♦ Above, Nude in a Landscape, 1883. Oil on canvas, 65 x 54 cm (25 1/2 x 21 1/2 in). Musée de l'Orangerie, Paris. This nude, whose amplitude is rendered by the brushwork, reminds one of Rubens' and Rembrandt's various "Rebeccas" and "Susans and the Elders."

164

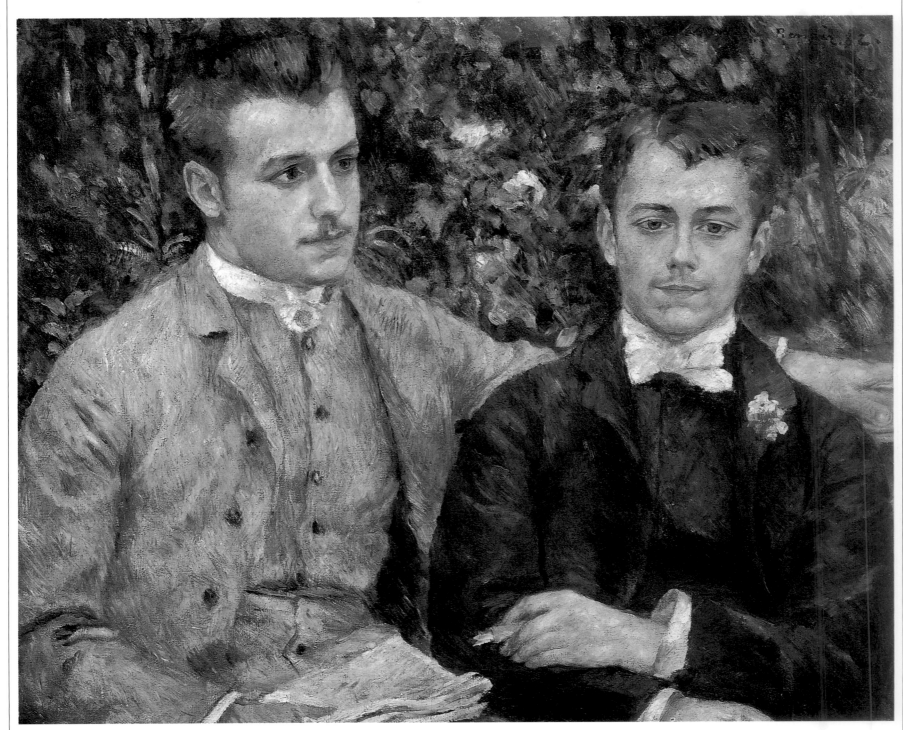

♦ *Above,* Charles and Georges Durand-Ruel, *1882. Oil on canvas, 65 x 81 cm (25 5/8 x 31 7/8 in). Durand-Ruel Collection, Paris. In 1882, the art dealer Paul Durand-Ruel asked Renoir to portray his five children; here we see the two eldest (Georges later became Jean* Renoir's godfather). *All the portraits are set in the garden of the Durand-Ruel summer house at Dieppe. The plein-air effect of changing reverberations can be noted in the handling of the background, but the faces are modeled with the utmost precision.*

♦ *Opposite,* The Umbrellas, *ca. 1881/1885. Oil on canvas, 180 x 115 cm (70 3/4 x 45 1/4 in). National Gallery, London. X-ray analysis has shown that this canvas was most probably executed in two different periods. The first phase includes the group of women and* children at right, *which has a soft and light brushstroke. In the second phase Renoir painted the couple at left and the entire "swarm" of umbrellas in the background, as is revealed by the crisper handling and the geometry of the volumes.*

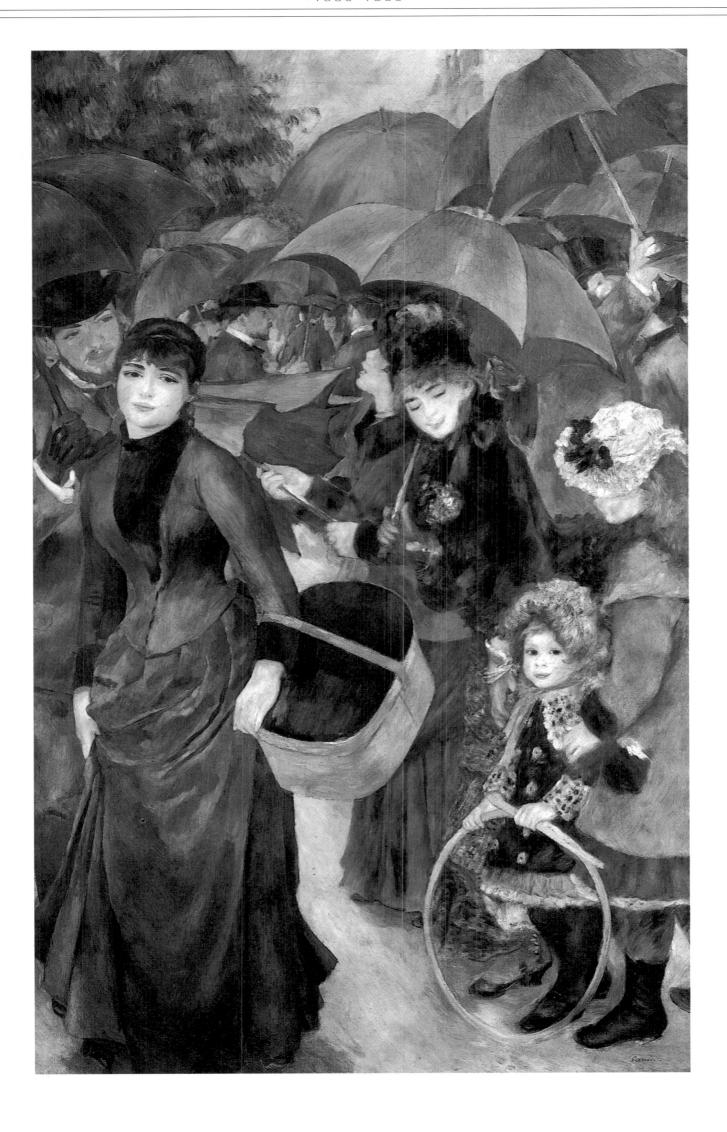

166

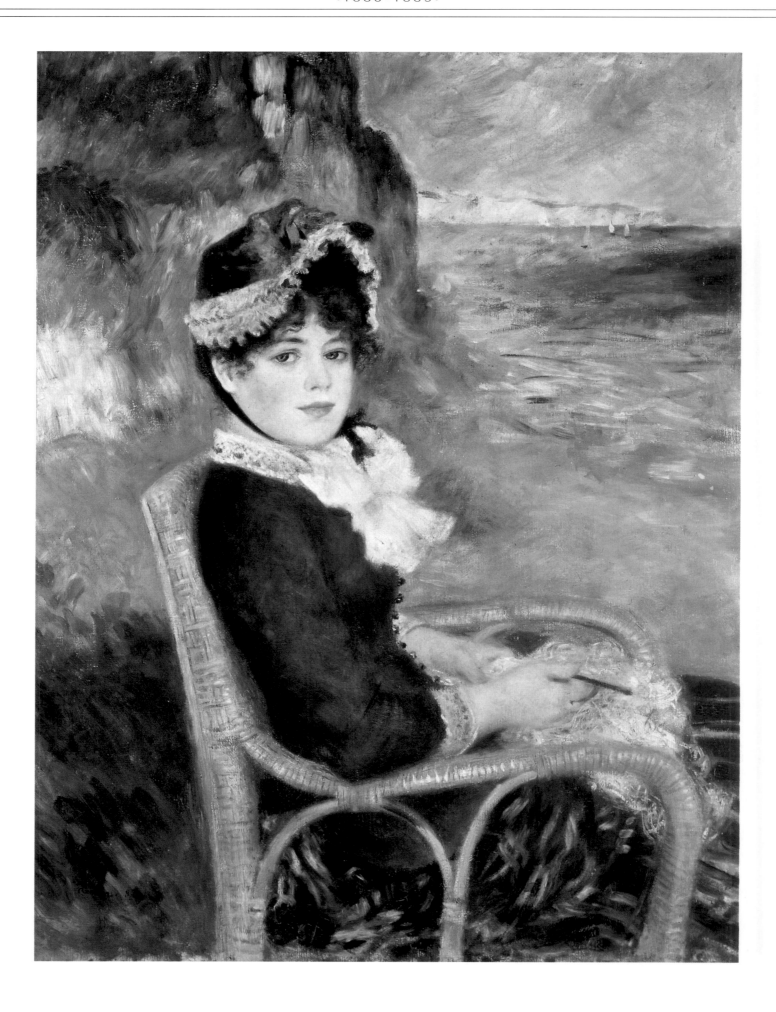

♦ *Above*, By the
Seashore, *1883. Oil
on canvas, 92 x 73 cm
(36 1/4 x 28 3/4 in).
Metropolitan Museum
of Art, New York. This
work was executed
either in Guernsey or,
more probably, in the
studio, based on
sketches Renoir did
outdoors.*

♦ *Opposite*, Dance at
Bougival, *1882-83.
Oil on canvas, 182 x
98 cm (71 3/4 x 38
5/8 in). Museum of
Fine Arts, Boston.
Another example of
an ideal slice of
Parisian life, this
series of three almost
life-size canvases
was not conceived as*
*a "triptych" of
companion pieces to
be exhibited together.
In fact this panel is
slightly larger than
the other two.
However, there is an
implicit sequence
than links the three
works, which
represent different
social settings.*

*Renoir used a
preparatory drawing
for this work to
illustrate a story by
his friend Lhote, who
together with
Suzanne Valadon
posed for this
canvas.*

168

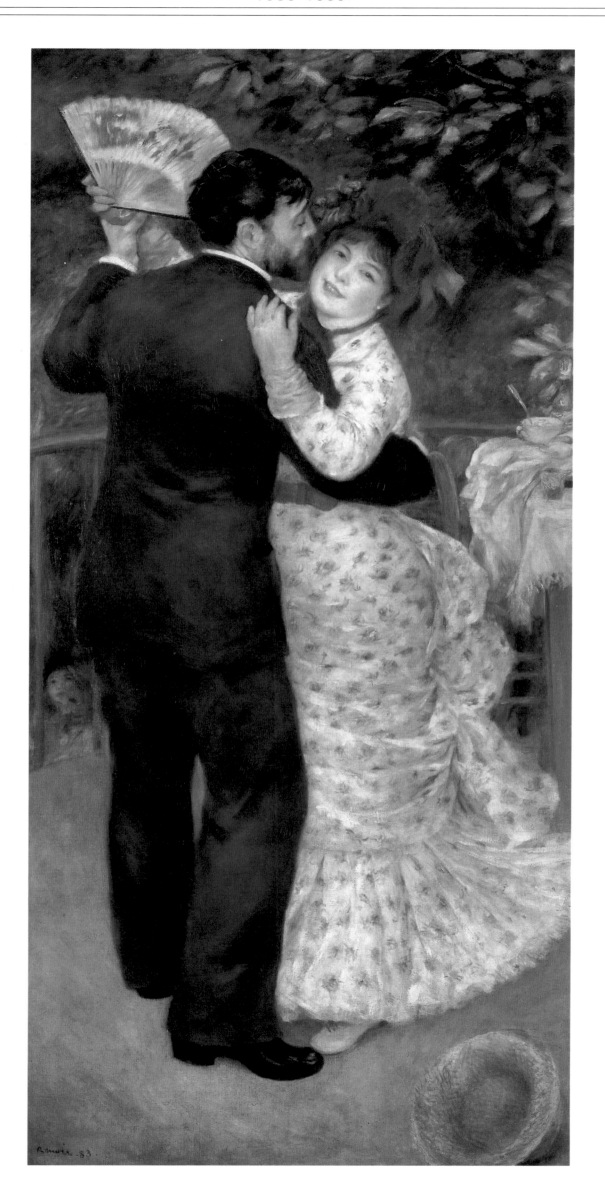

♦ Dance in the Country, *1882-83. Oil on canvas, 180 x 90 cm (70 7/8 x 35 3/8 in). Musée d'Orsay, Paris. Unlike Dance at Bougival, this canvas was a companion piece to Dance in the City and is the same size. The two panels have always been exhibited together and from 1892 on were hung in Paul Durand-Ruel's living room (he had purchased them in 1886). The models are Paul Lhote and Aline Charigot, whose winning smile involves the viewer in the scene.*

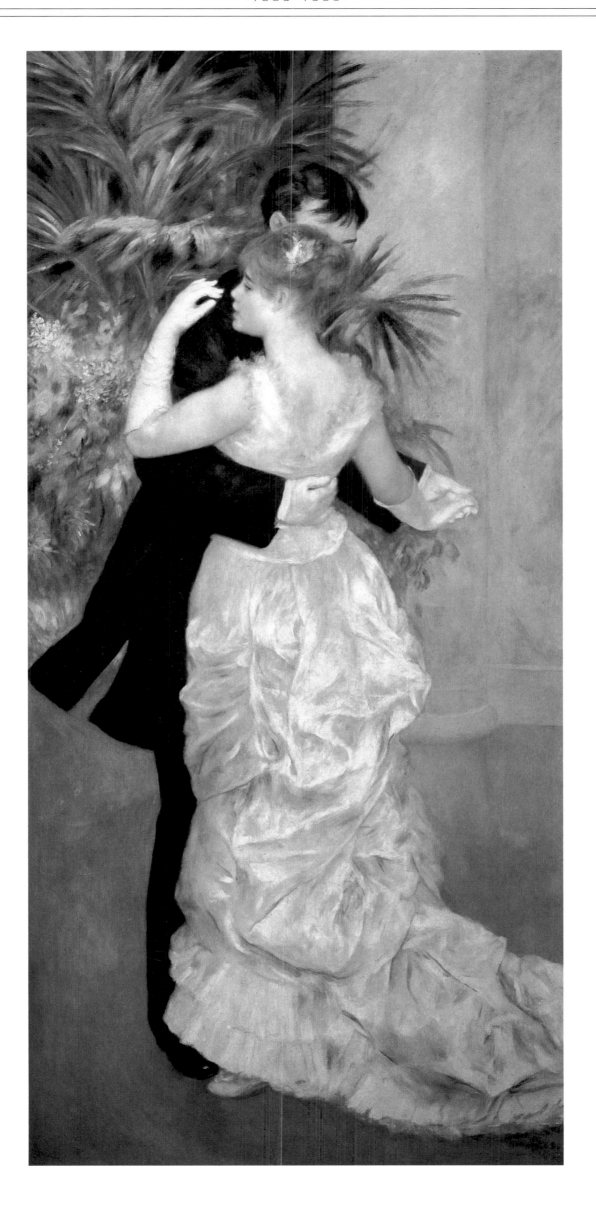

♦ Dance in the City,
1882-83. Oil on
canvas, 180 x 90 cm
(70 7/8 x 35 3/8 in).
Musée d'Orsay,
Paris. While in
Dance in the
Country the viewer
is made part of the
scene by Aline's
smile, here the
rotation of the
dancing couple
suggests a different
psychological
situation: one may
admire the woman's
delicate neck or the
plush folds of her
dress, but her
feelings are hidden.
Once again the
models were Paul
Lhote and Marie-
Clémentine Valadon,
later known as
Suzanne.

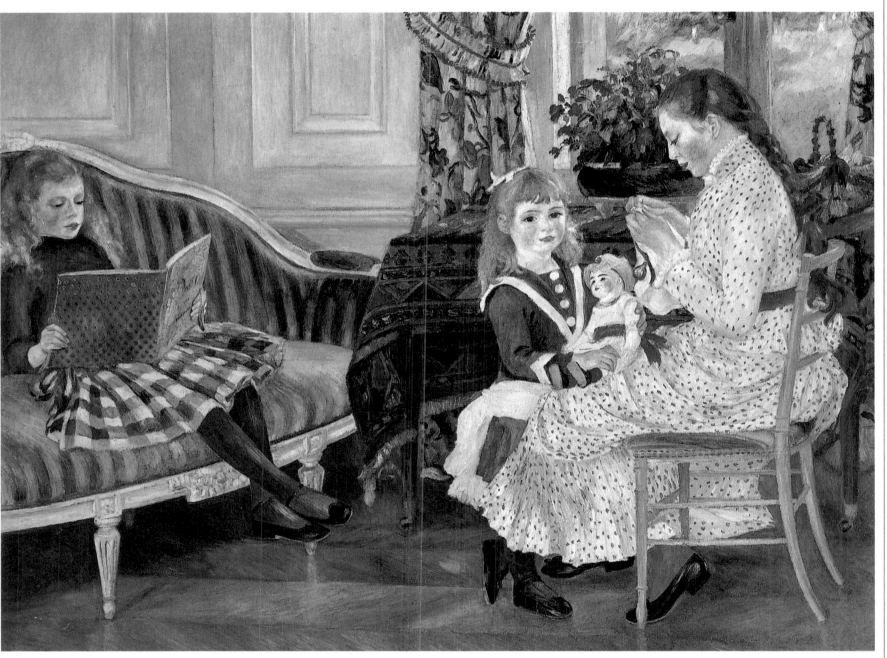

♦ Opposite, Sailor Boy (Robert Nunès), 1883. Oil on canvas, 130.2 x 80 cm (51 1/4 x 31 1/2 in). The Barnes Foundation, Merion, Pa. In August 1883 Alfred Nunès, Pissarro's cousin and mayor of Yport, a town on the coast of Normandy, asked Renoir to execute two companion portraits of his children Aline and Robert. While he based his canvas of the girl on her adolescent charm, the background rich in delicate light reflected from the garden, her brother is rendered in a proud pose in the midst of an animated coastal landscape. As usual, for "official" portraits Renoir draws upon the tradition of seventeenth-century portraiture, especially Velásquez and Van Dyck. The boy's face is rendered faithfully and the figure is carefully modeled. Yet, as is the case with his bathers. the artist blends the clothes with the landscape in a play of matching and complementary color nuances, heightening the blue of the sailor suit with red and purple and then repeating the red in the pompom of the cap and in the earth around him.

♦ Above, The Children's Afternoon at Wargemont, 1884. Oil on canvas, 127 x 173 cm (50 x 68 in). Nationalgalerie, Berlin. Paul Bérard's three daughters are portrayed here: Marthe, the eldest, at right, Marguerite at left, and little Lucie in the middle. The Wargemont living room competes explicitly in elegance with that of Madame Charpentier. Perhaps as a reply to criticism of his new style, Renoir creates a monumental space which is heightened by the carefully modeled volumes and the pure, classical structural rigor.

172

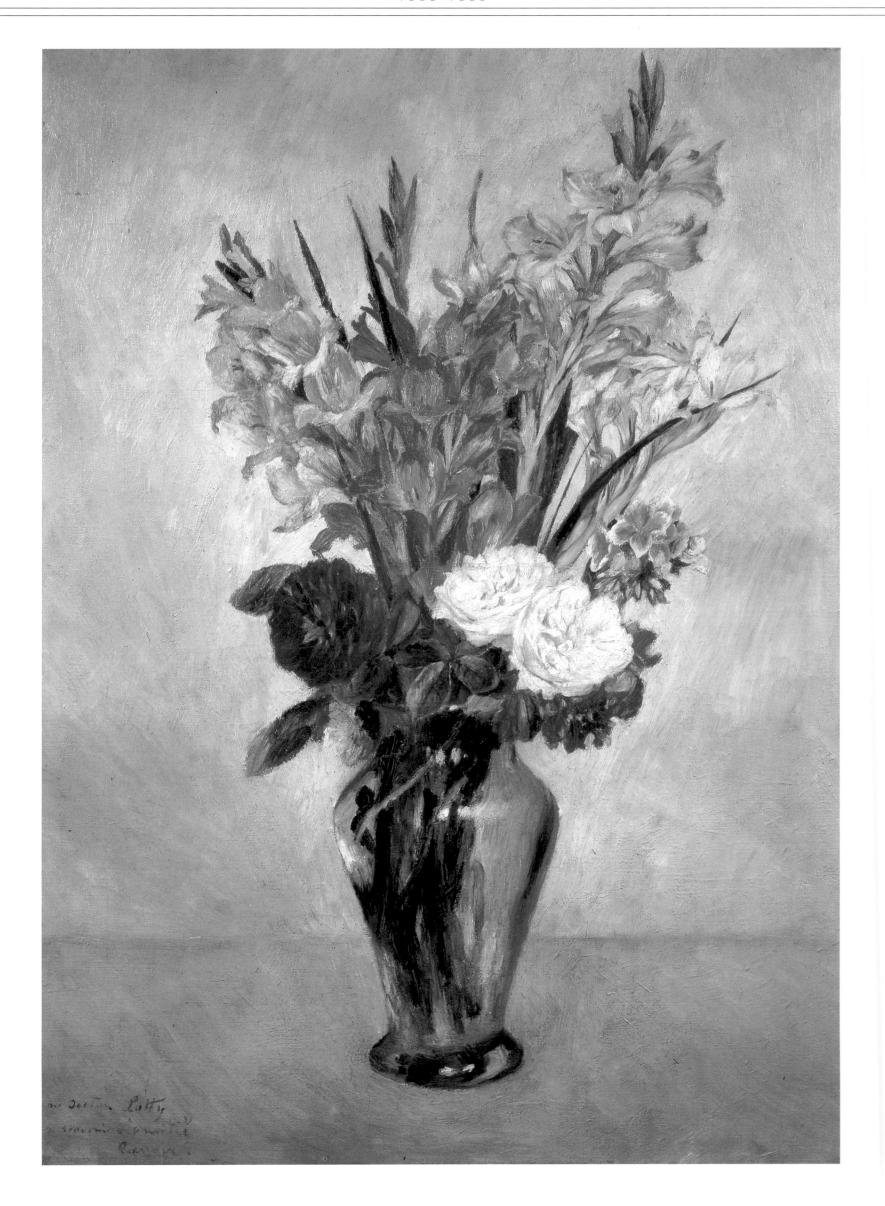

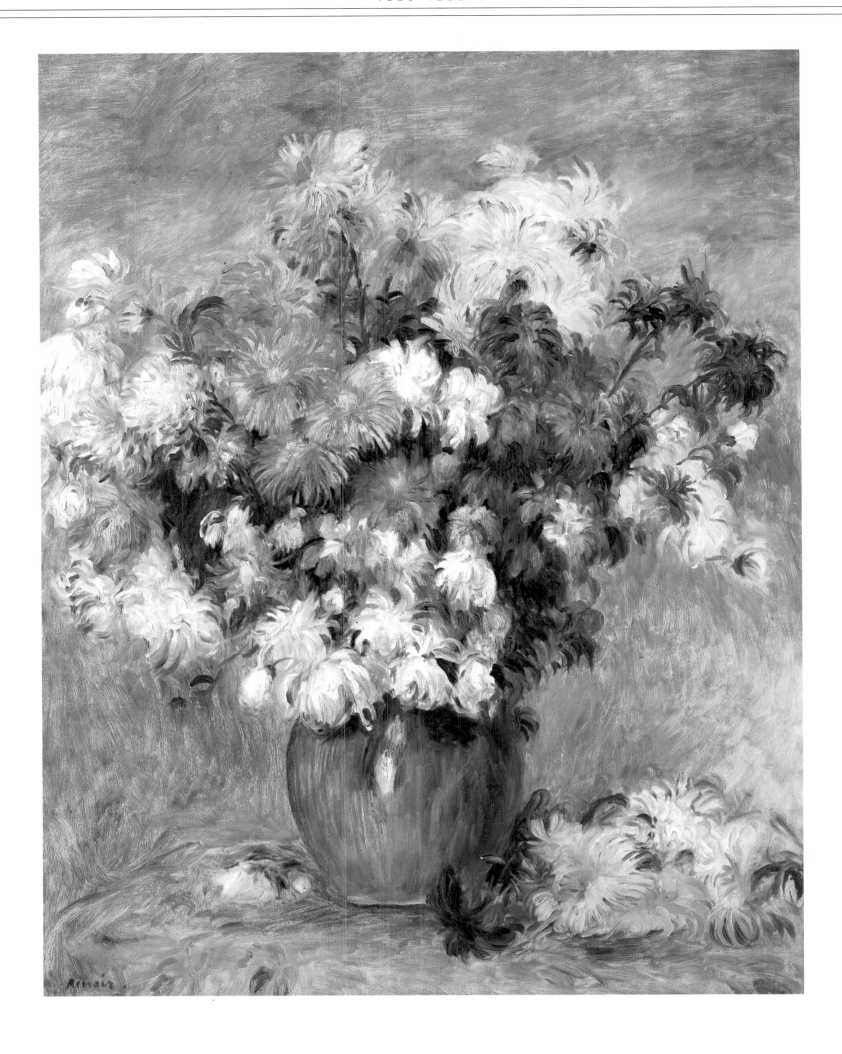

♦ Opposite, Gladioli, ca. 1885. Oil on canvas, 75 x 54.5 cm (29 1/2 x 21 3/8 in). Musée d'Orsay, Paris.

♦ Above, Chrysanthemums in a Vase, ca. 1884. Oil on canvas, 81 x 65 cm (31 7/8 x 25 5/8 in). Musée des Beaux-Arts, Rouen.

Art collectors had to persuade Renoir paint this luxuriant, decorative motif for them, though it was certainly congenial to his carefree nature and his love of rococo. There are traces of his "dry" manner in this work.

174

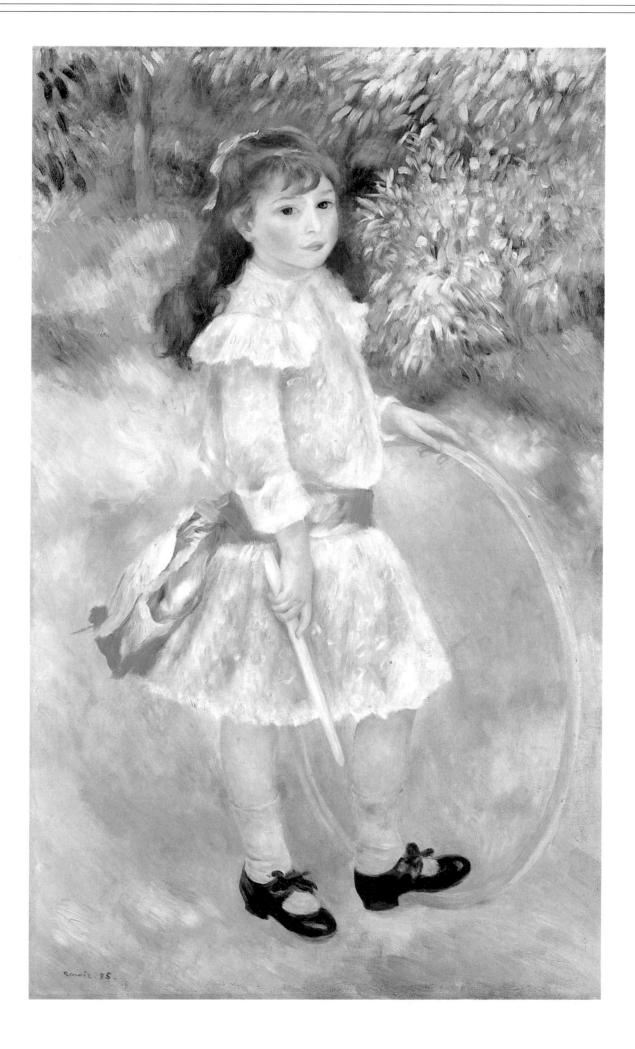

♦ Girl with a Hoop, 1885. Oil on canvas, 125.7 x 76.6 cm (49 1/2 x 30 1/8 in). National Gallery of Art, Washington D.C. In April 1885, Dr. Goujon asked Renoir to do portraits of his four children. Here Marie, the eldest, is depicted in a companion piece to the portrait of her brother Étienne, in their garden. The motif of the hoop seems to emphasize the new geometric, formal arrangement of space typical of the artist's aigre period. However, he still blends the figure and the background in a rich combination of color nuances and reverberations.

175

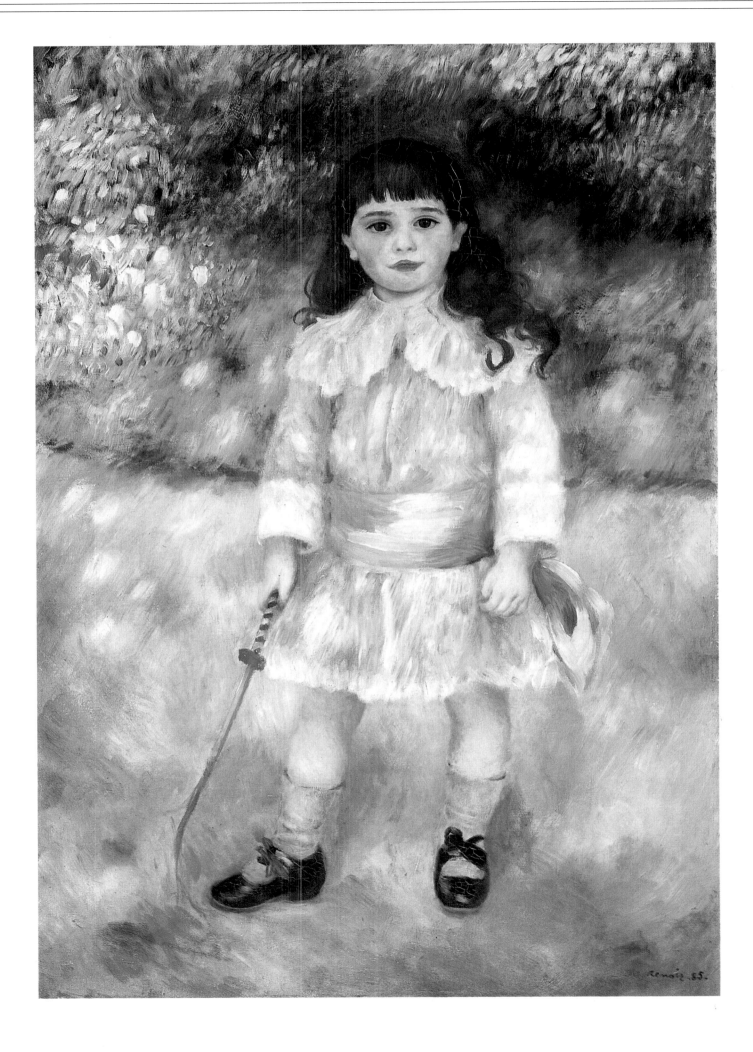

♦ Child with a Whip (Étienne Goujon), 1885. Oil on canvas, 105 x 75 cm (41 7/8 x 29 1/2 in). Hermitage, St. Petersburg. Little Étienne is staring naively yet impudently at the viewer. Just as in the portrait of his sister Marie, the garden is rendered with fluent but regular brushstrokes that return to the soft tonalities of Impressionist luminism. The background and figure are blended by means of color reflections: the green grass and blue sky "penetrate" the white dress and also serve to balance the warm tonalities of the background with a cold touch.

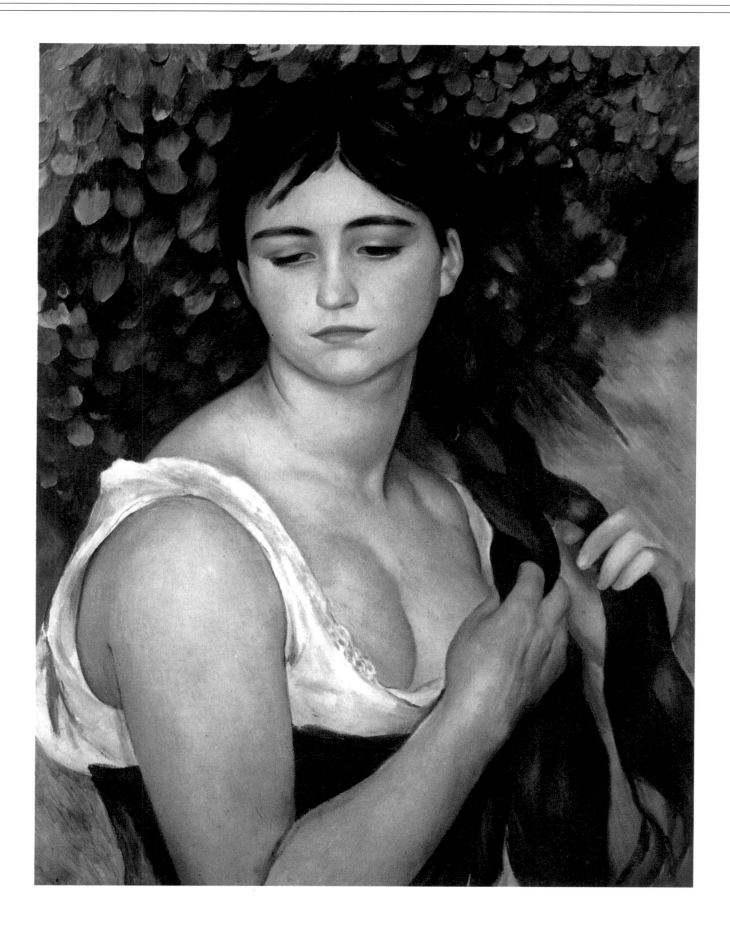

♦ *Above,* Girl Braiding Her Hair, *1886-87. Oil on canvas, 56 x 47 cm (22 x 18 1/2 in). Private Collection. Once again Suzanne Valadon was the model for this canvas, which could be considered one of Renoir's "driest" because of the many-faceted consistency of the brushstroke (similar to Cézanne's) and the opaque gradations of color, almost as if the artist were seeking the quality he admired Raphael's frescos and had studied in Cennini's treatise on art.*

♦ *Opposite,* Aline, *ca. 1885. Oil on canvas, 65 x 54 cm (25 3/4 x 21 1/4 in). Museum of Art, Philadelphia. This canvas was probably executed in Essoyes, Aline's home town, just after the birth of Pierre, the Renoirs' first child. The brushwork is solid and parallel, as in Cézanne, but the color is transparent, with carefully modulated nuances in the cold and warm yellow and sky-blue tonalities that are the fabric of the overall harmony of this work.*

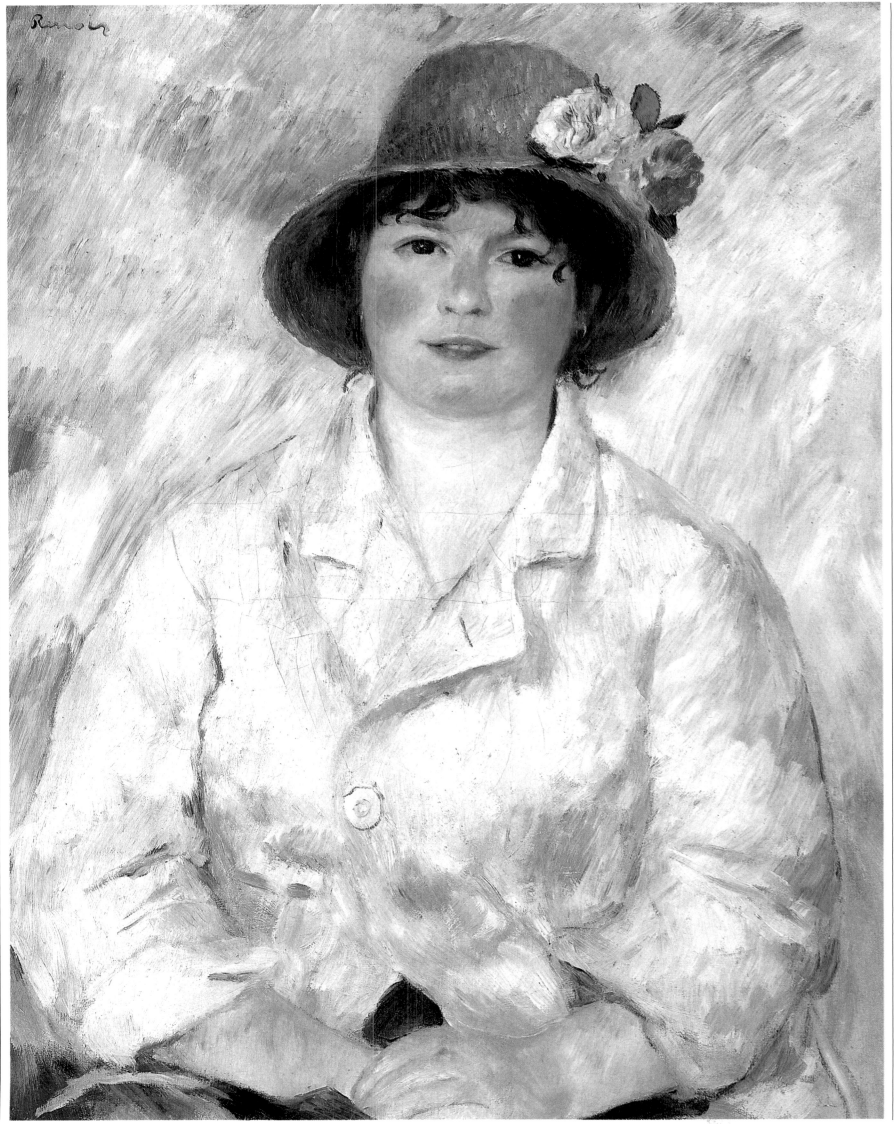

178

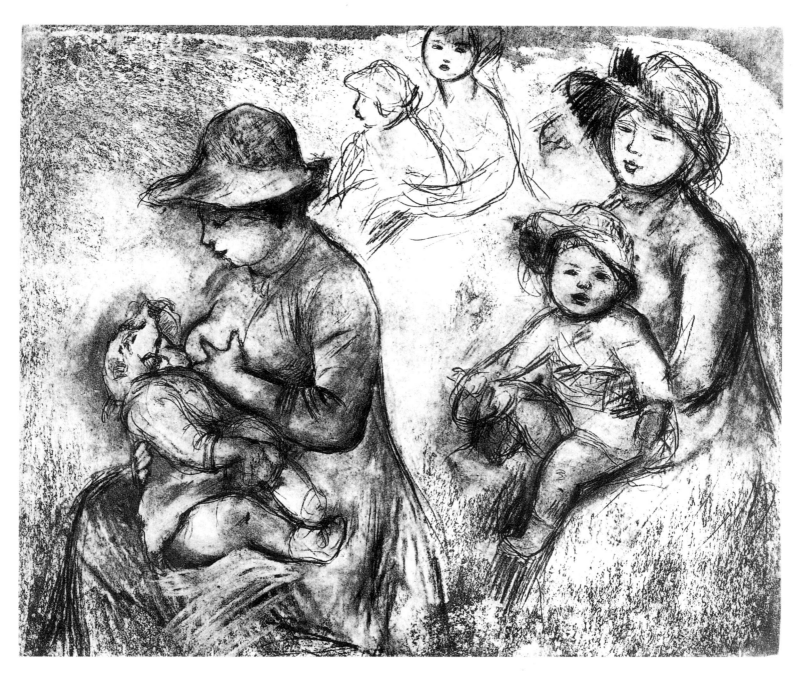

♦ *Above,* Three
Studies for "Nursing
(Maternity)", 1886.
*Lithograph, 20.2 x
24.3 cm (8 x 9 1/2
in). Bibliothèque
Nationale, Paris.*

♦ *Right,* Study for
"Nursing
(Maternity)", 1886.
*Sanguine and white
chalk on paper, 50 x
60 cm (19 5/8 x 23
3/4 in). Harry A.
Woodruff Collection,
New York.* Renoir
carefully planned his
major canvases
through a series of
preparatory studies

and drawings. With
Nursing he set out to
create an "archetype"
of the modern
Madonna and Child,
and drew on
Renaissance models
in the studies
reproduced here. The
pose he finally
selected is the most
intimate, much like
Leonardo da Vinci's
Madonna Litta.
In the group he
discarded, above at
right, he worked
from a Raphaelesque
model.

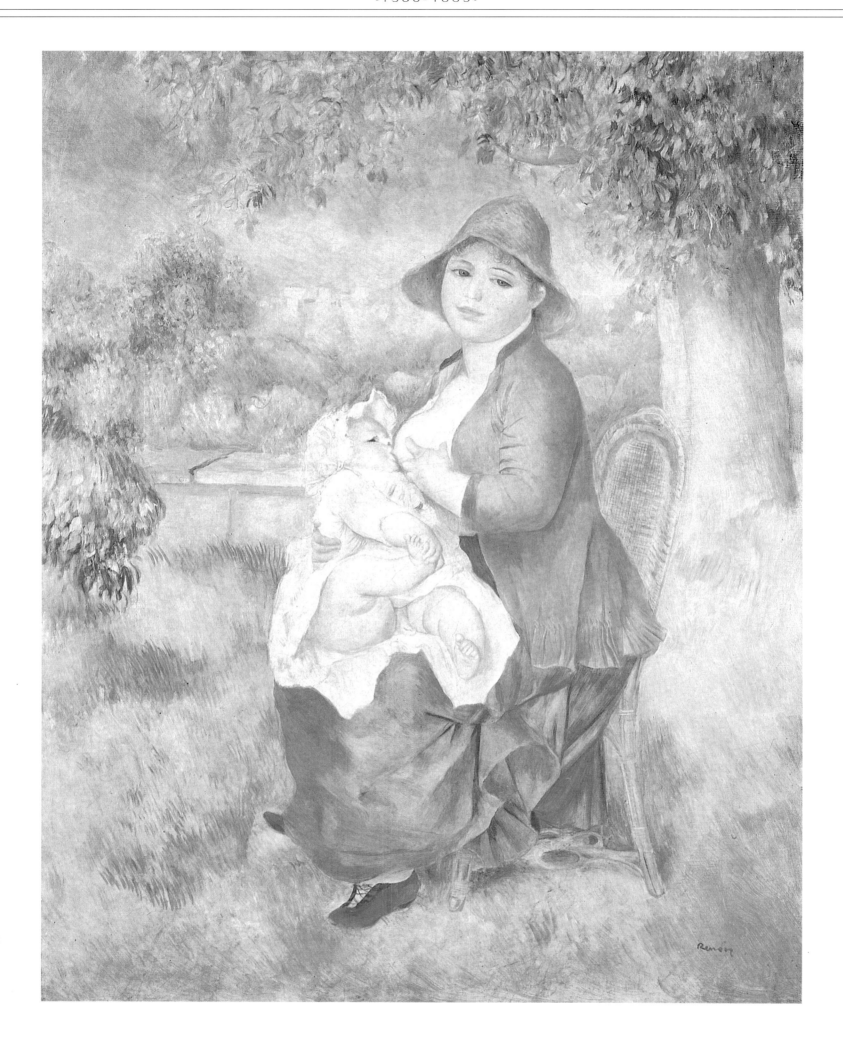

♦ Nursing (Maternity), 1886. Oil on canvas, 81 x 64 cm (31 3/4 x 25 in). Private Collection. "The freest, most solid, most marvelously simple and vivid painting one can possibly imagine, the arms and legs of true flesh and blood, and what an expression of maternal tenderness!" This is how Renoir described to Vollard the impression made during his trip to Florence by Raphael's Madonna of the Chair, which was one of the models for his Nursing. The refined arabesque of Renoir's contours, which reminds one of Ingres, is admirable.

180

♦ Above, Seated Bather, 1885. Pencil and white pencil on paper, 33.5 x 24 cm (13 x 9 1/2 in). Private Collection. Opposite top, Study for "The Bathers (Grandes Baigneuses)", 1884-85. Sanguine on paper, 108 x 162 cm (42 1/2 x 63 3/4 in). Cabinet des Dessins, Louvre, Paris.

♦ Opposite center, Study for "The Bathers (Grandes Baigneuses)", 1885-86. Watercolor, pencil and pen on paper, 32. 5 x 49.5 cm (12 3/4 x 19 1/2 in). Cabinet des Dessins, Louvre, Paris.

♦ Opposite bottom, Study for "The Bathers (Grandes Baigneuses)", ca. 1887. Pastel and red chalk

on paper glued to canvas, 82.8 x 119.3 cm (35 5/8 x 47 in). Christie's, London. These drawings are among Renoir's best works and allow us to appreciate the quality of his design— precise and fluid outlines, as elegant as Ingres and at the same time capable of capturing the "soul," the inner dynamism of a human body,

much like Degas. Note the endless variations of the pose, from the static monumentality of the first nude to the rhythm of the upraised legs and arms, as in a frieze. One of the many sources of Grandes Baigneues was François Girardon's Nymphs Bathing, sculpted at Versailles for Louis XIV.

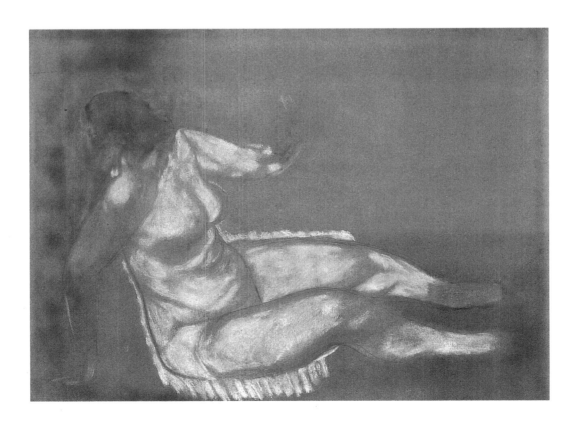

182

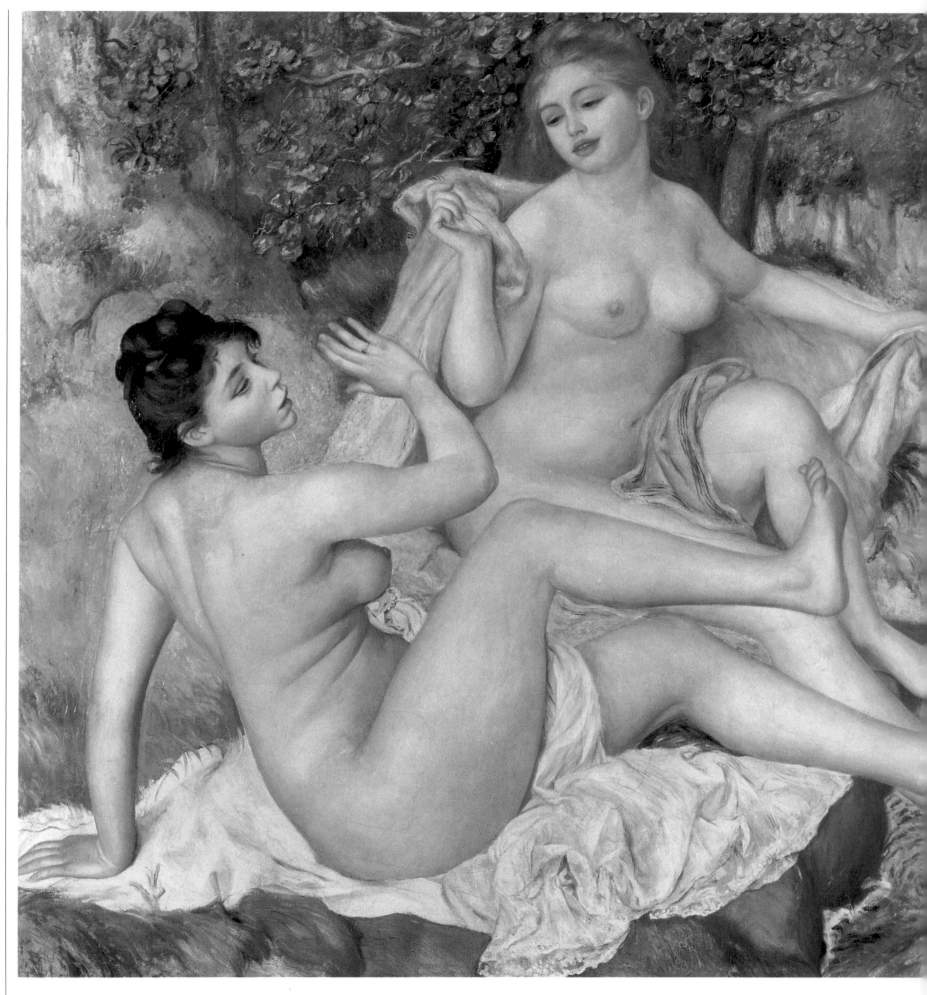

♦ The Bathers (Grandes Baigneuses), 1884-87. Oil on canvas, 115 x 170 cm (45 1/4 x 67 in). Museum of Art, Philadelphia. This large canvas seems to hark back to the opaque tones and thin brushwork typical of frescos. The subtitle of this work, "Essay in Decorative Painting," underscores the "timeless" quality of the subject and the artist's determination to be subject to only one obligation: "decoration," and not likeness; in other words, the pure pleasure of the free play of forms. Théodore de Wyzéwa later spoke of "supernatural emotion" and "the delightful mixture of vision and dream."

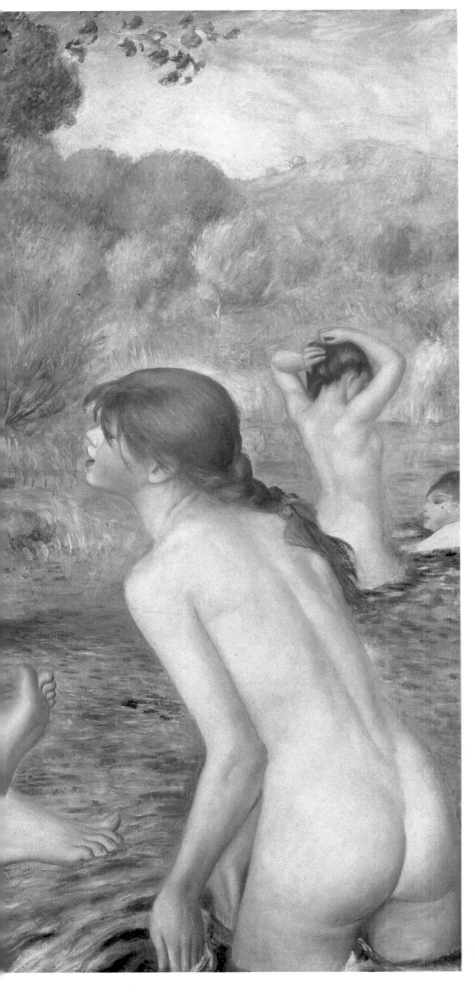

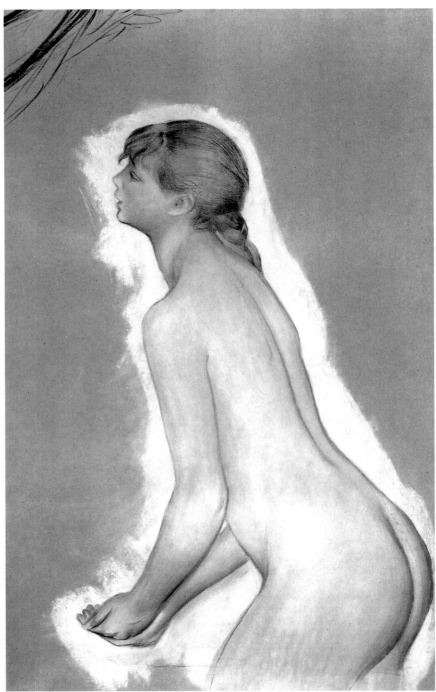

♦ Study for "The
Bathers (Grandes
Baigneuses)," ca.
1886-87. Pencil,
chalk and wash on
brown paper, 98.5 x
64 cm (38 3/4 x 25
1/4 in). Art Institute,
Chicago. This is one
of the most exquisite
homages to Ingres'
famous "odalisque
backs."

184

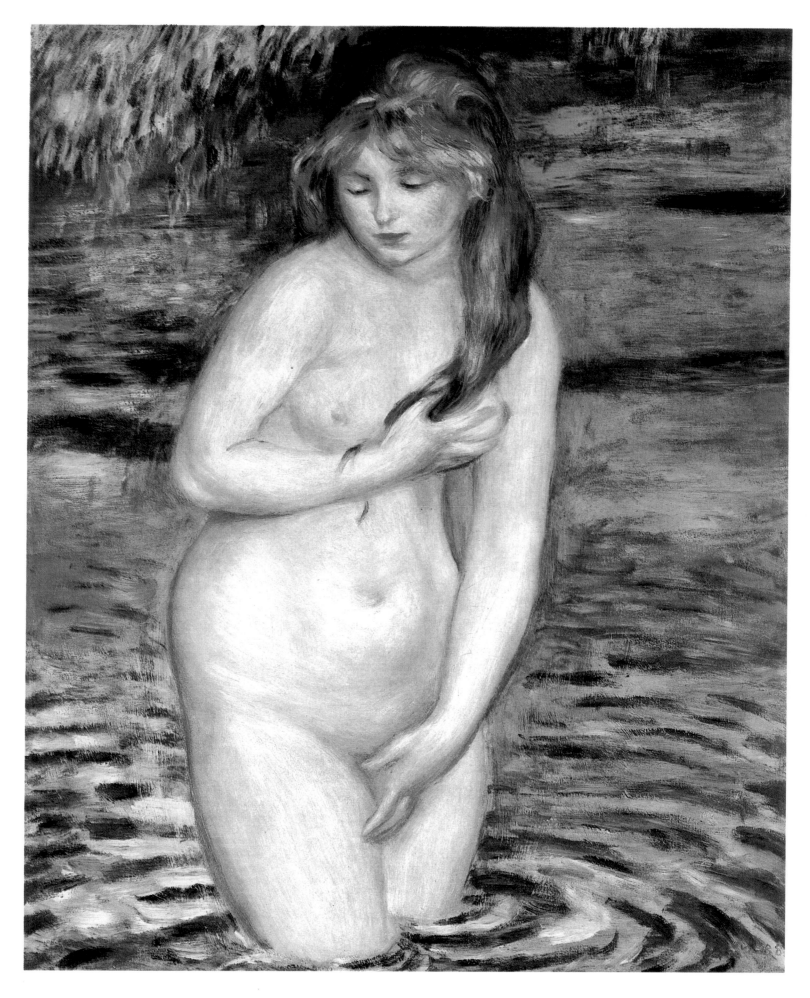

♦ *Above,* After the Bath, *1888.*
Oil on canvas, 81 x 66 cm (31 3/4 x 26 in). David Lloyd Kreeger Collection, Washington D.C.
The nude stands out clearly against the background, which is rendered in separate luminous brushstrokes; but there is a certain soft quality that heralds the approaching end of Renoir's aigre period.
The pose is taken from ancient statues of Venus bathing.

♦ *Opposite above,* Bather Arranging Her Hair, *1887. Oil on canvas, 40 x 31 cm (24 1/8 x 18 1/8 in). National Gallery, London.*

♦ *Opposite below,* Edgard Degas, Nude Woman Combing Her Hair, *1888. Pastel on paper, 61.3 x 46 cm (24 x 18 in). Metropolitan Museum of Art, New York. The two artists are here compared in the traditional motif of women busy at their toilette. Renoir sets his nude* outdoors amidst the subdued light emanating from the foliage and the truly eternal "décor" of nature. Degas on the other hand places his nude in a vague, almost neutral, context and renders it almost aggressively with rapid, dry pastel strokes. The only common denominator between the two works is the reference to Ingres' supple lines.

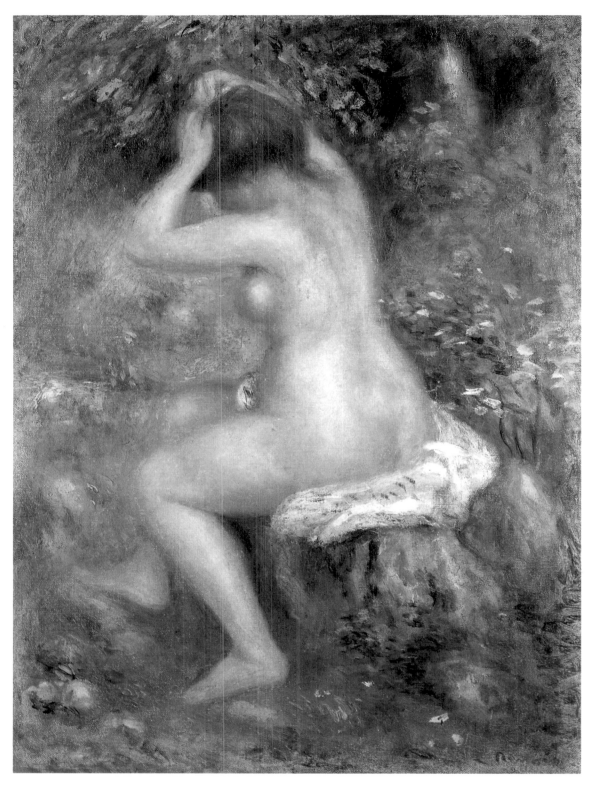

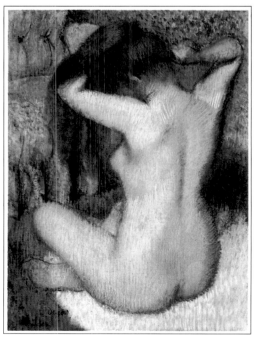

186

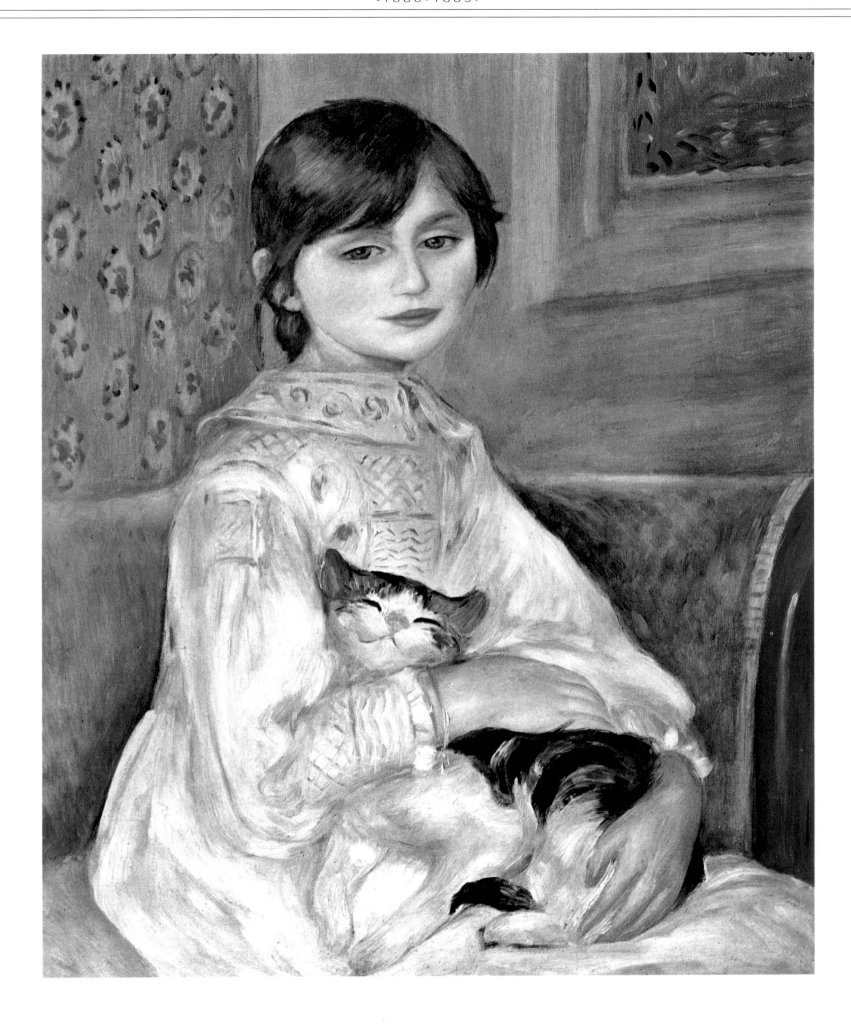

♦ Julie Manet with a Cat, *1887. Oil on canvas, 64.5 x 53.5 cm (25 1/2 x 21 in). Rouart Collection, Paris. The tender pose partly mitigates the rather rigorously rendered features of* Julie, Berthe Morisot's daughter who was entrusted to Renoir and Mallarmé's guardianship after her mother's death. Once again we are reminded of Ingres, *especially his* Mademoiselle Rivière, *who has the same perfectly oval face, almond-shaped eyes and slightly tilted head. Renoir also plays on the similarity of the* girl's face with that of the cat; this "feline" feature was part of the artist's ideal of feminine beauty: *"Cats are the only women that count, the most entertaining to paint..."*

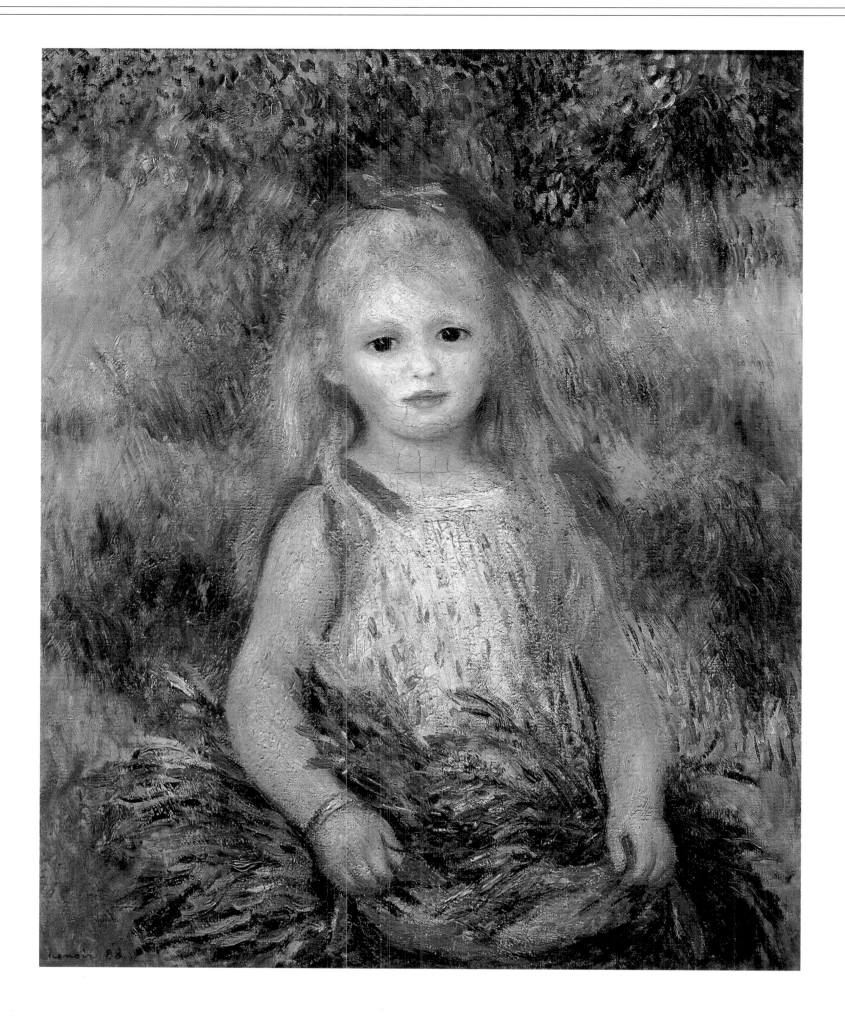

♦ Girl with a Basket ("Little Gleaner"), 1888. Oil on canvas, 66 x 54 cm (26 x 21 1/4 in). Museu de Arte, Sao Paulo. After overcoming the technical crisis that, up to The Bathers, had greatly reduced his production, and upon the insistence of Durand-Ruel, in 1888 Renoir returned to techniques that had previously inspired his oeuvre: the Impressionist tache, Corot's tonalism, rococo light, Cézanne's solid brushwork. Thus was born Girl with a Basket, whose figure is still clearly modeled but is rendered with thick, dynamic brushstrokes, blended with warm hues and softened in the vibrating, golden light.

188

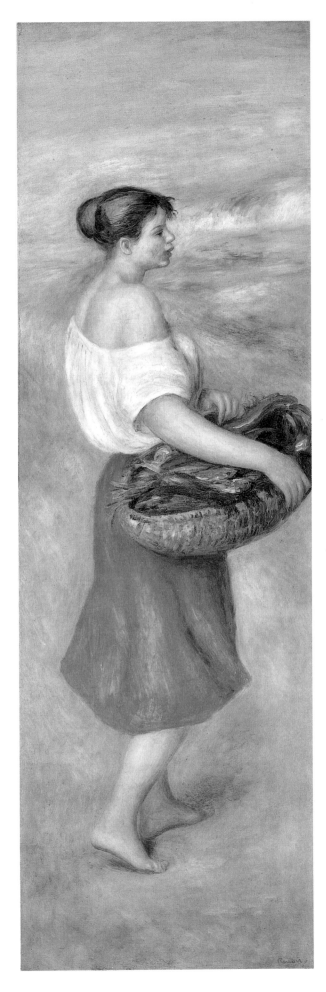

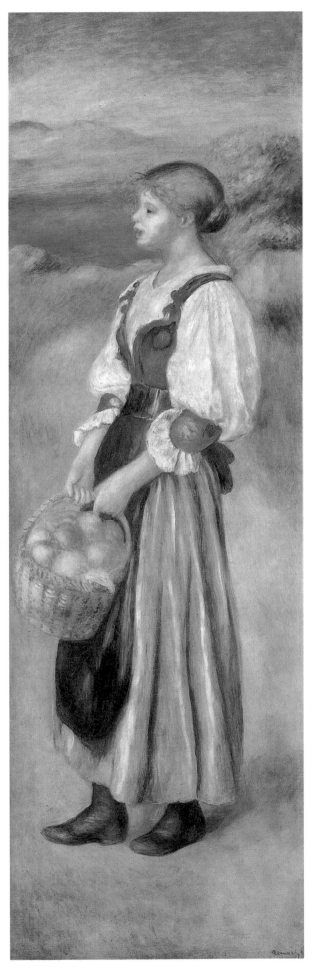

♦ *Left*, Girl with a Basket of Fish, *1889. Oil on canvas, 130.7 x 41.8 cm (51 1/2 x 16 1/2 in). National Gallery of Art, Washington D.C.*

♦ *Right*, Girl with a Basket of Oranges, *1889. Oil on canvas, 130.7 x 42 cm (51 1/2 x 16 1/2 in). National Gallery of Art, Washington D.C. These companion pieces were painted for the Durand-Ruels' living room in rue de Rome, Paris. The motif of the seasons is a modern revival of a typically eighteenth-century decorative theme.*

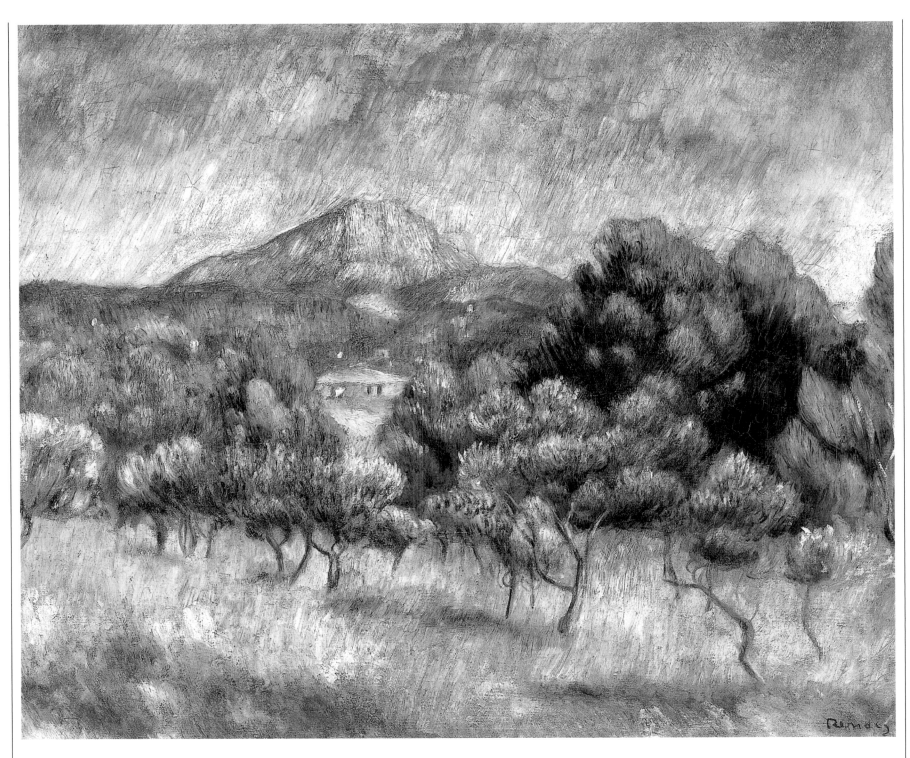

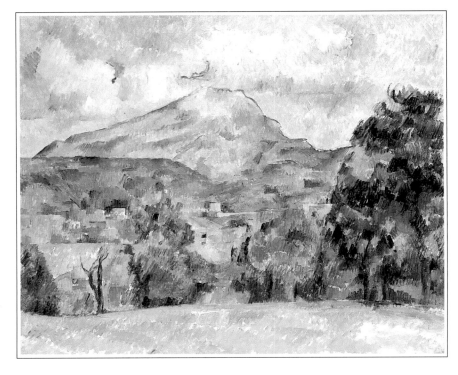

♦ *Above*, Mont Sainte-Victoire, *1888-89. Oil on canvas, 53 x 64 cm (20 7/8 x 25 1/4 in). Yale University Art Gallery, New Haven*

♦ *Right,* PAUL CÉZANNE, Mont Sainte-Victoire Seen from the Southwest, with Trees, *1888-89. Oil on canvas, 65.1 x 80 cm (25 1/2 x 31 1/2 in). Museum of Art, Baltimore. The artist from Aix-en-Provence called Mont Sainte-Victoire his petite sensation: the more familiar it was, the more ideal a tool to penetrate beneath pure sensory perception and reveal the hidden* structure of the natural universe. Renoir, who had to stay for long periods in the Midi because of his illness, tackled his friend's favorite motif. Whereas Cézanne creates his view as if he were really observing it "from within," Renoir, albeit with a solid brushstroke, views the mountain "from without," rendering the atmosphere bathed in light and adhering to traditional perspective in the rows of receding trees.

190

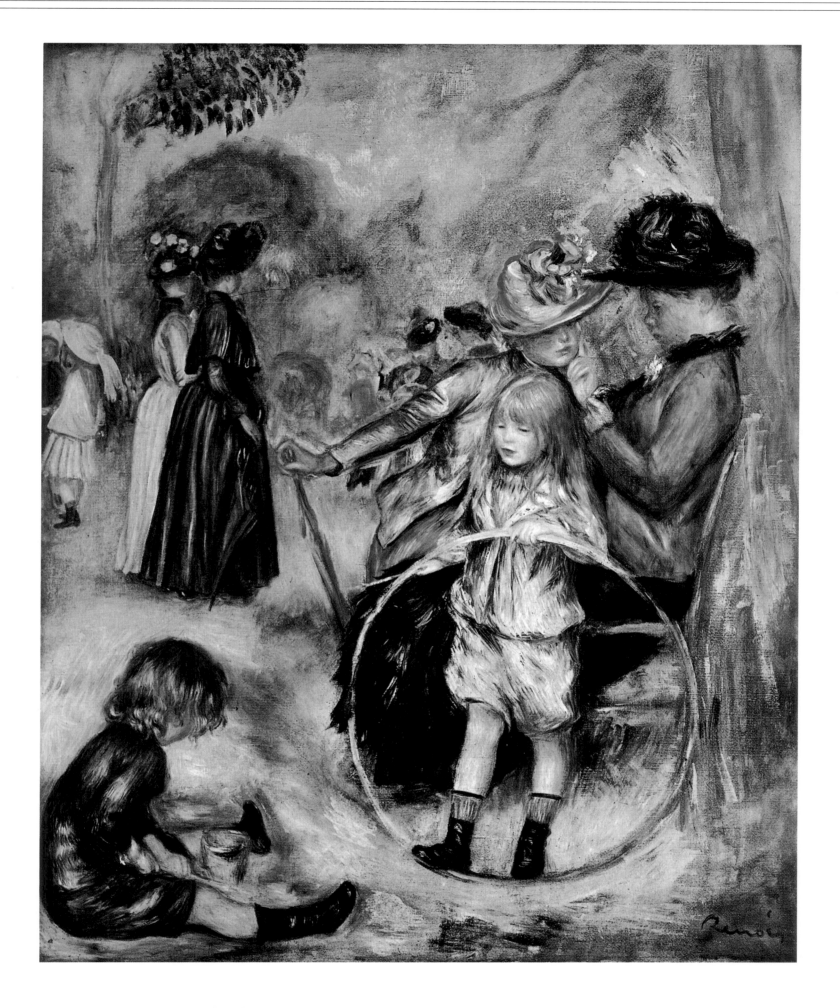

♦ *Above*, In
Luxembourg Garden,
1886-89 (?). Oil on
canvas, 64 x 53 cm
(25 x 20 3/4 in).
Private Collection.
Of Renoir's works,
this is one of the
most difficult to
date; it is usually
placed around 1883,
but the rather dry

modeling, typical of
his aigre period, and
the bright, feathery
brushstrokes suggest
a later date.

♦ *Opposite*, The
Vintagers' Luncheon,
ca. 1888-89. A.
Hammer
Foundation, Los
Angeles.
HHkkkHkjkjThis
work is also usually
dated around 1884.
but the subtle,
lengthened
brushwork around

the forms, the
complex spatial
structure in different
directions (which
reminds one of
Cézanne), and the
analogous handling
of the 1888 work The
Washerwomen,
suggest a later date
in this case as well.

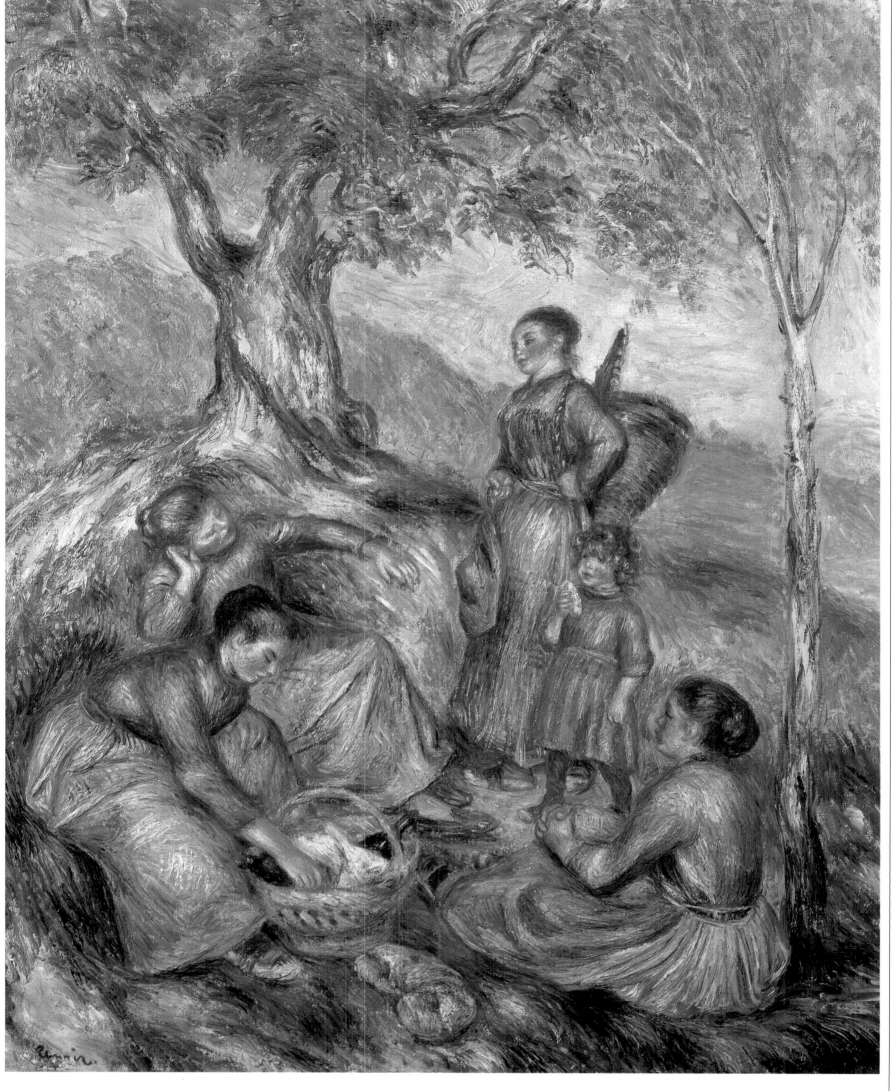

The "Pearly" Period

Just as Titian's "Michelangelesque" Mannerist crisis was the prelude to his magnificent late masterpieces (as the art historian Carlo Ludovico Ragghianti so brilliantly noted), the transition from Renoir's "dry" period seems to have eliminated all doubts and uncertainty, all need for self-assertion.

From this time on his style freely embraced elements from his previous works—the Impressionist brushstroke, the monumental clarity and design of *The Bathers*, and the flowing softness of his porcelain painting. In this serene mature period, which foreshadowed the expressive and creative liberation of his final works, Renoir finally achieved a felicitous synthesis of his entire formal procedure. "For me painting must be agreeable, joyful and pretty—yes, pretty! There are enough depressing things in life without our creating still more." This "aesthetic of pleasure and joy" made Renoir famous, but at the same time he was hastily labeled a superficial artist. Yet the young ladies who, from 1890 on, were painted in various occupations and pastimes—whether gathering flowers or plucking the strings of a guitar, or again gracefully arranging their hair—are direct descendants of the noble line of Lancret's and Watteau's shepherdesses—but without that veil of occasion, "purged of their frequent artificiality and recurrent banality and created with a universally human vigor and fascination."

In these works the color is brighter, the brushwork thicker and more carefully structured; but at the same time, Renoir's brighter palette imparts a heretofore unknown lightness to the whole. Renoir's new-found capacity to synthesize, a lesson he learned from Ingres' linear draughtsmanship, achieves a clear-cut conciseness that takes the image onto a plane of spontaneous myth-making. As Octave Mirbeau said: "Renoir has not given a thought to fulfilling his destiny. He has lived and painted. He has done his job. Perhaps it is there that his genius lies [...] He has painted women and children, trees and flowers with the admirable sincerity of a man who believes that nature is at the disposal of his palette as simply as if it had been created from all eternity to be painted."

In 1890, during his stay in the country at Mézy at the home of Berthe Morisot, Renoir initiated his "pastoral" works with the series of adolescent girls: *In the Meadow and Picking Flowers*—a motif that Morisot herself would take up the following year, portraying in *Cherry Pickers* the graceful silhouette of two girls intent on gathering fruit. As in his friend's canvas, in Renoir the color range revolves around the pastel register—blue-green, azure, pink and yellow—and the thin, fluid effect of the background under the white prime creates the utmost luminosity, quite similar to the koalin technique in porcelain. At the same time, the mysterious amplitude of the natural setting achieved through long and fluid brushwork creates a sense of indefinable suspension. This is an "aptitude for evocation" which, in my opinion, is connected to the musical overtones of Symbolist poetry and with Renoir's determination to suggest rather than describe. It is certainly no accident that he tried his hand at engraving for his friend Mallarmé; this technique obliges the artist to make broad, rough-hewn lines that are often swallowed up in the rather indistinct background, a technique subject to unexpected results in the printing process and which therefore lends itself to vagueness. An example of this is *The Frilled Hat*, executed in various impressions in 1897 and 1898; the pretext of the most commonplace everyday gesture, in the ambiguity of spatial and tonal transitions, takes on the refined grace of a timeless mystery. Just like the geishas in Japanese prints, these girls are immersed in a fluid and velvety atmosphere that transfigures their physical reality and the fortuitousness of this occasion. In another print dated 1900, *Girls Playing Ball*, the fuzziness of the line flattens the sketchy landscape in the foreground, thus imparting lively energy to the scene, which is already quite vibrant thanks to the mercurial line and extemporaneous pose of the girls.

Through Mallarmé's good offices, Renoir received an official commission from the Director of Fine Arts, Henri Roujon, that was to be placed in the "museum of living artists," the Luxembourg Palace. There are six almost identical versions of *Girls at the Piano*—one in pastel and five oil paintings, all large-format—which reveal the artist's concern with creating a work that would be representative of him. Mallarmé was right when, in a letter to Roger-Marx, he predicted that Roujon would be embarrassed when it came time to choose from among the different versions; the work chosen—which was hung first in the Luxembourg museum, then at the Louvre and is now in the Musée d'Orsay—is perhaps the least successful, in which the interior is depicted in a more conventional manner and the expression on the faces is more studied. Renoir gave Caillebotte a much fresher version which has attenuated outlines and indefinite tonal transitions. For our present-day taste the best version is perhaps the one in the Walter-Guillaume collection, which was probably one of the first to be executed, given the rapid, blotchy application of color.

Yvonne and Christine Lerolle at the Piano is a very similar work. It was executed in 1897 in a totally different manner; the two faces are again side by side and concentrated, but the horizontal format divides the space in a more accentuated, less traditional manner that brings it closer to the viewer. Much like a frieze, the foreground stands out against the compressed background and the play of a "picture within a picture" is utilized once again, this time with two works by Degas (ballet dancers and horses at a race)—perhaps an homage to his fellow artist. Renoir kept this canvas in his living room until 1899 and then entrusted it to Durand-Ruel, who looked after it until the artist's death.

The motif of music is to be seen again in certain purely "genre" studies such as *Woman with Guitar* and *Young Spanish Woman with a Guitar* (1898). While in the former work Renoir again refers to Fragonard's and Watteau's pastoral scenes through the white dress with its delicate intermingling of the pink ribbons, and the low-keyed green and golden hues of the interior, the latter marks a return to that "Spanish" taste that had been so fashionable in the early works of Manet, which Renoir had admired and copied at the beginning of his artistic career.

This carefree youthfulness is accompanied by the bathers motif, which retains the synthetic efficacy of design that clearly outlines the forms, while at the same time injecting a touch of atmosphere by means of clear, brightened color harmonies (hence the term "pearly") and brushwork that blends the volumes with the background without disintegrating them. Renoir also resumes the fluent handling of the

brushstroke which, however, was still painstakingly detailed compared to the broad tache used during the height of Impressionism; the result is a "congealed" effect that heightens the albeit summary consistency of the bodies. It is interesting to note the evolution of his brushstroke from the *Seated Bather*, executed in 1892, to *Bather with Long Hair* (ca. 1895) and the fragrant sensuality of *Sleeping Girl*, dated 1897. It is thin and still feathery in the 1892 canvas, though softened by the tonal nuances; it is more hazy, amalgamated and grainy in the 1895 work, with the sudden blaze of the hair and cheek, in which the pigment is thicker; and again broad and fluid, but applied with greater ease, soft and unified in the 1897 canvas, in which the radiance of the crimson and gold enhances the bright tangibility of the flesh and heralds the "precious" style of Renoir's final years. Together with the animated nudes there is often a profusion of clothes, white textile and hats—"still lifes" introduced to capture the light is isolated areas overflowing with bright color. Furthermore, the poses are drawn from illustrious precedents: ancient statues of Venus bathing, fixing her hair or demurely concealing her nudity; or again, the many odalisques by Ingres, with their long curved backs that resemble a refined arabesque. *Seated Bather in a Landscape*, also known as *Eurydice*, owes its plastic solidity to the "prototype" of the famous ancient sculpture *Spinario* (*Boy Removing a Thorn from His Foot*), whose pose it imitates: the legs crossed, the head inclined.

"The most simple subjects are timeless. A naked woman emerging from the sea or getting out of bed, whether her name is Venus or Nini— you could never invent anything better than that." Renoir brings into focus the unimportance and hypocrisy of all disguises, be they classical or realistic. The mythological titles crop up again and again, but it is the same beauty, the same primitive and instinctive sensuality of the female body that generate the myth. Among the most important motifs of this period, executed twice from 1895 to 1901, *The Source* harks back to a canvas by Ingres and the reclining nude reminds one of Giorgione's and Titian's *Venuses*, as well as of Lucas Cranach's *Reclining Nymph*; another wellspring of inspiration were the reliefs Jean Goujon executed for the *Fountain of the Innocents in Paris* (1548-59), which had struck Renoir many years before when he was painting porcelain. But at times, lying there on a bed is merely the body of an ordinary woman, whose refulgent beauty, steeped in a profusion of heightened color, is enough to make a goddess of her.

Another favorite motif of Renoir's in this period was children's portraits. His personal domestic tranquillity, made even more stable by his marriage and the birth of his second son Jean in 1894, undoubtedly played a part in instilling gentle, intimate grace and charm in these modest genre scenes. *Jean Playing with Gabrielle and a Girl*—Gabrielle Renard was Aline's young cousin from Essoyes who became the family nursemaid and Renoir's new model and who was the source of the unmistakable merriment in the future film director's memoirs— *Gabrielle and Jean, and Martial Caillebotte's Children* present a simplified scene, for the most part in half figures, which is like a countermelody to the almost classical monumentality of the various bathers. However, this simplification is more apparent than real. These interiors— which were influenced by Degas and were precursors of Bonnard's and Vuillard's oeuvre—flattened on to a foreshortened backdrop (be it a wall, a curtain, or a divan), are imbued with spatial ambiguity in the contrast between the obstacles set in the way of the viewer's gaze and the regular sequence of verticals that suggests a further extension "elsewhere" in space, and the whole is made uniform by the brushstroke. In Martial Caillebotte's Children a subtle psychological conflict permeates the room. The girl is holding the book on her lap, makes it difficult for her brother to see it, does not look at him and keeps the other books out of his reach: in this "battle of the sexes" the female wins the day.

The Artist's Family, now in the Barnes Foundation collection, is a large-scale work that is virtually sculpturesque. At left, the adolescent Pierre is leaning on his mother and linking arms with her, while at right the crouching Gabrielle is supporting Jean—who acts as a spatial link and hub, like the girl in Degas's *Bellelli Family*—and a girl, perhaps Paul Alexis's daughter, is playing with her hair in an act of precocious coquetry and naive provocation. This imposing family group, which as always is articulated in the foreground much like a bas-relief sculpture, has been likened to Velásquez's *Las Meninas*; but the entire century of Baroque art of Rubens, Van Dyck and Franz Hals is alluded to in this scene, perhaps with a touch of subtle and sympathetic irony. The opposite of such childlike innocence, which by the way is rendered with objectivity and without sentimentalism, is the Self-portrait executed in 1899; Renoir seems intent on showing us the fatigue and fragility of consciousness, the true "scourge" of adulthood. The acid yellow tonalities in the "Japanese" tapestry tighten the flesh and accentuate the hollowed volumes in the artist's face, which is in a three-quarter view towards the shadow, much like a premonition. If the date is correct, Renoir had just had the first terrible attack of rheumatism that paralyzed him; indeed, the disease seems to describe the invisible horizontal of his gaze. Julie Manet, who upon the death of her mother, Berthe Morisot, had been placed under Renoir's guardianship, recalled the work in her diary: "[...] He is finishing a self-portrait that is very nice. First he had made himself a little stern and too wrinkled; we absolutely insisted that he eliminate a few wrinkles and now it's more like him. "It seems to me that those calf's eyes are enough," he says." "Flowers and fruit are the passion of the most sincere Impressionists, since they offer the opportunity to render all the brightest luminosities," said Ugo Ojetti at the presentation of Renoir's works at the 1912 Venice Biennale exhibition, comparing him with the Italian painter Gaetano Previati. Yet in the still lifes that round off this brief account of motifs Renoir used in this period, the flowers and fruit may be luxuriant in the thick impastos, but their forms are slightly flaccid— perhaps another premonition, a vanitas, the sense of an end drawing near. However, the living quality of these objects emerges thanks to Renoir's bright red tonalities, the warmth of which more than compensates for any possible traces of melancholy. For those who know how to observe, life—or "still" life—can be seen and felt even in Peaches on a Plate, which are as delicate and touching as the nuances in a canvas by Chardin, the eighteenth-century master of the quiet, inexhaustible mystery of objects.

194

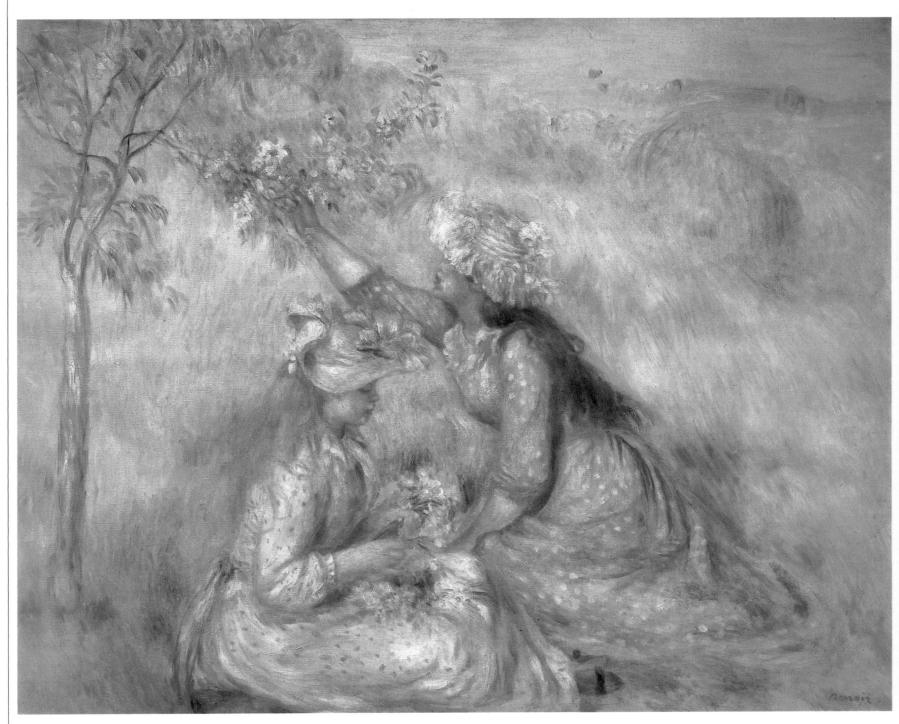

♦ Above, Picking Flowers, ca. 1890. Oil on canvas, 65 x 81 cm (25 5/8 x 31 3/4 in). Museum of Fine Arts, Boston. The pastel colors bring porcelain decoration to mind, and the motif is much like an eighteenth-century "pastoral scene" that is handled with the fluency of the Impressionist brushstroke.

♦ Opposite, In the Meadow, ca. 1890. Oil on canvas, 81 x 65 cm (31 3/4 x 25 5/8 in). Metropolitan Museum of Art, New York. With its lack of a "story" and of any psychological overtones in the figures, and the vagueness of the natural setting, this canvas a fine example of "genre" painting. The brushwork is vaporous, oblique, with sudden "blotches" of light inherited from Impressionist pictorial research

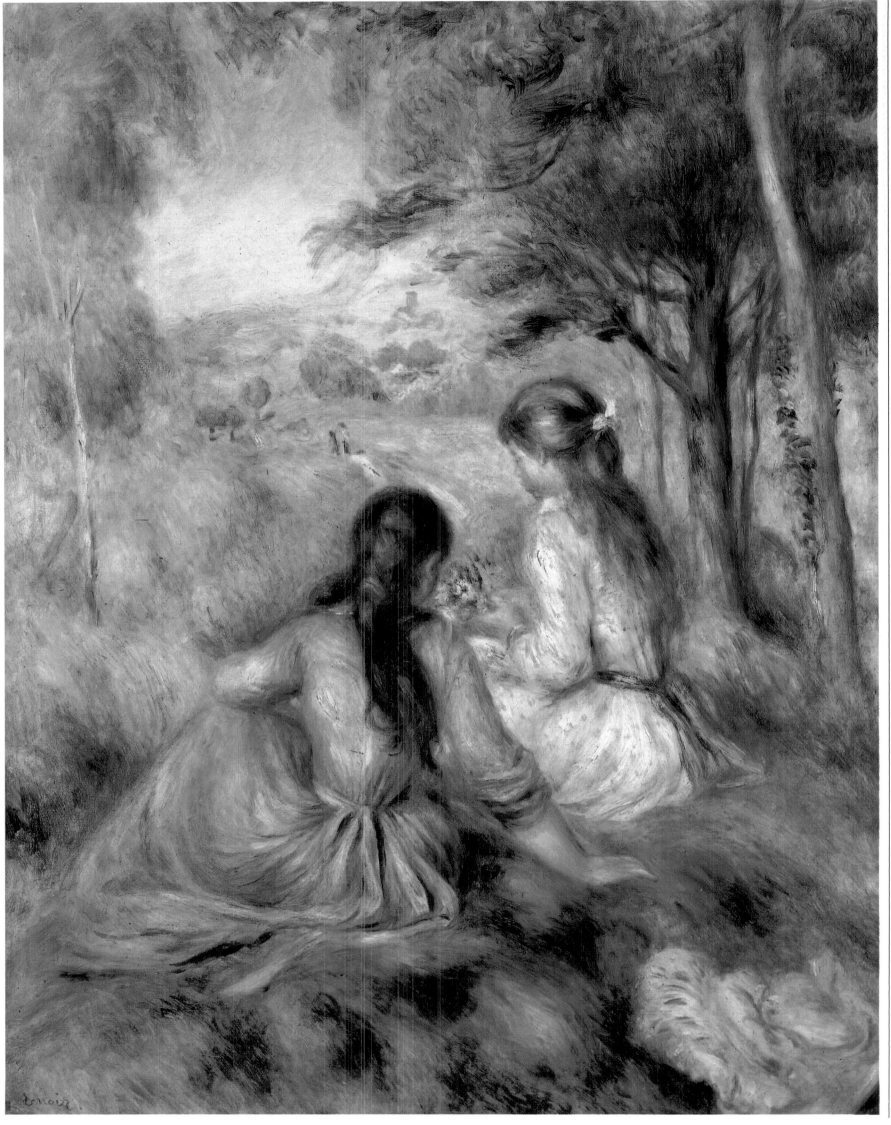

196

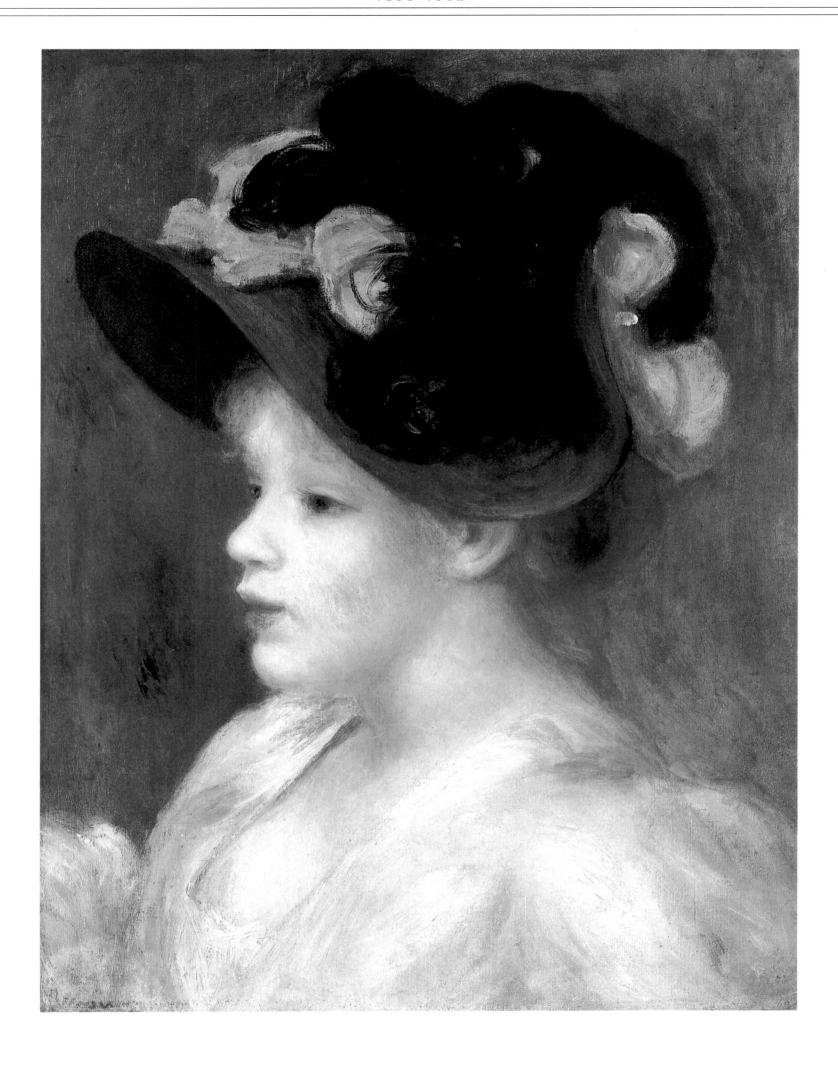

♦ Girl with a Pink and Black Hat, ca. 1890. Oil on canvas, 40.6 x 32.3 cm (16 x 12 3/4 in). Metropolitan Museum of Art, New York. Renoir here plays at "quoting" from his Impressionist period, immersing the elegant profile in the dark background and yet making sure to attenuate this contrast with his new, light brushstroke.

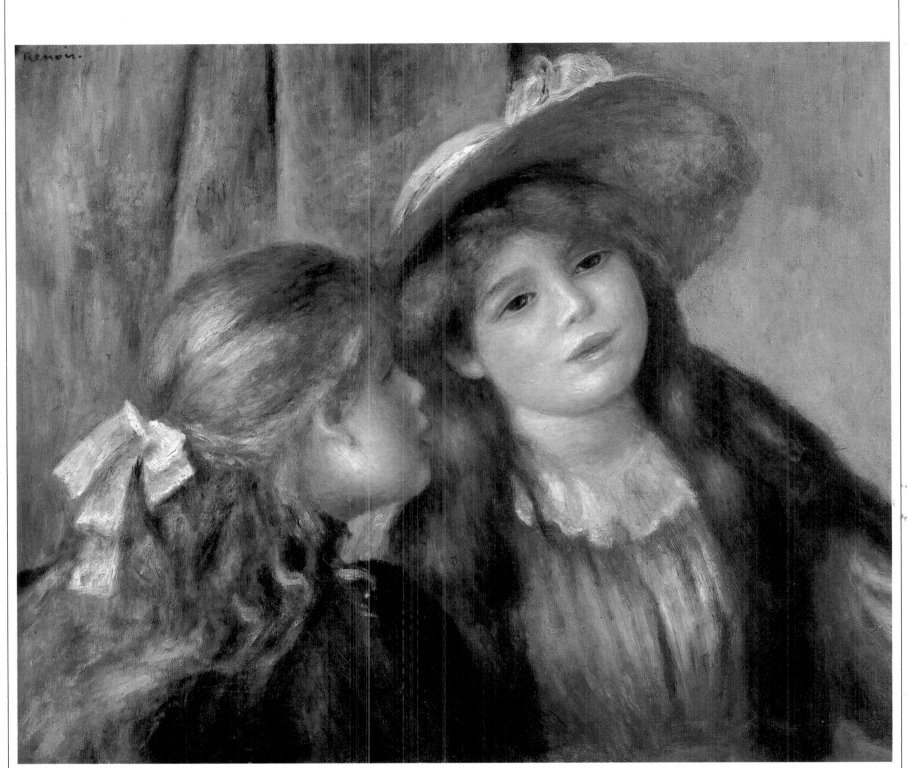

♦ Two Girls, *1890-92.*
Oil on canvas, 46.5 x
55 cm (18 1/4 x 21
1/2 in). Musée de
l'Orangerie, Paris.

This is a virtuoso
display of variations
on a theme: hair,
ribbons, hats.

198

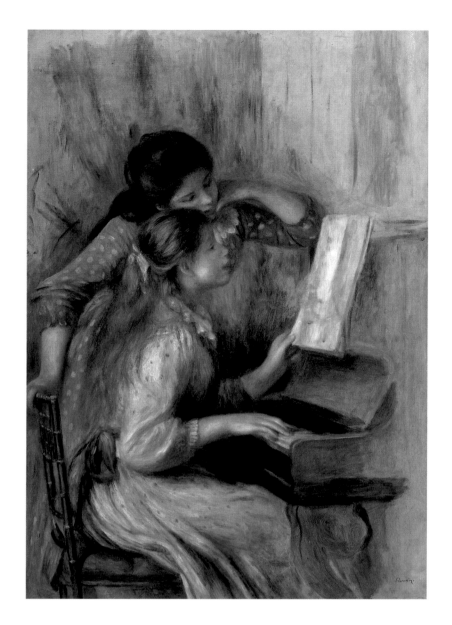

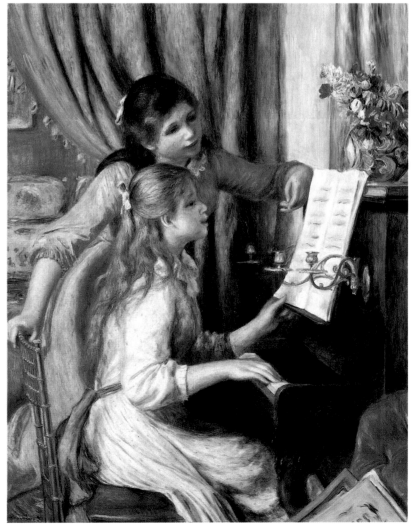

199

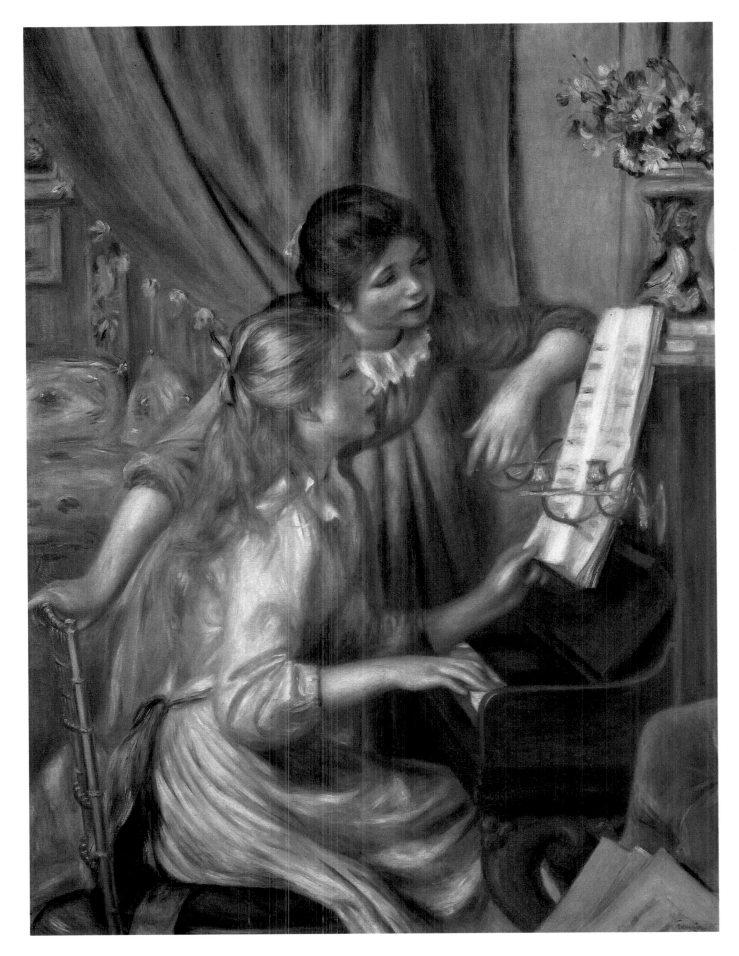

♦ *Opposite above,
Girls at the Piano,
1892. Oil on canvas,
116 x 81 cm (45 1/2
x 31 3/4 in). Musée
de l'Orangerie,
Paris.*

♦ *Opposite below,
Girls at the Piano,
1892. Oil on canvas,
111.8 x 86.4 cm (44
x 34 in).
Metropolitan*

*Museum of Art, New
York.*

♦ *Above, Girls at the
Piano, 1892. Oil on
canvas, 116 x 90 cm
(45 1/2 x 35 1/2 in).
Musée d'Orsay,
Paris. On 2 May
1892 the Director of
Fine Arts, Henri
Roujon, on behalf of
the "Museum of
Living Artists" at the*

*Luxembourg palace,
purchased Renoir's
Girls at the Piano for
4,000 francs. When
he received this
commission, Renoir
went through an
agonizing period of
stylistic indecision,
executing no fewer
than seven versions.
When Roujon made
his choice, the artist
admitted he had*

*"overdone" the
canvas selected.
Arsène Alexandre
commented: "The
very idea of a
commission
paralyzed him and
made him lose his
self-confidence [...]
He ended up leaving
to the government
the one now at the
museum, and
immediately*

*afterwards he said it
was the least
successful of the five
or six."*

200

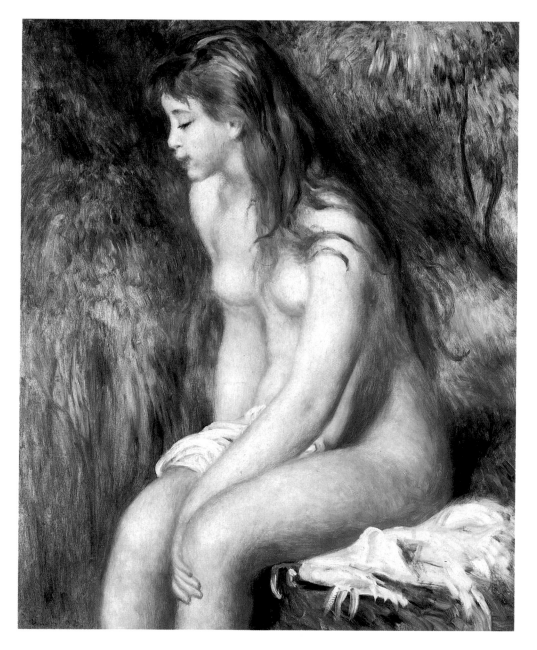

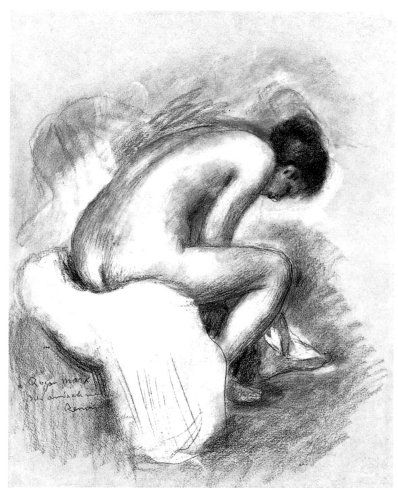

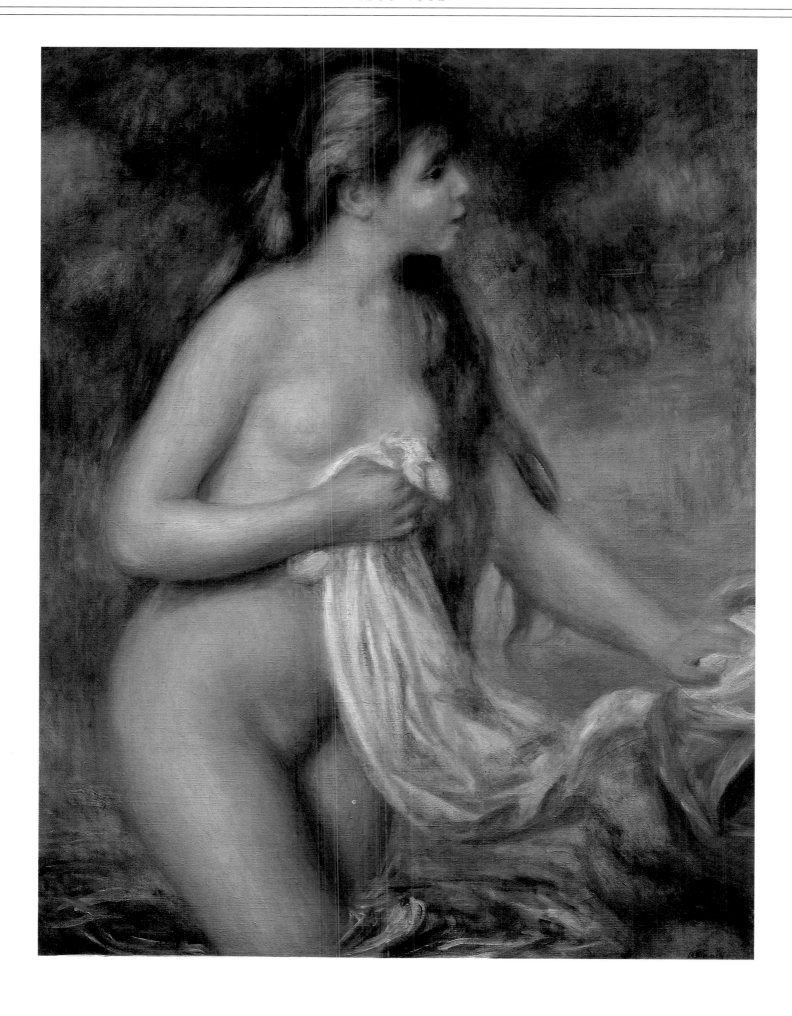

♦ Opposite above, Seated Bather in a Landscape, 1892. Oil on canvas, 81 x 65 cm (31 3/4 x 25 5/8 in). Metropolitan Museum of Art, New York.

♦ Opposite below, The Bath, ca. 1890. Sanguine and white pencil on paper, 58 x 49.5 cm (22 3/4 x 19 1/2in). Cabinet des Dessins, Louvre, Paris.

♦ Above, Bather with Long Hair, ca. 1895. Oil on canvas, 85 x 65 cm (33 1/2 x 25 5/8 in). Musée de l'Orangerie, Paris. Renoir's new canvases of bathers—their milky flesh speckled with the colors of the atmosphere, blended into the landscape in an empathy with nature with ancient overtones, gracefully absorbed in the most classical of pretexts for a motif, bathing—inaugurate his "pearly" period. The brushwork alternates in highlighting, and then softening, the forms, and the monumental amplitude of the nude dominates the canvas.

202

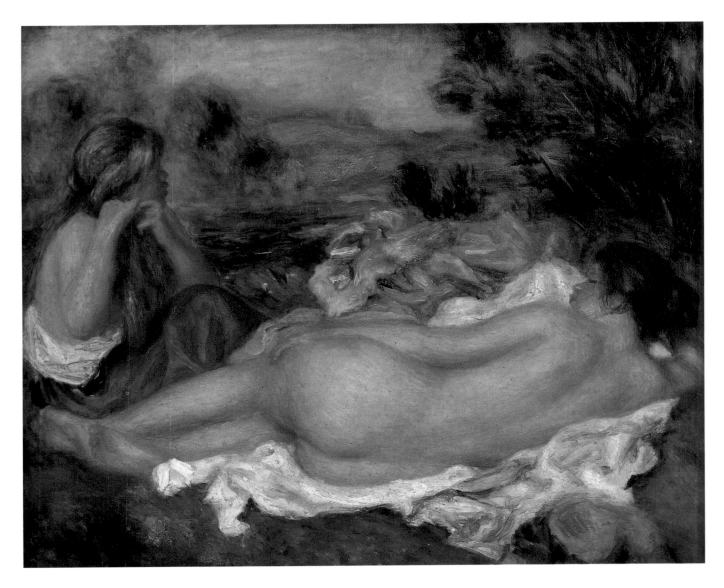

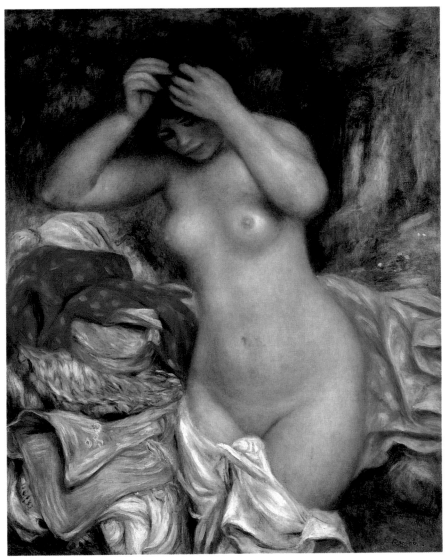

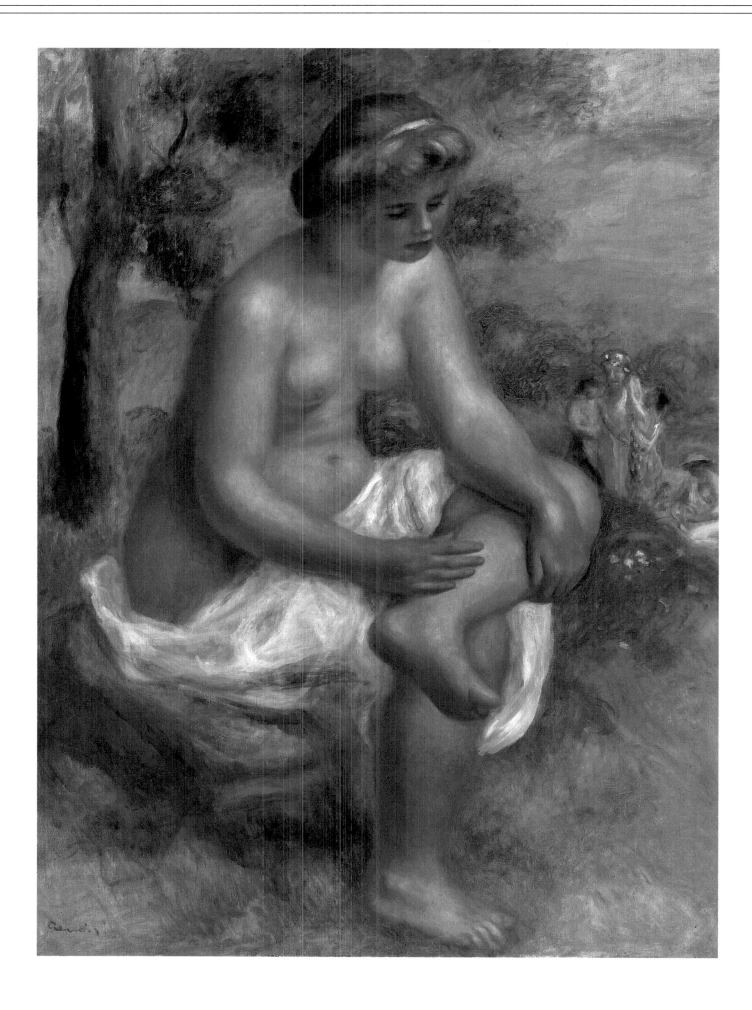

♦ Opposite above, Two Bathers, ca. 1892-95. Oil on canvas (size unknown). Private Collection. The reclining nude with her back to us has classical lineage, from Velásquez to Ingres' famous Grande Odalisque, while the other bather's pose brings to mind Suzanne Valadon in Girl Braiding Her Hair.

♦ Opposite below, Bather Arranging Her Hair, 1893. Oil on canvas, 92.2 x 73.9 cm (36 3/8 x 29 1/8 in). National Gallery of Art, Washington D.C. From the ancient statues of Venus to the sculptor Pradier, famous in mid eighteenth-century France, this nude boasts a long line of illustrious models. However, the pose betrays a modern, almost "Degas-like" touch—the body leaning slightly, the face half-hidden by the woman's gesture.

♦ Above, Seated Bather in a Landscape (Eurydice), ca. 1895-1900. Oil on canvas, 116 x 89 cm (45 5/8 x 35 in). Musée Picasso, Paris. The lyrical atmosphere, permeated with the freshness of spring (perhaps an allusion to awakening, the only reference to the myth of Eurydice), attenuates the classical stateliness of the nude in an airy, serene dialogue with nature.

204

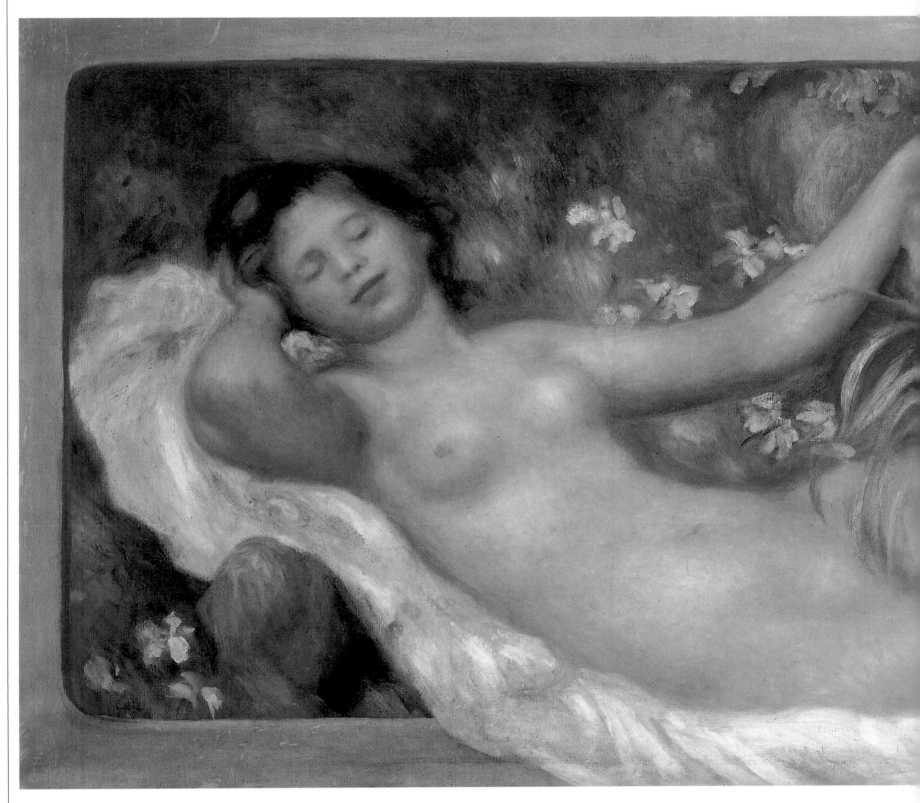

♦ Reclining Nude, ca. 1895-97. Oil on canvas, 65.4 x 115.6 cm (25 3/4 x 45 1/2 in). The Barnes Foundation, Merion, Pa. With Renoir's revived pantheism, nature is again animated by personifications: the Renaissance motif of the "nymph of the source," who, however, acquires the absolutely human connotations of a common, and freshly sensual, female body. Renoir's models range from Giorgione (Sleeping Venus) to Goujon's reliefs (Fountain of the Innocent) and Ingres.

206

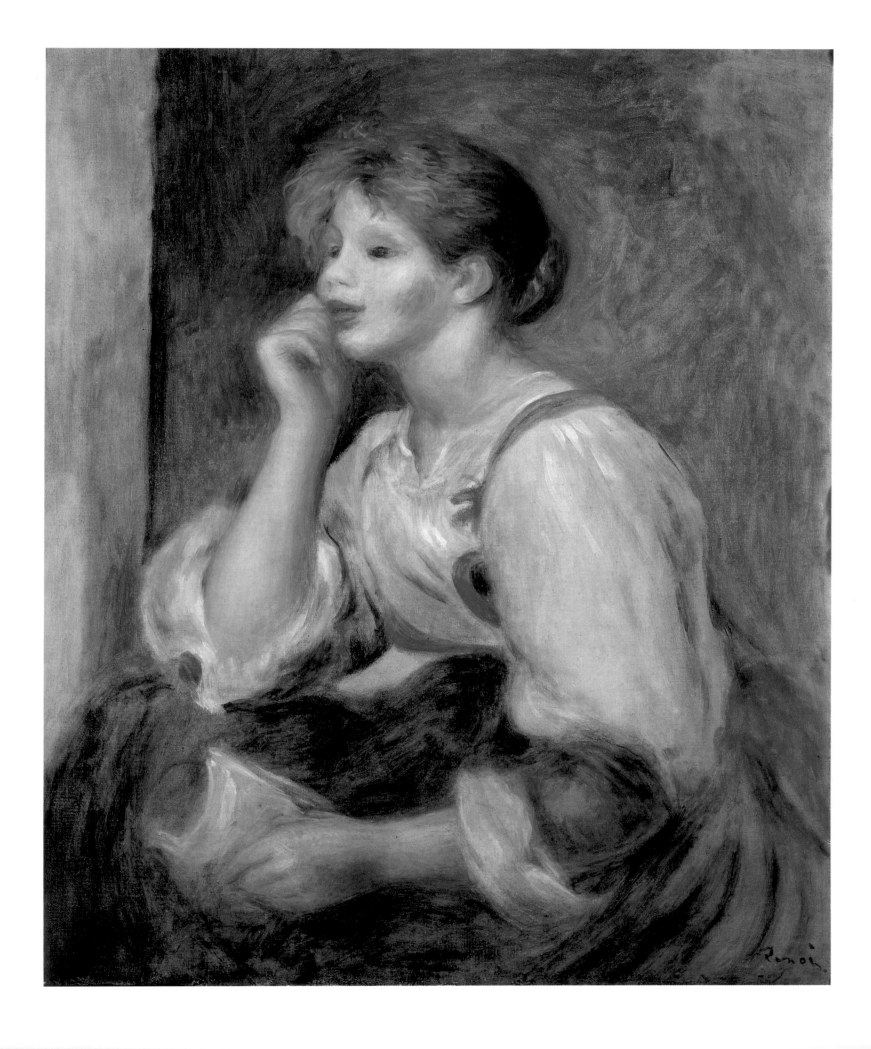

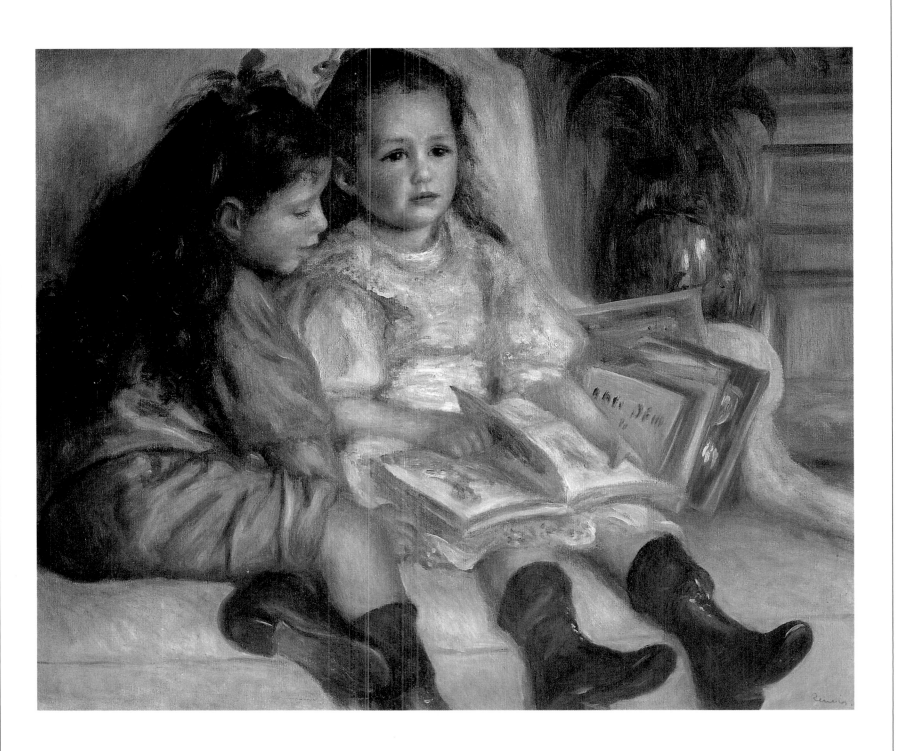

♦ *Opposite,* The Letter, *1895-96. Oil on canvas, 65 x 54 cm (25 1/2 x 21 1/4 in). Musée de l'Orangerie, Paris. In nineteenth-century anecdotal painting a woman holding a letter was often a pretext for depicting a* sentimental or dramatic situation. *But Renoir never paints women with particular problems; here his reader is charming and dreamy, with all the innocence and artfulness typical of joie de vivre.*

♦ *Above,* Martial Caillebotte's Children, *1895. Oil on canvas, 65 x 82 cm (25 5/8 x 32 1/2 in). Private Collection. Renoir was a long-time friend of Gustave Caillebotte's brother, and they were executors of the* artist's will. In the midst of the stir caused by Caillebotte's bequest, Renoir painted a portrait of Martial's children, Jean and Geneviève, captured in the ever serious activity of children's play.

208

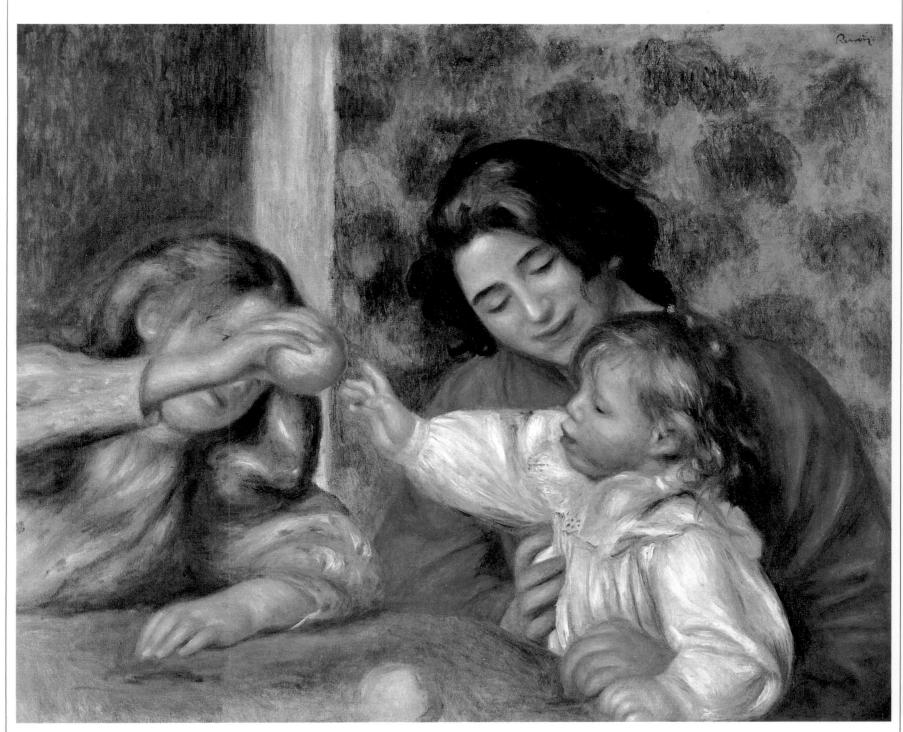

♦ *Above,* Jean Playing with Gabrielle and a Girl, *1985-96. Oil on canvas, 65 x 80 cm (25 5/8 x 31 1/2 in). Norton Simon Foundation, Los Angeles.*

♦ *Opposite,* Gabrielle and Jean, *ca. 1895. Oil on canvas, 65 x* 54 cm (25 1/2 x 21 1/4 in). Musée de l'Orangerie, Paris. *The artist executed a rather large series of canvases of his son Jean being held by Gabrielle while playing or eating. But compared to the portraits commissioned by* rich Parisian patrons, in which the children are always smiling and richly dressed, here the mature Renoir does away with all sentimentalism or picturesque qualities and carefully scrutinizes and depicts the seriousness, sacredness, mystery and inaccessible innocence of infancy. It is no mere accident that the model for this canvas was a religious painting by Correggio—The Mystic Marriage of St. Catherine.

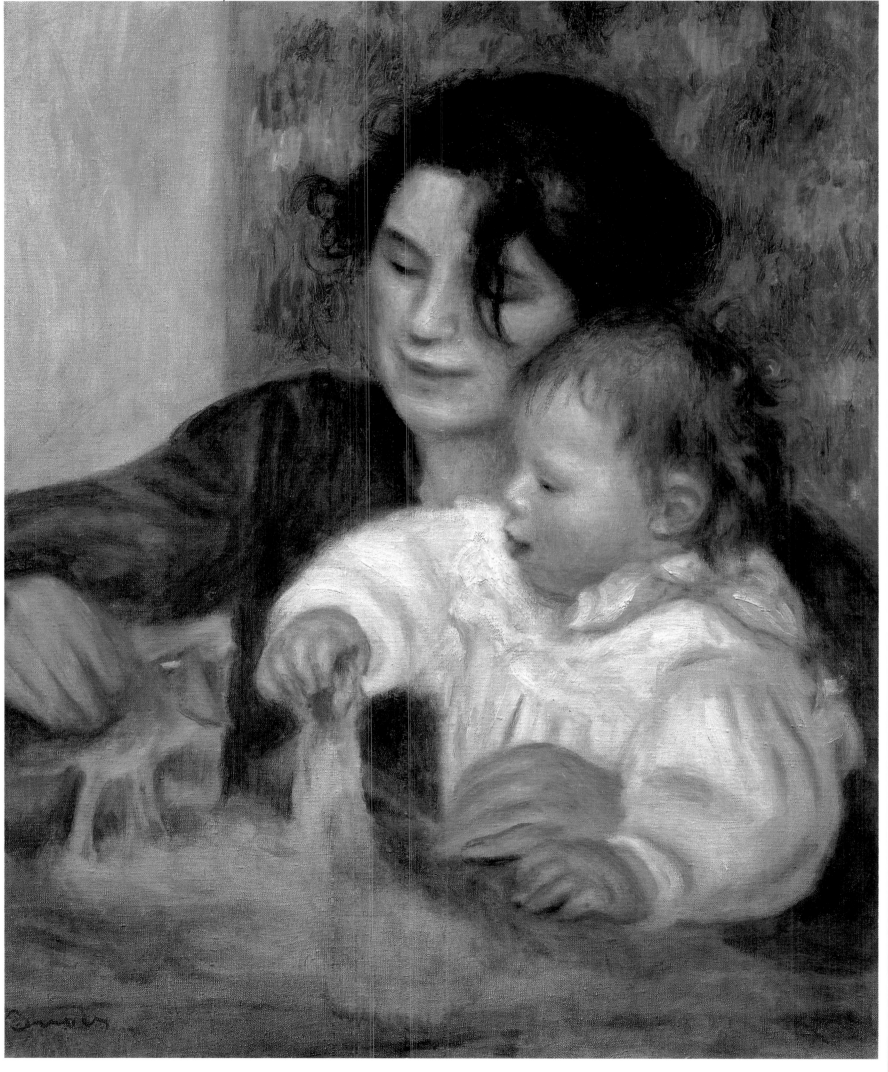

210

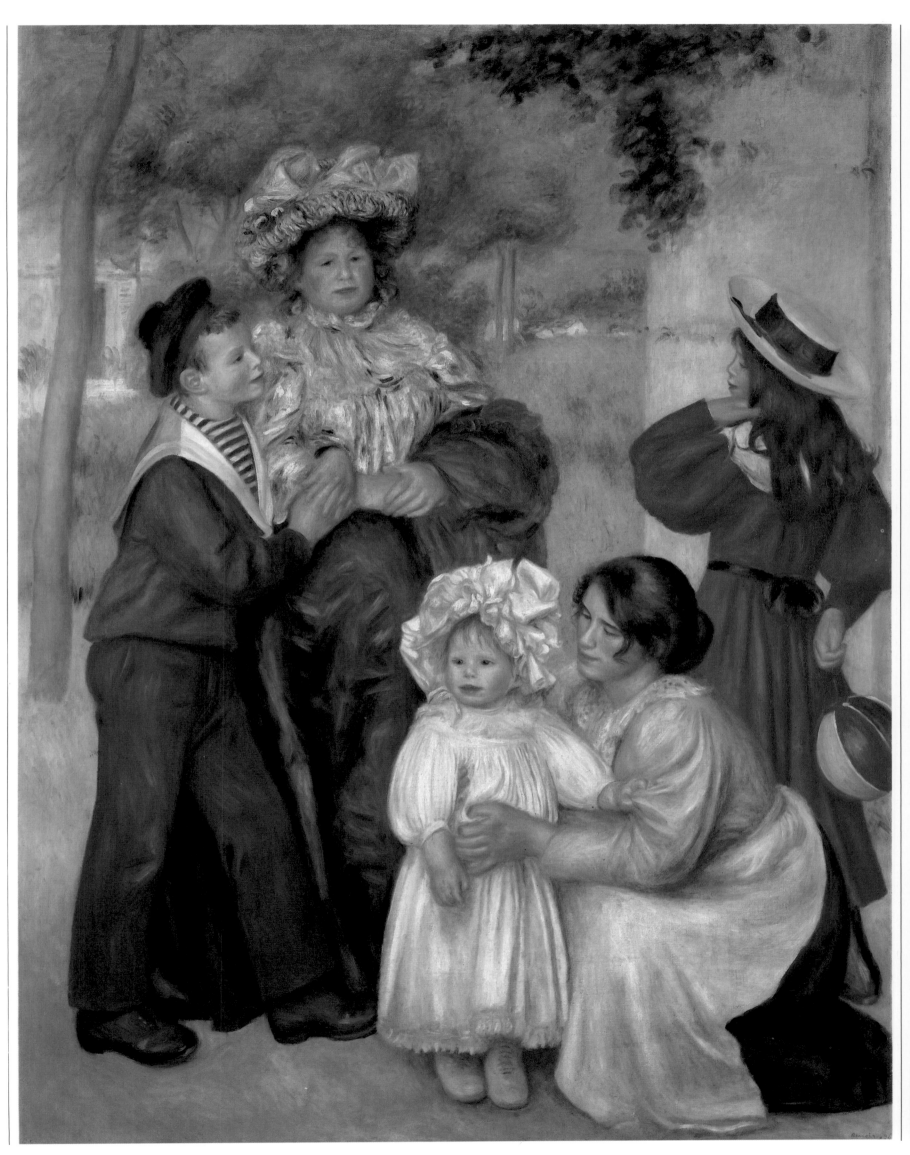

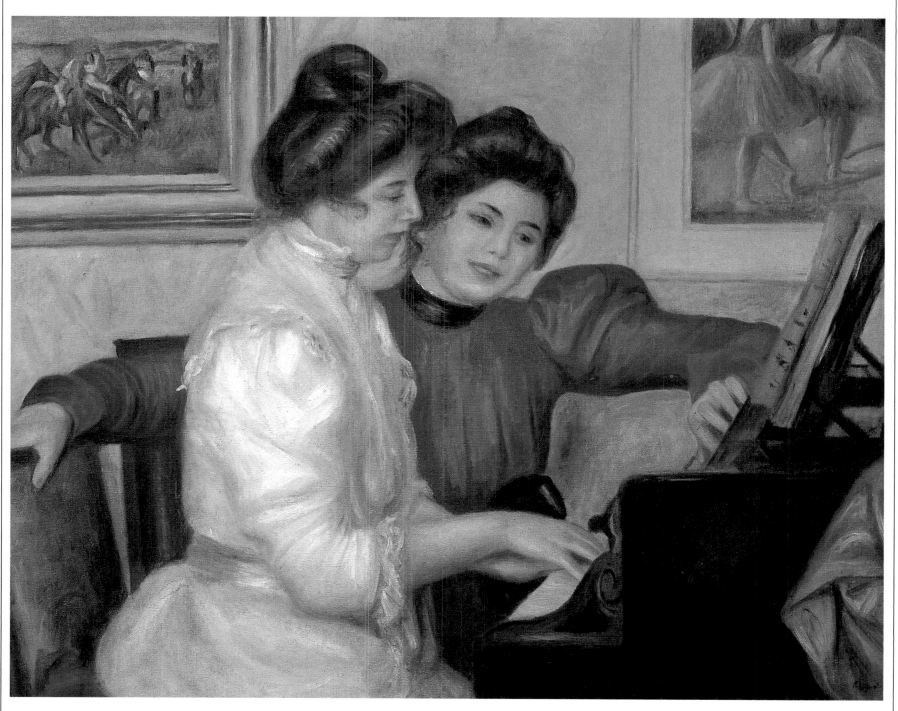

♦ *Opposite, The Artist's Family, 1896. Oil on canvas, 173 x 140 cm (68 x 55 in). The Barnes Foundation, Merion, Pa. In the courtyard of the Château des Brouillards, Renoir portrays Aline and their two sons— Pierre, next to his mother, and Jean being held up by Gabrielle—and a neighbor girl (perhaps the daughter of the writer Paul Alexis) fondling her hair. Despite the outdoor setting, the group is not in an everyday situation but is represented in an imposing, even hierarchical, pose similar to the seventeenth-century group portraits by Van Dyck or Velásquez's Las Meniñas, with the Infanta in the foreground, like little Jean.*

♦ *Above, Yvonne and Christine Lerolle at the Piano, 1897. Oil on canvas, 73 x 92 cm (28 3/4 x 36 1/4 in). Musée de l'Orangerie, Paris. The two daughters of the painter and art collector Henri Lerolle are portrayed in a domestic setting with two works by Degas on the wall.*

212

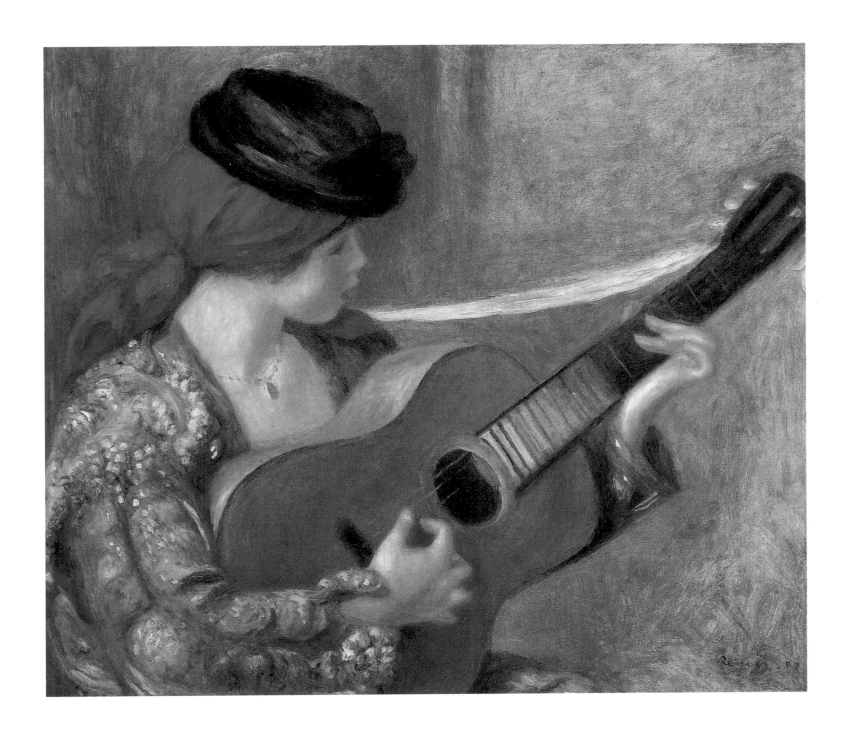

♦ *Above,* Young
Spanish Woman with
a Guitar, *1898. Oil on
canvas, 55.6 x 65.2
cm (21 7/8 x 25 5/8
in). National Gallery
of Art, Washington
D.C.*

♦ *Opposite,* Woman
with a Guitar, *1896-*
*97. Oil on canvas, 81
x 65 cm (31 3/4 x 25
5/8 in). Musée des
Beaux-Arts, Lyons.
Around the end of the
century Renoir began
his variations on a
recurring theme: a
young woman
playing the guitar,
which marked an*
*important stylistic
change. Up to then
his female models—
except for the
nudes—were dressed
in modern clothes,
whereas they now
appear in fantasy
costumes, either
Spanish or gypsy,
with a purely*
*decorative function.
According to Renoir's
pupil Jeanne Baudot,
he had been inspired
by the "lovely Otero,"
a ballet dancer at the
Folies-Bergères and
the incarnation of
"Spanish
seductiveness."*

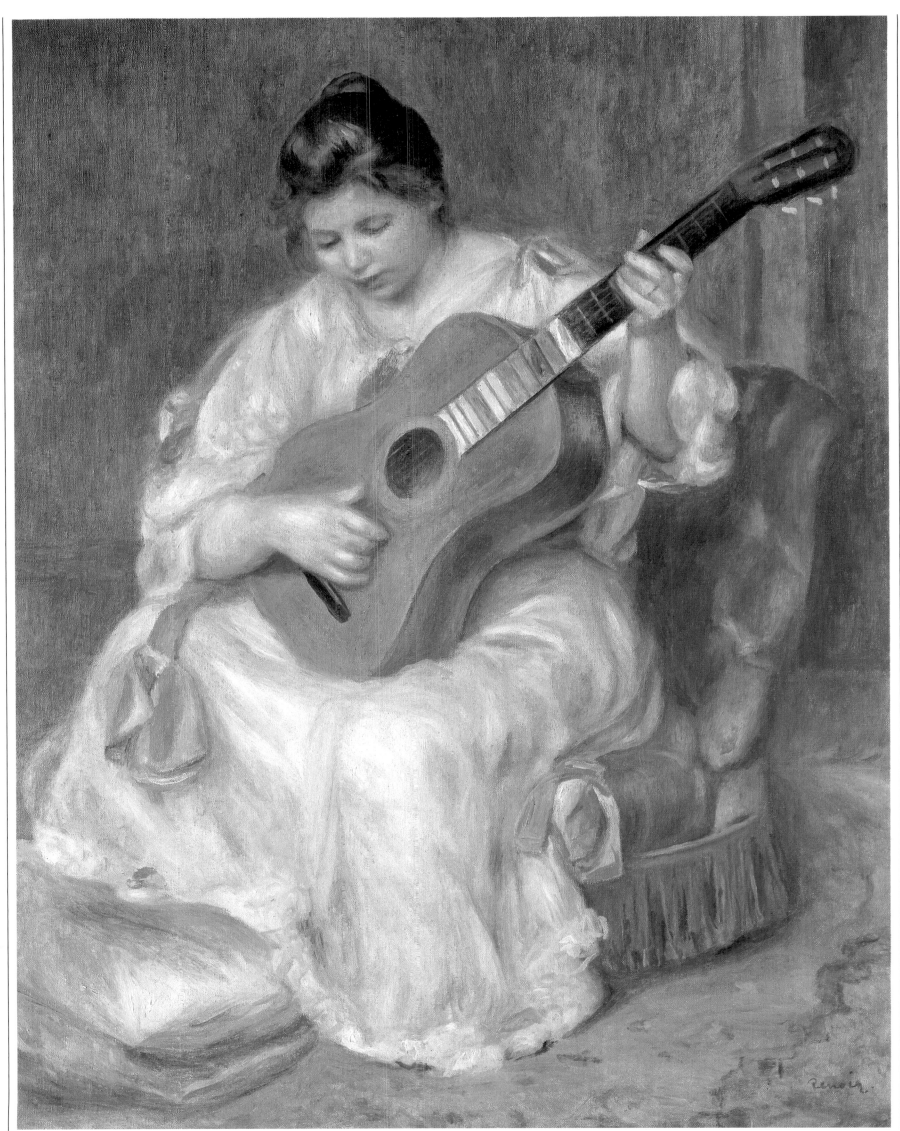

214

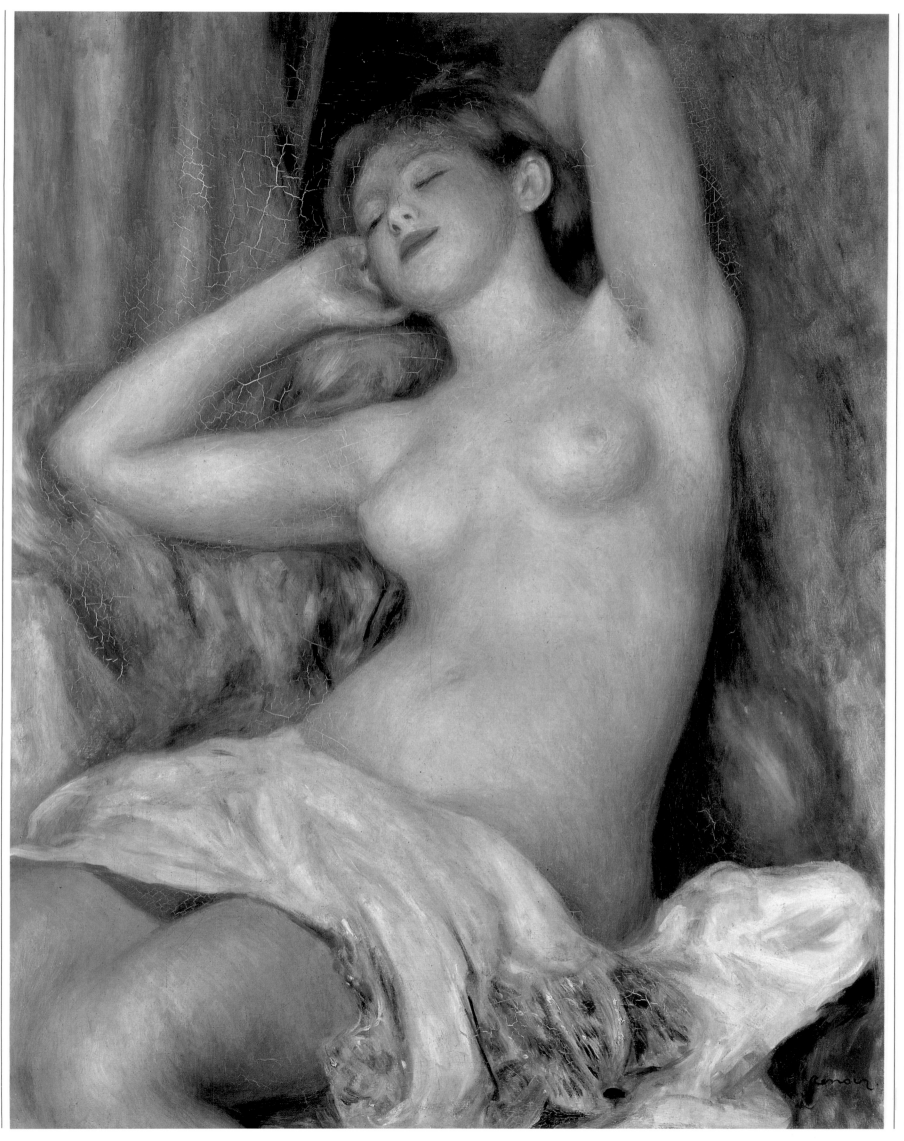

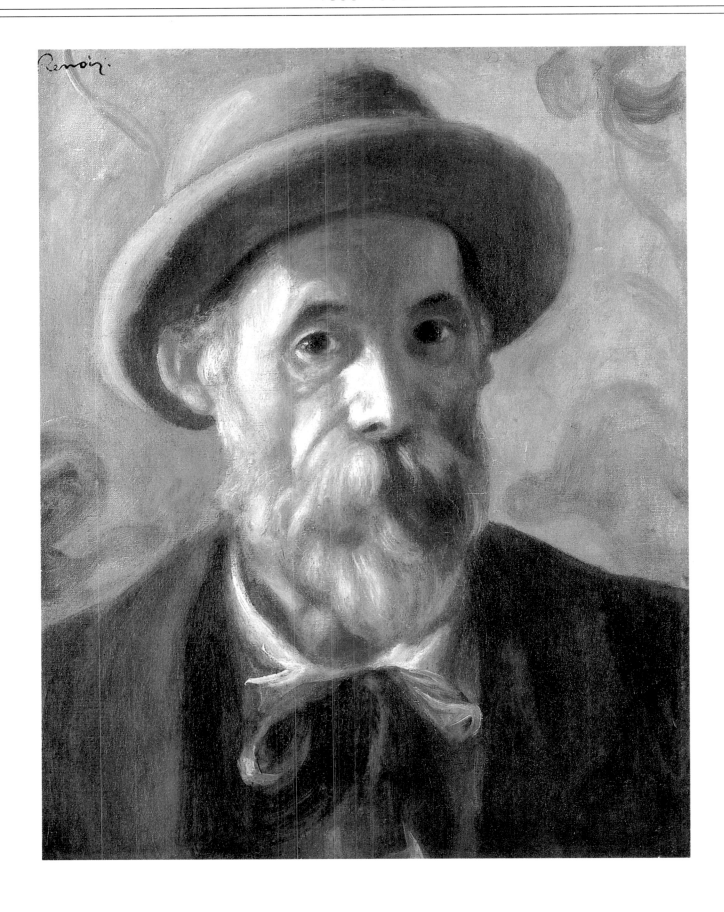

Renoir.

♦ Opposite, Sleeping
Girl, 1897. Oil on
canvas, 81 x 65 cm
(31 3/4 x 25 5/8 in).
Oskar Reinhart
Collection,
Winterthur. Placed
in a plush interior
whose golden and
red tonalities
prefigure the palette
of Renoir's last

period, the girl is
stretched out in the
instinctive
voluptuousness of an
animal at rest.
Renoir loved this
primitive,
unpremeditated
female sensuality.
According to his son
Jean, he "wanted the
subject to slide into a

state of irrationality,
precipitate into the
void." This state of
semi-consciousness
is depicted in the
girl's closed eyes.

♦ Above, Self-portrait,
ca. 1899. Oil on
canvas, 41 x 33 cm
(16 x 13 in).
Sterling and
Francine Clark Art
Institute,
Williamstown, Mass.

216

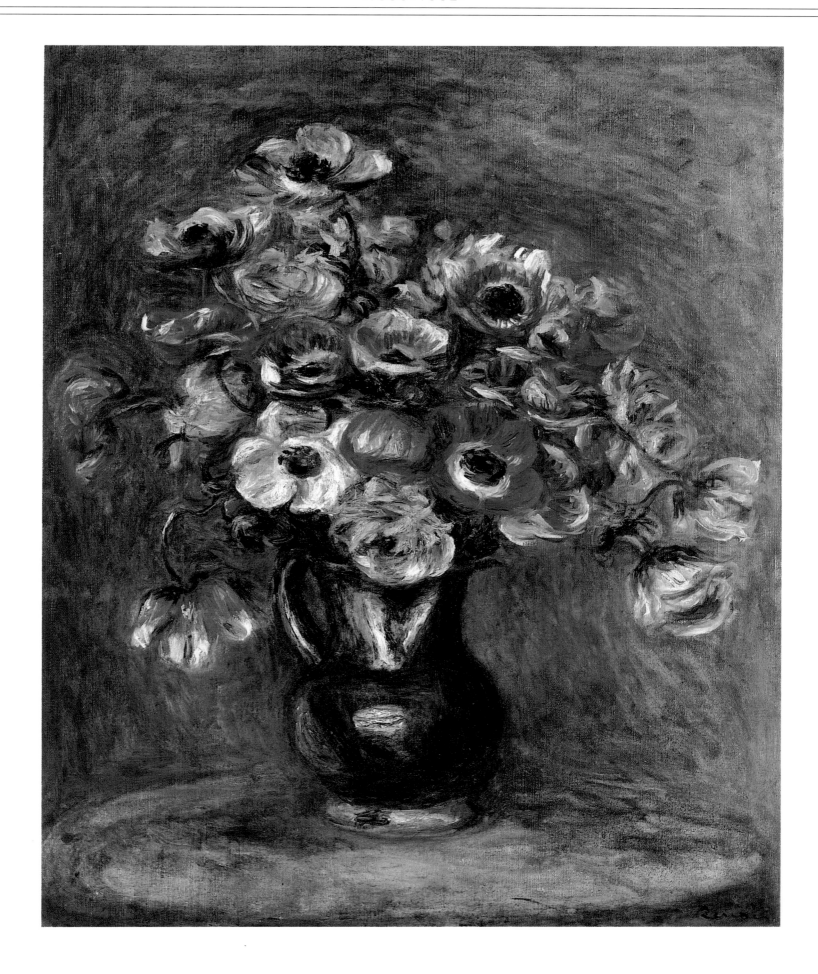

♦ Above, Anemones, 1898. Oil on canvas, 58 x 49 cm (22 3/4 x 19 1/4 in). James W. Johnson Collection, New York.

♦ Opposite, Flowers in a Vase, ca. 1898.

Oil on canvas, 55 x 46 cm (21 5/8 x 18 in). Musée de l'Orangerie, Paris. For Renoir, flowers also contained the innocence and unconscious fascination of

dawning beauty, whilejwhile at the same time exemplifying the ephemeral nature of all human pleasure. This is perhaps the reason why the more the flowers in his

final period are amplified in the light, the more charged they are with melancholy—exactly like his nudes.

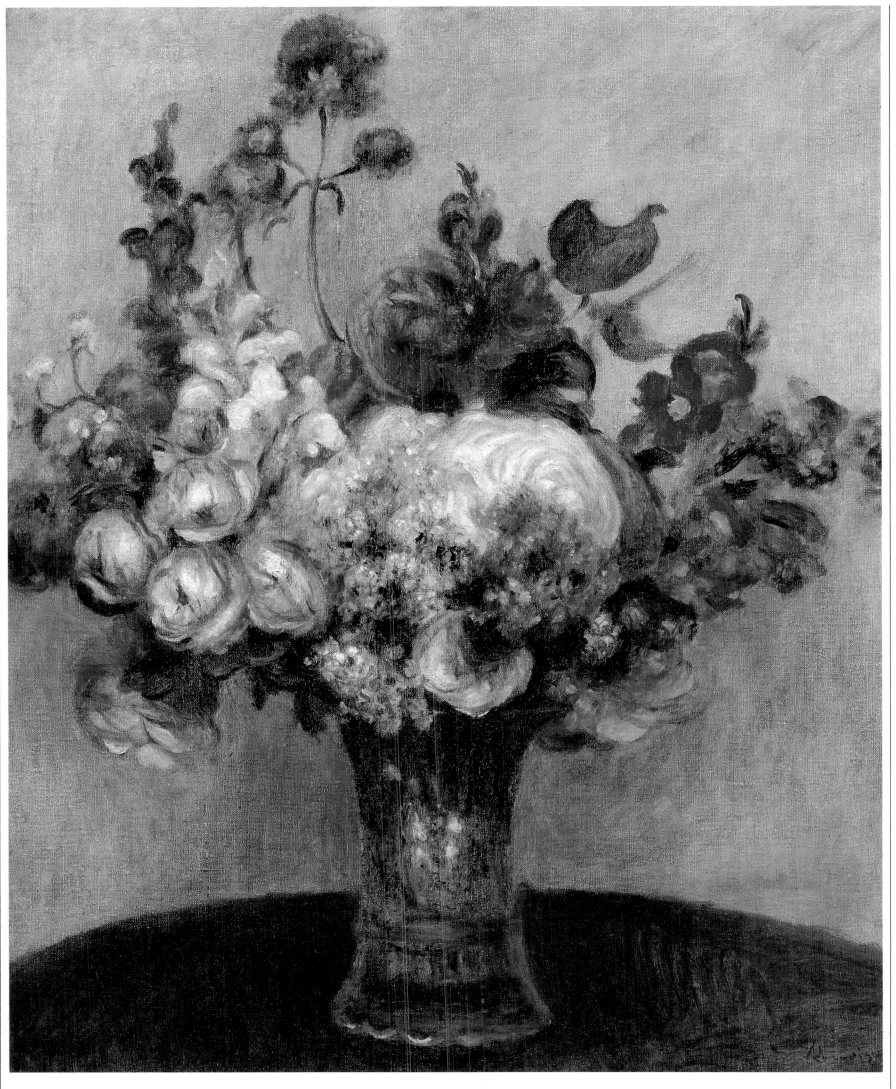

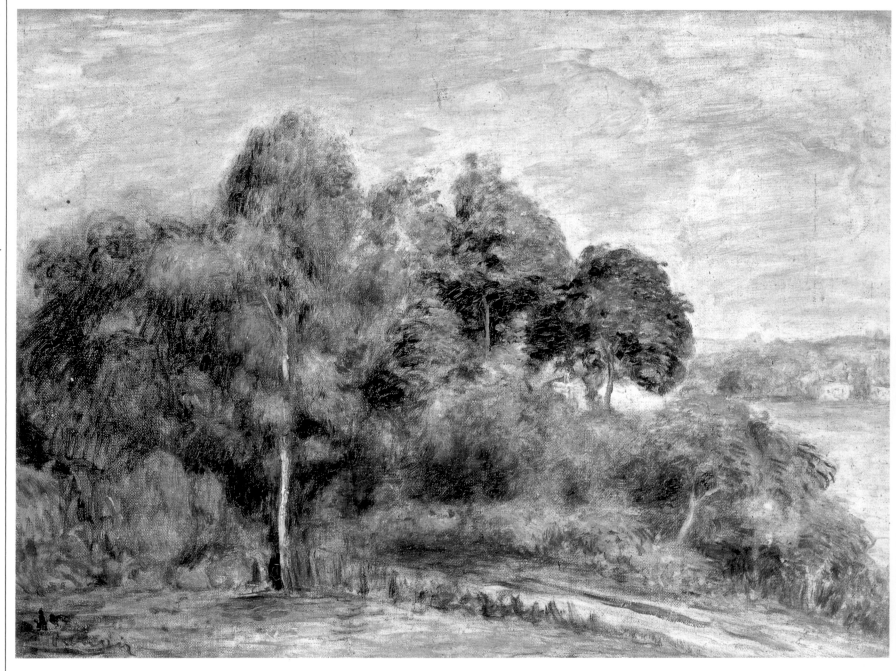

♦ *Above*, Landscape, ca. 1900. *Oil on canvas, 54 x 66 cm (21 1/4 x 26 in). Musée des Beaux-Arts, Reims. Executed during a sojourn in the Midi, this rare landscape (Renoir almost always placed a figure in a natural setting) reveals an exuberant, dynamic nature in a carefully structured composition.*

♦ *Opposite above*, The Frilled Hat, *1898. Colored lithograph, 60 x 48.8 cm (23 1/2 x 19 1/4 in). Museum of Modern Art, New York. What motif could be more futile, bizarre, colorful and "baroque" than a hat with frills? This is probably why Renoir used it in so many canvases, including* Girl with the Red Feather *and The Artist's Family. The artist did many versions of this lithograph, taking advantage of the vague quality of this medium to establish an osmotic space, vibrant and supple like a diaphragm, between the figures and the background. The necessarily limited palette revolves around pastel hues.*

♦ *Opposite below*, Girls Playing Ball, *1900. Colored lithograph, 60 x 51 cm (23 1/2 x 20 in). Bibliothèque Nationale, Paris. Here Renoir adopts the thick lithograph line as if it were the comma-like Impressionist brushstroke, merging it with the color, thus achieving great vivaciousness.*

220

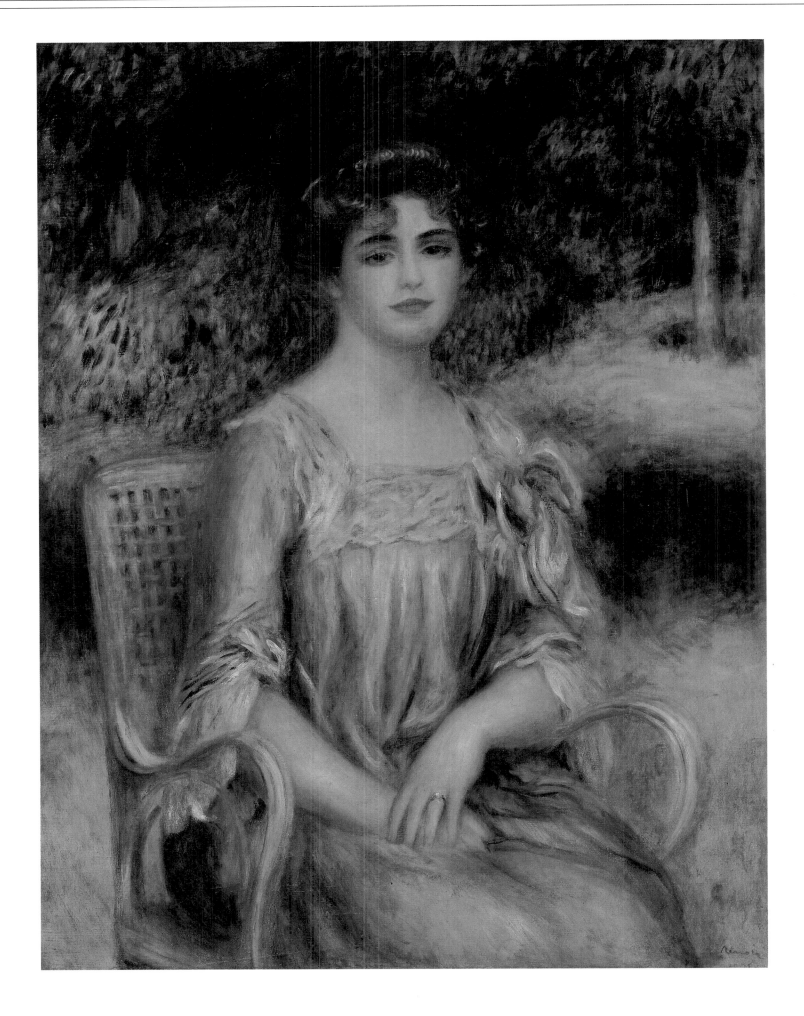

♦ Opposite above, Jean Renoir Drawing, 1901. Oil on canvas, 45 x 54.5 cm (17 3/4 x 21 1/2 in). Virginia Museum of Fine Arts, Richmond. The exquisite tonalities based on a harmony of grays, reminds one of Corot.

♦ Opposite below, Four Studies of Jean, ca. 1900. Oil on canvas, 56 x 46 cm (22 x 18 in). Museu de Arte, Sao Paulo. Renoir here seems to be analyzing movement rather than doing a preparatory work for a painting.

♦ Above, Madame Gaston Bernheim de Villers, 1901. Oil on canvas, 93 x 73 cm (36 1/2 x 28 3/4 in). Musée d'Orsay, Paris. The end-of-the-century popularity of Leonardo da Vinci perhaps induced Renoir to choose this Mona Lisa pose for an official portrait. The palette marks a return to Corot's delicate hues, while the light strikes the transparent dress, thus harmonizing the figure with the natural setting.

222

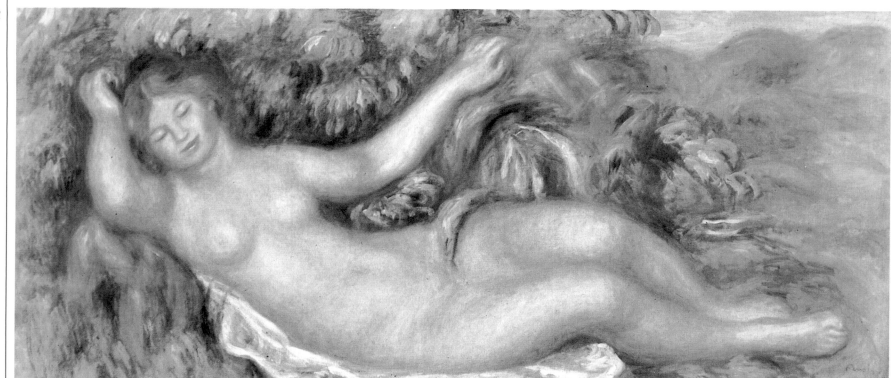

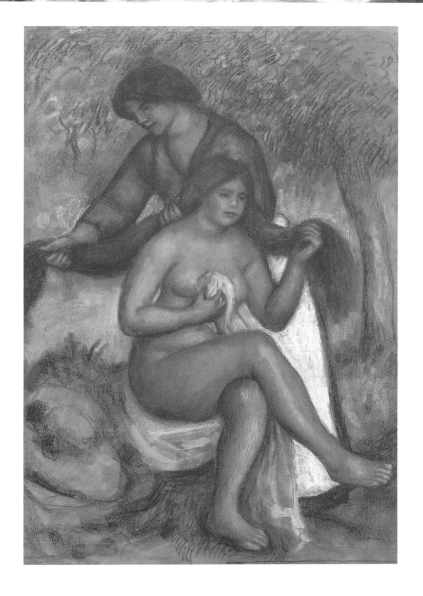

223

♦ Opposite above, The Source, ca. 1902. Oil on canvas, 67 x 153 cm (26 3/8 x 60 1/4 in). Museum of Modern Art, New York. In accordance with ancient mythology, the woman is the personification of the elemental forces of nature, the wellspring of fertility and life, like the water pouring on to her loins. This motif. quite popular with the Symbolists, had been prefigured by Ingres, interpreted by Puvis de Chavannes and even influenced Picasso

♦ Opposite below, The Toilette, ca. 1900. Sanguine and white chalk on canvas, 145 x 103 cm (57 x 40 1/2 in). Musée Picasso, Paris. This is a preparatory drawing for the monumental canvas kept in the Barnes Foundation. With the technical skill of an attentive academic artist, Renoir structures the image around the two figures, which are simple and balanced in the reciprocal contrast of lights and darks. As in The Source, the reference to water as a feminine element is hidden by the long hair that flows like a waterfall.

♦ Above, Peaches in a dish, 1902-1905. Oil on canvas, 22.2 x 35.6 cm (14 1/6 x 8 3/4 in). National Gallery of Art, Washington. The rather trivial subject matter is transfigured by a delicacy of touch which delightfully blends the shades of colour.

The Paradise of the Gods

The style of Renoir's final period seems to undergo an "organic" inner evolution, reproducing itself as in a process of gemmation, with the inevitability of fruit ripening. The more his illness limited his activities, the more comprehensive his perception became, the larger his forms, the more light-saturated his canvases. However, this light was no longer an atmospheric effect, but an entity with its very own solid and dense consistency—the light of the Midi.

"The sun makes their nerves become torpid, the sun opens their eyes to the splendor of eternal things." This is what the art critic Théodore de Wyzewa, a friend of Renoir's, wrote in 1895 concerning the Mediterranean localities. And indeed Renoir's pains seemed to drain away in the sun of Cagnes and his eyes opened out to a magnificent, grandiose natural setting. Ragghianti wrote: "His vision became grander, majestic, at one with nature, ridding itself of all psychology and circumstance in favor of a pure lyricism of triumphal breadth. His style became cosmic, with a violence of inspiration and solemn, choral unity that are inimitable." Renoir's "pantheism" is translated in pictorial terms into a new feeling for compositional unity, in which the difference between foreground and background, landscape and figures, is virtually eliminated and the whole seems to be produced by the same vibrations. Every detail and aspect is a part of the whole and is physically equal, just as in nature, and it is the brushwork, with an ever thicker impasto, that imparts this equivalence—thicker and more full-bodied around the figures, more fluid in the background. In this "new

humanism," which is classical per se, over and above any passing fashion or occasion, the figure is in a truly intimate relationship with its setting, and no longer needs the programmatic—and somewhat external—Impressionist *tache*. Formerly, the body was conditioned by the light and color it received from the landscape; now, figure and landscape are generated together by the canvas. Albert André and Jean Renoir relate how, while observing Renoir at work, the impression was that of seeing the images slowly rise from the priming of the canvas in successive layers, much like a body of land rising up from the sea. A procedure totally foreign to academic painting, which required that every individual part be completed and perfected separately.

In fact, as time passed Renoir seemed to resort more and more often to Cézanne's expedient of merging different viewpoints on to the surface; naturally, the former's aims and results were quite different from Cézanne's—rather than spatial complexity, Renoir strove for a sort of "gigantism" of the forms, a static expansion of the figure on the painted surface. And just as was the case with Cézanne, but in a wholly coloristic key, Renoir achieved a solidification of the Impressionist *tache* with structural repercussions. It seems that another sense is added to Renoir's vision, precisely the one that his arthritis was depriving him of—touch. A confirmation of this is the sequence of nudes, bathers and odalisques and the mythological subjects that were becoming more and more frequent: the various versions of *The Judgment of Paris, Alexander Thurneyssen as a Shepherd,* and the *Ode to Flowers*. The texture around the

figures becomes thicker, even weighty; the frayed outlines are rendered with broad, combined brushstrokes that replace the chiaroscuro. The effect of monumental concentration of the masses is corresponded, and partly created, by a noteworthy simplification of the palette, which consists for the most part of pure colors: yellow, red, a complementary such as green, and a dash of blue to "cool" and balance the color range. The more the passages are rendered in the same tone, the more the relief is heightened. Already in the second version of *Bather* (1905) one appreciates the difference with respect to the earlier 1903 canvas; the dominating silver tonalities are replaced by a bright golden red that consolidates the flesh tones with the crimson in the ribbon and dress, while the yellow in the background enhances the woman's blond hair and seems to want to root out the straw of the hat with flashes of light.

Other works executed a few years later—*Large Seated Nude* (1912) and various bathers—present the solitary figure of the red-headed model Dédée in all her majestic beauty. Here the combinations of reds unfold in a vibrant and wavy yet clear-cut profile. This is the final version of Ingres' famous "backs"—an outline made arabesque—restored to full-blooded life, powerful physicality at the "breaking point" of pleasure and aesthetic violence. This is the "savage" aspect of Renoir that his son Jean spoke of and that, significantly enough, is rendered in French by a word that would later become part and parcel of avant-garde art—*fauve*. It seems that the models complained about this amplitude of form, without understanding that the physical

exaggeration was the artist's hallmark, just as lines or geometric shapes would be for an abstract painter. "No soul... that's what August Renoir's *Bathers* are, blondes and brunettes, indifferent and yet admirable, flowers of flesh and nothing more," as Ugo Ojetti wrote in the already mentioned 1912 Venice Biennale presentation.

The isolated lyricism of the individual figure becomes all-enveloping in Renoir's group compositions. Perhaps even more than *The Judgment of Paris*, it is the bathers (just as in Cézanne and yet unlike Cézanne) that embody the *summa* and spiritual testament of an entire painting style. In this series there is the familiar repertory of nudes depicted in different poses, much like a "theme with variations" that is explicitly and purposely lacking in any external references; there is the dilation of the body that reverberates in the nearby figures like an overflowing sound wave; and there is the implication of the title, which is timeless and yet modern, everyday and yet classic. Renoir models his forms through color and his brushstrokes are applied in a flowery, refulgent manner as in late Gothic art, as radiant as gold work. This rhythmical painting can truly be likened to a musical composition or poetry in rhyme; it is intensely lyrical, pregnant with meaning, "literary" in the fullest, most comprehensive sense of the word because it does not bother to narrate a story or represent a motif, but rather intrinsically alludes to all this by means of the purity of its specific means—line and color.

This is the case, for example, with *Ode to Flowers*, painted for Maurice Gangnat in 1909, as well as with

Dancer with a Tambourine and *Dancer with Castanets*; in the Ode, the couplet by Anacreon that inspired it is not represented in the illustration of a myth, but is distilled in an image that is really analogous to "metre," that is to say, in the evocative power of the color, which is at once vaporous and fiery.

What Fantin-Latour had attempted for such a long time with Wagner—the creation of an equivalent of musical expression—is fully achieved in Renoir, without any need for allusions and in an absolutely modern context, purged of all meaning. This is also how "decoration" should be understood when speaking of Renoir: painting that cheers, soothes and elevates through the pictorial language, with a glance backwards to the eighteenth century and forwards, towards Matisse. This capacity to transfigure the most common subject and genre without making use of symbols and remaining solidly anchored to "everyday magic," is perhaps the most felicitous quality in late Renoir, a quality he had striven for ever since his Impressionist period. Plagued by illness, he creates his paradise on earth, his Olympus of common yet magnificent women—as in Pompeii or ancient Greece. "What admirable humans, those Greeks. Their existence was so happy that they thought the gods descended to the Earth to find their paradise and learn to love. Yes, the Earth was the paradise of the gods. And that's what I want to paint."

In Dancer with a Tambourine and *Dancer with Castanets*, which Renoir painted for the dining room of his new patron Gangnat, he freely draws upon Phidias; the flowing play of folds and veils reflects the spirit of the purely Greek conception of the human body as the very breath of nature, the material involucrum of light. This is the drapery of the so-called Elgin marbles—the three goddesses by Phidias from the Parthenon frieze that were taken to London in the last century and have been venerated by generations of artists—and of *The Winged Victory of Samothrace*. But Renoir's fluid impastos remind one of Delacroix, just as the *Sleeping Odalisque* (1915-17), with its array of babouches and curtains and its indolent atmosphere, is an allusion to *Women of Algiers*. The paint is a triumph of golden, solar hues, and yet an "inner combustion" of the light betrays the artist's meditations on Rembrandt and late Titian (Renoir jokingly said of Titian: "Not only is he like me, but he's always stealing my tricks").

In all the "genre" pieces of this period (from *Woman with a Mandolin* to the numerous portraits of Gabrielle, which are not true portraits, but occasions, "chamber works"), Renoir's capacity to elevate the banality of a motif to the most intense contemplation of the old masters is simply astounding. One need only think of the open gown in Gabrielle with a Rose: an exercise in the luminous blaze of white against the black hair and the luxuriant red of the velvet. There is always a rose next to her face—a graceful reference to female charm and its transitory nature, but a technical expedient as well. It is the middle color range, the harmonious background, that defines the tonality of the whole: another of his "tricks," which he had learned from Velásquez's *Infanta*. "Studies of roses are also useful for the research into light hues that I make for a nude," the incurable "painter of figures" said to Vollard. The monumentalization of the nudes, with the amplified volume of their bodies and faces, is also to be seen in Renoir's portraits. His growing popularity and fame afforded more "official" commissions which, however, for the most part were limited to portraits of his friends. This was the case with the *Bernheim de Villers* couple—the art dealer who often came to Renoir's aid and his beautiful wife whom the artist had already portrayed alone in her garden in 1901—who were painted side by side on the divan in an unusual viewpoint, their gazes turned away from the spectator; whereas in *Madame Josse Bernheim and Her Son Henry* the pose is based on the traditional, seventeenth- and eighteenth-century models. *Misia Godewska* was also an old friend of Renoir's, but in her portrait the artist does not fail to depict this wealthy woman's brilliant toilette. She was the "muse" of the Symbolists associated with the "Revue Blanche," the periodical run by her first husband Thadée Natanson, then she married the financier Edwards. Though Godewska was totally ignorant in artistic matters, the aged Renoir always appreciated her companionship in pleasant conversations.

The 1910 portrait of "Papa Durand," as Renoir's children affectionately called the art dealer Paul Durand-Ruel, was executed in a more intimate, almost domestic vein; the artist's long-time friend is depicted in a paternal pose, leaning back in his armchair, his hand on his stomach. His black suit is the only rather somber note in the overall scale of values, which is otherwise quite warm, and his glance is tinged with the melancholy of old age. One notes in his hand and head Renoir's tendency to merge different points of view in the single, broadened plane that was mentioned above, a procedure that creates an effect of solemnity which attenuates the domestic tone of the portrait and makes it touching. Something similar can be seen in the portrait of Renoir's wife Aline, executed the same year: the face, which is not idealized, is flattened onto the surface and her dress is rendered in a succession of parallel brushstrokes that seem to carve the pictorial space. In keeping with the reserve that always characterized Renoir's approach to his deep personal feelings, the only manifestation of tenderness is in the little dog; just as in Titian's *Venus of Urbino*, Aline holds this meek symbol of faithfulness in her lap—and the imposing figure of the woman keeping watch over the sleeping dog is an ulterior homage to maternity. Renoir kept this canvas for the rest of his life. The lack of idealization is also seen in the last of Renoir's already rare self-portraits (again executed in 1910), in which he does not even look at us with his flashing, penetrating glance but is in profile, like the medallions of artists he was sculpting in the same period, his head in the shade afforded by a wide hat that absorbs all the light. Grace, the "paradise of the gods," belong only to youth or to the tender unconsciousness of infancy. His last-born son Coco, portrayed while playing or writing, totally absorbed in what he is doing and untouched by suffering, represents Renoir's final hymn to the love of life, again in the soft, subdued tones of Chardin's still lifes. "Renoir was never younger, never more radiant than he was at the end."

226

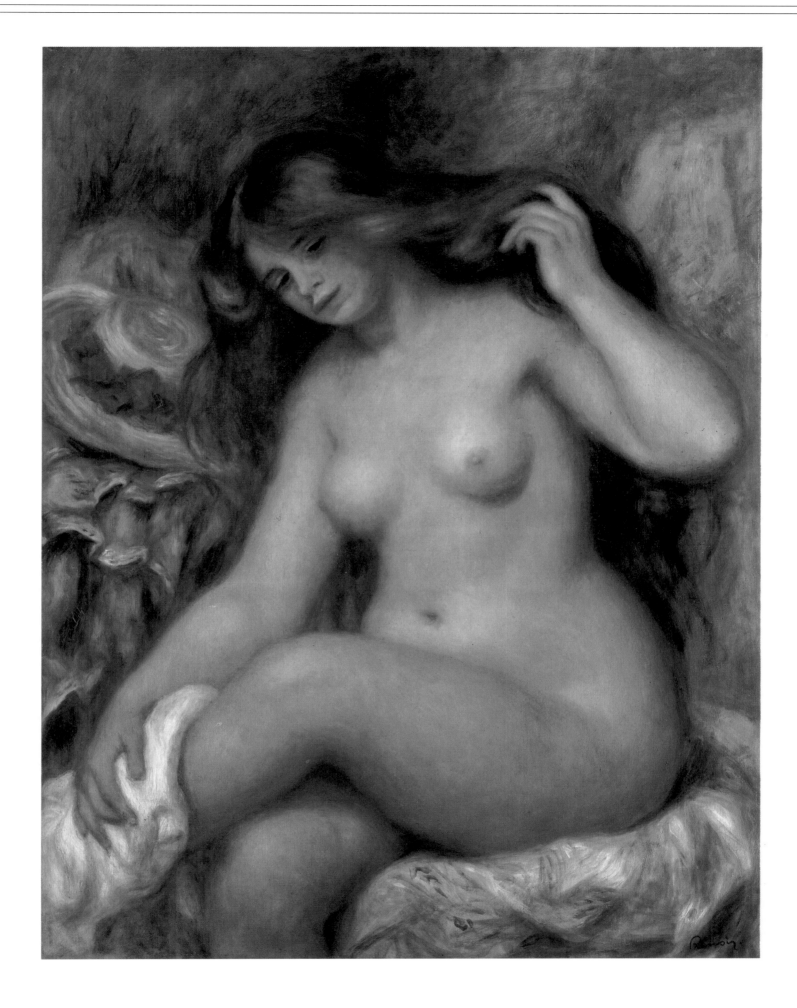

♦ *Above*, Bather, ca.
1903-05. *Oil on
canvas, 92 x 73 cm
(36 1/4 x 26 3/4 in).
Neuegalerie,
Kunsthistorisches
Museum, Vienna. In
a pose similar to
that in* The Toilette
*(without the figure
of the servant),
Renoir concentrates
totally on this
isolated,
monumental nude.
The clothes cast off at
her side are modern,
but rather than
offering an occasion
for a contemporary*
setting, serve as a
fulcrum of color
whose highest-keyed
hues lie in the
complementaries of
yellow and red in the
straw hat. These
warm tonalities are
characteristic of
Renoir's final
period; the only cold
note is the bluish-
white of the dress.
The artist did at
least four versions of
this motif.*

♦ *Opposite above*,
Strawberries, ca.
1905. *Oil on canvas,
28 x 46 cm (11 x 18
1/8 in). Musée de
l'Orangerie, Paris.*

♦ *Opposite below*,
Bouquet of Flowers
in a Vase, 1905. *Oil
on canvas, 40 x 33
cm (15 3/4 x 13 in).
Musée de
l'Orangerie, Paris.*

228

♦ Coco Renoir
Playing, 1905. 46 x
55 cm (18 1/8 x 21
3/4 in). Musée de
l'Orangerie, Paris.
Claude Renoir,
nicknamed Coco,
was born in 1901
and soon replaced
Jean as the model for
his father's portraits
of children. Aline's
placid, voluptuous
roundness—a
characteristic
common to almost
all of Renoir's
females—is
recognizable in the
boy's face.

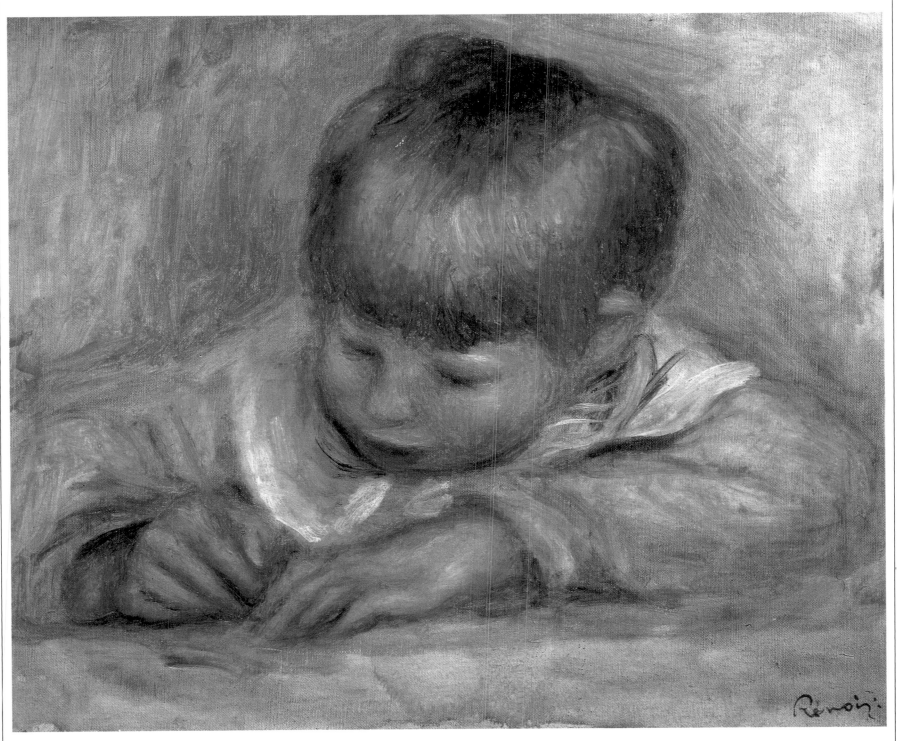

♦ Coco Renoir Writing, ca. 1906. Oil on canvas, 29 x 37 cm (11 1/2 x 14 1/2 in). Musée des Beaux-Arts, Lyons. Compared to the analogous portrait of Jean executed in 1901, this smaller canvas concentrates more on the intimacy of the scene. Renoir has acutely interpreted—without a trace of sentimentality—his son's infantile seriousness and total absorption in his task.

230

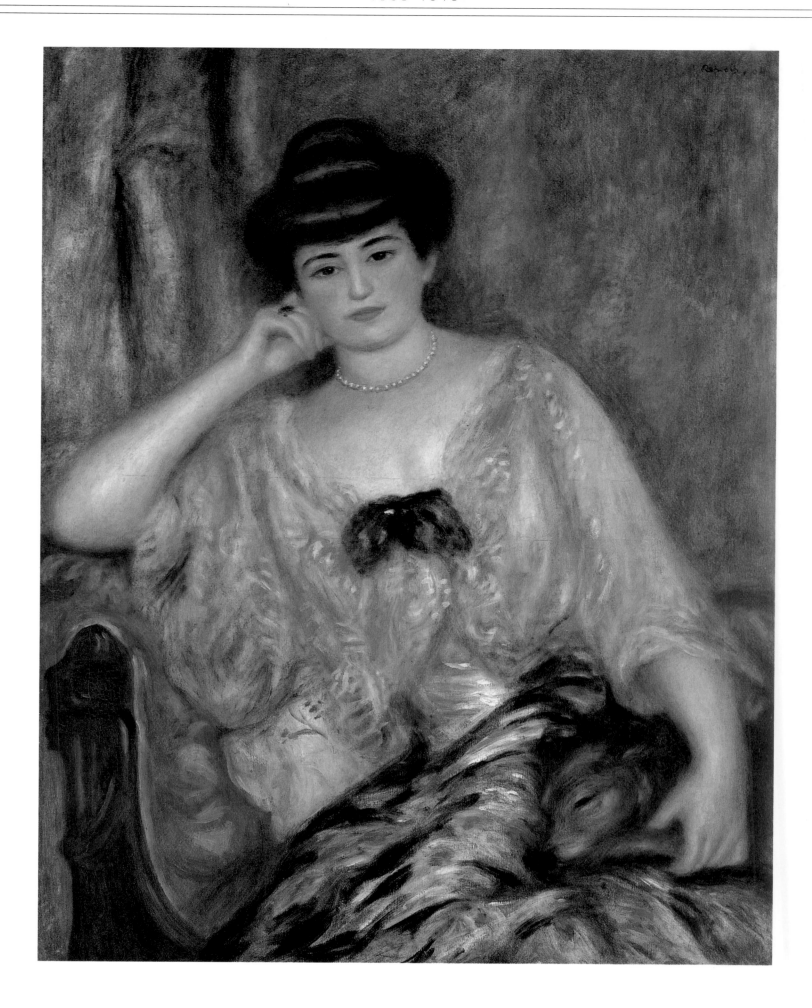

♦ *Above,* Misia Godewska Edwards, *1904. Oil on canvas, 92 x 72 cm (36 1/4 x 28 3/8 in). National Gallery, London. With sophisticated skill, Renoir structures this composition around the play of lines* formed by Misia's body, slightly leaning to the left, which imparts a touch of restlessness he must have noted in his model. The string of pearls enhances her luminous flesh and the pink of her dress modulates its paleness, while the black ribbon draws one's eyes to her breasts, the quintessence of femininity, and acts as a counterpoise to the black hair.

♦ *Opposite,* The Walk, *ca. 1906. Oil on canvas, 165 x 129 cm (65 x 50 3/4 in). The Barnes Foundation, Merion, Pa. "A blond Venus who walked like a goddess," Jean Renoir said of the model, Adrienne.*

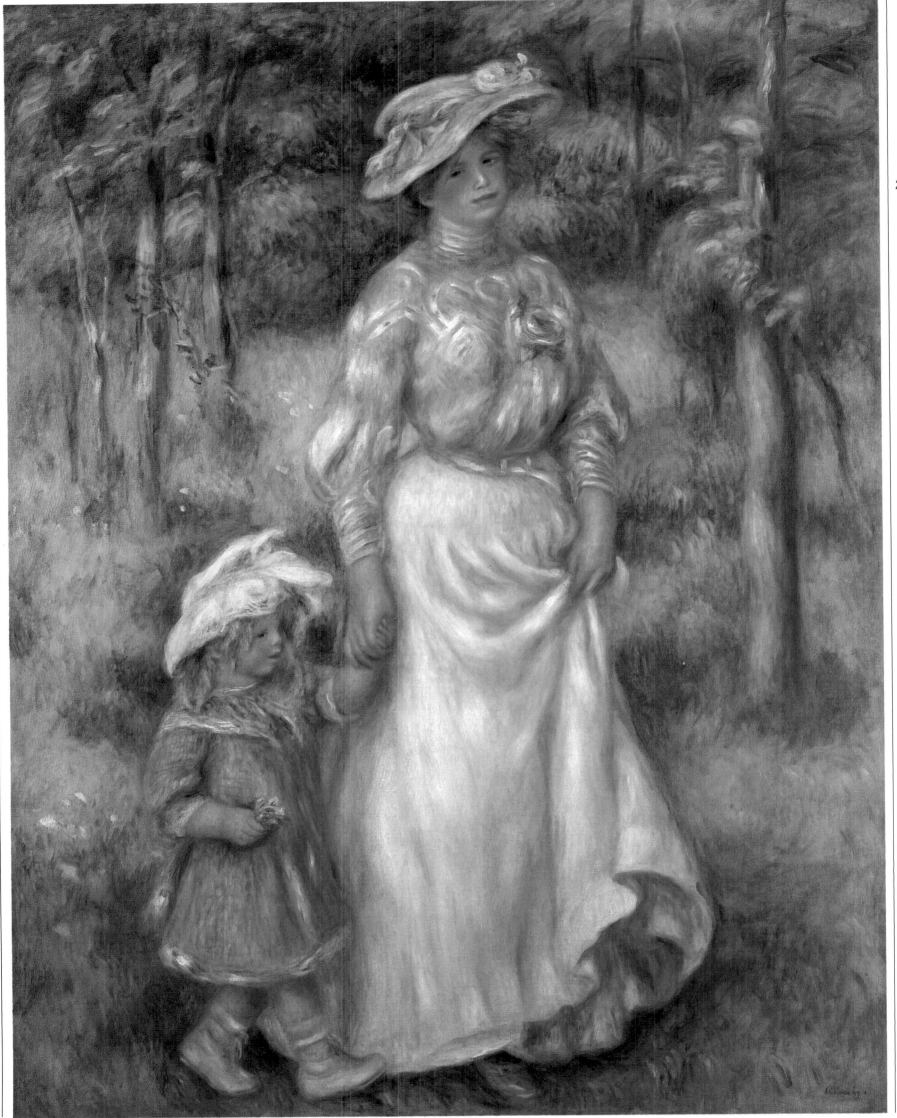

232

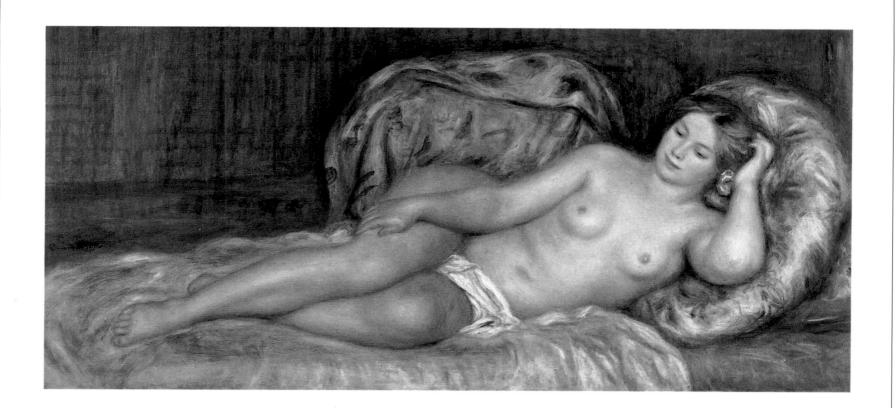

♦ *Above*, Nude Reclining on Cushions, *1907. Oil on canvas, 70 x 155 cm (27 1/2 x 61 in). Musée d'Orsay, Paris.*

♦ *Opposite above,* Reclining Nude (Gabrielle), *ca. 1903-06. Oil on canvas, 67 x 160 cm (26 3/8 x 63 in). Musée de l'Orangerie, Paris.*

♦ *Opposite below,* Gabrielle with Her Gown Open, *1907. Oil on canvas, 65.5 x 53.5 cm (25 3/4 x 21*

in). Durand-Ruel Collection, Paris. The model for these three canvases was Gabrielle Renard. In 1903 Camille Mauclair gave an "exotic" interpretation of these nudes: "One would say that he [Renoir] hardly observes the line, as he is so taken by the splendor of her flesh [...] For him the female nude is a flash of lightning, flesh at once luminous, lily-white and floral that no

male model and no red-head with diaphanous skin can match. He paints her like a true poet. She is the "ideal clay" for him [...] Like an academic nude, she has no age, no date, no origin; but she does not come from the Academy, she comes from a ferocious, primitive land of dreams [...] His type of woman, without any cerebral qualities, does not invite you to shift your glance from the exciting flesh of her

breasts or stomach to seek some thought in her face: this happy animal has a head, cheeks and mouth like fruit, unconscious eyes, signs of a sweet brutality, enclosed in a tropical nature in which modesty is as unknown as vice is [...] And this mixture of japonaiserie, of Orientalism, of the savage and of eighteenth-century taste, so bizarre and attractive—he has it."

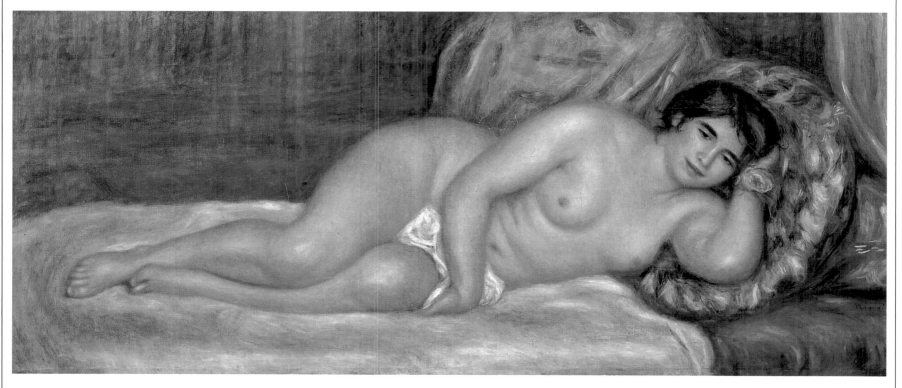

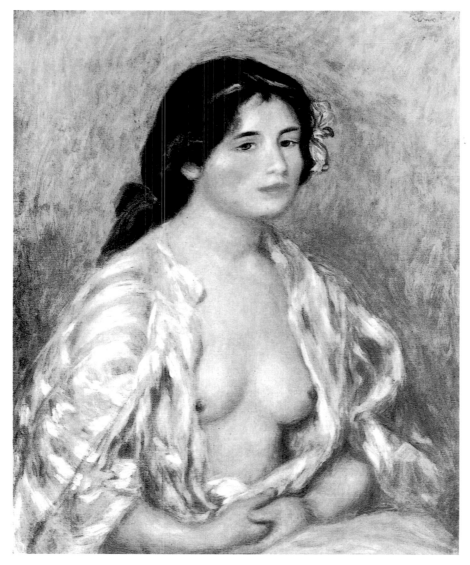

234

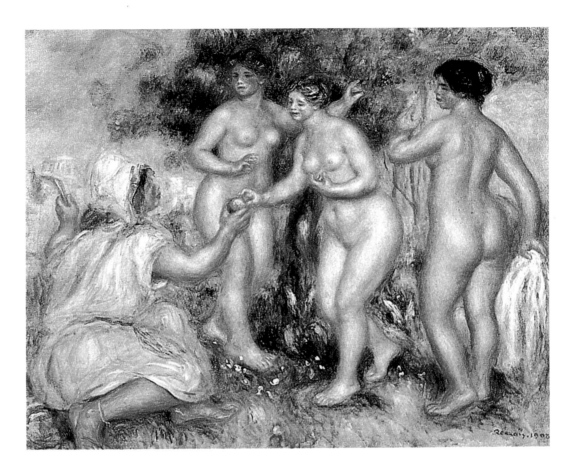

♦ *Above,* The
Judgment of Paris,
*1908. Oil on canvas,
81 x 101 cm (31 3/4
x 39 3/4 in). Private
Collection. This is
certainly not the first
openly mythological
theme Renoir
painted; he tried to
be accepted at the
1867 Salon with
Diana, and he later
executed other such
motifs to please his
patrons—Pan's Feast
for Paul Bérard and
the four Scenes from
"Tannhäuser" for Dr.*
*Blanche in 1879. But
near the end of his
life Renoir felt ready
to face the challenge,
with total artistic
freedom, of the most
ancient and
pregnant themes in
Western art. It was
not by accident that
the motif he selected
is an homage to
beauty: Paris
awarding Venus the
"apple of discord."
But here there is no
allusion to the future
Trojan war; on the
contrary, the three*
*voluptuous nudes
appear in a setting
of idyllic nature and
are totally merged,
in a pantheistic
vision, with the
landscape through
the thick and vibrant
brushwork. The three
goddesses and Paris
are actually
representations of
Gabrielle, who
according to Jean
Renoir posed for all
four figures.*

♦ *Opposite,* Ode to
Flowers, *1909. Oil*
*on canvas, 46 x 36
cm (18 1/8 x 14 1/8
in). Musée d'Orsay,
Paris. This work,
inspired by a couplet
by Anacreon, was
executed for Maurice
Gangnat's dining
room. Renoir poured
all of his decorative
skill into this
canvas, which was
conceived to please
the eye through a
paean to beauty in
and for itself.*

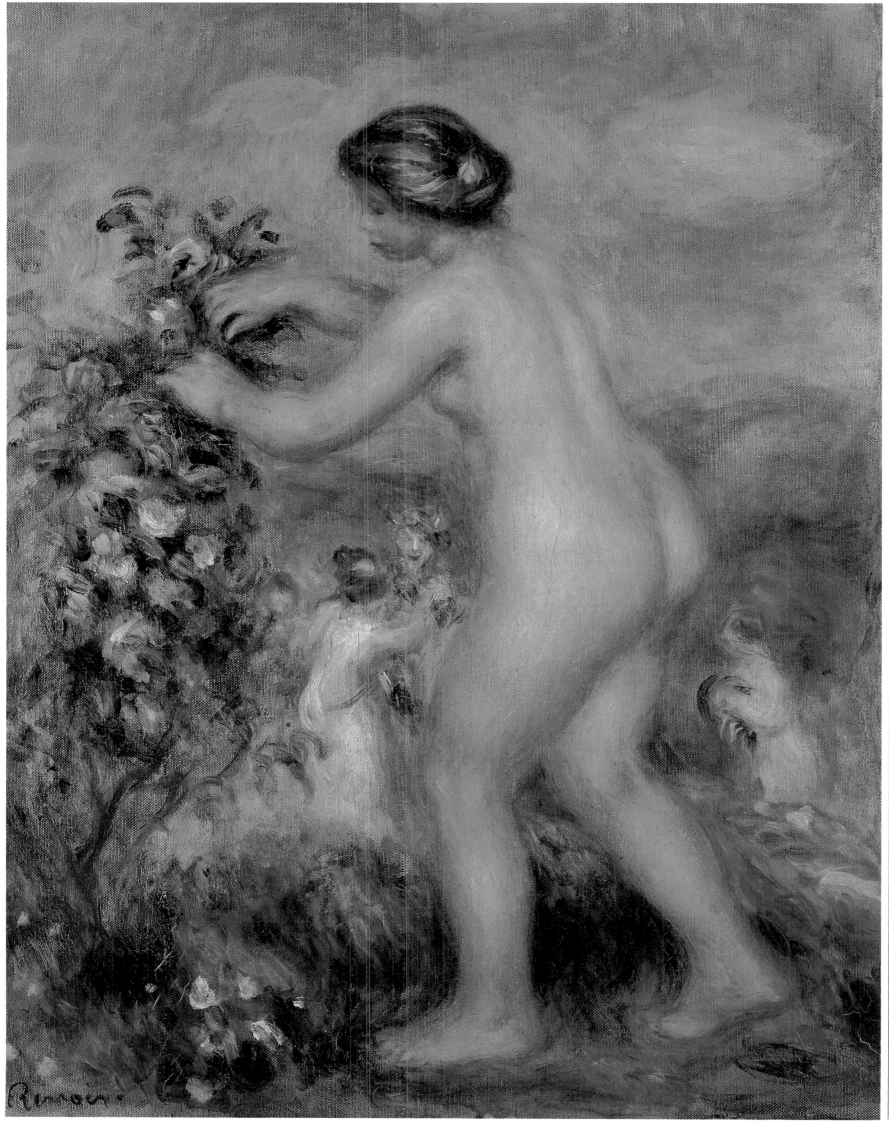

236

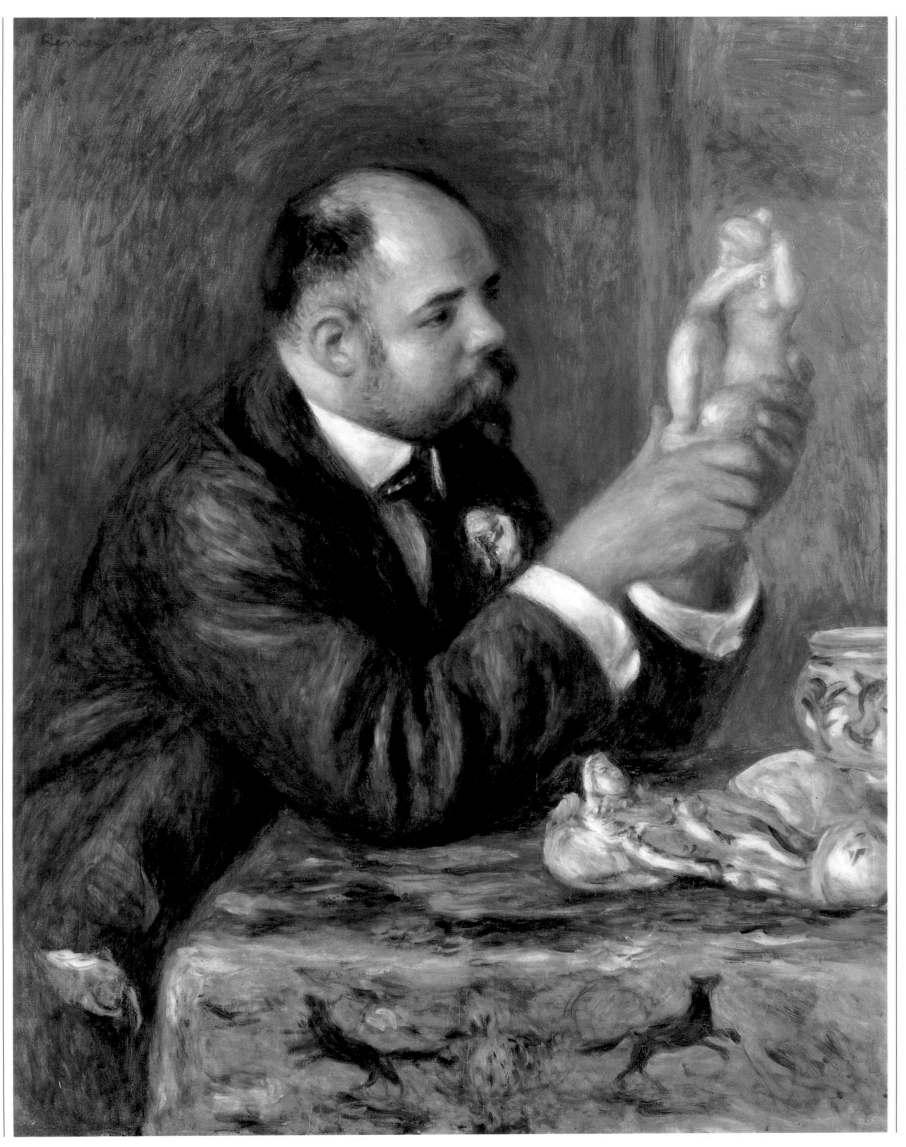

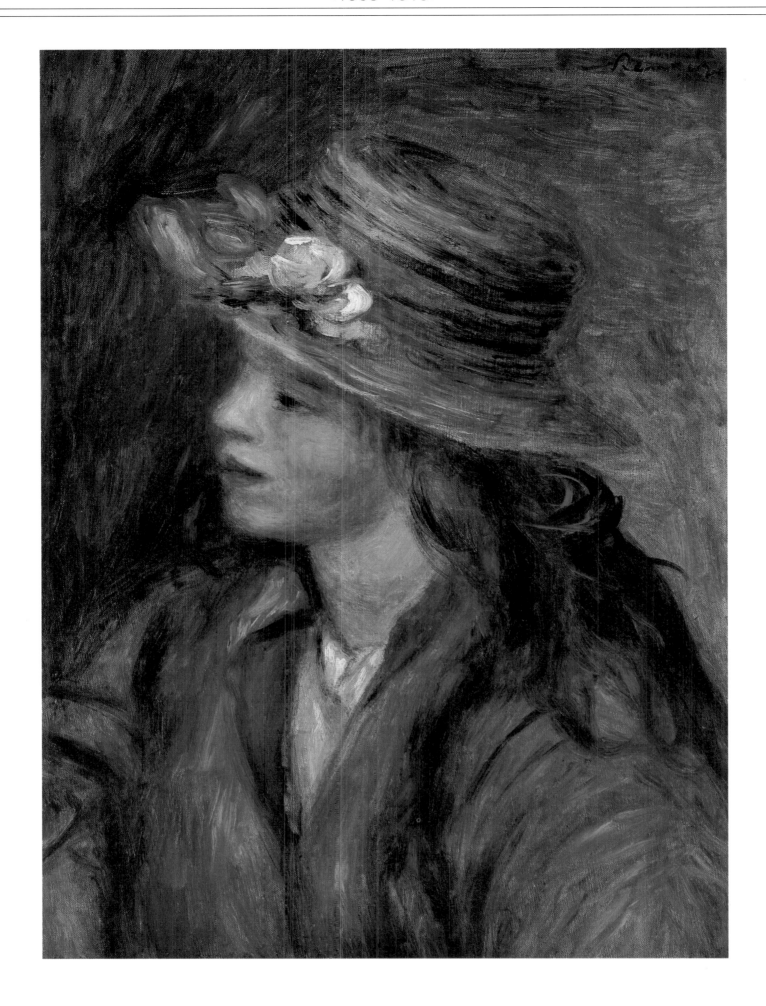

♦ *Opposite*, Portrait of Ambroise Vollard, *1980. Oil on canvas, 82 x 65 cm (32 1/4 x 25 1/2 in). Courtauld Institute Galleries, London. A native of Réunion Island, the corpulent Vollard had striking features; very little of* this is seen in *Renoir's portrait, where he seems more interested in the effect of the pictorial surface than in a physiognomic or psychological representation of his model. Vollard had begun art collecting* in rue Laffitte by purchasing Renoir's works; after 1900 he had become one of his most important dealers, along with Durand-Ruel and Bernheim.

♦ *Above*, Girl with a Straw Hat, *ca. 1908. Oil on canvas, 46 x 35 cm (18 1/8 x 13 3/4 in). Musée d'Orsay, Paris.*

238

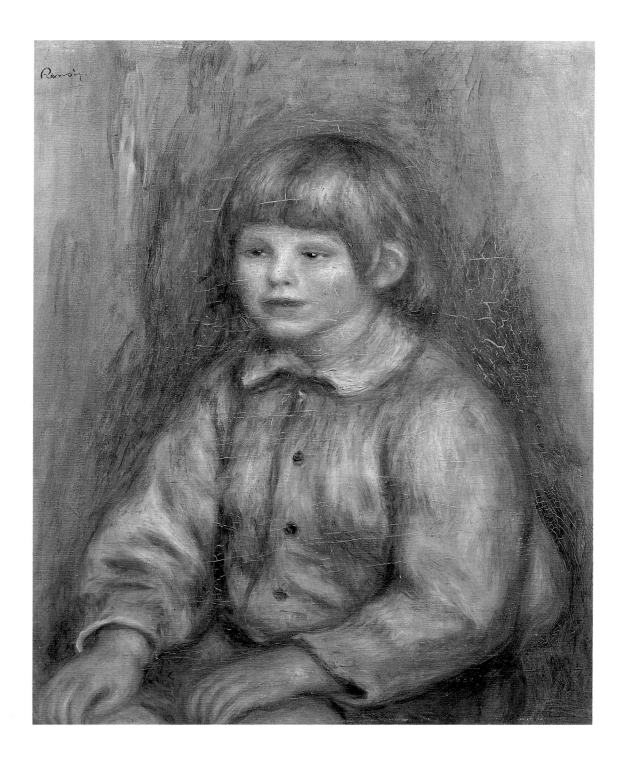

♦ *Above, Coco, ca. 1908-09. Oil on canvas (size unknown). Museu de Arte, Sao Paulo.*

♦ *Opposite,* The Clown, *1909. Oil on canvas, 120 x 77 cm (47 1/4 x 30 1/4 in). Musée de l'Orangerie, Paris. Claude Renoir is portrayed in everyday clothing and in the "Baroque fantasy" of a clown's costume. Coco is a rather sullen clown, and had the following to say when he was an adult: "The costume was rounded off with white stockings that I obstinately refused to wear. In order to finish the canvas, my father demanded I put them on; but I stood firm [...] First there were threats, followed by negotiations; in turn he promised me a spanking, an electric train, threatened to send me to a college, offered me a box of oil paints. In the end I agreed to put on the cotton stockings, but only for a minute; my father, barely repressing a wild fury that was about to break loose, finished the canvas..." Despite all this, Renoir kept the canvas for the rest of his life.*

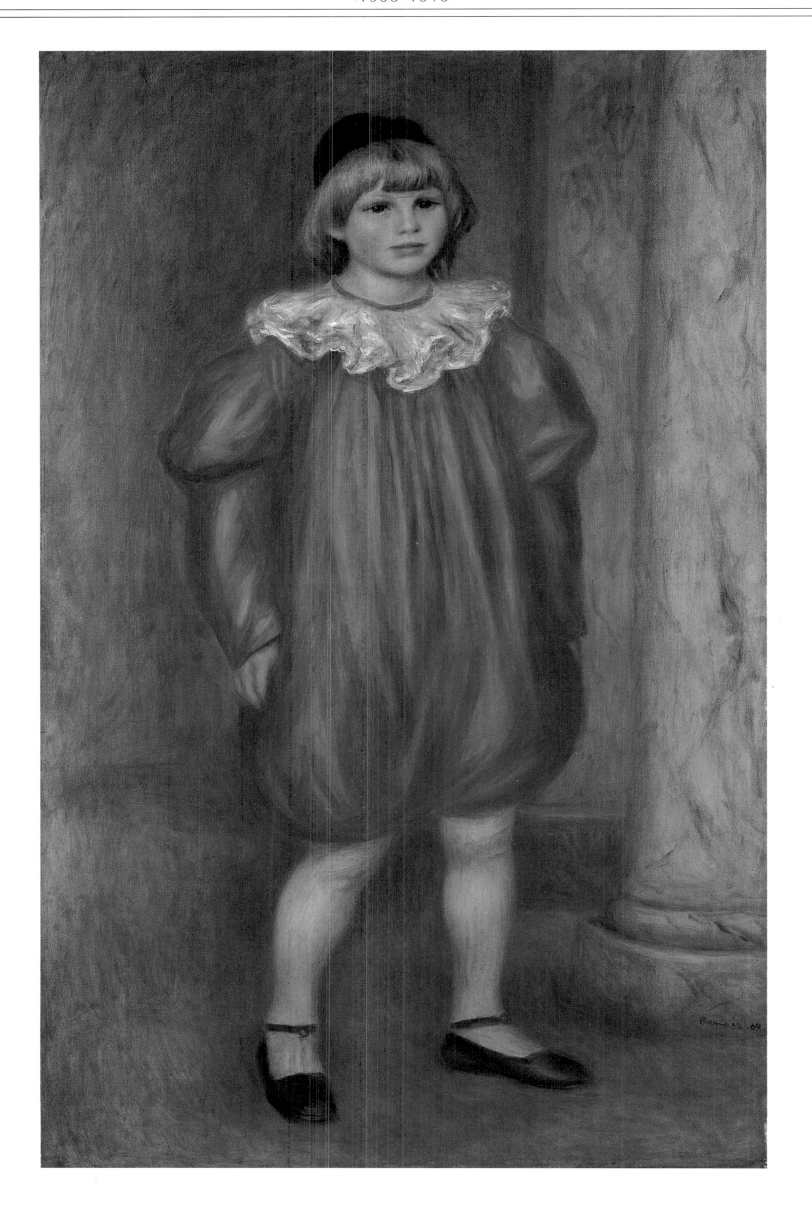

240

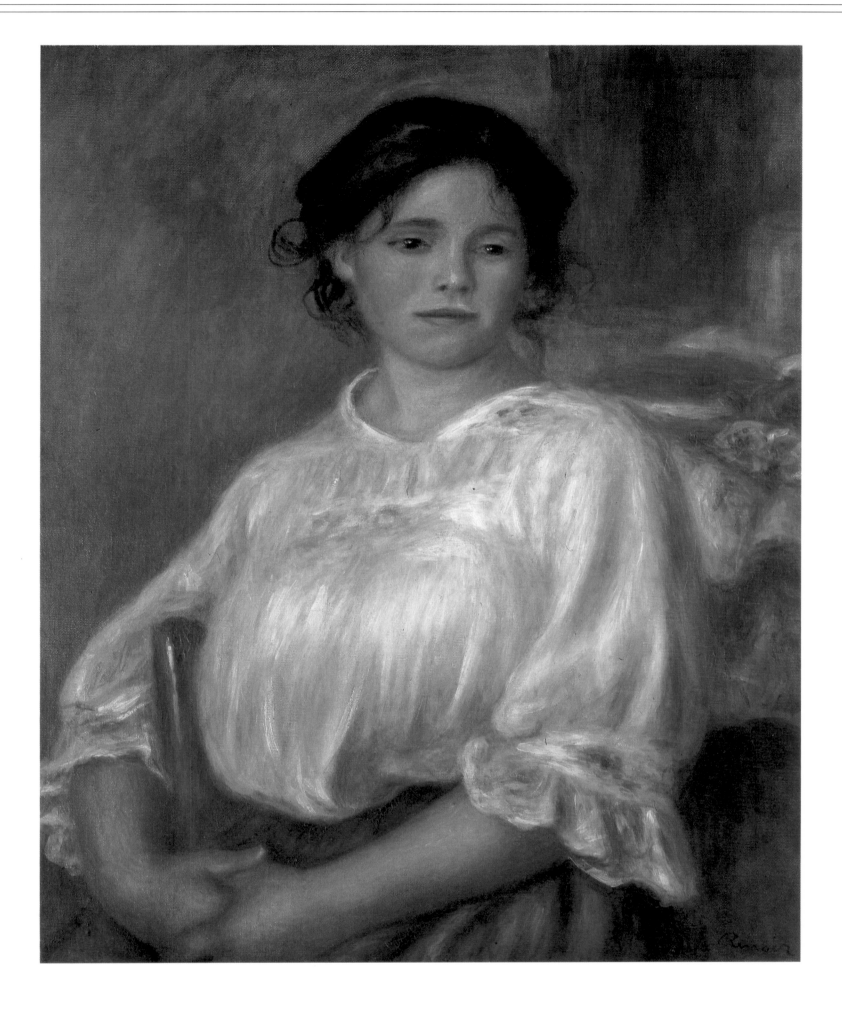

♦ *Above*, Gabrielle Seated, *ca. 1909. Oil on canvas, 65.5 x 54.5 cm (25 5/8 x 21 1/8 in). Musée d'Orsay, Paris. The background barely* suggests a room; the compressed space magnifies the figure, while the light bathes the folds of Gabrielle's blouse with its iridescent reverberations.

♦ *Opposite*, Gabrielle with a Hat, *ca. 1909. Oil on canvas, 55 x 37 cm (21 5/8 x 14 1/2 in). Musée de Peinture et Sculpture, Grenoble. Gabrielle Renard,* with her spontaneous "peasant" beauty, was Renoir's favorite model in this period.

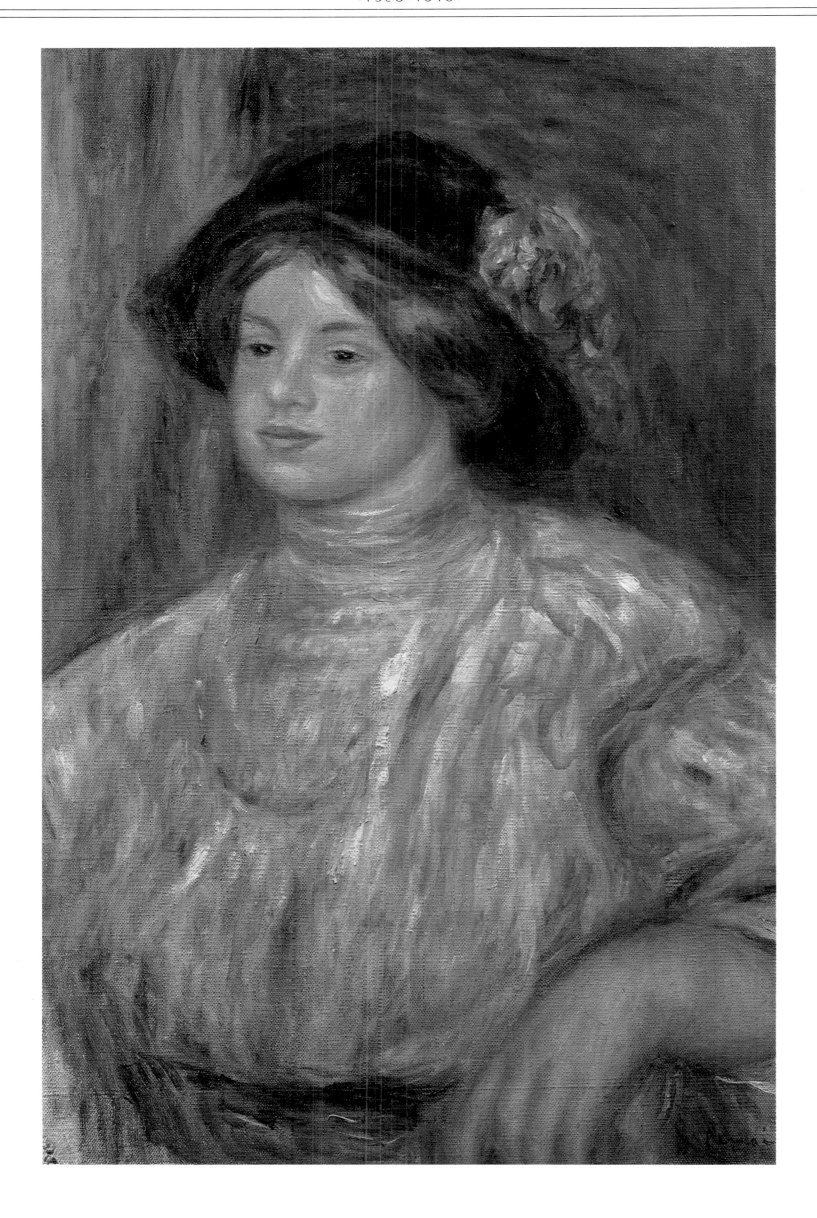

242

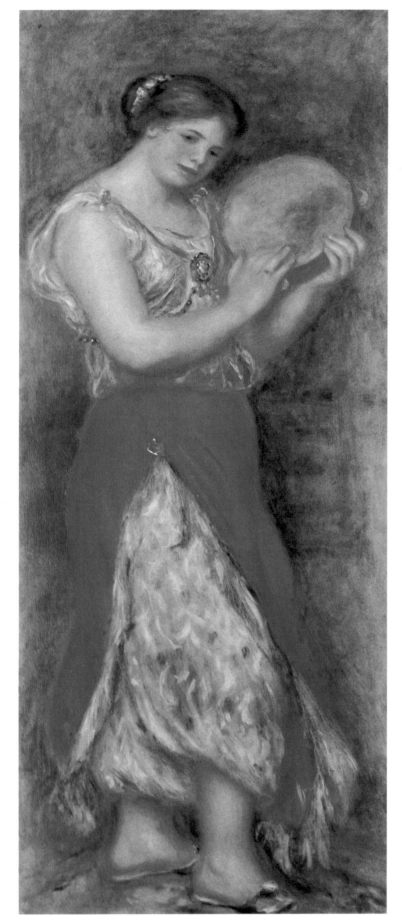

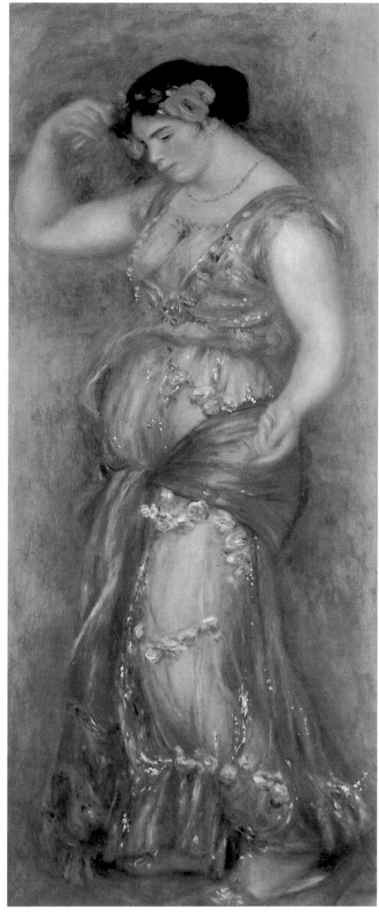

♦ *Left*, Dancer with
Tambourine, *1909.*
Oil on canvas, 155 x
65 cm (61 x 25 1/2
in). National Gallery,
London.

♦ *Right*, Dancer with
Castanets, *1909. Oil*
on canvas, 155 x 65
cm (61 x 25 1/2 in).
National Gallery,

London. These
companion pieces
were executed
together with Ode to
the Flowers for
Maurice Gangnat's
dining room. The
great English
sculptor Henry Moore
had the following to
say about their
monumental

sculptural character:
"The shapes of these
two girls are melted
into the background,
so that what you see
and feel about them
come from inside the
forms, not just from
the outlines. And yet
these rounded forms
have a marvelous
supple rhythm, such

as people are apt to
associate only with
outlines. What one
likes about them is
that, though they are
so monumental, yet
if you compare them,
for instance, with
Maillol's sculptures,
they have none of the
stiffness which these
are apt to have."

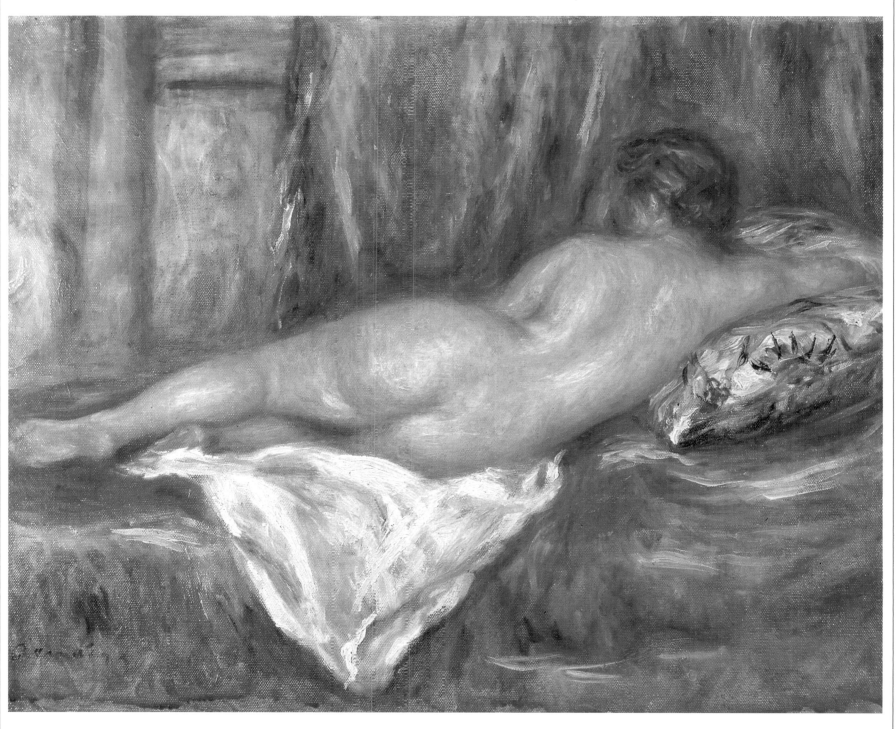

♦ Reclining Nude, ca. 1909. Oil on canvas, 41 x 52 cm (16 1/8 x 20 1/2 in). Musée d'Orsay, Paris. As was the case with Two Bathers (1892-95), this is an almost literal "quotation" from Velásquez's The Toilet of Venus.

"There is another thing about Velásquez that delights me: his painting radiates with the joy the artist had in doing it [...] When I feel the passion with which the artist has created, I enjoy his very pleasure."

244

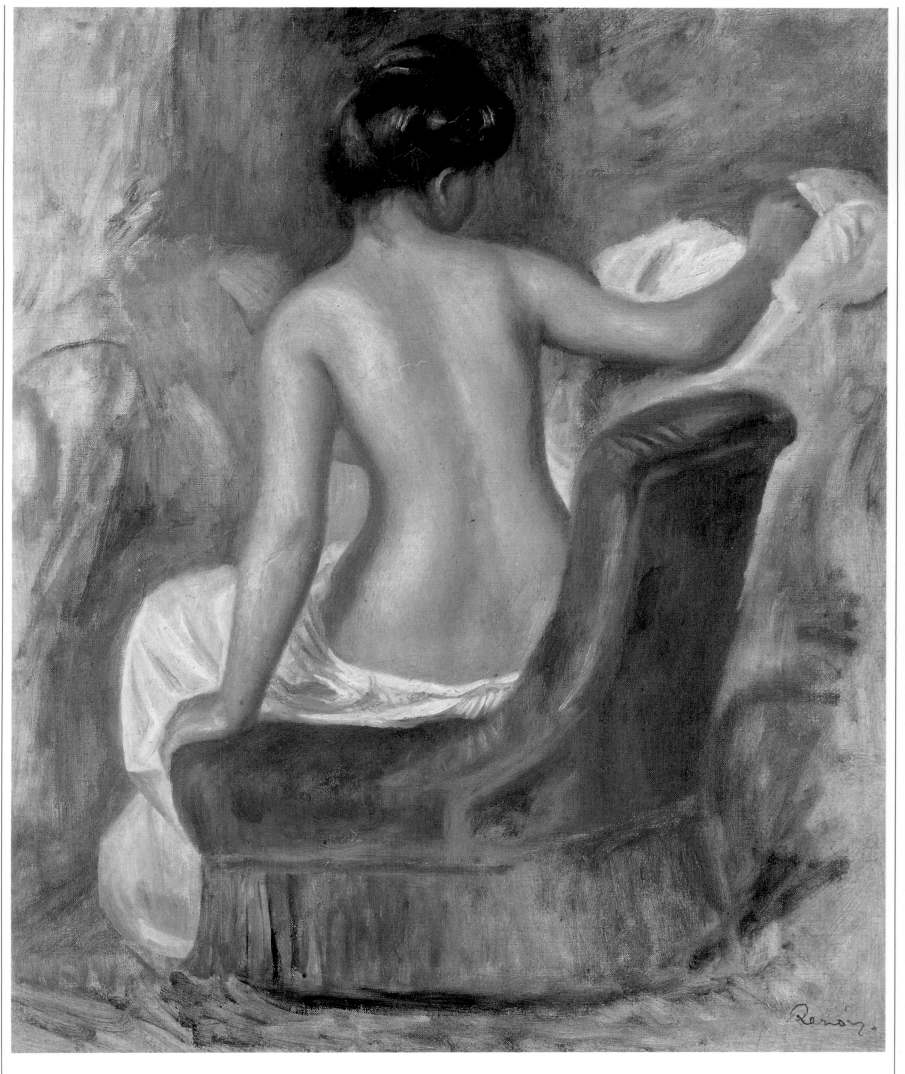

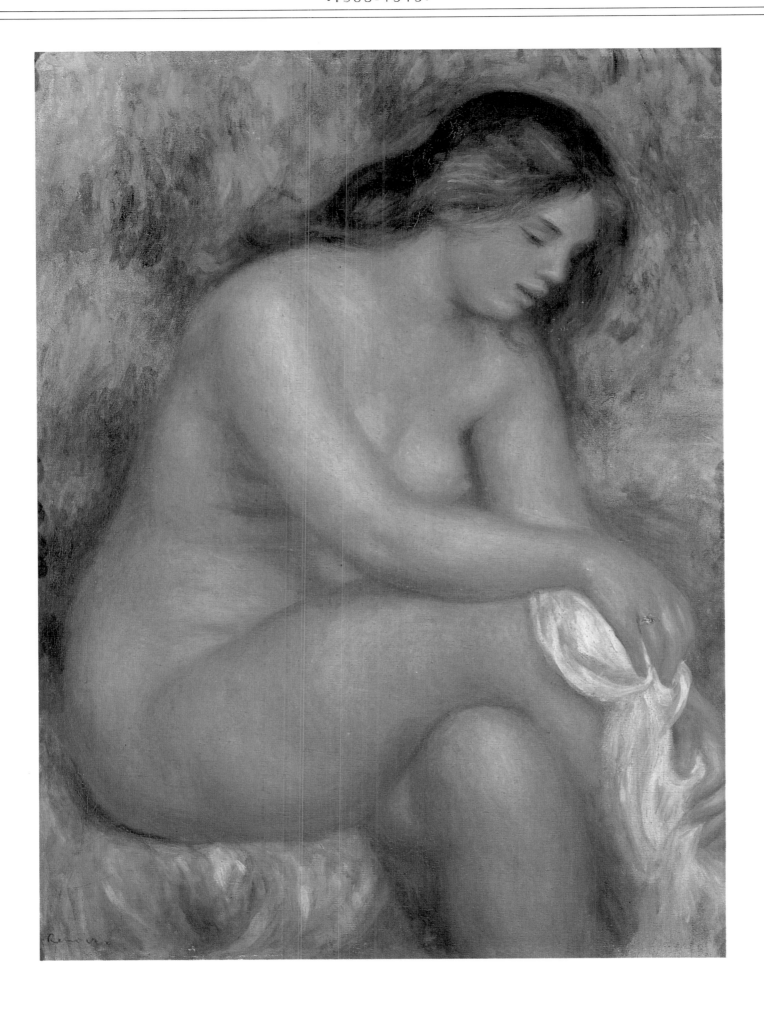

♦ *Opposite*, Nude in an Armchair, *1910. Oil on canvas, 55.5 x 46.5 cm (22 x 18 1/4 in). Kunsthaus, Zurich. The canvas does not show the viewer the woman's intelligent face but the exquisite grace of her soft, arched back.*

♦ *Above*, After the Bath, *ca. 1910. Oil on canvas, 84 x 65 cm (33 x 25 5/8 in). Museu de Arte, Sao Paulo. The figure wholly dominates the surface; the background, rendered with a thin, fluid impasto, is* reduced to a minimum. The repeated undulating brushstrokes around the nude heighten the abundance of her form. The figure is merged with the setting through the unified tone rather than the inner reverberations of color.

246

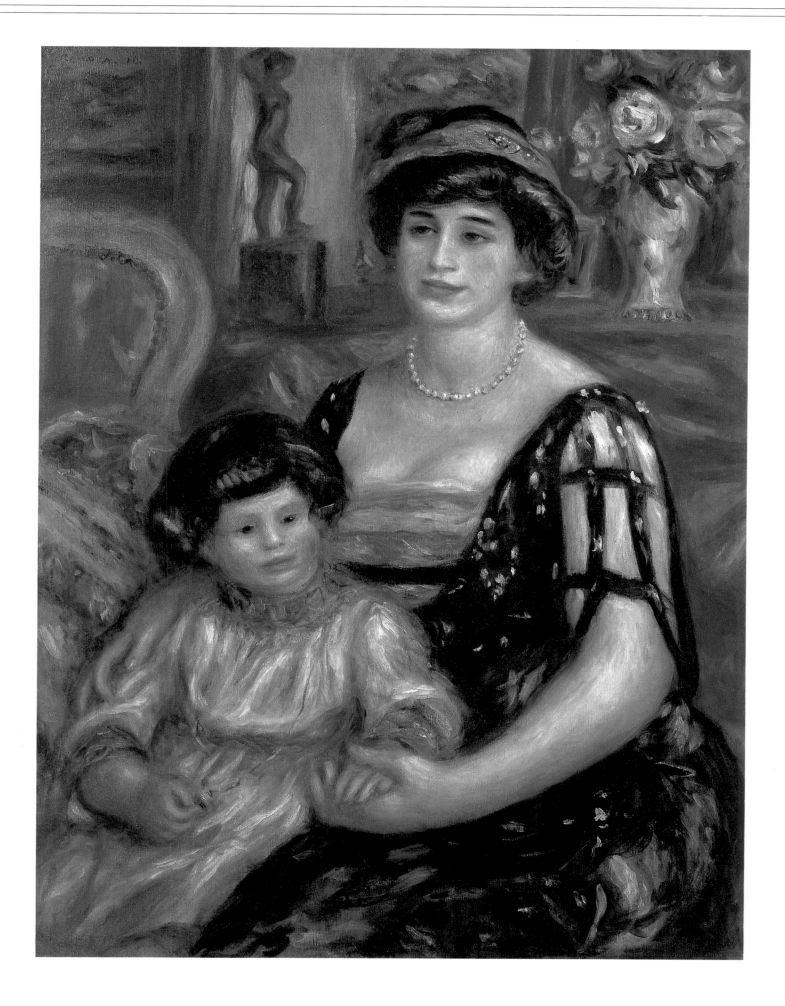

♦ *Above*, Madame
Josse Bernheim-
Jeune with Her Son
Henry, *1910. Oil on
canvas, 81 x 65 cm
(31 3/4 x 25 1/2 in).
Musée d'Orsay,
Paris.*

♦ *Opposite*, Monsieur
and Madame
Bernheim de Villers,

*1910. Oil on canvas,
81 x 65.5 cm (31 3/4
x 25 5/8 in). Musée
d'Orsay, Paris.
Renoir renders these
two "official, public"
portraits differently.
The first is
traditional,
structured around
the pyramid of the
two figures like a*

*Renaissance
Madonna, without
neglecting the touch
of maternal love in
the interlocked
hands. The second
work is more
unusual, with its
close-up view that
cuts off part of M.
Bernheim's body,
much like a snapshot*

*angle. The Bernheim
brothers were among
the most famous art
gallery owners in
Paris and had
amassed a fine
collection of Renoir's
works, especially
from his final
period.*

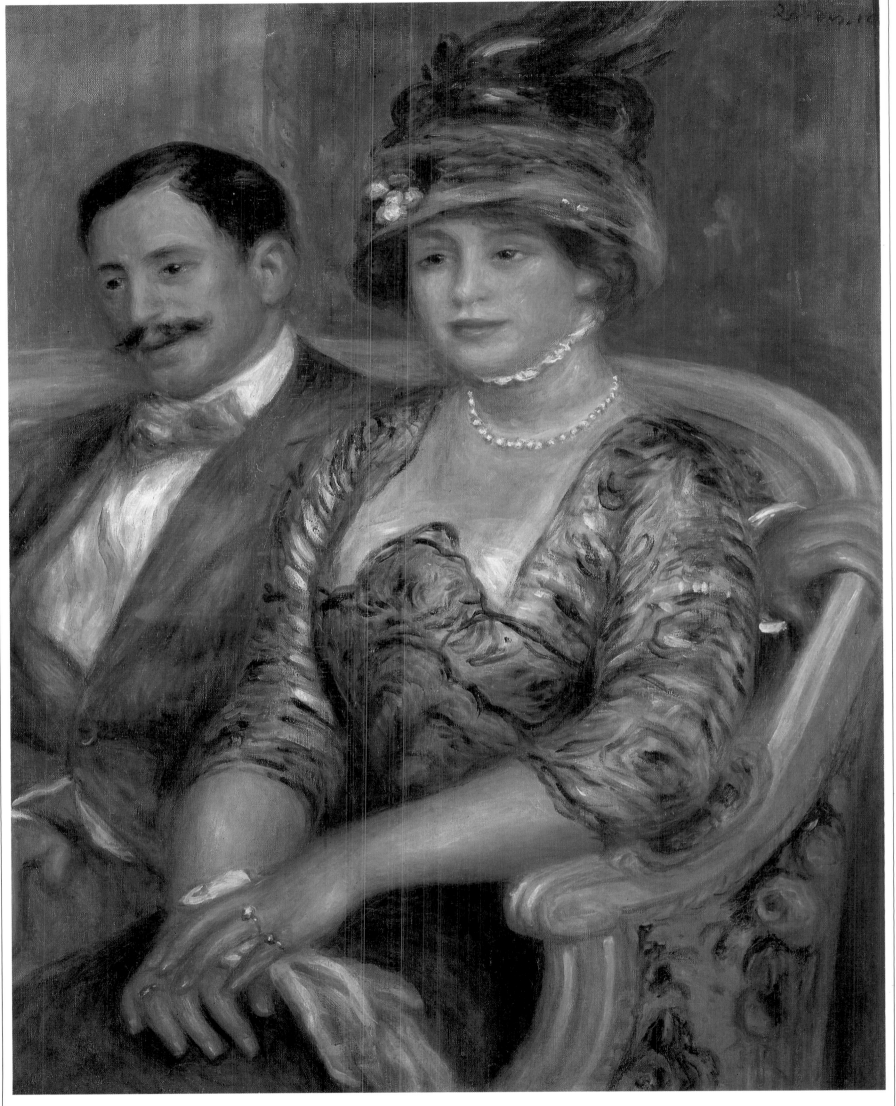
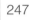

248

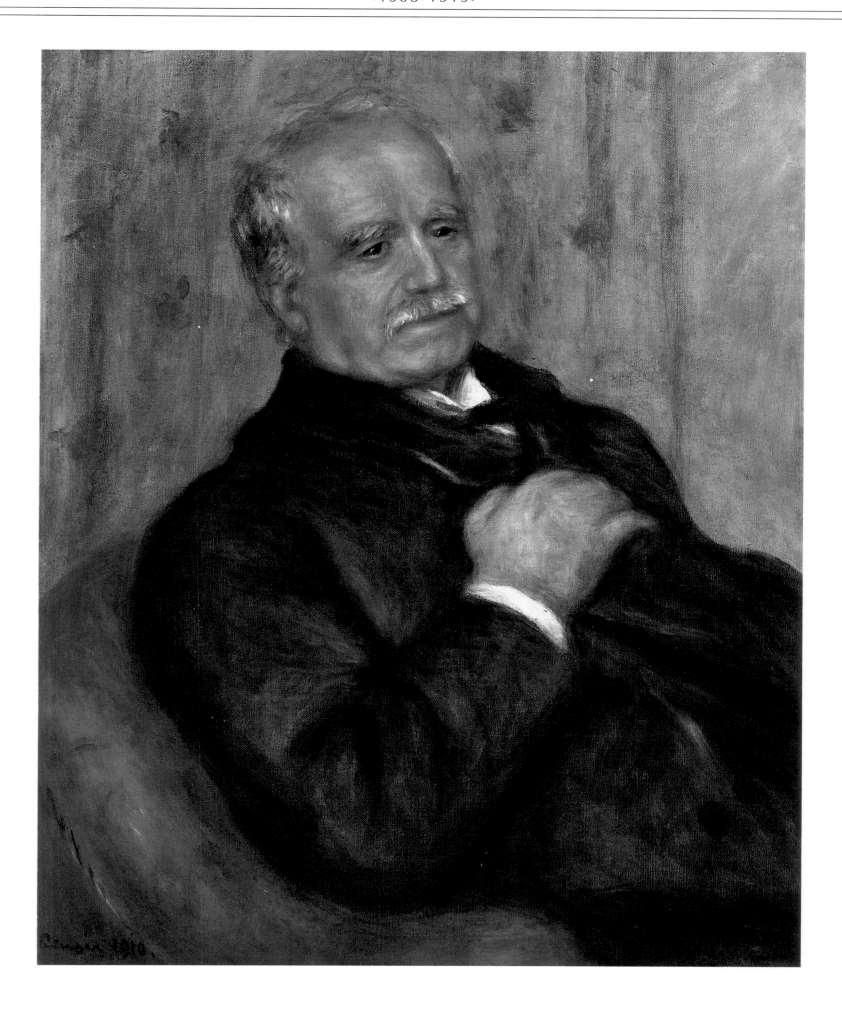

♦ Portrait of Paul Durand-Ruel, *1910. Oil on canvas, 65 x 54 cm (25 1/2 x 21 in). Durand-Ruel Collection, Paris. This is the only portrait Renoir did of the* Impressionists' art dealer and mentor. It was executed when both were old. In this truly heartfelt tribute the artist does not conceal his sitter's advanced age, depicting his baldness and his tired and sad look with feeling that is masked by the resplendent colors. The texture is thin and in some areas one can see the white of the canvas. Durand-Ruel was eighty years-old at the time; he kept this portrait for the rest of his life (d. 1922).

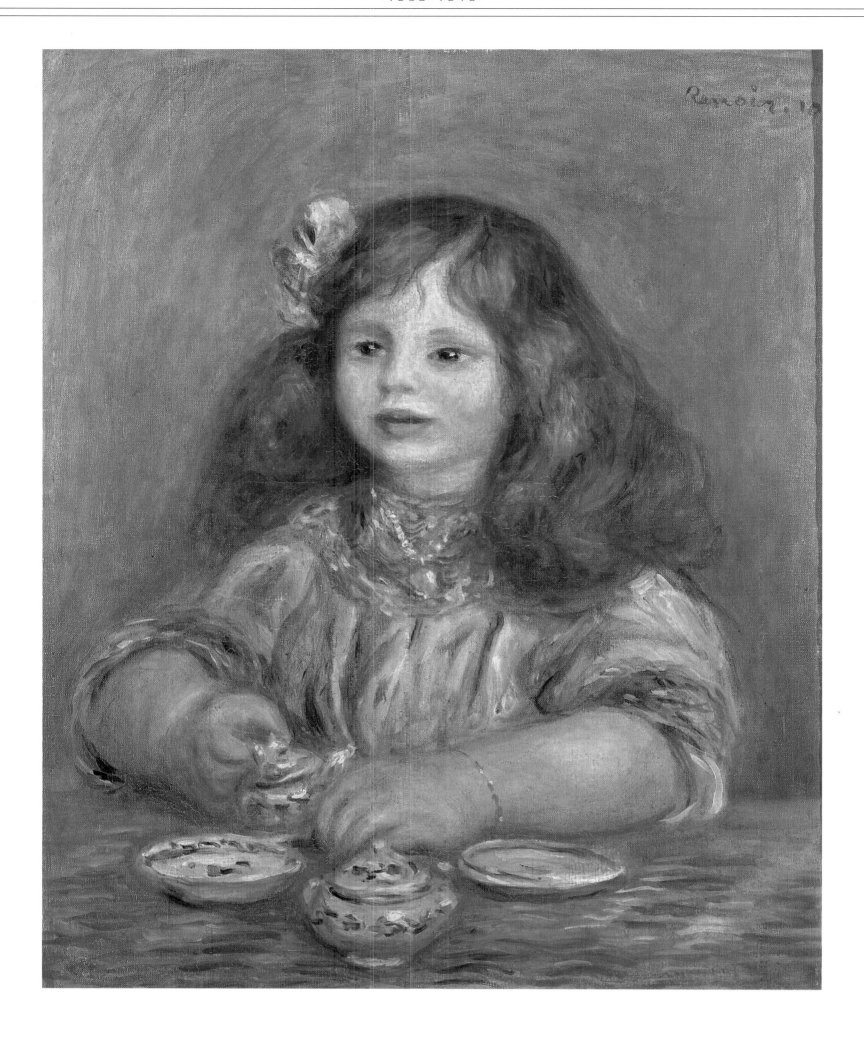

♦ *Opposite, Portrait of Geneviève Bernheim de Villers, 1910. Oil on canvas, 53 x 44 cm (20 3/4 x 17 1/4 in). Musée d'Orsay, Paris. The art dealer's daughter is depicted in a* *simple domestic scene while seated at a table, but Renoir does not fail to introduce a social nuance in the detail of the luxurious necklace.*

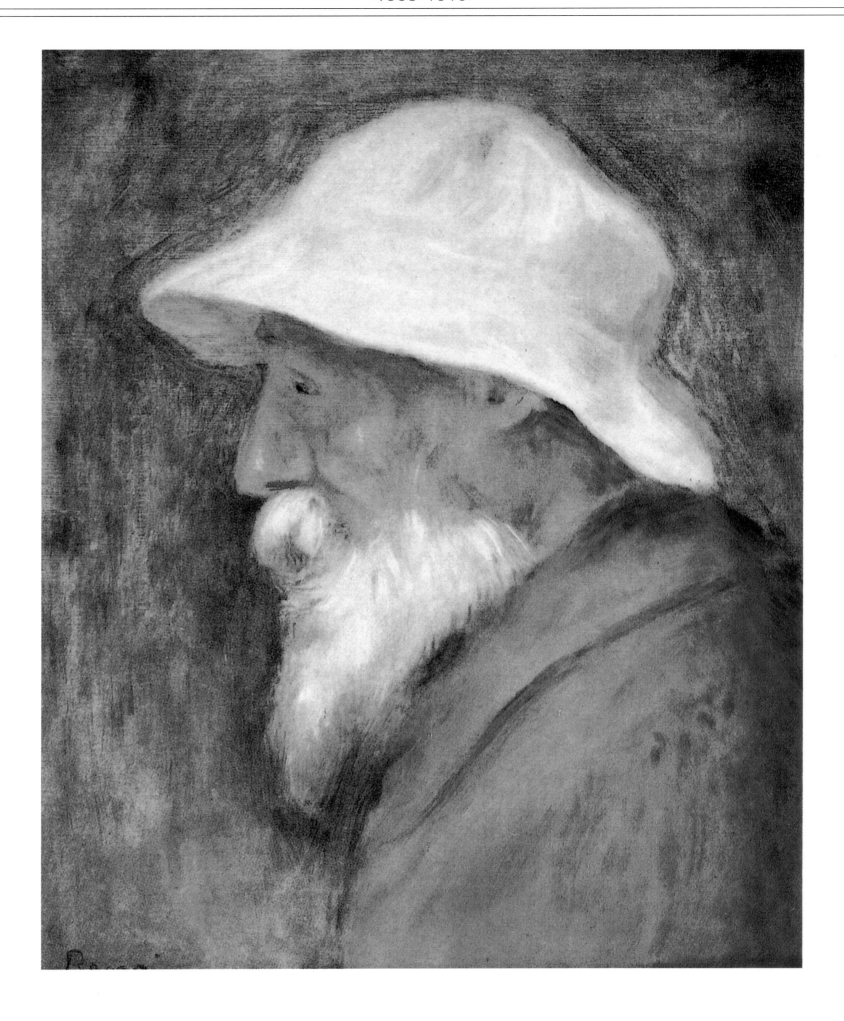

♦ *Above, Self-portrait, 1910. Oil on canvas, 42 x 33 cm (16 1/2 x 13 in). Durand-Ruel Collection, Paris. Renoir used the expedient of two large "intersecting" mirrors to obtain his image in profile.*

Jean accidentally broke one, and the artist used this as an excuse not to finish the painting and in order to return to his favorite motifs.

♦ *Opposite above, Alexander Thurneyssen as a Shepherd, 1911. Oil on canvas, 75 x 93 cm (29 1/2 x 36 1/2 in). Museum of Art, Rhode Island School of Design, Providence.*

♦ *Opposite below, Portrait of a Child, ca. 1910-12. Oil on canvas, 41 x 33 cm. Musée Picasso, Paris.*

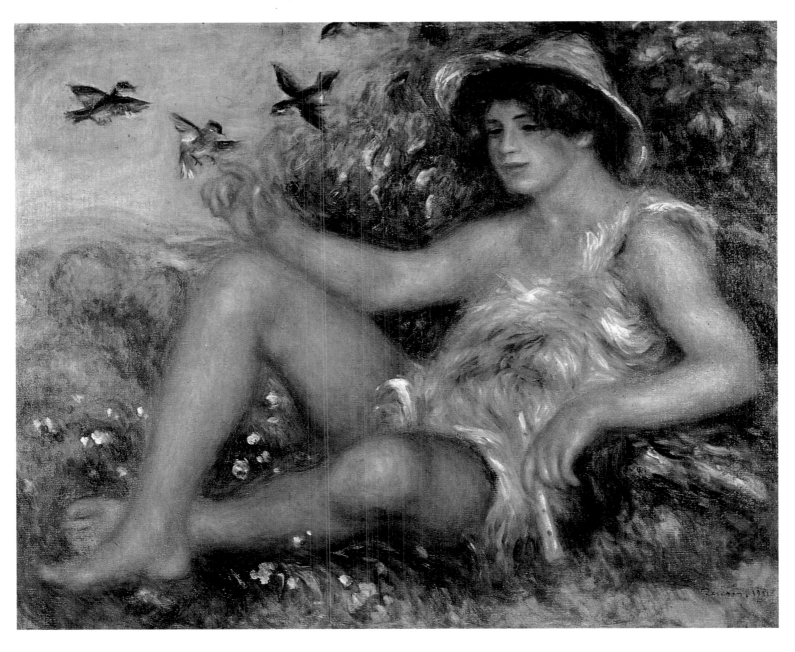

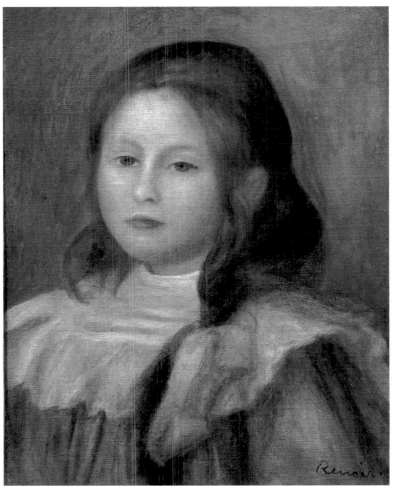

254

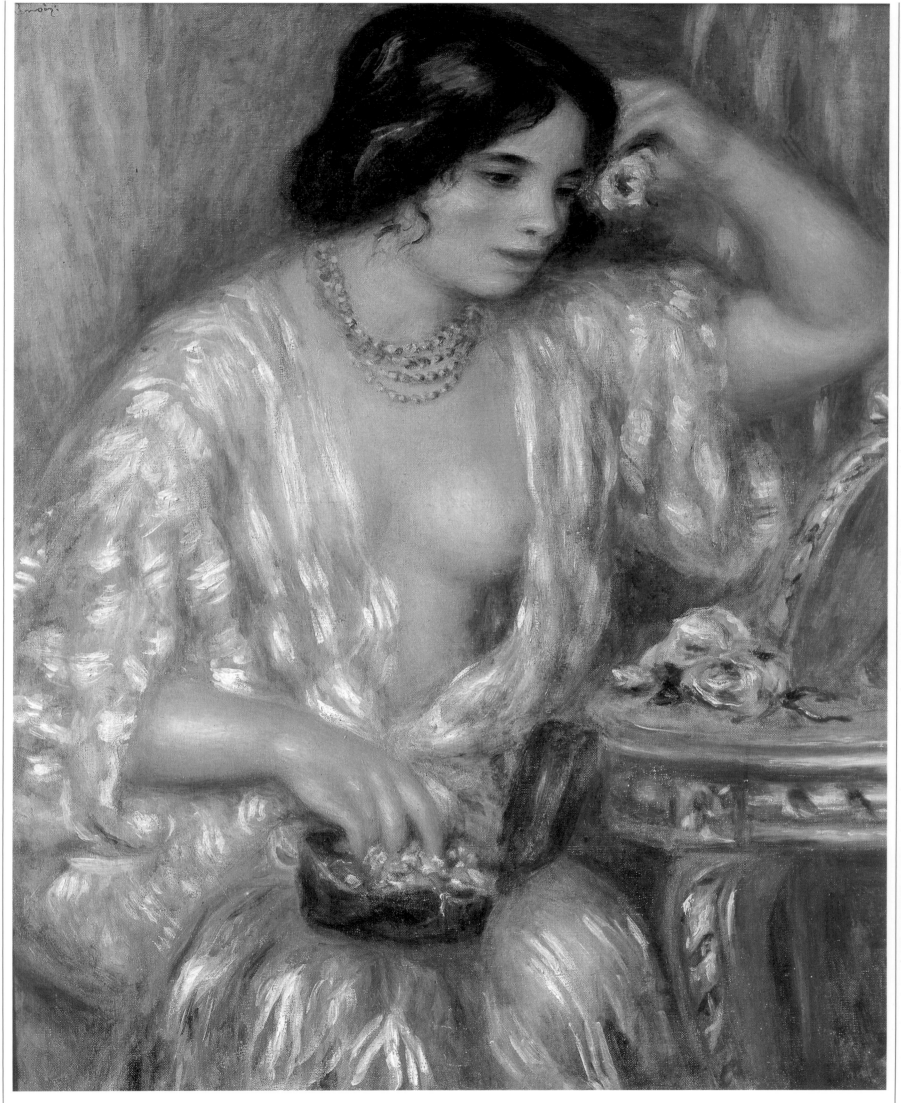

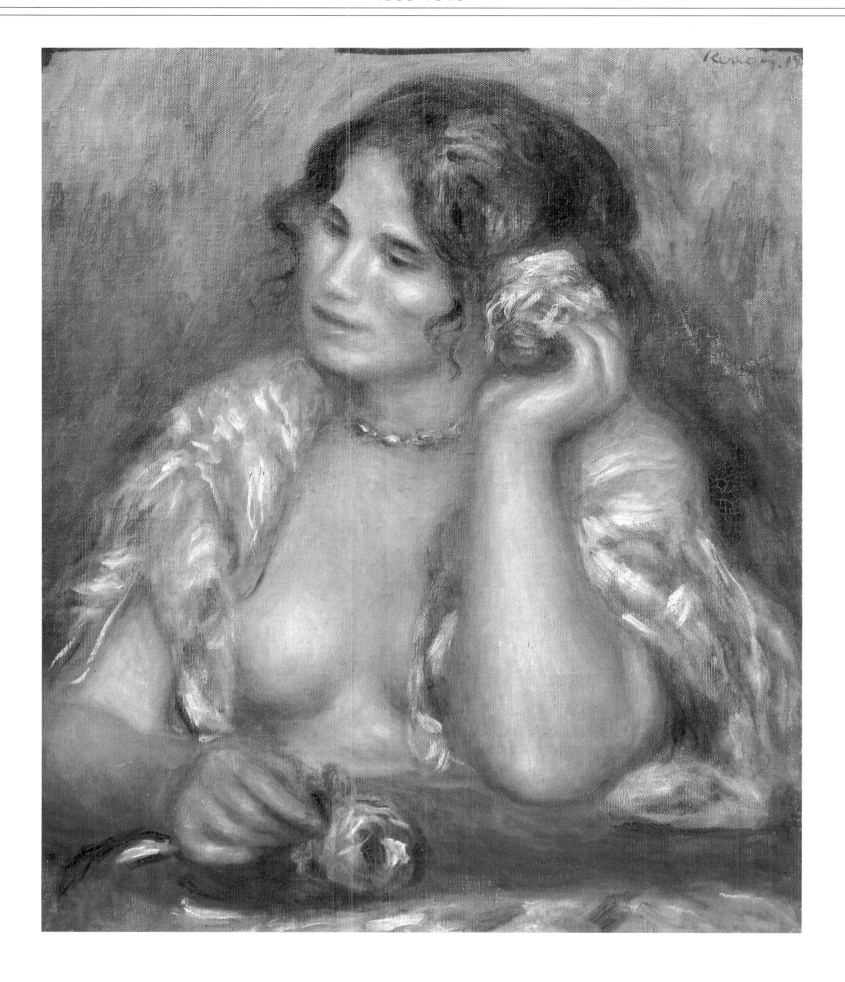

♦ *Opposite,* Gabrielle with Jewelry, *ca. 1910. Oil on canvas, 81 x 65 cm (31 3/4 x 25 1/2 in). Skira Collection, Geneva. This not a portrait, but an idealized archetype of female beauty. According to Besson, Renoir often said he needed to have models but also* had to forget their personality. One anecdote has it that Aline was jealous of Gabrielle and accused her of having taken some of her jewels, so that the portrait is a recollection of that argument.

♦ *Above,* Gabrielle with a Rose, *1911. Oil on canvas, 55 x 47 cm (21 1/2 x 18 1/2 in). Musée d'Orsay, Paris. The brilliant white of the open, transparent and plush gown enhances the pink flesh against the bright red of the flowers* and the rug, and almost imperceptibly evokes a timeless, indefinite space filled with luxury, voluptuousness and exotic splendor. It is beauty which by itself is the harbinger of dreams.

256

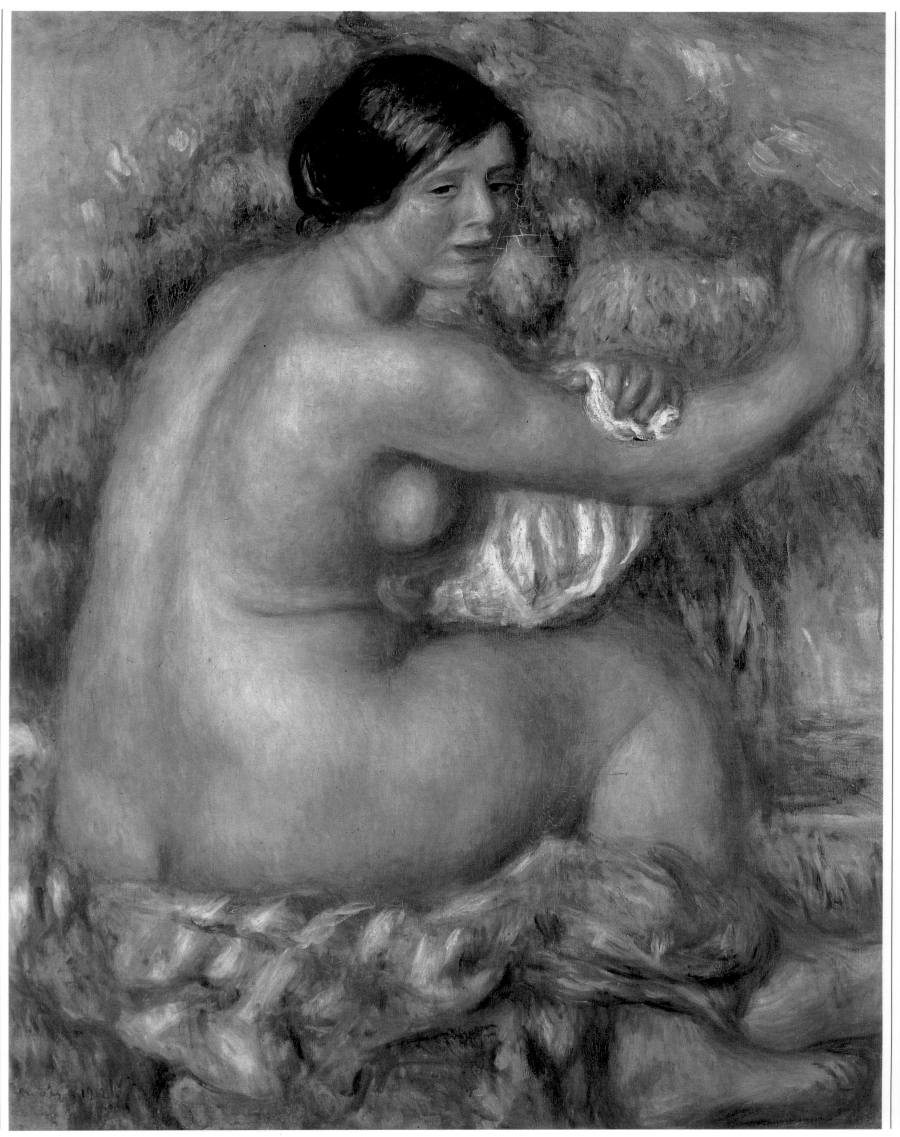

257

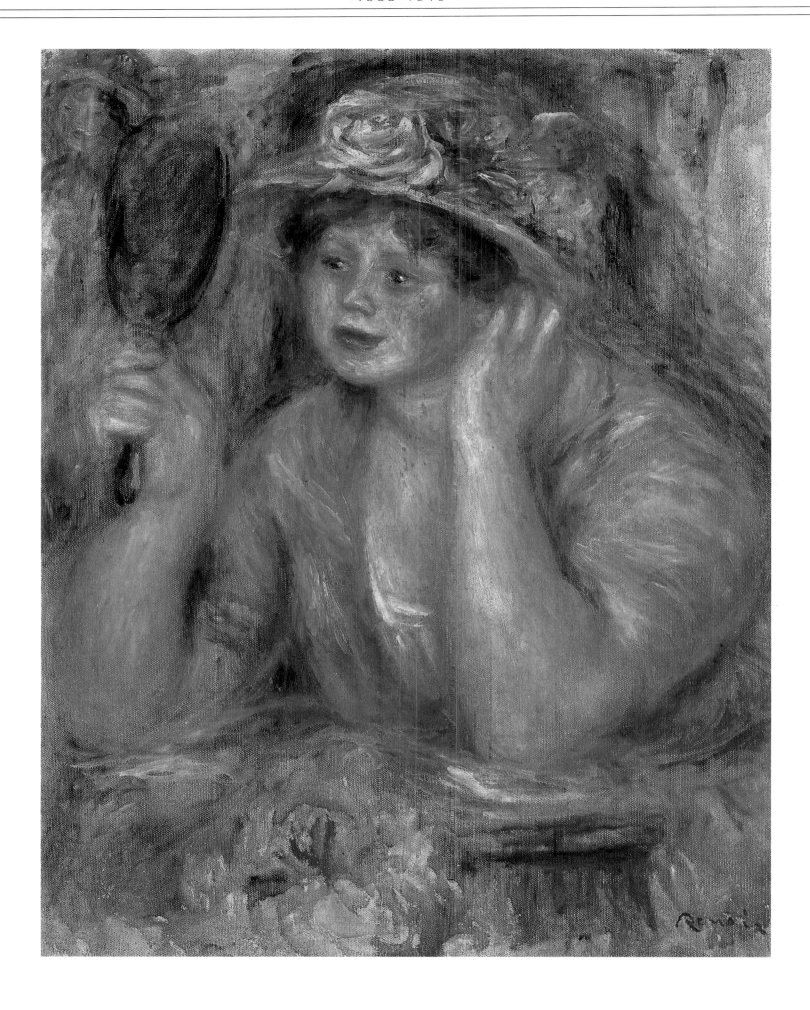

♦ *Opposite,* After the Bath, *1912. Oil on canvas, 93 x 74 cm (36 1/2 x 29 1/8 in). Museu de Arte, Sao Paulo. In his last portraits of isolated nudes that imperiously dominate the space* *either indoors or outdoors, Renoir achieves the height of his monumental classicism. The brushstrokes model the volumes in thick, repeated touches that build up the tonal modulations as in a* *purely chromatic chiaroscuro. The result is an enlargement of the planes on the painting surface, as if the different viewpoints were summed up in a single frontal* *perspective. It has been said that this feature of Renoir's influenced Picasso's plastic, synthetic nudes during his "neo-classic" period.* *♦ Above,* Girl Looking into a Mirror, *ca. 1912. Oil on canvas, 60 x 47 cm (23 1/2 x 18 1/2 in). Musée des Beaux-Arts, Rouen. This motif is similar to the ones of Gabrielle's toilettes, though it is more* *definite and the setting is less formal. As usual, the palette is concentrated on the hat with flowers.*

258

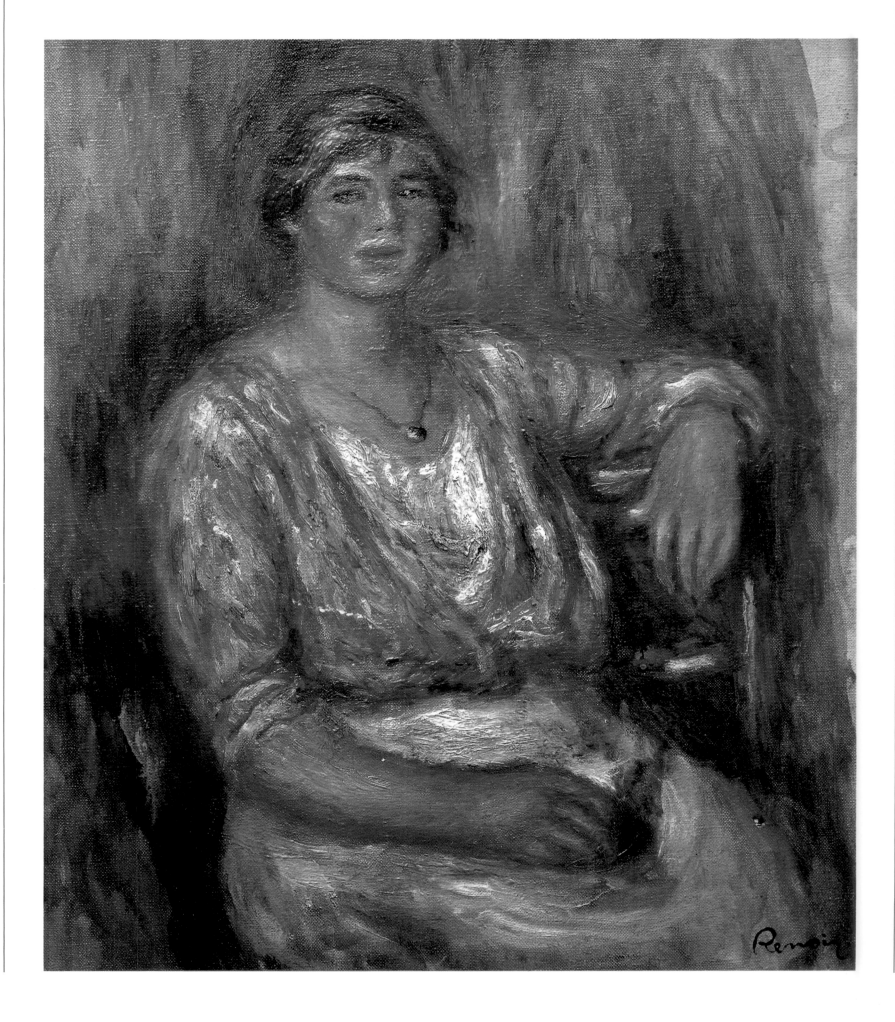

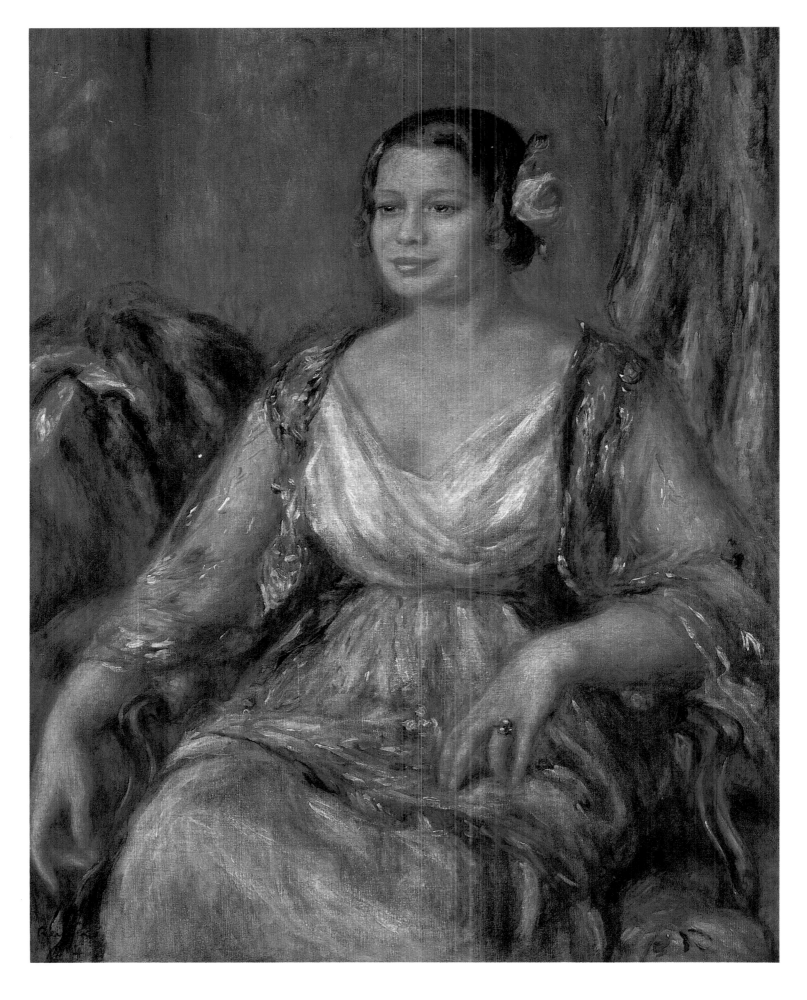

♦ Opposite, The Milkmaid, *1913-14. Oil on canvas, 39 x 32 cm (15 3/8 x 12 1/2 in). Musée des Beaux-Arts, Grenoble.* "I like women best when they don't know how to read and clean their children's behinds," *Renoir said to his son Jean. Above, Portrait of Tilla Durieux, 1914. Oil on canvas, 92 x 74 cm (36 1/4 x 29 1/8 in). Metropolitan Museum of Art, New York. The pose is taken directly from Bronzino's Portrait of Lucrezia Panciatichi in the Uffizi, but the brilliance of the warm, vibrant paint, which almost disintegrates in the light, belongs to Titian's final production. For the German actress Tilla Durieux, the wife of the art dealer Paul Cassirer, Renoir wanted the costume she had worn in Shaw's Pygmalion, in an allusive homage to eternal beauty.*

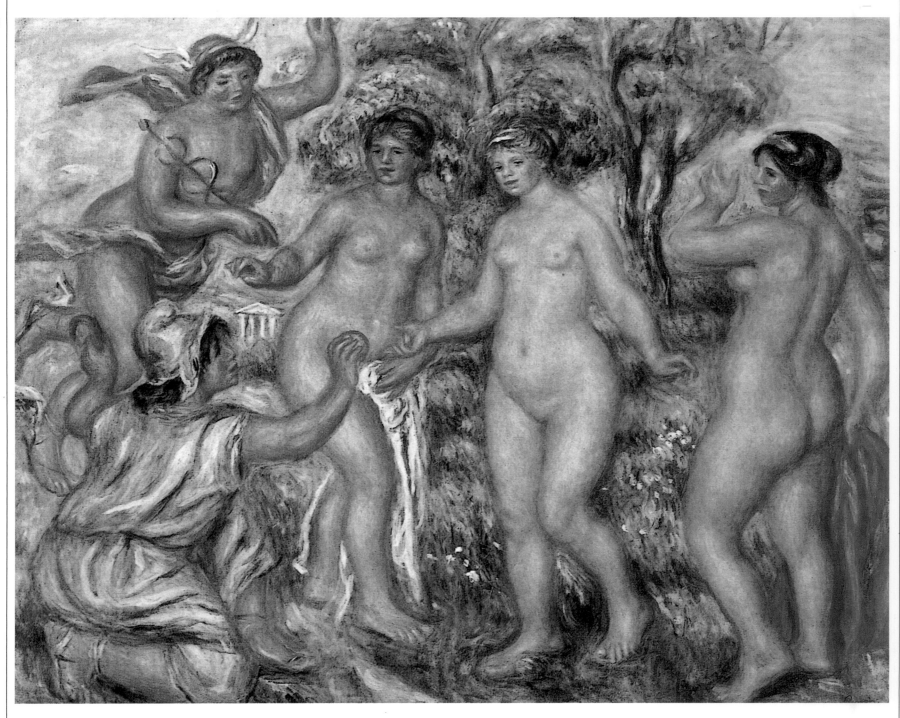

♦ *Above,* The
Judgment of Paris,
*1913-14. Oil on
canvas, 73 x 92 cm
(28 3/4 x 36 1/4 in).
Museum of Art,
Hiroshima.
Compared to the
previous version of
this motif, the space
is animated by a
more rapid brush-*
*stroke and, in a sort
of horror vacui,
Mercury has been
added to the other
figures (the god is in
the Rubens canvas
that served as a
model). The composi-
tion is identical to
the bas-relief that
was to be the base of
Venus Victorious*
*sculpted by Guino in
1914.*
♦ *Opposite,* Sleeping
Odalisque, *1915-17.
Oil on canvas, 50 x
53 cm (19 3/4 x 20
3/4 in). Musée
d'Orsay, Paris.
Another famous
painting in the
Louvre, Correggio's*
*Antiope, was the
model for this
canvas, which has no
narrative aims
whatsoever. As usual,
the dark tones of the
curtains makes a
perfect contrast to the
velvety flesh of this
indolent figure.*

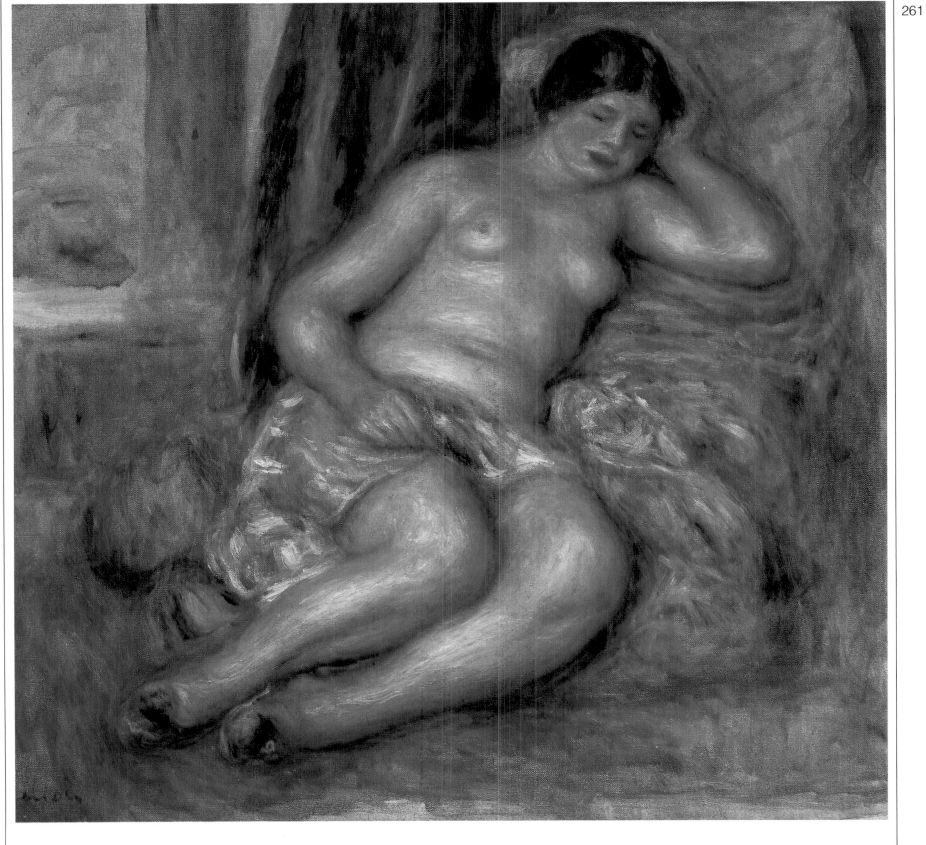

262

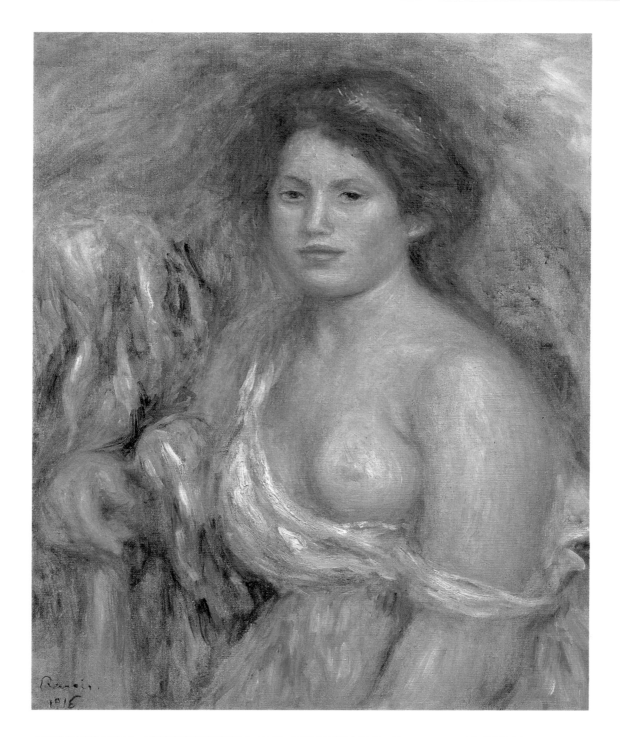

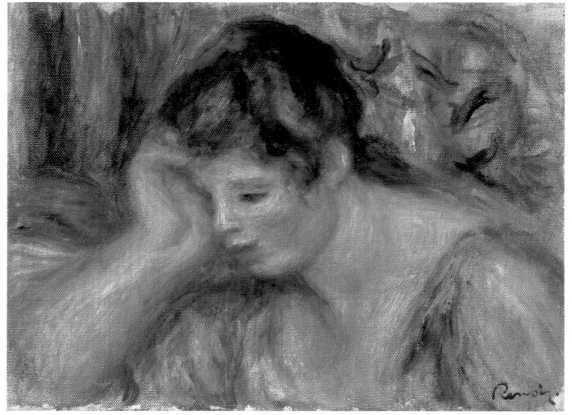

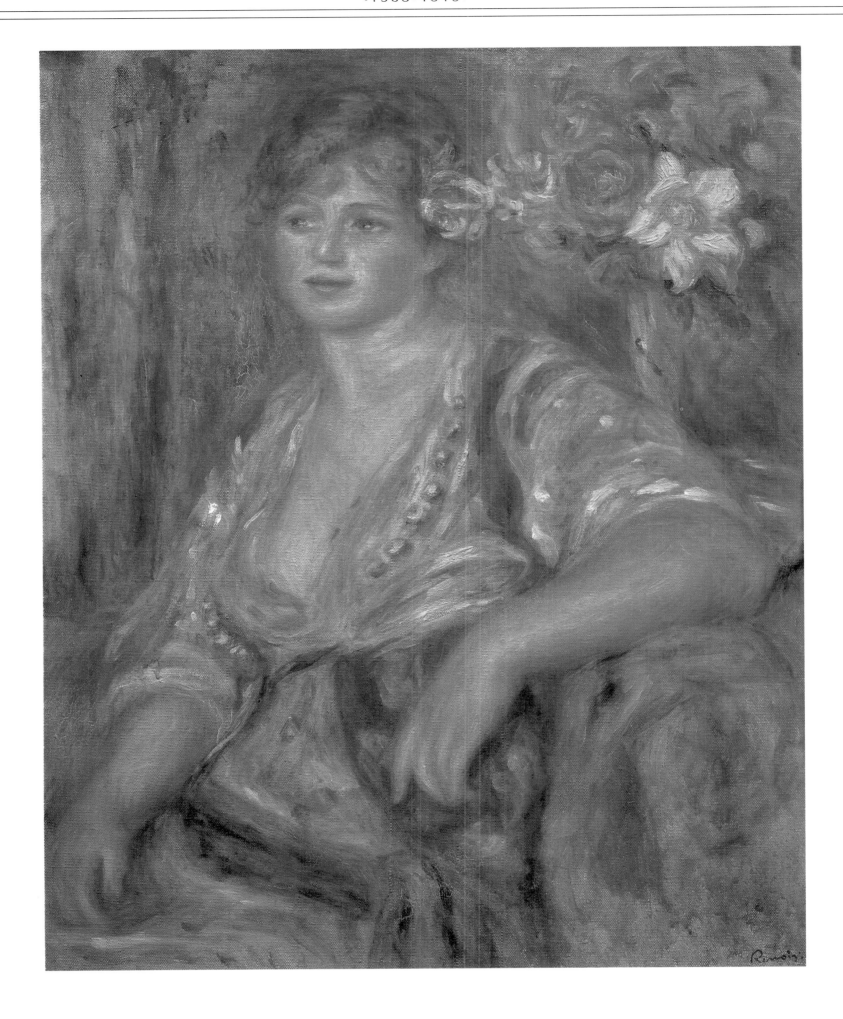

♦ *Opposite above,*
Model with Bare
Breast, *1916. Oil on
canvas, 55 x 46 cm
(21 3/4 x 18 1/8 in).
Musée Picasso,
Paris.*

♦ *Opposite below,*
Woman Leaning on
Her Elbow, *1917-19.
Oil on canvas, 23 x
32 cm (9 x 12 5/8
in) Musée de
l'Orangerie, Paris.*

*Above, Dédée in
Spanish Dress, 1914-
17. Oil on canvas, 65
x 53 cm (25 5/8 x 20
3/4 in). Musée de
l'Orangerie, Paris.
The costume, be it
Greek or Spanish,*
*serves to accentuate
the deliberate
ambiguity of the
setting by inserting
the girl in a
mythical backdrop
that is alien to both
time and space. The*
*model is Andrée
Hessling, known as
Dédée, who
enraptured Renoir
with her white skin
and voluptuous
body. "How
beautiful she is! I*
*have used my old
eyes on her young
flesh, and
understood I was not
a master, but a
child."*

264

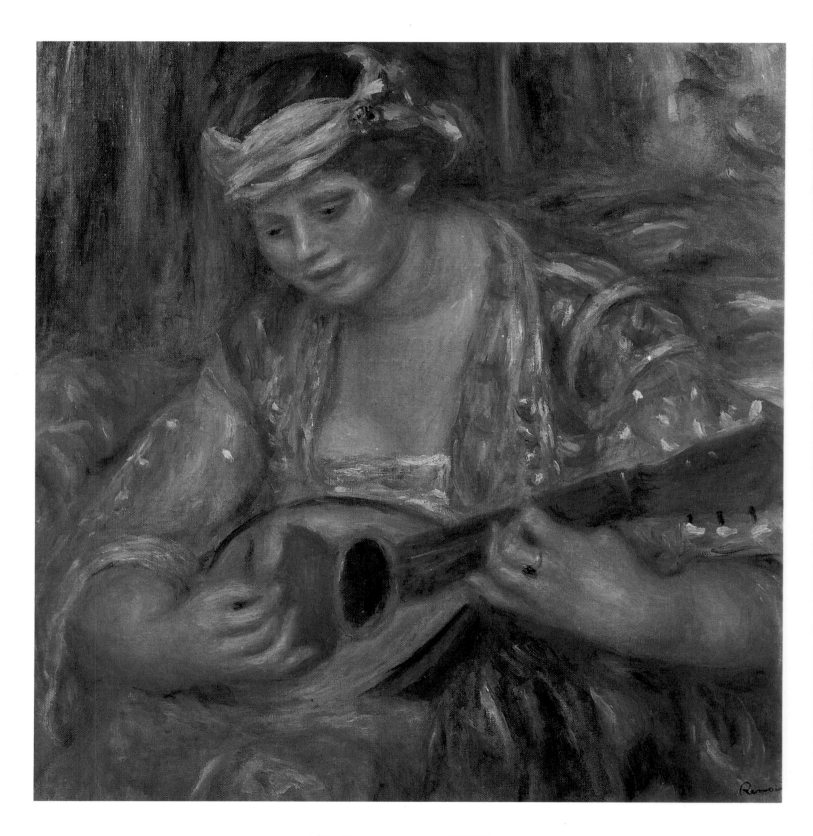

♦ Girl with a Mandolin, *1919. Oil on canvas, 55 x 55 cm (21 3/4 x 21 3/4 in). Private Collection. Dédée again poses in a Spanish or gypsy costume. Compared to the analogous subject painted* *around 1897-97, there is a difference in viewpoint as well as in the handling; here the figure is set in compressed space filled with precious, feathery brushstrokes that are both delicate and decorative.*

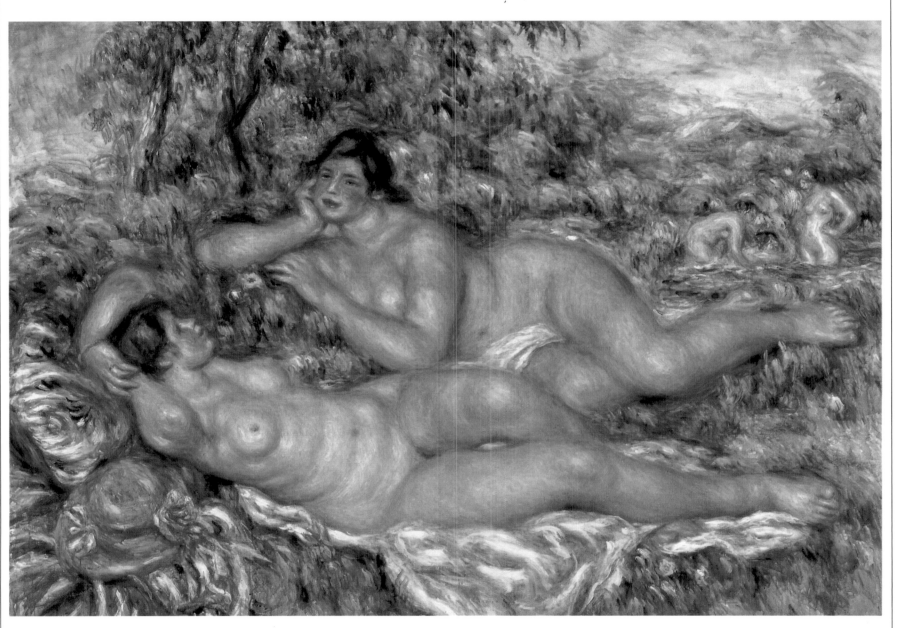

♦ Bathers ("Grandes Baigneuses"), 1918-19. Oil on canvas, 110 x 160 cm (43 1/4 x 63 in). Musée d'Orsay, Paris. "The state of grace comes from the contemplation of God's most beautiful creation, the human body [...] Suffering passes, but beauty remains. I am perfectly happy and will not die before having finished my masterpiece." This remark, made to Matisse, who went to see Renoir at Cagnes, demonstrates the importance the latter placed on this canvas, which was conceived as the testament of his style through a motif he had used all his life. His children tried to respect his wishes in 1923 by offering this work to the French government, which, however, accepted it rather reluctantly, as it was considered "loud." In this final hymn to life (which is so large that the artist had to have a mobile easel on rollers built in his Cagnes garden so that he could paint on the canvas while seated), Renoir reveals the qualities of an intimately perceptive painting procedure that is in total empathy with the senses, which he incorporates in an overall synthesis of his artistic vision. The example of Ingres and the French mannerists, which is quite evident in his magnified nudes, is merged with Rubens's profusion of curves as well as with the fiery, exuberant material properties of the canvas in late Titian. The thick brushstrokes expand the masses, almost deforming the profiles, thus transcending the individuality of the models to achieve the regal volumes of the "eternal feminine."

266

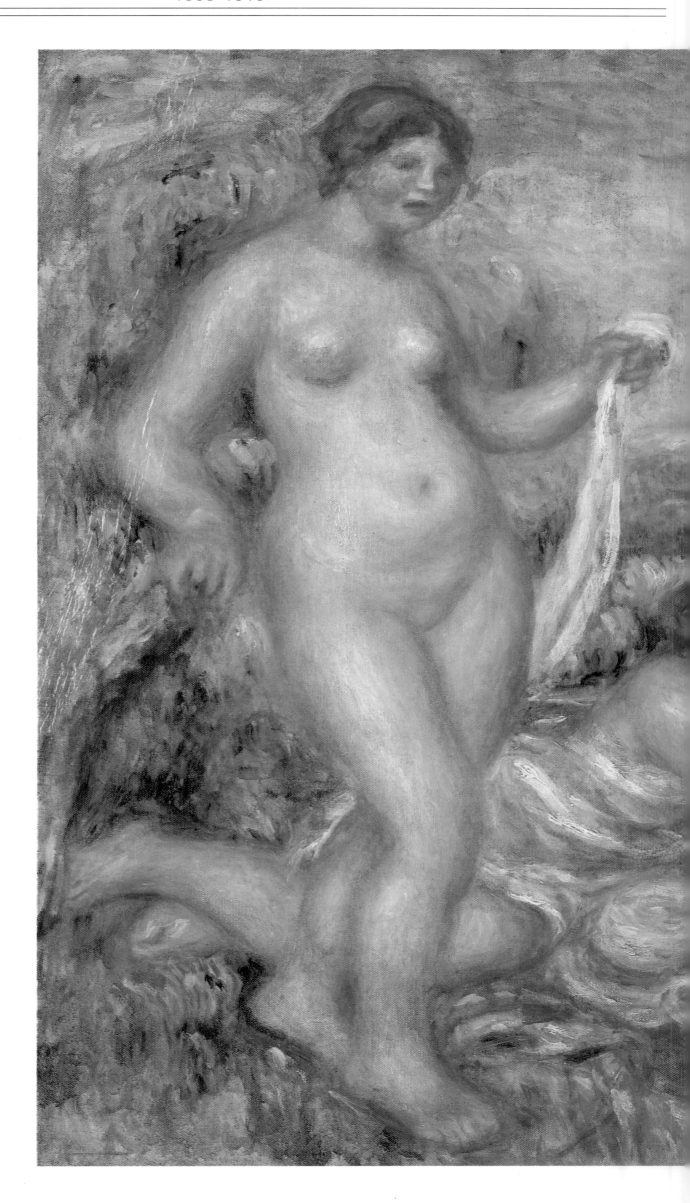

♦ Bathers, ca. 1918. Oil on canvas, 80 x 65 cm (31 1/2 x 25 5/8 in). The Barnes Foundation, Merion, Pa. Without illustrating a particular myth, as he had done with The Judgment of Paris, Renoir totally succeeds in evoking classical imagination in the energy of nature itself (which is mythological per se), personified in the spontaneous and primitive sensuality of the female. In this eminently decorative repertory of poses (which later influenced Matisse and Picasso) the

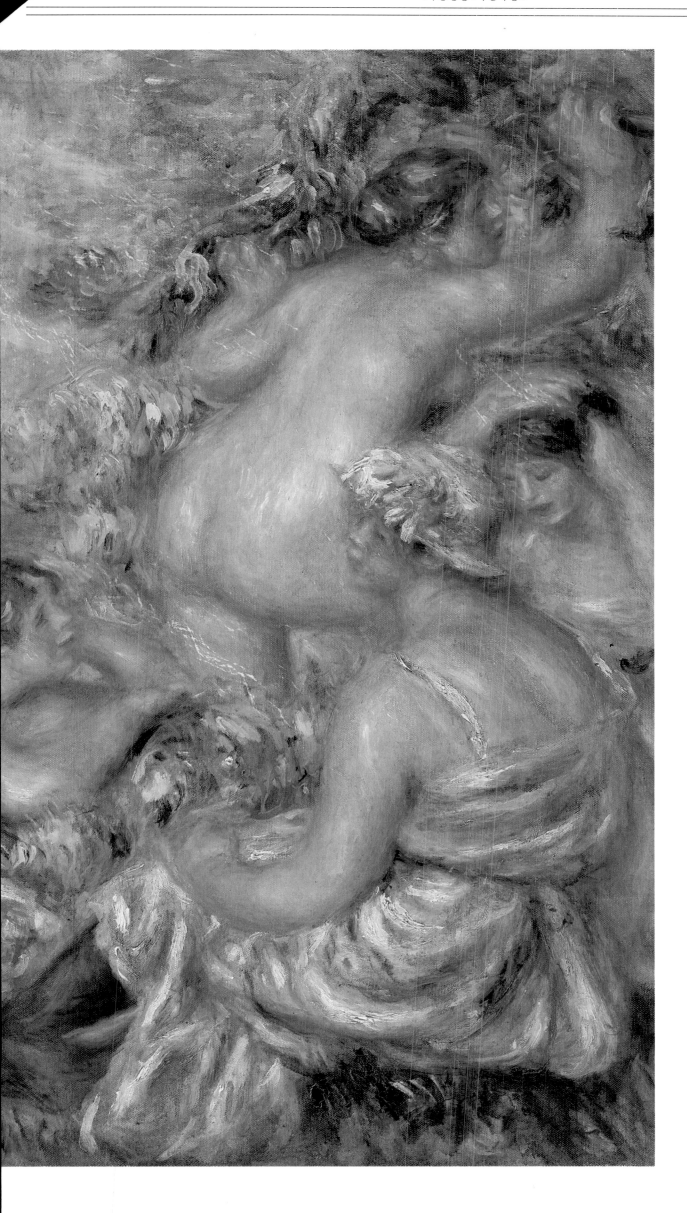

figures are isolated and do not create a narrative relationship among themselves. As in The Grandes Baigneuses of Renoir's "dry" manner, the harmony and relation among the bodies is purely formal, that is, they regard only the mutual rhythm of the volumes and outlines. But whereas at that time Renoir linked the figures through the simple arabesque of the line, now in his mature style it is the sheer physical energy of the colors that does so.

BIBLIOGRAPHY

André, Albert and George Besson. *Renoir*. Paris, 1918.

André, Albert and M. Elder Bernheim-Jeune. *L'Atelier de Renoir*. Paris, 1921.

Aurier, Albert. *Renoir*. In *Oeuvres postumes*, Paris, 1893.

Bade, Patrick. *Renoir*. Paris and Torriano (Fo), Italy, 1989.

Barnes, Albert C. and V. De Mazia. *The Art of Renoir*. New York, 1935.

Baudot, Jeanne. *Renoir, ses amis, ses modèles*. Paris, 1949.

Bessonova, M. and W. J. Williams, eds. *Impressionism and Post-Impressionism*. St. Petersburg and New York, 1986.

Bouchardeau, Huguette. *La famille Renoir*. Paris, 1994.

Burty, Philippe. "Exposition de la Société Anonyme des Artistes." *La Republique Française*, 25 April 1874.

Castagnary, Jules. "L'exposition du Boulevard des Capucines, Les Impressionnistes." *Le Siècle*, 23 April 1874.

Centenaire de l'impressionnisme. Exhibition Catalogue. Paris, 1974.

Daulte, François. *Auguste Renoir. Catalogue raisonné de l'oeuvre peint*. Lausanne, vol. 1, 1971; vols. 2-5, 1972.

Denis, Maurice. "Le salon du Champ de Mars, l'exposition Renoir." *La Revue Blanche*, 25 June 1892.

Denvir, Bernard. *Impressionismo. I pittori e le opere*. Florence, 1991. 1st ed. London, 1988.

Distel, A., J. House, J. Walsh, Jr. *Renoir*. Exhibition Catalogue (Hayward Gallery, London, 30 January-21 April 1985; Grand Palais, Paris, 14 May-2 September 1985; Museum of Fine Arts, Boston, 9 October 1985-5 January 1986). Paris, 1985.

Distel, Anne. *Les collectionneurs des impressionnistes, amaterus et marchands*. Düdingen, 1989.

Duranty, Edmond. *La Nouvelle Peinture. À propos du groupe d'artistes qui expose dans les galeries Durand-Ruel*. Paris, 1876.

Durbè, Dario and Anna Maria Damigella. *La scuola di Barbizon*. Milan, 1967.

Duret, Théodore. *Histoire des peintres impressionnistes*. Paris, 1906.

Feist, Peter H. *Auguste Renoir, 1841-1919. Un sogno di armonia*. Cologne, 1990.

Fezzi, Elda. *L'opera completa di Auguste Renoir, 1869-1883*. Milan, 1972.

Fosca, François. *Renoir, l'homme et son oeuvre*. Paris, 1961.

House, J., K. Adler and A. Callen, eds. *Renoir: Master Impressionist*. Exhibition Catalogue (Queesland Art Gallery, Brisbane, 30 July-September 11, 1994; National Gallery of Victoria, Melbourne, 18 September-October 30, 1994; Art Gallery of New South Wales, Sydney, 5 November 1994-15 January 1995). Art Exhibitions Australia, 1994.

Howard, Michael, ed. *Gli impressionisti. La vita e le opere attraverso i loro scritti*. Novara, Italy, 1992. 1st ed. London, 1991.

Katz, Robert. *The Impressionists in Context*. Enderby, 1991.

Lhote, André. *Peintures de Renoir*. Paris, 1944.

Loyrette, G. and G. Tinterow. *Impressionisme. Les origines 1859-1869*. Exhibition Catalogue (Grand Palais, Paris, 19 April-8 Agust 1994; Metropolitan Museum of Art, New York, 19 September 1994-8 January 1995). Paris, 1994.

Mauclair, Camille. *L'impressionnisme, son histoire, son esthétique, ses maîtres*. Paris, 1904.

Meier-Graefe, Julius. *Auguste Renoir*. Munich, 1911. Paris, 1912. Leipzig, 1929.

Mirbeau, Octave. *Renoir*. Paris, 1913.

Monneret, Sophie. *Renoir*. Paris and Milan, 1989.

Ojetti, Ugo. "Mostra individuale di Pierre-Auguste Renoir." In *Catalogo IX Esposizione Internazionale d'Arte della Città di Venezia*. Venice, 1910, pp. 36-41.

Pach, Walter. *Pierre-Auguste Renoir*. Paris, 1950.

Perruchot, H. *La vie de Renoir*. Paris, 1964.

Pevsner, Nicolaus. *Le Accademie d'arte*. Turin, 1982. 1st ed. Cambridge, 1940.

Renoir, Claude. *Seize aquarelles et sanguines de Renoir*. Paris, 1948.

Renoir, Edmond. "La Vie Moderne," 19 June 1879.

Renoir, Jean. *Renoir*. Paris, 1962. *Renoir mio padre*. Milan, 1963.

Rewald, John. *La storia dell'impressionismo. Rievocazione di un'epoca*. Milan, 1976. 1st ed. New York, 1946. 4th rev. ed. New York, 1973.

Rivière, Georges. "Les intransigeants et les impressionnistes. Souvenir du Salon libre de 1877." *L'artiste*, 1 November 1877.

L'Impressionniste, Journal d'art, 6-28 April 1877 (with contributions by P.-A. Renoir). *Renoir et ses amis*. Paris, 1921.

Roger-Marx, Claude. *Renoir*. Paris, 1933.

Rouart, Denis. *Renoir*. Geneva, 1954.

Renoir. Geneva and Rome, 1990.

Venturi, Lionello. *Les Archives de l'Impressionnisme*. Paris, 1939.

Vollard, Ambroise. *Tableaux, pastels et dessins de Pierre-Auguste Renoir*. Paris, 1918.

Vollard, Ambroise. *La vie et l'oeuvre de Pierre-Auguste Renoir*. Paris, 1919.

Vollard, Ambroise. *Recollections of a Picture Dealer*. Boston, 1935. *Souvenirs d'un marchand de tableaux*. Paris, 1937.

Wattenmaker, R., ed. *I capolavori della Barnes Foundation. Da Manet a Matisse*. In A. Distel, Exhibition Catalogue (Musée d'Orsay, Paris, 6 September 1993-2 January 1994). Milan, 1993.

Wolff, Albert. "Les Impressionnistes." *Le Figaro*, 3 April 1876.

Wyzéwa, Théodore de. "Pierre-Auguste Renoir." *L'art dans les deux mondes*, 6 December 1890.

INDEX

*This is an index of Renoir's works
and of people and places.
Numbers in roman characters refer to page numbers,
bold numbers to color plates
and italicized numbers to captions.*

REFERENCES